Islamic Arts Jonathan Bloom and Sheila Blair

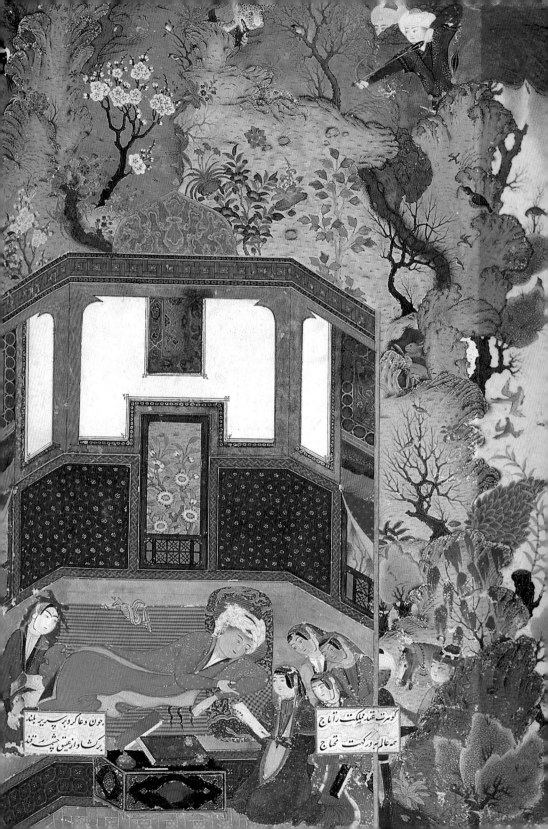

Islamic Arts

Opposite
*Bahram Gur in
the Green
Pavilion* (detail),
from a copy
of Nizami's
Khamsa
prepared for
several 15th-
century
princes.
Ink and colour
on paper;
30 × 19.5 cm,
11⁷⁄₈ × 7²⁄₃ in.
Topkapi Palace
Library, Istanbul

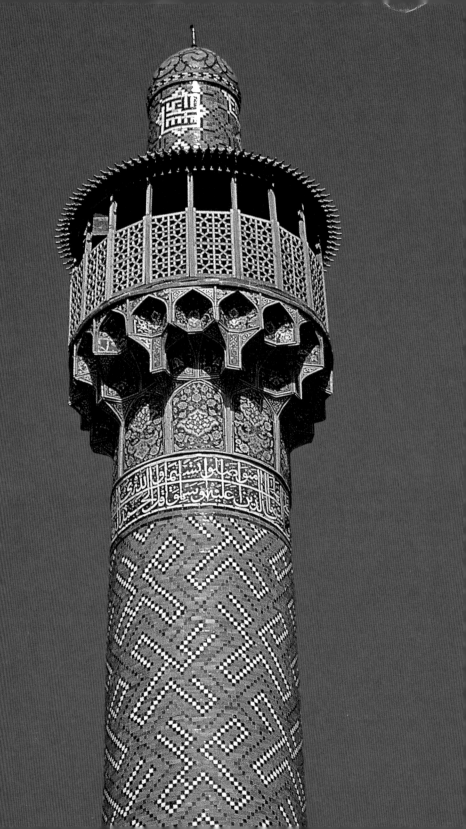

Introduction

The term 'Islamic art' refers not only to the art made for Islamic practices and settings but also to the art made by and for people who lived or live in lands where most – or the most important – people were or are Muslims, that is believers in Islam. The term is, therefore, used somewhat differently than such comparable terms as 'Christian' or 'Buddhist' art: Islamic art refers to the arts of all Islamic cultures and not just to the arts related to the religion of Islam. Indeed, as we shall see, specifically religious art plays a relatively small role in the great variety of Islamic art.

It is easier to say what Islamic art is not than what it is. Unlike such terms as 'Renaissance' or 'Baroque', 'Italian' or 'French', Islamic art refers neither to art of a specific era nor to that of a particular place or people. Whereas the art of Anatolia (now Turkey) was decidedly not Islamic in 1000 AD but was Islamic 500 years later, the art of Spain was Islamic in 1000 AD but was decidedly not five centuries later. Islamic art is neither a style nor a movement, and the people who made it were not necessarily Muslims, so that we cannot define it by confessional affiliation of the makers. Whereas some Islamic art was undoubtedly made by Christians and Jews for Muslim patrons, some 'Islamic' art made by Muslims was intended for Christians or Jews.

In short, the idea of Islamic art – beginning in seventh-century Arabia and encompassing by the fifteenth century all the lands between the Atlantic and the Indian oceans, the steppes of Central Asia and the deserts of Africa – is a distinctly modern notion generated not by Islamic culture itself but by outsiders. No artist or patron mentioned in this book ever thought of his work as an example of 'Islamic' art, although it is possible that artists at some times and places may have thought of their work in geographical or dynastic terms, such as 'Syrian' and 'Egyptian'

or 'Ottoman' and 'Mughal'. Paradoxically, restrictive geographic and ethnic rubrics, such as 'Indian' or 'Hindu', 'Persian', 'Turkish', 'Arab', 'Moorish' and 'Saracenic', which had been popular in early nineteenth-century Europe to refer to the arts of a specific region or period, came to be replaced by the end of the century with such all-embracing terms as 'Mohammedan' or 'Islamic' and 'Moslem/Muslim'. These terms bring together ideas and works of art that were not necessarily grouped together in their own time. For example, the Alhambra (2) and the Taj Mahal (3) are two examples of Islamic art, but it is unlikely that the builders of one ever thought that the other had much, if anything, to do with it.

The use of these new terms reflects the impact of nineteenth-century scholarship on the Orient which based its understanding of contemporary kaleidoscopic realities on the presumed unity of an imagined golden age of Islamic civilization a thousand years earlier. In the twentieth century this model of a unified Islamic civilization has continued to be elaborated by scholars from the West and the Islamic lands alike. For Westerners it continues to be easier to understand one tradition than a dozen; for those from the Islamic lands, many of which threw off the yokes of European colonialism and gained power in the petroleum-based world of the twentieth century, the great pan-Islamic tradition imagined for the past has existed uneasily alongside the conflicting claims of national and regional cultures. One can easily find many books and exhibitions devoted to, say, Persian or Turkish art, both before and during the Islamic period. Nevertheless, there are many features that connect the various arts of all the Islamic lands, and it is the purpose of this book to underscore these common features without minimizing the differences between Spain and India, or Anatolia and Egypt.

In world history, the heyday of Islamic civilization is the millennium from the seventh to the seventeenth century. This is the period between the collapse of the Roman and Byzantine empires and the rise of western European nation-states. During this time, the heartlands of the Islamic world – Syria, Egypt, Iraq and Iran –

were the pivots of transcontinental trade between East and West in such luxuries as silk textiles and spices. In the centuries before the Portuguese discovered a sea route around Africa to India and the Europeans discovered the Americas, the Islamic lands were truly the middle ground, and they prospered. After these discoveries, however, the world economy shifted from the centre of the Eurasian landmass to its fringes and to the New World, and the Islamic lands suffered. The discovery of huge petroleum reserves under the desert sands has again transformed the economies of this region. The cultural implications of this great new wealth are still emerging.

There are many ways to slice up a chronological pie. We have chosen here to divide Islamic history into three periods. The early period encompasses the origins of Islam and the emergence of Islamic societies until the year 900. During this period, most if not all of the Islamic lands were united under a single caliph who ruled from Arabia, Syria or Iraq. The middle period covers the breakup of the caliphate in the tenth century and the emergence of many regional powers with distinct artistic traditions. In the late period most of the Islamic lands were ruled by one of the great imperial superpowers – the Ottomans in the Mediterranean lands, the Safavids in Iran, and the Mughals in India. Even where these powers did not rule directly, their cultural institutions created the norms for artistic expression.

The arts of the Islamic lands differ from those of the West, where for centuries the Christian Church was the major patron of, and inspiration for, the arts. Muslims were no less religious than their Christian brethren, but Islam never developed institutions comparable to those that played such an important role in the making of Christian art. There were, for example, no clerical officials comparable to popes or bishops to commission mosques or works of art for them, although secular rulers and private individuals often did so. The major forms of Western art, apart from architecture, are painting and sculpture, which were used to make religious images used in worship. Although architecture plays comparable roles in

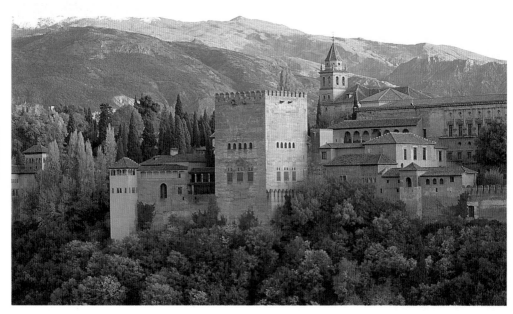

2
Alhambra palace, Granada,
Spain, 13th century and later

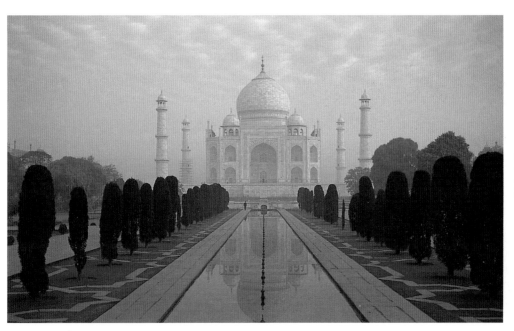

3
The Taj Mahal, Agra, India,
1631–47

Islamic art and Western art, there is little, if any, large-scale painting or sculpture in Islamic art. This lack of painting and sculpture is often attributed to a supposed prohibition in Islam against representing the human form, but as we shall see, this explanation is wrong. Rather, there was no place in Islamic religious art for the depiction of God.

By contrast, the arts often considered 'minor' or 'decorative' in the Western scheme of things, played a major role in Islamic culture. The arts of the book were culturally the most important, principally because of the veneration accorded to writing God's revealed word. The significance of writing spilled over into the other arts, as inscriptions were added to all works of art from buildings to coins. The significance of writing also carried over into the secular realm, and beautifully copied books came to be illustrated with exquisite paintings. Textiles were economically the most important of the arts, for they were the basis of many medieval Islamic economies. Before the widespread use of paper and pictures, textiles provided a ready means of transferring artistic ideas and designs from one region to another. Many of the other arts important in the Islamic lands – ceramics, glass and metalwork – can be subsumed under the rubric 'arts of fire', for they are based in the transformation by fire of minerals extracted from the earth. Other arts, such as carved rock crystal and ivory, often show many of the same techniques and motifs of decoration. Within each chronological section, therefore, we have divided the arts into architecture, the arts of writing and the book, textiles, and the other arts.

This book is a narrative that touches on many significant facets of Islamic culture, particularly those that are expressed visually in architecture and the other arts. Within each chapter we have adhered to a roughly chronological framework but have painted with broad strokes. Our premise is that art is a window into culture and history, and that works of art were created with specific intentions and meanings that demand to be explained. We have put forward only some of the possible hypotheses, but

with time and more knowledge, others will undoubtedly emerge. Indeed, much of our excitement about Islamic art is due to the new discoveries and interpretations possible.

We have tried to present a complicated subject in the most accessible manner possible. We have used English words wherever appropriate and have made generalizations without citing every exception. We have also used a simplified system to transcribe words taken from Arabic, Persian and Turkish. Those who know these languages will recognize the simplifications we have made to avoid frightening the novice; those who don't know won't care.

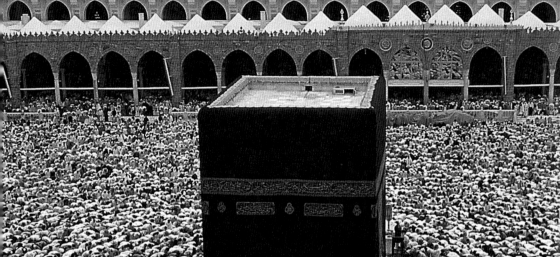

Islam, derived from an Arabic word meaning 'submission [to God]', is the latest of the great world religions to emerge. It was revealed to the Prophet Muhammad in the early seventh century of the Christian era. Muhammad had been born about the year 570 in Mecca, a city in western Arabia that had long been a centre of both commerce and religion. It was ruled by a tribe called the Quraysh, who were the guardians of a pagan shrine there known as the Kaaba (from the Arabic word for cube, on account of its shape). About 610, Muhammad began to receive his revelations from the angel Gabriel about the one God (or, in Arabic, *allah*), and began to preach to his fellows that those who accepted his teachings and became 'Muslims', that is, agreed to submit themselves to God, would prosper; all those who turned away in contempt would face fearful retribution in this world and the next. These revelations are known as the Koran, from the Arabic word for recitation.

Muslims accept the teachings of both the Jewish Torah and the Christian Gospels because they believe that Islam is the perfection of the religion revealed first to Abraham (who is therefore the first Muslim) and later to other prophets, including Jesus. Muslims believe that Jews and Christians have been led astray from God's true faith but hold them in higher esteem than pagans and unbelievers. They called Jews and Christians the 'People of the Book' and for centuries allowed them to practise their own religions in Islamic lands.

By Muhammad's time religions such as Christianity and Zoroastrianism had become complicated in both ritual and organization. Islam, in contrast, was simplicity itself: believers worshipped God directly without the intercession of priests or clergy or saints. Even today, to be faithful to their religion,

4
View of the Kaaba at Mecca surrounded by worshippers

Muslims have only to follow five rules, the so-called Five Pillars of Islam. The first rule is to testify that 'There is no god but God and that Muhammad is his messenger.' The second is five times a day – at dawn, noon, midafternoon, sunset and early evening – to wash according to a particular ritual and then to pray by prostrating oneself and reciting certain phrases while facing in the direction of Mecca, a rite that takes only a few minutes to perform and can be done anywhere. On Fridays, in addition, all men are required to gather together for the noon prayer and listen to a sermon by the leader of the community.

The third rule is not to eat or drink from sunrise to sunset during the month of Ramadan, the ninth month in the Muslim calendar. Since Muslims measure their year by the cycles of the moon rather than the sun, it is eleven days shorter than the Christian solar calendar, and because they are forbidden to adjust it by adding an extra month (as is done in the Jewish lunar calendar) the months of the year do not relate to the seasons. Ramadan therefore regresses around the Christian or seasonal year, from the autumn to the summer, when days are long and hot, to the spring and winter, when days are short and cool.

The fourth rule is to give alms to the poor; Muslims are supposed to donate a fixed amount of their income to charity. The fifth rule is to go on a pilgrimage to Mecca, called in Arabic a *hajj,* at least once in one's lifetime, if one is able, during the first days of the twelfth month, called Dhu'l-Hijja, of the Muslim calendar; that month too moves around the seasonal calendar year by year. The ceremonies of the pilgrimage are associated with Abraham and centre on the Kaaba (4), which Muslims believe to be the house that Abraham erected for God. This cubical structure now lies in the centre of the Haram Mosque at Mecca. The pilgrimage then moves to Arafat, a plain 20 km (12 miles) east of the city, where the ceremonies culminate on the tenth day of the month in the Feast of the Sacrifices. Livestock is sacrificed in commemoration of the readiness of Abraham, the first Muslim, to sacrifice his son.

Although the new religion incorporated many practices from earlier times, the teachings of Muhammad nevertheless challenged the pagan religion of the Meccans who worshipped many gods. In 622 he and the small band of followers he had converted to the new religion were forced to flee from Mecca, and they went to an oasis some 300 km (200 miles) to the north. This flight, called the Hegira, from the Arabic word for emigration, was later taken to mark the beginning of the Muslim polity and the new Muslim era, so that Muslims date events as coming after the Hegira, much as Christians date events as coming after the birth of Christ. The oasis the Muslims settled in was called Medina (from the Arabic word for city, in this case by implication, *the* city of the Prophet). Muhammad eventually became both its political and spiritual leader, replacing earlier ties of community based on kinship with the tie of voluntary submission to the will of God. Within a few years all the neighbouring tribes had been brought into the Muslim fold – whether voluntarily or by force. Even Muhammad's old enemies, the Quraysh of Mecca, were forced to accept his doctrines before his death in 632.

5 Overleaf
The Islamic
World,
c.900 AD

Under Muhammad's successors, known as caliphs (from the Arabic word for follower), Islam spread with amazing rapidity, as brilliant military campaigns succeeded against fortuitously weakened adversaries. Within a decade, all of Arabia had been conquered by the armies of Islam. Palestine and Syria were taken from the Byzantine Empire, which had ruled the region from its capital at Constantinople as the successor to Rome since the fourth century. Iraq and Iran were taken from the Persian Sasanian dynasty, who had ruled the area from their splendid palace at Ctesiphon near present-day Baghdad. Egypt, another Byzantine province, fell to Muslim-led armies in 646. The armies moved swiftly across North Africa to the Atlantic, crossed the Straits of Gibraltar in 711 to take the Iberian Peninsula from the Visigoths, and advanced into France until they were finally stopped by Charles Martel, King of the Franks, at the Battle of Poitiers in 732.

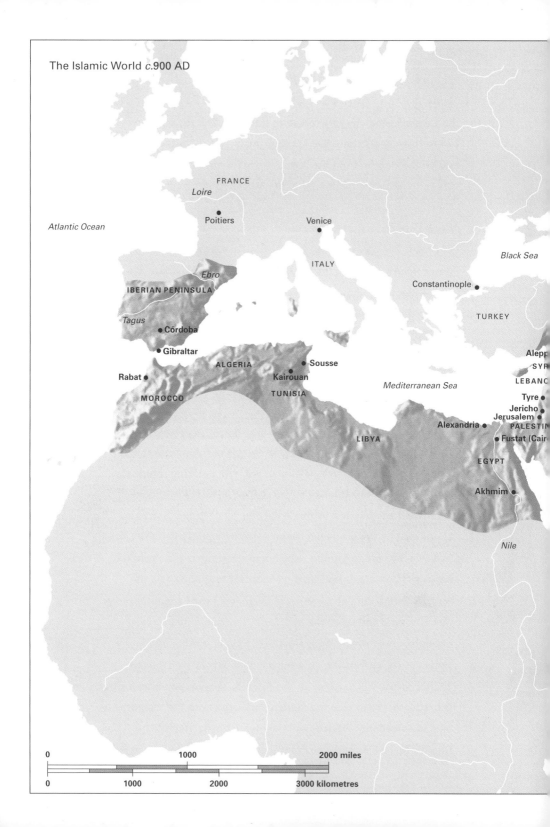

The Islamic World *c.*900 AD

Atlantic Ocean

FRANCE
Loire
● Poitiers
● Venice
ITALY

Black Sea

Constantinople ●

TURKEY

Ebro
IBERIAN PENINSULA
Tagus
● Córdoba
● Gibraltar

Alepp
SYR
LEBANO
Mediterranean Sea
Tyre ●
Jericho ●
Jerusalem ●
PALESTIN

ALGERIA
● Sousse
Kairouan ●
TUNISIA

Rabat ●
MOROCCO

LIBYA

Alexandria ●
● Fustat (Cair

EGYPT

Akhmim ●

Nile

0 1000 2000 miles

0 1000 2000 3000 kilometres

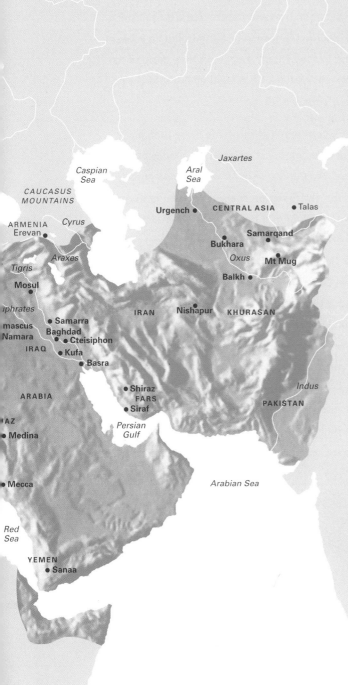

Pazyryk ●

Jaxartes

Caspian
Sea

Aral
Sea

CAUCASUS
MOUNTAINS

Urgench ● CENTRAL ASIA ● Talas

ARMENIA *Cyrus*
Erevan ● Samarqand ●
 Bukhara ●
Araxes *Oxus* Mt Mug ●
Tigris Balkh ●
Mosul ●

uphrates IRAN ● Nishapur KHURASAN
mascus ● Samarra
Namara ● Baghdad
 ● Cteisiphon
IRAQ ● Kufa
 ● Basra

ARABIA ● Shiraz
 FARS
 ● Siraf *Indus*
AZ PAKISTAN
● Medina *Persian*
 Gulf

● Mecca *Arabian Sea*

Red
Sea

YEMEN
 ● Sanaa

The Muslim advance to the east was equally swift and far-reaching. In 667 the Arabs crossed the Oxus river (Amu Darya), the traditional boundary between Iran and Central Asia. By 751 they had met and vanquished the Chinese near Samarqand (in present-day Uzbekistan) at the Battle of Talas, but there they decided to halt their eastward march, perhaps because they felt that they had overextended their supply lines.

All these conquests (5), completed within little more than a century after Muhammad's death, established the extent of the Islamic lands from Spain to Central Asia for centuries to come. With some variation, the entire region shares common features of geography and climate. Most of it is arid – mountain, steppe or desert – and short of drinking water, but it has a few great rivers – the Nile in Egypt, the Tigris and Euphrates in Iraq, the Oxus and Jaxartes (Syr Darya) in Central Asia – that provided water for agriculture through canals and vast irrigation schemes that had been in use for millennia to increase the amount of cultivated land. Because of the scarcity of water, only a few regions could support large populations. In most places settlements were scattered amid vast empty expanses inhabited only by nomads who raised the sheep, goats and camels that provided meat and transportation for the settled population and fertilizer for their fields. Settled populations made goods and provided markets for the nomads.

Mosques, Mansions and Mosaics The Arts of Building

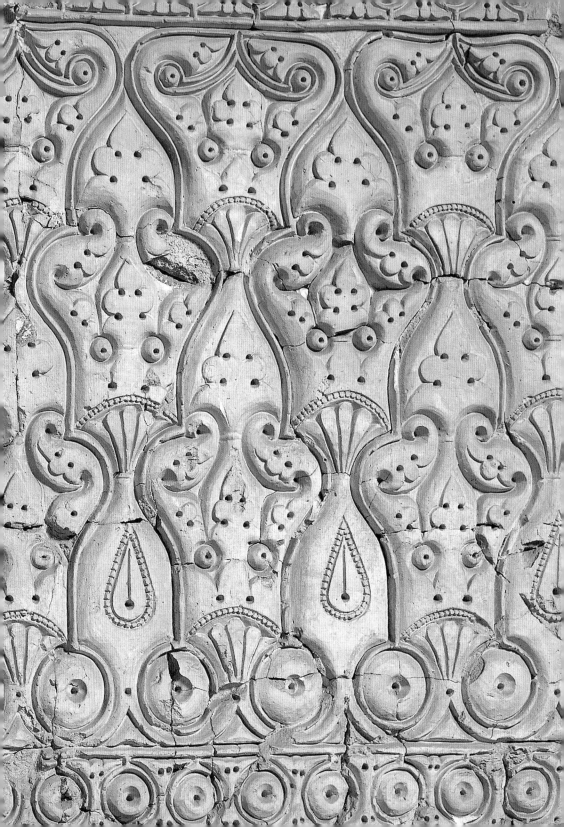

In Medina Muhammad built a house that also served as a kind
of community centre and as a prayer hall. Since that time it has
become one of the most venerated places in Islamic lands and has
been repeatedly enlarged and restored. We do not know what it
originally looked like; there are descriptions of it, but they were
written much later and it is difficult to know how accurate they
are. It seems clear, however, that like all buildings in an Arabian
oasis, the house was a simple structure built of bricks made of
sun-dried mud (adobe) around a central open courtyard (7). Along
its north and south walls there were porches made of palm tree
trunks with thatched roofs made of palm fronds. These many-
columned, or 'hypostyle' spaces provided shelter and shade from
the blazing Arabian sun for the faithful as they worked, prayed or
rested. Muhammad, his wives and his family lived in small rooms
along the western side. This house had three features that later
became requirements for all buildings used for communal prayer:
a praying space, a way of showing the direction of Mecca (known
in Arabic as the *qibla*) so that the worshippers would know which
way to face for prayer, and some sort of covering to protect
worshippers from the weather. Buildings with these features are
known as mosques, or in Arabic *masjid*, 'a place of prostration'.

Following the rapid spread of Islam, wherever Muslims settled in
this vast region, they first required a place for their Friday congre-
gational prayer. Since Muhammad had not specified the form
these buildings should take, Muslims used whatever came to
hand. In old cities such as Damascus in Syria, sometimes they
purchased a church from the Christians, sometimes they shared a
church with them, and sometimes they expropriated one. In new
cities, first founded as garrisons for the army, such as Basra and
Kufa in Iraq and Fustat (now part of Cairo) in Egypt, they built new
buildings on the model of the Prophet's house in Medina, with a

6
Stucco wall-
panel moulded
in the bevelled
style, Samarra

central courtyard surrounded by columned porches. Although these structures provided shade, they were largely open to the elements; in some cases they did not even have walls, but were marked out by ditches.

Muhammad's house, Medina, as it may have appeared before his death in 632. Reconstruction drawing

As far as we know, these first mosques had no decoration. The Muslim community showed no interest in making buildings beautiful until the reign of the caliph Abd al-Malik (r.685–705). He belonged to the first Islamic ruling dynasty, known as Umayyads because they were descended from a Meccan clan named Umayya, who were distant relatives of the Prophet. The first Umayyad came to power after the fourth caliph, Ali, who was the Prophet's cousin, son-in-law and first convert to Islam, had been assassinated in 661. One of Abd al-Malik's predecessors, then governor of Syria, had seized power and moved the capital from Mecca to Damascus, the capital of Syria and an ancient city with a great architectural heritage. These first Umayyads were too busy gaining power and quelling civil wars to have time for building, but after Abd al-Malik ended all this strife in 692, he began to erect splendid buildings in all the most important cities of his realm.

One of these cities was Jerusalem, long holy to Jews and Christians, but also important to Muslims from the very beginning of Islam because it was the first *qibla* toward which one turned to pray until Muhammad received his revelation in 624 that Muslims

should instead direct their prayers towards the Kaaba in Mecca. Jerusalem was also believed to be the 'furthest place of prayer' from which Muhammad made a miraculous night journey to heaven that is mentioned in Chapter 17 of the Koran. When Muslim armies conquered Jerusalem in 638, they found the Temple Mount – the traditional religious centre of Jerusalem where Solomon's Temple had once stood – in ruins, abandoned since the Romans destroyed the Second Temple in 70 AD. Development after that had shifted to Golgotha, the hill to the west of the Temple Mount where Christ was crucified and buried and where the emperor Constantine, who converted the Roman Empire to Christianity, had erected a magnificent church called the Holy Sepulchre in the fourth century.

A Christian pilgrim named Arculf, who came from Britain to Jerusalem on a pilgrimage a few decades after the Muslim conquest, noted that the 'Saracens' (as the Muslims were called in the West) had already erected a crude, if large, mosque on the otherwise abandoned Temple Mount, but at the end of the seventh century Abd al-Malik ordered the entire area renewed. Its walls and gates were repaired or rebuilt, some administrative buildings were constructed, and two magnificent structures were erected on the platform where the Temple had stood. The first of these, known as the Dome of the Rock, stood in splendid isolation in the centre of the platform, built over a rocky outcrop variously identified as the place of Adam's burial, Abraham's sacrifice of his son, Muhammad's night journey, and the Holy of Holies of the ancient Jewish temple. In the rock is a room-sized cave.

The Dome of the Rock is often called the first work of Islamic architecture (8), and if it is, the building must be the finest first effort in the history of architecture. Its architect – whoever he may have been – was certainly acquainted with late antique and Byzantine buildings in Syria and Palestine, for those were its inspiration. In typical Byzantine buildings, beautifully coloured marble columns and piers sheathed in plaques of veined marble support arches and walls. The walls are covered with more marble

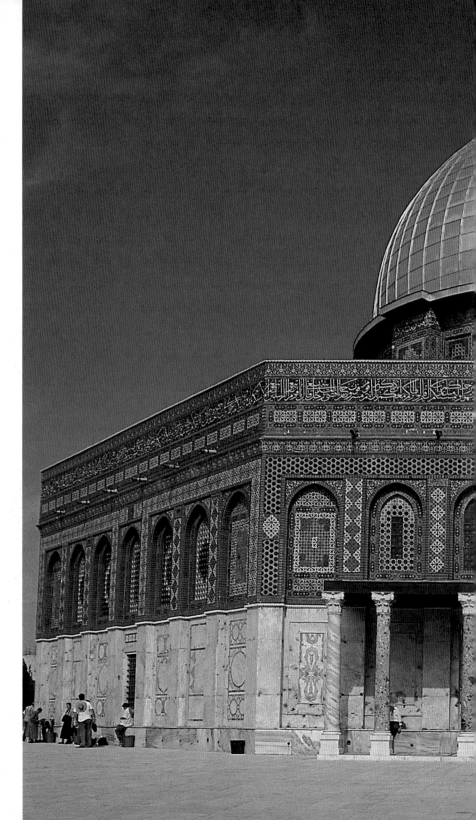

8
The Dome
of the Rock,
Jerusalem,
692 and later

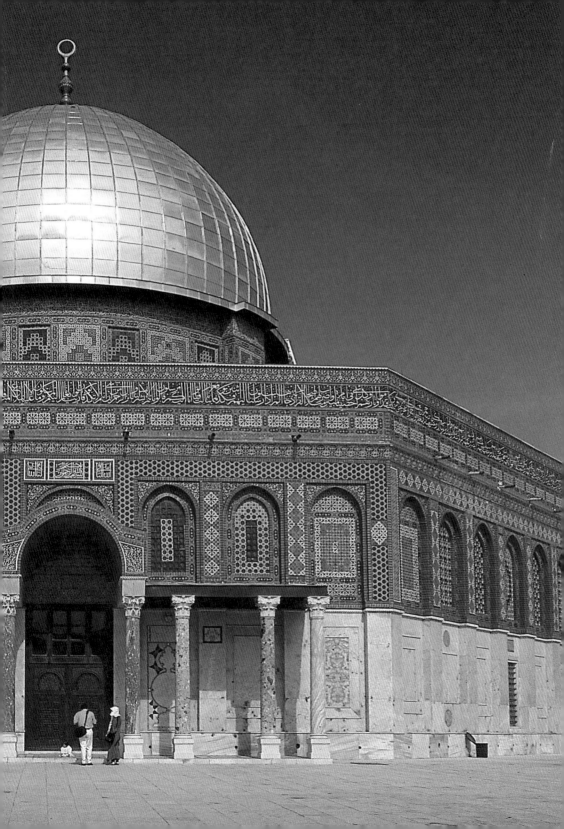

plaques or with mosaics in which thousands of small cubes, or tesserae, of coloured and gilded glass and stone are set closely together in mortar to form patterns and images that reflected the light. Timber roofs and wood or masonry vaults covered with metal protect these magnificent spaces from the weather, which is often rainy during the short Mediterranean winter.

The Dome of the Rock stands today essentially as it was built in the late seventh century. It is an eight-sided building with a tall central space 20 m (65 ft) in diameter encircled by a lower area that was so broad it had to be divided by an arcade into two octagons. A high wooden dome, whose lead roof is plated with gold, spans the central space above the rock. The dome sits on a vertical cylindrical wall or 'drum' which is supported by four heavy masonry piers and twelve stone columns arranged in a circle (9). One can enter through doors on the north, south, east or west. The building is dimly lit by windows in the side walls and in the drum. The glory of the building is its interior decoration (10), the most lavish programme of mosaics to survive from ancient or medieval times. It was once even more lavish, but in the sixteenth century all the mosaics on the outside were replaced with tiles, which were themselves replaced in the twentieth century. The lower walls are covered in plaques of veined marbles, cut and fitted in patterns. Mosaics of coloured and gilded glass cubes envelop the upper walls of the octagons and the drum. A narrow band of inscriptions in Arabic written in gold on a blue ground and quoting passages from the Koran runs for some 250 m (820 ft) at the top of the arcade.

This building so completely follows the traditions of late antique and Byzantine architecture that some people do not even regard it as Islamic at all. The people who built it, however, undoubtedly meant it to serve an 'Islamic' function. Like much Islamic art of later times, it was the function that made a work of art 'Islamic', not the religious affiliation of the craftsmen who made it. For many centuries the building was thought to commemorate Muhammad's night journey, but the inscriptions do not mention

9–10
The Dome of the Rock, Jerusalem, 692 and later
Above right Interior view showing the Rock
Below right Interior view of marble panelling and mosaic decoration, including jewelled crowns and inscription

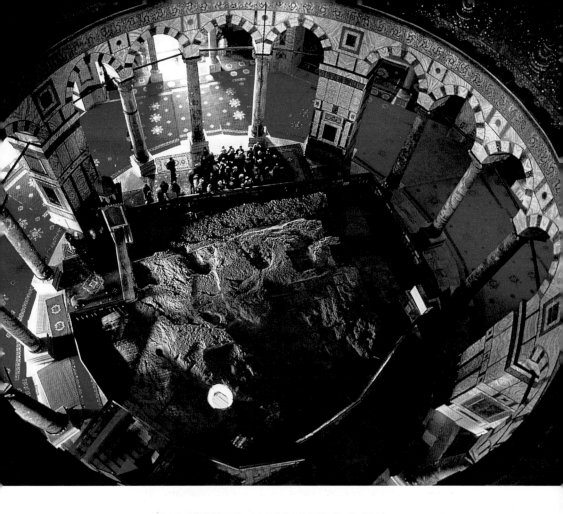

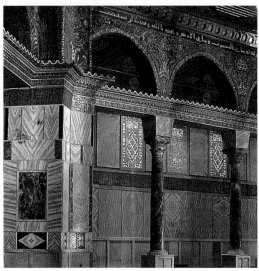

anything of the sort, so this seems unlikely (the night-journey explanation in any case dates from the ninth century, long after the building was built, so it could have been a later invention). Another explanation (also from the ninth century) was that Abd al-Malik built it to replace the Kaaba in Mecca, which had been seized by a rival claimant to the caliphate and was in enemy hands, but the inscriptions on the building say nothing about that either. The koranic inscriptions themselves, which are really the only contemporary clue we have for explaining the building's function, deal with the nature of Islam and refute the tenets of Christianity; they suggest that the building was meant to advertise the presence of Islam in a city already full of important monuments to Judaism and Christianity. Building the structure on the site of Adam's burial, Abraham's sacrifice and Solomon's Temple, and copying the domed form of the Holy Sepulchre that Constantine had erected over Christ's burial place on Golgotha, also suggest an effort to symbolize the role of Islam as a worthy successor to these earlier revealed religions.

Most of the mosaic decoration inside the Dome of the Rock consists of representations of fantastic trees, plants, fruits, jewels, chalices and crowns; unlike a Byzantine building, it has no scenes from the Old or New Testaments or devotional images of Christ, the Virgin or saints; in fact it has no human or animal figures at all. The absence of figures is a characteristic feature of Islamic religious art. It is often said that figures were banned in Islam from the start, but this is untrue. The Koran itself has very little to say on the subject. Muslims believe that God is unique and without associates and therefore that he cannot be represented. He is worshipped directly without intercessors, so there is no place for images of saints. Since the Koran has little in the way of narrative, there was little reason to present stories in religious art, and in time this absence of opportunity hardened into law.

Byzantine artists had used a great deal of vegetal (that is, stylized fruits, flowers and trees) and geometric (that is, shapes and patterns) ornament to set off, frame or link their figures. When

working for Muslim patrons, as they often did, these artists simply made what had been subsidiary elements in Christian art the main subject of the decoration. Whether the decorative motifs on the Dome of the Rock were meant to symbolize something or convey some message to the beholder is not known. Perhaps they were meant to suggest the tribute of defeated kings or the gardens of paradise. Given the experimental nature of the building and the absence of comparable structures, we may never know what, if any, thought the decoration inside the building was meant to convey, but the structure's general purpose to represent the presence of Islam in Jerusalem is clear.

The second building the Muslims erected on Temple Mount in the late seventh century was built south of the Dome of the Rock on the southern edge of the Temple platform. It was a place for congregational prayer – for, whatever it was meant to be, the Dome of the Rock was *not* a prayer hall – where the entire male Muslim population of Jerusalem was expected to assemble every Friday. Today this building is known as the Aqsa ('furthest') Mosque, after a mosque mentioned in Chapter 17 of the Koran. Unlike the Dome of the Rock, the Aqsa Mosque has been repeatedly rebuilt, and once even served as headquarters for Crusaders coming from the West to reconquer the Holy Land. Therefore we do not know what it originally looked like, except that it was undoubtedly a hall whose roof was supported on columns taken from ruined buildings in the vicinity.

A clearer example of what an Umayyad type of congregational mosque must have looked like can be gained from the mosque built by Abd al-Malik's son al-Walid (r.705–15) in his capital Damascus. That building does retain much of its original appearance, though it has been damaged, especially in a great fire in 1893. This mosque (11) began as a Roman temple which the Byzantines had turned into a church. Like their counterparts in Jerusalem, the original Muslim settlers in Damascus had first contented themselves with using part of this church for their communal prayers, but by the time of al-Walid, the Muslim

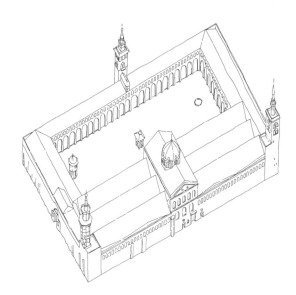

11
Umayyad
Mosque,
Damascus,
707–15.
Axonometric
view

community had grown so large that a new, larger structure was needed. Both the Roman temple and the Byzantine church had stood inside an enormous enclosure with massive walls. The planners of the mosque tore down the church in the centre and used the enclosure walls (157×100 m, 500×330 ft) as the walls of the mosque. The building has a broad courtyard surrounded by arcades and a huge prayer hall constructed against the southern – or *qibla* – wall. The major façade of the building was turned inside-out to face the interior court, since the outside of the building was of secondary importance. This inward looking façade would become one of the most characteristic features of Islamic architecture.

The prayer hall at Damascus has three parallel covered spaces separated by massive stone columns (undoubtedly salvaged from some earlier building) which supported a wooden roof. An axial space, which leads from the centre of the court to the *qibla* wall, had a gabled roof facing the court and was originally covered with an arrangement of wooden domes. Despite several rebuildings, the gable end facing the court and one or more wooden domes have made this space special since Umayyad times. The gable was used to mark the place where ceremonies took place inside a screened space, called a *maqsura* in Arabic, which stood under the

dome. This space would have included a *minbar,* or stepped pulpit, for the preacher – in this case the caliph himself, who as the Prophet's successor still led prayers in Umayyad times – and a semicircular recessed niche in the centre of the *qibla* wall.

Known as a *mihrab,* this niche had just been introduced to the Prophet's mosque in Medina to commemorate the spot where the Prophet, when leading prayers, had planted his lance to indicate the space where people should pray. The niche was rapidly disseminated to mosques throughout the lands of Islam, where it apparently defined the place where the leader of communal prayer should stand. The niche probably had a symbolic meaning, for a rare group of silver coins minted ten years before the semicircular *mihrab* was introduced into the mosque (12) depicts a ribboned lance within an arch supported by a pair of spiral columns, an image thought to represent the Prophet's lance in a *mihrab.* Although this coin type was quickly abandoned, worshippers may have continued to associate the empty semicircular niche in the mosque with the memory of the Prophet and his lance. In any event, similar niches were common in late antique buildings where they were used for statues of gods in temples, the Torah in synagogues, and devotional images in churches, so their reappearance in mosques is not surprising.

Like the Dome of the Rock in Jerusalem, the Umayyad mosque in Damascus was lavishly decorated. The lower walls were again covered in marble plaques; the upper walls were covered with vast expanses of glass mosaics. Inscriptions from the Koran – as

12
Silver dirham, minted 695–6
Left
Idealized portrait of the caliph as a Sasanian emperor (front)
Right
Representation of the Prophet's lance in a niche (back)

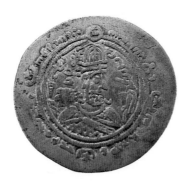

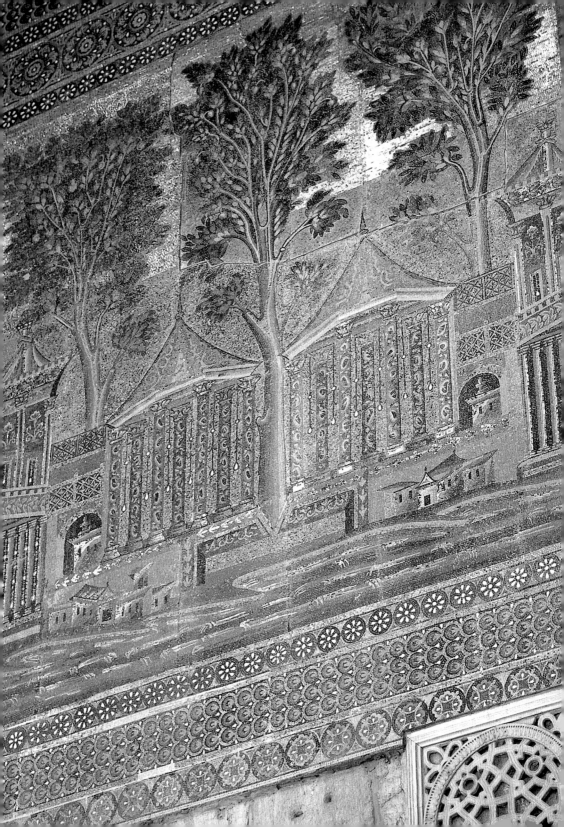

at the Dome of the Rock – as well as landscapes were done in mosaics, but only one large panel (13), showing an idyllic landscape of a river flowing beneath fantastic houses and pavilions separated by trees, has survived. It seems likely that the other mosaics might also have shown the beautiful landscape of Paradise described in the Koran, where true believers go after death, just as Christian mosaics often showed the company of saints the Christian believer would keep in Heaven.

Next to the congregational mosque of Damascus was the caliph's residence. It was built of brick and had a magnificent dome, much like the heavenly domes that marked the palaces of rulers in antiquity. The caliph could go directly from the palace into the *maqsura* of the mosque. None of the Umayyad palaces in cities has survived – subsequent generations were more concerned with keeping prestigious religious buildings in repair than with maintaining outmoded houses – but some idea of contemporary secular architecture can be gleaned from the remains of several Umayyad palaces in the desert steppe of Syria and Palestine. The best known is Khirbat al-Mafjar ('the ruins of Mafjar'), north of Jericho. It was levelled in an earthquake in 747, but at its height the complex had a square palace, a bath, a mosque, an enclosed court in front with a fountain, and a service building.

The most lavishly decorated building was the bath. When it was excavated in the 1930s and 1940s, it was found to have had a projecting doorway decorated with stucco statues of a prince and voluptuous dancers, suggesting the pleasures that lay within. A passage led to a grand hall once covered with vaults and a central dome. The outer walls were lined with alcoves, and there was a pool along a side wall. The floor was decorated with an enormous mosaic pavement. Most of the patterns are geometric, but one small mosaic panel opposite the entrance shows a fruit and a knife, perhaps an obscure reference to the person who built the house. Hanging from the vault above was a chain, carved like a Chinese puzzle from a single block of stone. The 33-seat latrine in one corner gives some idea of the number of people who were

13
Umayyad
Mosque,
Damascus,
715.
Mosaic
decoration
showing a
fantastic
landscape

entertained in the bath hall, but a tiny four-room bath and a private audience room show that only a few were invited to share all of the prince's pleasures. The small audience room, *diwan*, was lavishly decorated with heavenly decoration of carved stucco that was painted in bright colours. Winged horses supported birds which in turn supported the dome, from the top of which peered heads of handsome young men and women emerging from luscious acanthus leaves. The heavenly theme seems to hint at the apotheosis, or deification, of the ruler, and this theme was complemented by a splendid mosaic pavement on the floor that imitates a rug. It shows two gazelles grazing peacefully by a pomegranate tree while a ferocious lion devours the crumpled body of a third gazelle (14). The mosaic is thought to symbolize the peace that follows the triumph of Islam.

The hodge-podge of decoration in the bath hall reflects the *nouveau riche* tastes of the occupant, whose immediate ancestors had suddenly found themselves masters of much of the world (and its treasures) between the Oxus and the Loire. These

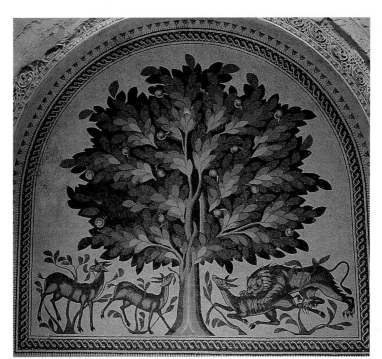

14
Khirbat al-Mafjar, near Jericho, *c.*740. Mosaic pavement in small audience room

far-flung conquests had brought extraordinary wealth to the Umayyad caliphs, whose attempts to avoid the moral constraints of city life led them to construct these rural hideaways. Khirbat al-Mafjar was once attributed to the virtuous caliph Hisham (r.724–43), whose name appears painted on the building, but the spirited decoration seems far more in keeping with the libertine al-Walid II (r.743–4), who for twenty years partied in the wings while waiting to succeed his uncle as caliph. Al-Walid's amorous exploits and tastes for wine, women and song were extolled by contemporary poets, whom he supported liberally, and their poems suggest that the pool was filled with wine (forbidden to Muslims) in which the prince and his courtiers would cavort.

The figures in the decoration at Khirbat al-Mafjar demonstrate that in early Islamic times, as at most other times and places, what one did – or saw – in the privacy of one's home was entirely different from what one did under public scrutiny. The exuberant subject matter in this private palace intended for the *dolce vita* of a playboy prince contrasts sharply with the disciplined vegetal and architectural decoration in the shrine and congregational mosque, which were designed to represent the new faith officially. At Khirbat al-Mafjar the formal and decorative themes of Byzantium and Sasanian Iran – ranging from the carpet-like floor mosaics and textile-like paintings on the walls (see 54) to stucco portraits of the ruler in Persian dress – were appropriated freely, and much of the visual attraction of Umayyad architecture and its decoration lies in the way in which old forms were recombined, reinvigorated and reinvented by the new culture blessed with unlimited wealth and looking for a distinctive Islamic style of art.

Nevertheless, the Umayyads did not manage to establish a dynastic style of art all over their vast empire; beyond their capital provinces in Syria and Palestine it is difficult to speak of an Umayyad art. There was as yet no one particular form a mosque should take, except that it often had a courtyard, and builders in such outlying lands as Iran and Egypt followed local traditions rather than any directives from the capital. The similarities among

the few surviving examples of Umayyad architecture derive not so much from the directives of the men who paid for them as from their common source in the artistic vocabulary of the late antique period in the Mediterranean lands conquered by Islam. When the Umayyad caliphate was overthrown in 750 by a new dynasty, the Abbasids, the centre of power was shifted from Syria to Iraq and the first distinctly *Islamic* style of architecture emerged.

The Abbasids (r.750–1258) were also related to the Prophet, this time through his uncle Abbas. They drew much of their support from disaffected minorities in the eastern Islamic lands, particularly from the Shiites (derived from the Arabic word 'party' or 'faction'), who believed that the Umayyads had usurped power from the Prophet's son-in-law Ali and his descendants. The Abbasids chose Iraq as their capital province because it was connected by land with Arabia and the Iranian plateau and by river with the Gulf and the Mediterranean. In contrast to the beautiful stone buildings of the Umayyads in Syria, the structures of the Abbasids in Iraq were largely constructed of mud brick or baked brick, both made from the ubiquitous clay deposited for eons by the Tigris and Euphrates rivers. Baked brick is quite durable, and even sun-dried or mud brick can last for centuries with proper maintenance to keep it from dissolving in rain. Covering it with a layer of of baked brick or hard gypsum plaster will adequately protect it, and the plaster can also provide an ideal surface for decoration, whether by carving or moulding or with paint. Unmaintained, however, mud brick soon returns to mud, as the great mounds or tells of successive ancient settlements in Mesopotamia testify. The remains of the buildings the Abbasids built therefore give only a feeble image of what they were originally like.

Islamic civilization came of age under the Abbasids. From their capital cities in Iraq, the caliphs were lavish patrons of the arts, letters, and both religious and natural sciences. Baghdad became the Islamic Rome where Greek science was revived and many classical works were translated into Arabic, thereby saving them

from oblivion and providing the means by which they would later become known in the medieval West. The traditions of the earliest years of Islam were codified by the doctors of religious law, and the four 'schools of law' – actually legal traditions – that predominate to this day were established by the followers of the most important religious scholars. Diplomatic relations were opened between the caliph Harun al-Rashid and Charlemagne. Iraq was the hub of a worldwide economy; Islamic silver coins have been discovered in Scandinavia, where they were traded for the furs, slaves and amber prized at the Abbasid court, and Chinese ceramics were brought by caravan across Central Asia or by boat around the Malay Peninsula and India to the Gulf. The Abbasids were justly proud of their achievements and encouraged the writing of geographies and histories to extol them. These books also provide invaluable help in reconstructing the splendours of this now-vanished time.

The early Abbasids continued the late Umayyad tendency to build increasingly self-sufficient palaces of great size. In 762 the caliph al-Mansur (r.754–75) founded *madinat al-salam* ('the City of Peace') near the former Sasanian capital of Ctesiphon at the point on the middle course of the Tigris and Euphrates where they come close together and are linked by canals. The site had not only the obvious commercial advantage of easy communication with the Gulf and the Mediterranean but also the symbolic associations of succession to the ancient capital of Iraq and Iran. Abbasid culture owed a good deal to Persian culture and ceremony, and – apart from the natural sciences – the role of late antique Mediterranean culture diminished.

The new Abbasid capital was known popularly as Baghdad, after the village of that name that stood nearby. Like earlier Persian cities, it was round. Two sets of mud-brick walls and four gates protected it; inside was a ring of residences and government bureaux with the caliph's palace and the congregational mosque in the centre. This layout meant that the population had to pass the palace to reach the mosque for Friday prayer, thereby

disrupting the caliph's privacy; so markets, mosques and new palaces were soon erected outside the walls on both banks of the Tigris. The caliphs imported large numbers of Turkish slaves from the steppes of Central Asia to serve as soldiers, but these Turkish guards and the native Arabs and Persians were soon at each other's throats. It was impossible to control these factions in bustling Baghdad, so for some sixty years in the middle of the ninth century the caliphs moved with their Turkish guard to Samarra, 100 km (60 miles) upriver, where there was ample space to build immense palaces and mosques. Today nothing remains of the early Abbasid Baghdad they left behind, but the round city and its splendid buildings remained a strong image throughout all the medieval Islamic lands.

The remnants of the two great congregational mosques that survive at Samarra give a powerful impression of the Abbasid religious architecture created there. The mosque of al-Mutawakkil (r.847–61), built between 848 and 852, measures 240×156 m (roughly 800×500 ft) – nearly two and a half times the size of the Umayyad mosque in Damascus – and was for centuries the largest mosque in the world (15). Al-Mutawakkil's mosque stood within an even larger enclosure of 376×444 m (about 1,200×1,500 ft) where the latrines and ablution facilities might have been, but which also served, much like the temple enclosures of ancient times, further to separate the mosque from the surrounding city.

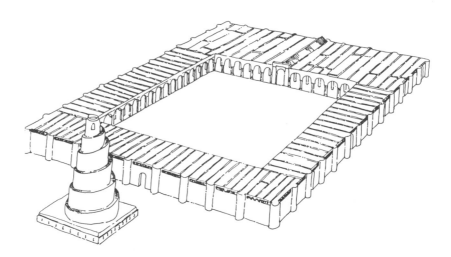

Inside the brick walls, strengthened and decorated with buttresses, columns supported a flat wooden roof. Covered halls, the deepest on the *qibla* side, surrounded the court on all four sides. The foundations remaining in the *mihrab* area suggest that the *mihrab* had doors on either side; one allowing the *imam*, or prayer leader, to enter the mosque, the other belonging to a closet where the *minbar* was kept when not needed for the Friday sermon. Like the Great Mosque of Damascus, this mosque was extensively decorated with glass mosaic and marble panels.

The mosque's most novel feature is the spiral tower which stands opposite the *mihrab* outside the mosque proper (16) but was once linked to the mosque by a bridge. This tower, originally more than 50 m (165 ft) tall, is known in Arabic as the *malwiya* ('spiral') and around the outside is a ramp of increasing slope that winds from the base to the summit, on which a pavilion once stood. The tower has often been likened to the supposed form of Mesopotamian ziggurats, but it is more likely the other way round – the spiral ziggurats, particularly the Tower of Babel, in European depictions were probably inspired by the Malwiya tower itself. The spiral form was an Abbasid innovation, permitting the construction of an immense – if somewhat inelegant – structure that would tower over the surrounding plain. The common explanation, that it was a minaret used to call the faithful to prayer, can be dismissed for practical as well as historical reasons. It is far more likely that the tower is exactly what it appears to be, an identifying marker for the mosque's location that could be seen from afar in this flat land. Towers – a traditional symbol of power – had first been added to mosques a few decades earlier to symbolize the new institutional status mosques had gained in the early Abbasid period. The first mosque towers must have been built at Baghdad but the early mosques there have long since perished. While most mosques had some place for the call to prayer, which was still given at that time from the doorway or roof of the mosque, adding a tower seems to have been a matter of local preference: some communities readily copied the Abbasid idea, while others continued to build mosques without towers.

15
The mosque of al-Mutawakkil, Samarra, 848–52. Reconstruction drawing

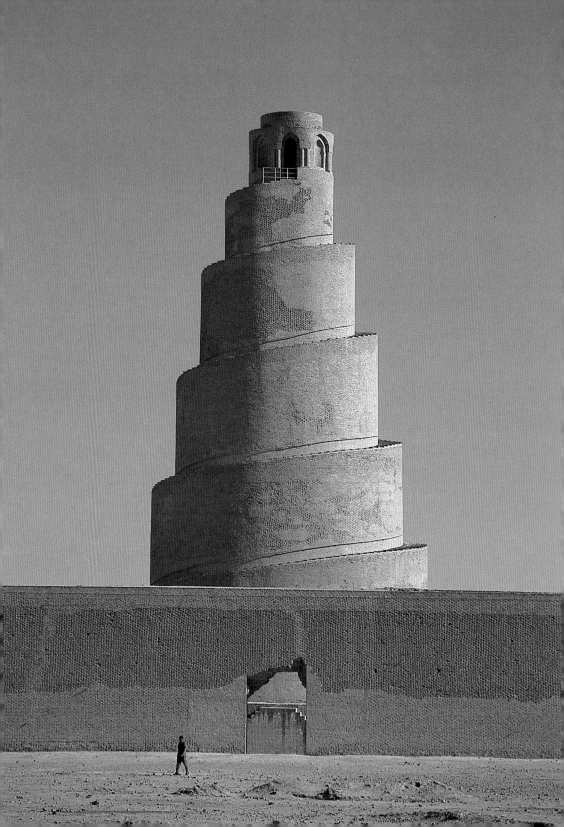

The other congregational mosque at Samarra, known as the mosque of Abu Dulaf, was constructed between 859 and 861 to serve another district of the city. It is slightly smaller (213×135 m, 700×450 ft) than the first, but shared most of its essential features, including the spiral tower opposite the mihrab. The major difference is that the columns used for supports of the mosque of al-Mutawakkil were replaced by brick piers in the copy. The Abbasid type of congregational mosque, with a covered prayer-hall and an open court enclosed within a rectangle, with a ratio of width to length of approximately 2 to 3 and a tower opposite the *mihrab* outside the mosque walls, spread throughout the immense empire of the Abbasids which stretched from North Africa to the frontiers of India and testifies to the power and pres-tige they had. At Isfahan in central Iran, for example, excavations of the congregational mosque have revealed an Abbasid-style mosque (88×128 m, roughly 300×420 ft) built around the year 840. Its large courtyard was enclosed by halls on three sides and a wider prayer hall on the fourth; brick columns supported a flat wooden roof. The aisle leading from the court to the *mihrab* was slightly wider than the others, and the outside of the building was minimally decorated with arches.

16
The mosque of
al-Mutawakkil,
Samarra,
848–52.
Spiral tower

The best copy of this Abbasid style of congregational mosque to survive is a mosque erected in Cairo in 879 by the Abbasid gover-nor of Egypt, Ahmad ibn Tulun (17). The son of a Turkish slave who had been brought to serve at the caliph's court, Ibn Tulun rose to a high position at Samarra and was eventually appointed governor of Egypt. The mosque he had built in Cairo shares many features with the mosque of Abu Dulaf at Samarra: the open space surrounding the mosque itself, the use of rectangular brick piers instead of the columns used in earlier Egyptian mosques, and the spiral tower opposite the *mihrab*. The Cairo mosque, however, is quite square, suggesting that its proportions were dictated by local practice. It was undoubtedly modelled on one of the congregational mosques at Samarra, but the Egyptians of the time were apparently unaware of such copying. Instead they tried to explain the mosque's unusual features by making up

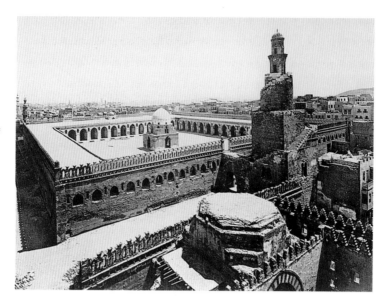

17
The mosque of
Ahmad ibn
Tulun, Cairo,
879. View of
court and
minaret

anecdotes. One contemporary historian, for example, explained the spiral tower in this way: during construction the mosque's builders asked the governor, 'What model shall we follow when we build the tower?', to which the governor, who usually never let his mind wander during business, replied 'Build it like this,' showing a piece of paper he had been toying with to cover his inattention. So they did, giving the tower its distinctive spiral shape.

Another mosque in the Abbasid style was erected at Kairouan, the capital of the North African province of Ifriqiya (roughly equivalent to present-day Tunisia), which was ruled for the Abbasids in the ninth century by a dynasty of governors called the Aghlabids. The first mosque on the site was a simple building of sun-dried brick; it had been constructed in the late seventh century and rebuilt several times. In 836 this mosque was demolished and rebuilt in its present form (18–19) by the Aghlabid ruler Ziyadat Allah. Like other Abbasid mosques, the Kairouan mosque is a roughly rectangular structure (135×80 m, nearly 450×260 ft) and has a court surrounded by arcades, with a hypostyle prayer hall occupying about one-third of the enclosed area. It differs slightly from the standard type in such features as the location and design of the minaret, which stands on top of the wall

opposite the *mihrab*. Perhaps in a later renovation, the courtyard was extended to include the minaret. The distinctive three-storey design apparently copied the nearby Roman lighthouse at Salakta on the Mediterranean coast, showing that there was no particular style of tower that ninth-century mosques had to follow. Also diverging from the Abbasid model are the marble columns and stone walls, which can be explained by the Tunisian tradition of fine stone construction, visible in other buildings of the period. The prayer hall has finely crafted stone domes at either end of the central aisle, and the colonnades along it were doubled in the later ninth century to strengthen the building. One dome marks the area in front of the *mihrab;* the other, rebuilt in the nineteenth century, abuts the courtyard. The purpose of this additional dome is unclear.

The interior (20) of the Kairouan mosque is particularly interesting, for it still has some of its medieval furnishings: the *mihrab* itself is decorated with carved marble panels and is surrounded by tiles. These tiles were imported from Iraq and must have been immensely expensive. The builders did not have enough to cover the entire wall, so they laid them in a chessboard pattern to fill the space with only half as many tiles. To the right

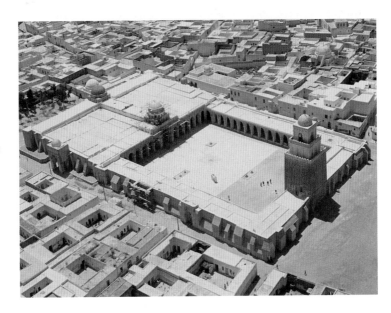

18
The congregational mosque, Kairouan, 836 and later. Aerial view

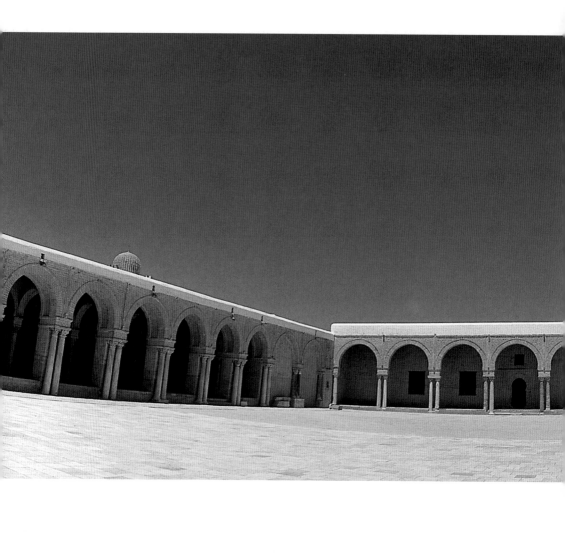

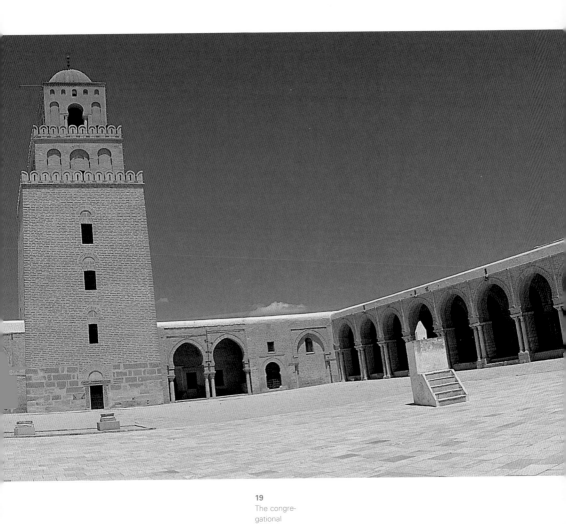

19
The congre-
gational
mosque,
Kairouan,
836 and later.
View of
courtyard

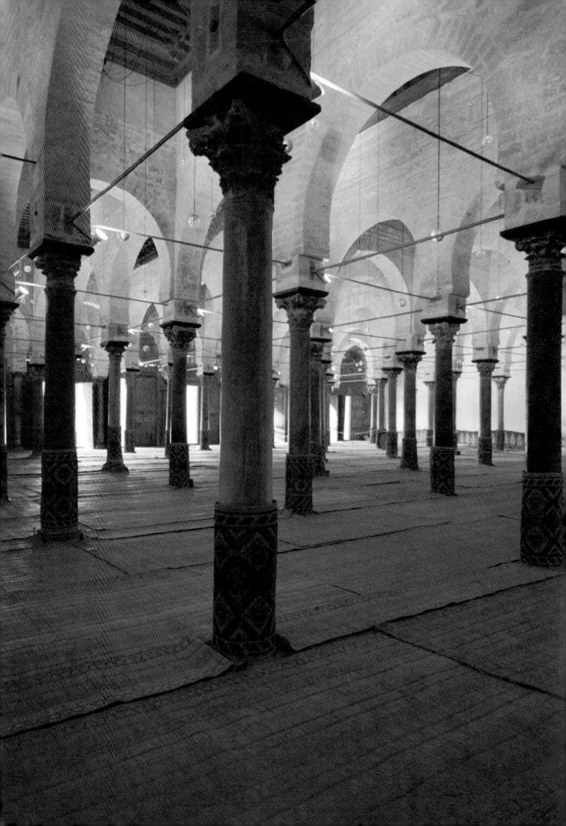

of the *mihrab* is a large carved wooden *minbar,* the oldest in existence. It was made in 862–3; its triangular teakwood frame encloses rectangular panels of carved teak. Most of the panels, which vary in width and height, were – like the tiles – probably imported from Iraq (the teak would have come from Java), since the wonderfully delicate relief carving of the panels is quite similar to that on several panels found in Iraq and later medieval writers say that the wood for the *minbar* was imported from Mesopotamia.

Not all mosques, however, were large structures for congregational prayer on Friday. According to Islamic law daily prayers can be performed anywhere, and small mosques for prayer in a street or quarter of a city became popular from an early date. Remains of several examples from the ninth century have been found in the lands that formed the Abbasid Empire. The mosque of the Three Doors in Kairouan (21), built in 866, has a stone façade finely carved with floral and geometric motifs. An elegant inscription across the top states that it was ordered by a certain Muhammad ibn Khayrun al-Maafari, the Andalusian. This reference to the Spanish origin of its patron, who is otherwise unknown, testifies to the movement of men and ideas throughout the medieval Islamic lands. A cheque written in Córdoba in Spain, for example, could be cashed in Samarqand in Central Asia! The interior of the mosque of the Three Doors is new; it once had nine small domes or vaults arranged in three rows of three, similar to a mosque called Bu Fatata (838–41) in nearby Sousse. Another example of this type of small mosque with no courtyard is found at the opposite end of the Islamic world, at Balkh in Afghanistan (22). The badly-ruined mosque there measures about 20 m square (some 60 ft on a side) and has four massive cylindrical piers which once supported its nine domes. This type of mosque probably originated in buildings that once stood but have now been destroyed in the central lands of the Abbasid Empire.

Most of the palaces for the Abbasid caliphs in Iraq and their governors in the provinces have, like the Umayyad ones, disappeared,

20
The
congregational
mosque,
Kairouan,
836 and later.
Interior

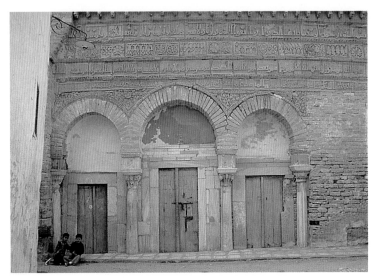

21
The mosque of the Three Doors, Kairouan, 866. Façade

22
The Abbasid mosque, Balkh, Afghanistan, 9th century. Axonometric drawing

but we know something about them from books. For example, one historian records that an embassy from the Byzantine emperor was received by the Abbasid caliph al-Muqtadir in his palace in Baghdad in 917. The caliph impressed the ambassador by having him led through an endless succession of palaces, courtyards, corridors and rooms. After cooling his heels for two months in one palace, the ambassador was then conducted to another. He passed 160,000 cavalry and infantry before reaching

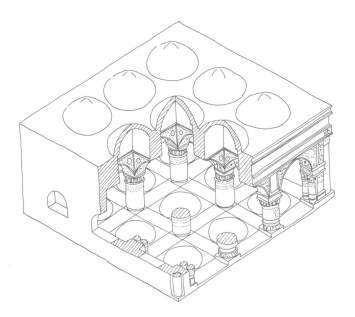

a vaulted underground passage. He was then guided about the palace in which 7,000 eunuchs, 700 chamberlains and 4,000 Black pages were stationed along the rooftops and in upper chambers. Later, he was conducted to a third palace, and from there through corridors and passageways that led to a zoological garden. The entourage was then brought to a first court where there were four elephants and to a second with one hundred lions. They were taken to a building situated amid two gardens, from which they were conducted to the Tree Room and then to the Paradise Palace. Next, they went through a passageway 300 cubits long. After touring twenty-three palaces, they were conducted to a large court known as the Court of the Ninety. Because it was such a long tour, the author of the account adds, the ambassador's retinue sat down and rested at seven particular places and was given water when necessary.

Al-Mansur's palace at the centre of the round city of Baghdad next to the city's congregational mosque was not quite so large. It had a reception hall leading to a domed audience chamber 20 cubits (10 m) square. A second audience hall surmounted the first and also had a domed ceiling; at the summit of this upper dome, 40 m (130 ft) above the ground, was a weathervane in the shape of a horseman. Contemporaries considered the horseman to be the 'crown' of Baghdad and an important landmark. It was said that if the sultan saw the horseman's lance pointing in a given direction, the sultan knew that that was the direction from which some trouble would appear. It was also a metaphor for the caliph's power and authority, for a few years after the horseman was destroyed in a storm, the city was taken by enemies.

Something remains of the palaces the Abbasids built at Samarra because no one lived there after the city was abandoned, and since the beginning of the twentieth century many of them have been excavated. In contrast to the self-contained and blocklike palace of al-Mansur at Baghdad, the one al-Mutawakkil built at Samarra covered an immense area enclosed by blank walls and removed from the urban hubub. The Dar al-Khilafa ('House of the

Caliphate' 23), a complex of courts and gardens much like the palaces where the Byzantine ambassador was received, covered over four hundred acres and measured 1,400 m (nearly 1 mile) from the riverbank to the viewing stand overlooking an even more enormous cloverleaf racetrack. A vast flight of broad steps, the only grand staircase in Islamic architecture before the eighteenth century, ascended from the Tigris River to the Bab al-Amma, a great brick gate with three large arches. The interiors of the immense and extremely complex palaces comprised row upon row of courtyards and chambers leading to special halls, such as a cross-shaped unit made up of a central domed hall surrounded by vaulted halls open on one end, called *iwans*. Sunken apartments arranged around pools provided relief from the torrid climate.

The palaces, like many other buildings at Samarra, were constructed of mud brick protected and embellished with a covering of carved or painted plaster. Baked brick, earth rammed into moulds until it hardens (*pisé*) and an unusual brick made of gypsum were also used. Fragments of paintings found there (24) show that figures continued to be acceptable for interior decoration in private, especially in palaces. The large expanses of carved stucco (25) were made in three different styles, which show how a new technique and subject matter evolved. The first style is a carved technique clearly derived from the geometricized vegetal

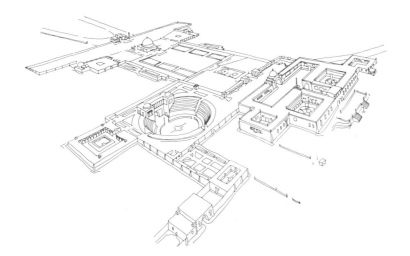

23
Dar al-Khilafa palace, Samarra. Reconstruction drawing as it might have appeared in mid-9th century

decoration used in the Umayyad period. The second style is
characterized by the use of cross-hatching for details. Subjects
are somewhat simplified but are still distinguished from the
background. The third style, also known as the 'bevelled' style,
is a moulded technique suitable for covering large wall surfaces. It
uses a distinctive slanted cut which allowed the plaster to be
released easily from the mould. Decoration in the bevelled style
is distinguished by rhythmic and symmetrical repetitions of
curved lines ending in spirals that form abstract patterns in which
the traditional distinction between the subject and background
of the decoration has been dissolved (see 6). The bevelled style
was undoubtedly developed for stucco, but was soon applied to
wood and other carving, particularly rock crystal, not only in the
major cities of Iraq but also in provincial centres.

The palaces at Samarra were also different in another way. Earlier
palaces had tended to be high and have domes that made them
seem even higher, whereas palaces in Samarra covered huge
areas. At roughly the same time, the towers and elaborate portals
that had earlier been used for palaces began to be used in
mosques. The tower-minaret in fact became the standard marker
for mosques. We do not know why architecture changed in this
way. One possibility is that architecture reflects the change from
the more egalitarian society of early Islamic times into the more

24
Dar al-Khilafa
palace,
Samarra, mid-
9th century.
Reconstruction
of a wall-
painting
showing
dancing girls

25 Overleaf
Balkuwara
palace,
Samarra,
849–59. Interior
of excavated
room showing
stucco
decoration

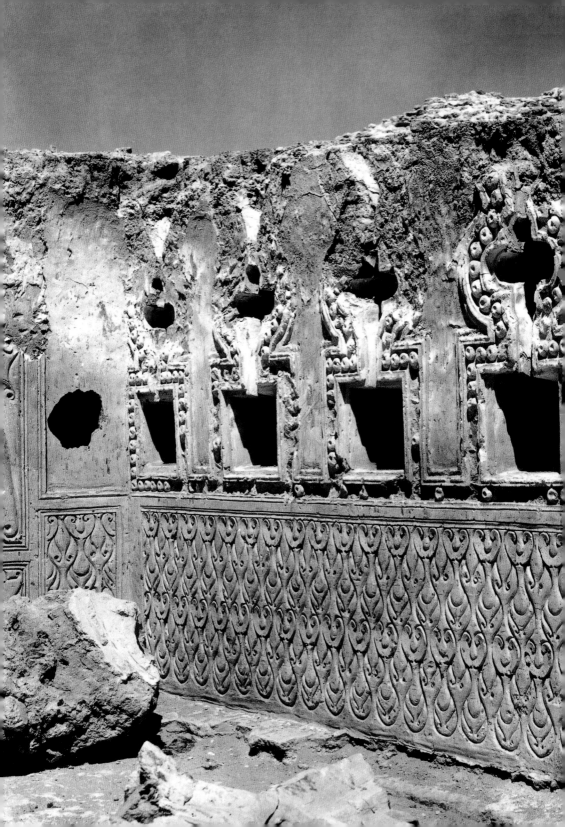

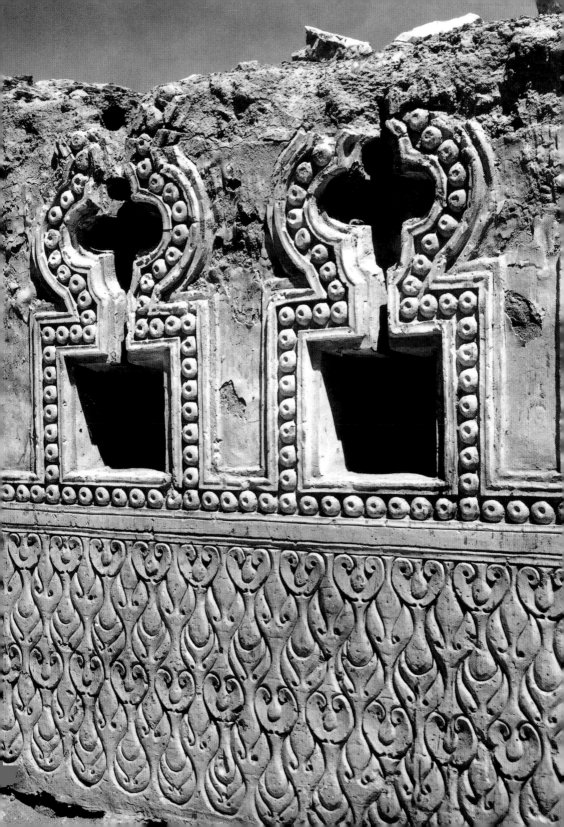

hierarchical society of Abbasid times, where Persian ideas of kingship were increasingly adopted by Islamic rulers. For example, when the Byzantine embassy was received in Baghdad, the ambassador was kept moving while the caliph remained stationary. This 'Oriental' mode of reception contrasts sharply with the traditions of the Mediterranean lands, where the ruler was expected to progress through cheering, but stationary, throngs. Another reason for these architectural changes may be that the mosque as an institution was becoming less and less attached to the ruler and more and more to a class of learned scholars called the *ulema,* which had developed in the meantime. The Umayyad caliphs, like the Prophet himself, had led Friday prayers in the congregational mosque; the Abbasid caliphs ordinarily left that job to their governors and appointees. Although there was no theoretical distinction between religious and secular authority in Islam, by the Abbasid period in practice the two had begun to diverge: the congregational mosque became the centre of a self-perpetuating class of religiously-minded people, while the ever more splendid palaces became the centres of secular power in which the caliphs and their governors were increasingly removed from the people they ruled.

Pens and Parchment The Koran and Early Writing

فقال أما الله لطيف جواز أربع وللصدق وخفر بن يفع أن ينفع إذا بقوم لبحكم الله اليوم لنحيكم وقال فكان الجماعة

أن أبي سبع قوة وأبي نصر يؤدوه قنوحبس ما محن في أفكارهم ونظر لما باطن من أشكالكم وخاذران

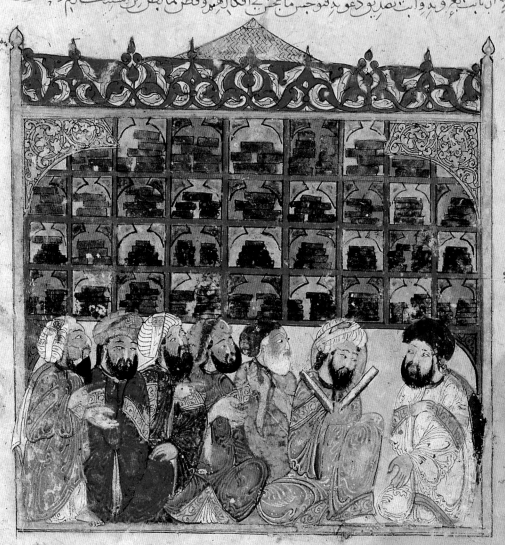

ثم قال يا رواة البعض وأشاه القول لا يعز أظفة طائفة الجوهر

الشك وقذفيا فيها من الزمان عبد الامتحان يكرم إرحل اوبان

Recite in the name of thy lord who created,

Created man from a clot;

Recite in the name of thy lord,

Who taught by the pen,

Taught man what he knew not

(Koran 96.1–5)

These were the first words God revealed to the Prophet Muhammad. They are thought to mean either that writing was relatively new to Arabia or that man is able to learn from writing (*ie* from reading books) what he does not otherwise know. Whichever is correct, these verses underscore the central role of writing (and by extension language) in Islamic culture and art. It runs through the Koran: Chapter 68, for example, opens with the words, 'By the pen and what they write', and later commentators suggested that the pen (*qalam,* whether a reed pen [from the Greek *kalamos*] or a shaft of light), was the first thing created by God so that he could write down events to come. Man's every deed is recorded in the Book of Reckoning for the final accounting on Judgement Day (Koran 69.18–19).

In Arabia before the coming of Islam many dialects of Arabic were spoken, but the same poetic language with extremely refined grammar and vocabulary was used and understood by every tribe throughout the region. The literature of pre-Islamic Arabia was largely spoken, and poetry was regarded as the highest form of art. The poet was like a prophet or king of the market gathering, and poetry was the summit of Arabic eloquence. The *qasida,* or ode, was the supreme verse form. In general, poems were short, especially in comparison to those of Homer or Chaucer, and were composed to be recited in public, either by the poet or by a professional reciter, who would add his own details and

26
A medieval
Arabic library,
illustrated in
a manuscript
of al-Hariri's
Maqamat,
copied and
illustrated at
Baghdad by
Yahya al-Wasiti,
1237.
Ink and opaque
pigments on
paper;
37×28 cm,
14¹₂×11 in
(page).
Bibliothèque
Nationale, Paris

background. The idea that there was a single 'authentic' version of a particular work did not exist, because poems were constantly reworked and embellished by the transmitters. The professional reciter relied on his prodigious memory, and the great pre-Islamic poems were not written down until centuries after composition.

Nevertheless writing was known to the pre-Islamic Arabs. They certainly used it for commercial transactions, for it would have been impractical to carry on long-distance trade without it. As elsewhere in the ancient world, two flexible surfaces were most commonly used for writing (other materials such as stone, wood, pottery or bone were occasionally used for notes and jottings). Papyrus, made from the pressed fibres of a plant that grew along the Nile in Egypt, was used for business correspondence, while the more durable parchment, made from the skin of an animal (usually a sheep, goat or gazelle) that had been wetted and stretched, was used for books.

Evidence for writing in Arabia goes back many centuries before the advent of Islam. Inscriptions in South Arabian script dating from before the birth of Christ have been found in the Yemen, and later inscriptions in various ancient alphabets have been found in northwest Arabia. The first evidence for classical Arabic and the Arabic script appears in Syria. An inscription from al-Namara dated 328 has Arabic words written in the Nabatean alphabet. The oldest examples of Arabic writing, dating between 512 and 568, are three inscriptions found near Damascus and a trilingual one in Greek, Syriac and Arabic found near Aleppo.

Arabic script, like Hebrew and Syriac but unlike Greek and Latin, is written from right to left; like Greek and Latin but unlike Egyptian hieroglyphics and Chinese, it has an alphabet (27). It has twenty-eight distinctive sounds (called phonemes by linguists), but only eighteen letter forms, so the same form had to be used for as many as five different sounds. For example, *ba*, *ta*, *tha*, *nun* and *ya* are represented by the same letter shape. Most of the Arabic phonemes are also found in English or other European languages: the letter *kha*, for example, sounds the same as the *ch* in Scottish

27
Chart of the letters of the Arabic alphabet showing their transcription and various forms

Name	Transcription	Final	Medial	Initial	Independent
alif	ā	ـا	ـا	ا	ا
bā'	b	ـب	ـبـ	بـ	ب
tā'	t	ـت	ـتـ	تـ	ت
thā'	th	ـث	ـثـ	ثـ	ث
jīm	j	ـج	ـجـ	جـ	ج
ḥā	ḥ	ـح	ـحـ	حـ	ح
khā'	kh	ـخ	ـخـ	خـ	خ
dāl	d	ـد	ـد	د	د
dhāl	dh	ـذ	ـذ	ذ	ذ
rā'	r	ـر	ـر	ر	ر
za'	z	ـز	ـز	ز	ز
sīn	s	ـس	ـسـ	سـ	س
shīn	sh	ـش	ـشـ	شـ	ش
ṣād	ṣ	ـص	ـصـ	صـ	ص
ḍād	ḍ	ـض	ـضـ	ضـ	ض
ṭā'	ṭ	ـط	ـطـ	طـ	ط
ẓā'	ẓ	ـظ	ـظـ	ظـ	ظ
'ayn	'	ـع	ـعـ	عـ	ع
ghayn	gh	ـغ	ـغـ	غـ	غ
fā'	f	ـف	ـفـ	فـ	ف
qāf	q	ـق	ـقـ	قـ	ق
kāf	k	ـك	ـكـ	كـ	ك
lām	l	ـل	ـلـ	لـ	ل
mīm	m	ـم	ـمـ	مـ	م
nūn	n	ـن	ـنـ	نـ	ن
hā'	h	ـه	ـهـ	هـ	ه
wāw	w/ū	ـو	ـو	و	و
yā'	y/ī	ـي	ـيـ	يـ	ي
lām-alif	lā	ـلا	لا	ـلا	لا

loch, and the letter *ghayn* sounds the same as the Parisian *r*.
The letter *hamza*, the glottal stop, sounds exactly the same as
the pause before 'idea' in 'an idea'. Only the sounds represented
by the letters *ha* (an emphatic *h*), *'ayn* (explained by linguists as
a voiced pharyngial fricative; a sort of gagging sound), and *qaf*
(a velar stop; a *k* sounded in the back of the throat) are distinct
to Arabic and have no European-language equivalents.

Many other languages have at least two distinct forms of writing:
a monumental ('printed') form in which the letters are written
separately and a cursive ('handwritten') one, in which they are
connected together. Compare, for example, an English printed
book with a handwritten letter. Arabic, however, has only the
cursive form, although it has many styles of script. To complicate
matters, the individual letters change their shape depending on
their position in a word. The same letter can have one form when
it stands alone (independent), another at the beginning of a word
(initial), another in the middle of a word (medial), and yet another
at the end of a word (final). Fortunately, there are no upper and
lower case forms! Particular words or phrases are used to indicate
the beginning of a declarative sentence, a new thought, or a ques-
tion. Western-style punctuation – commas, full stops, question
marks and so forth – was not used until modern times.

28
Forms of *k-t-b*

Like all other Semitic languages, Arabic is based on a system of
roots, where three (or sometimes four) consonants (called 'radi-
cals' by linguists) denote a semantic concept. A vocabulary is
generated from these roots by their grammatical transformation
according to regular patterns. Thus the combination *k-t-b* is a
root that conveys the idea of writing; from it are generated words
including *katib* a writer or scribe, *kitab* a book, *kutubi* a book-
seller, *kuttab* a school, and *maktab* a place of writing or office (28).
Similar transmutations produce words from other roots. Written
Arabic, like other Semitic languages, records only the consonants
and the long vowels. As the root and the grammatical form define
virtually every word in the lexicon, the reader can supply the
unwritten short vowels from the context. Thus *k-t-b* can be read

Definition	Transcription	Arabic Form
to write	kataba	كتب
piece of writing	kitāba	كتابة
bookseller	kutubī	كتبى
Koran school	kuttāb	كتاب
office	maktab	مكتب
offices	makātib	مكاتب
bookstore	maktaba	مكتبة
typewriter	miktāb	مكتاب
correspondence	mukātaba	مكاتبة
enrolment	iktitāb	اكتتاب
dictation	istiktāb	استكتاب
writer, scribe	kātib	كاتب
written	maktūb	مكتوب
correspondent	mukātib	مكاتب
subscriber	muktatib	مكتتب

either as *kataba* ('he wrote') or *kutiba* ('it was written'), and it is up to the reader to decide which is correct from the context.

Given the oral nature of pre-Islamic literature in Arabia, it is probable that God's revelations to Muhammad were transmitted orally and preserved in memory. Since Mecca was a commercial centre where writing was in common use, it is also probable that some of the revelations were written down in Muhammad's lifetime. He is said to have used secretaries in Medina to write down some revelations as well. This was particularly important in the case of the later revelations that were primarily legislative in nature. Some revelations were undoubtedly written down on separate

sheets of papyrus or parchment, but the whole of the text, which came to comprise the Koran, was not yet compiled into a book.

Soon after the Prophet died in 632, Muslims began to write down as many of the revelations as possible. There was apparently no great variety in the wording of the texts preserved by one transmitter or another, but the order in which they were kept was not yet fixed, and slight variations in readings and interpretations were undoubtedly generated by the peculiarities of the Arabic script. The third caliph Uthman (r.644–56) decided to produce a uniform written text and had Muhammad's revelations collected and collated. The importance of this collation should not be exaggerated, for knowledge of the Koran was still based more on memory than writing. The text written in the often ambiguous Arabic script could have served as little more than a mnemonic device for people who had already committed it to memory.

The process of codifying the Koran was apparently not completed until the end of the ninth century, and by the tenth century only the readings of seven eighth-century scholars – one each from Medina, Mecca, Damascus and Basra and three from Kufa – were widely accepted as authentic. Scholars were forbidden to use 'unorthodox' readings, and the fierce discussions that developed for or against variant readings show that there were many divergent tendencies in the medieval Islamic community.

This system of writing Arabic, with the possibilities for variant readings and interpretations, was patently unsuitable for the preservation of God's revelations, and significant changes were introduced by caliph Abd al-Malik. Marks were used to distinguish the different sounds sharing the same letter form. For example, *ba* was expressed by adding a short stroke under the basic letter form, *ta* by adding two strokes over the basic form, *tha* by adding three strokes over the basic form, *nun* by adding one stroke over the basic form, and *ya* by adding two strokes under the basic form (the strokes were later replaced by dots). Short vowels were indicated by marks above or below the appropriate letters; these marks were also used to distinguish long vowels from

consonants. Doubled consonants were also marked by a special sign, as was the absence of a vowel.

This new system can be seen on the first monument of Islamic architecture, the Dome of the Rock in Jerusalem (see 8), which Abd al-Malik built. The inscription around the inner face of the octagonal arcade (see 10) uses these marks to make the intended reading precise. It is a single statement running counter-clockwise from the southwest corner and contains the invocation to God, 'In the name of God, the Merciful, the Compassionate' (known in Arabic as the *basmala* from the first words, *bism allah al-rahman al-rahim*), several koranic quotations, and the profession of faith or *shahada* 'In the name of God, there is no god but God; Muhammad is the messenger of God.' Another inscription on the outside of the octagonal arcade is broken into six parts by decorative rosettes. The letters, which are angular and rise or descend from a horizontal base line, are carefully proportioned and show a great concern for the total aesthetic effect. These inscriptions are also the earliest evidence for the written text of the Koran.

This same style of script was also used in the other arts. As part of Abd al-Malik's effort to increase the importance of Palestine and Syria, the roads leading to Jerusalem and Damascus, the capital city, were improved. Milestones were erected showing the distance to the cities and recording the extensive roadwork done in the caliph's name. For example, one stone (29), discovered in 1961, records how Abd al-Malik's uncle, the governor of Palestine, supervised the levelling of a difficult pass near the village of Fiq on the road from Damascus to Jerusalem in May–June 692. Eight lines of text are carved into the surface of a very hard grey basalt stone. Like the inscriptions on the Dome of the Rock, the milestones display an angular script which is extremely easy to read. The only difficulty is that lines are not necessarily broken between words but between letters that do not connect. For example, the second line ends with *alif*, the first letter of *allah* ('God'), and the next line begins with the final three letters of the word. The text is more spacious in the first lines than at the bottom, where the

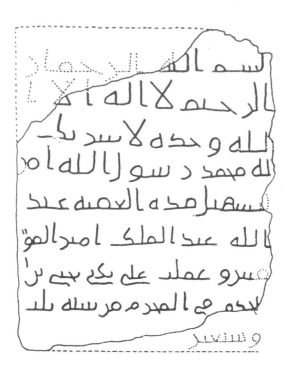

29
Drawing of
basalt
milestone
erected on the
road between
Damascus and
Jerusalem,
692.
64×52 cm,
2¹⁄₄×2¹⁄₂ in.

letters are increasingly cramped, as the artisan apparently
realized that he was running out of space.

The increasing importance and regularity of writing in this early
period is most clearly seen on coins. During the first sixty years of
Islamic rule, apparently no coins were minted in Syria. Presumably
the supplies of Byzantine coins and coins minted in the East were
sufficient for the limited local demand. Minting in Syria began in
Abd al-Malik's time. The first issues closely follow Byzantine or
Sasanian weights and designs. A gold dinar datable to 692–4 (31),
for example, shows three standing figures on the front and
imitates coins of the Byzantine emperor Heraclius; only the
Christian symbolism was simply removed by eliminating offensive
crosses and changing the Byzantine imperial costume to Arab
dress. The most notable addition is the Islamic profession of faith
inscribed around the edge on the reverse. A second type of dinar
issued from 694–7 (32) adapts Byzantine designs. The front shows
a single standing figure, undoubtedly intended to be a portrait of
the reigning caliph, surrounded by the profession of faith. Other
silver coins (see 12) adapt Sasanian designs.

These coins with modified Christian or other symbols quickly disappeared in 696–7, when a third type of gold dinar was struck (30, 33). The weight standard was changed from the Byzantine *solidus* to 20 Arab carats (4.25 g, $^1\!/_7$ oz) and figures disappear. The profession of faith fills the centre of the coin and part of the edges; the rest of the space is taken up by Koran 9.33, which concerns the prophetic mission. On the reverse is Koran 112, a statement of God's oneness and a refutation of the Trinity. The invocation, mint and date are inscribed on the edge. All of this writing appears on a coin less than 20 mm ($^3\!/_4$ in) in diameter (*ie* smaller than a British penny or an American quarter). Over the course of the decade, coin design improved and the inscriptions showed many of the same features as much larger inscriptions. This type of coin would be characteristic of virtually all Islamic coinage up to modern times.

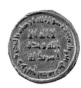

The Koran, which is about the same length as the New Testament, contains 114 chapters (Arabic *sura*). Following the opening chapter, or Fatiha, a short prayer used as an invocation, the other chapters, from the time they were written down in the seventh century, have been arranged in descending order of length, from the 286 verses of Chapter 2 to the final two chapters comprising short incantory prayers of a few lines. Although Westerners refer to these chapters by number, Muslims know them by a conventional name or title, and most copies of the Koran accompany the title by a statement of where the verses were revealed – either Mecca or Medina – and the number of verses. For example, the second chapter is known as the *surat al-baqara* ('the Cow') and was revealed in Medina. For recitation, Muslims usually divide the Koran into 30 parts (*juz*) of about equal length. This division corresponds to the number of days in the month of Ramadan, when the entire Koran is read in the mosque. These parts are often further subdivided into halves and quarters. Another way of dividing the Koran is by sevenths, to correspond with the days of the week. The divisions are often marked with circles or some other mark in the text and a corresponding mark in the margin. None of these divisions appear in the text, and they have nothing to do with the verses themselves, which Muslims believe to be the word of God.

To judge from the thousands of fragments that have survived, many parchment manuscripts of the koranic text were undoubtedly made from an early period. There are many fragments that carry pious or spurious attributions, such as the manuscript with bloodstains reported to be the one the pious caliph Uthman was reading when he was murdered in 656. None of the fragments bears any indication of date or place, and it is difficult to know how old they are. Various scripts are mentioned by medieval Arabic authors who wrote the history of Arabic writing, but it has been difficult, if not impossible, to match the names and descriptions of these scripts with surviving examples. One of the scripts mentioned is Kufic, associated with the city of Kufa in Iraq, which was a centre of Koran scholarship. Since the eighteenth century Western scholars have conventionally – but erroneously – applied this name to all scripts in which angular letters are posed on a horizontal base line.

Early manuscripts of the Koran are written in one of two formats. In the first or vertical format, the book is taller than it is wide. This format is comparatively rare, although it was the customary format for the book in antiquity and became standard in later Islamic times. These pages, which measure some 30×20 cm (12×8 in), have about twenty-five lines of a distinctive script in which the vertical strokes slant to the right (34). This script is known either as *Hijazi* ('from the Hijaz', the region of western Arabia including Mecca and Medina) or *ma'il* ('sloping'), and manuscripts written in it have few diacritical marks except for occasional short strokes to differentiate one letter from another of similar shape. The absence of vowels, chapter headings and verse markings might indicate that these were very early manuscripts, perhaps dating to the seventh century, though the prestige of this script and the veneration in which such early manuscripts were held might have led to the occasional revival of this style in the eighth or even ninth century.

The second, more common format for manuscripts of the Koran is horizontal, that is, the pages are wider than they are

31 Above
Gold dinar, imitating a Byzantine coin design, minted Syria, 692–4. American Numismatic Society, New York

32 Centre
Gold dinar, adapting a Byzantine coin design, minted Syria 694–7. American Numismatic Society, New York

33 Below
Gold dinar, showing new design consisting entirely of inscriptions, minted Syria, 696–7. University Museum, Philadelphia, on loan to American Numismatic Society, New York

34
Double-page from a vertical-
format manuscript of the
Koran, written in slanted
script, 8th century or later.
Ink on parchment;
30×20 cm,
12×8 in (each page).
British Library, London

high. Thousands of fragments and manuscripts in this format are known, ranging in size from tiny pocket-books to large manuscripts meant for public display and for reading in the mosque. The great number testifies to the popularity of this format for some three centuries throughout the Islamic lands. This distinctive horizontal format may well have been adopted to distinguish manuscripts of the Islamic holy text from other books, especially the Christian Bible, which was written as a vertical-format book, and the Jewish Torah, which was written as a scroll. The format also distinguishes manuscripts of the Koran from other early Islamic books, which were in a vertical format.

Horizontal Koran manuscripts used a variety of angular scripts, from a cramped sloping script close to that found on the vertical manuscripts to a spacious stately script with some curved letters. Parchment manuscripts of the Koran were transcribed with reed pens and ink; the style of writing used was extremely measured and purposeful. The movement of the pen was carefully controlled and horizontal lines are straight. The effect is much closer to the style of writing used on inscriptions in mosaic and on stone than to that used in contemporary documents written on papyrus, such as a receipt for thirteen ewes dated 723 AD (35). Although various details of the scripts used on papyrus resemble contemporary styles used on buildings and coins, the documents were penned comparatively hastily in an 'everyday' script. They serve to show how carefully the Koran manuscripts were planned and written, with a painstakingly modulated line, where thicks and thins are meticulously delineated against the unwritten spaces and letter shapes are subtly repeated.

One of the few fixed points for dating these early Koran manuscripts is the one made for Amajur (36), governor of Damascus for the Abbasid caliphs between 870 and 878. The largest part of the manuscript, 242 folios, is in the Museum of Turkish and Islamic Art in Istanbul, which has probably the largest collection of early Islamic manuscripts (210,000 folios). Many of these manuscripts were kept in a storehouse in the courtyard of the Great Mosque

الرحمن الرحيم...

حماد مولاه عسر ... ارسل المسور ...

الرجل بها حوه و ... يوسر لسلمه ... عظمه

وقه ... عمر ان الله وعيد ... رسم ...

... بيوه ...

... بيود جوز ...

... في ... ان ثمر وامراه ...

بعد بدر منذ يشهد عبد الله بر مسلم

احمد وعلى حسن وعبد الملك بر ايوب

لئلا امام رسم السنه اربع

of Damascus until a fire at the end of the nineteenth century made it necessary to remove them. As Syria was then part of the Ottoman Empire, the collection was carried off to Istanbul, the Ottoman capital.

According to a note in the Amajur Koran, the thirty-volume set was given to a mosque during the year 875–6 in the city of Tyre (now in Lebanon), and may have been carried from that city to Damascus just before the Crusaders arrived in the twelfth century. The lavishness of the Amajur set is emphasized not only by its size – each volume had perhaps 200 leaves, requiring in total the

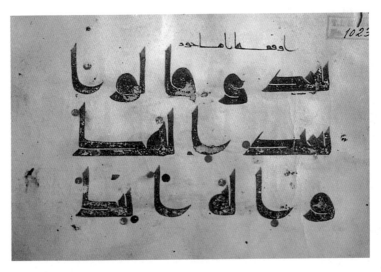

skins of some 300 sheep (about 140 sq. m, 170 sq. yards) to provide sufficient parchment – but also by the script. Although the aesthetic effect of three lines per page works very well, it is particulary wasteful of parchment. Most manuscripts of this size have many more lines of writing per page (37) and are consequently much shorter books.

Many pages in this and similar manuscripts were decorated. Decoration was used within the text to indicate the division between verses or groups of verses. A circle often marks the end of a verse, the teardrop-shape letter *ha* – the letter which by convention also stands for the number 5 – indicates the end of five

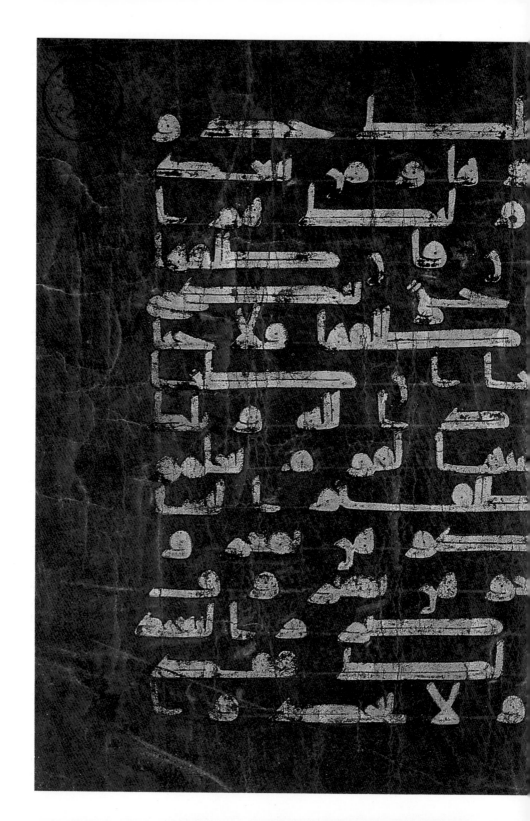

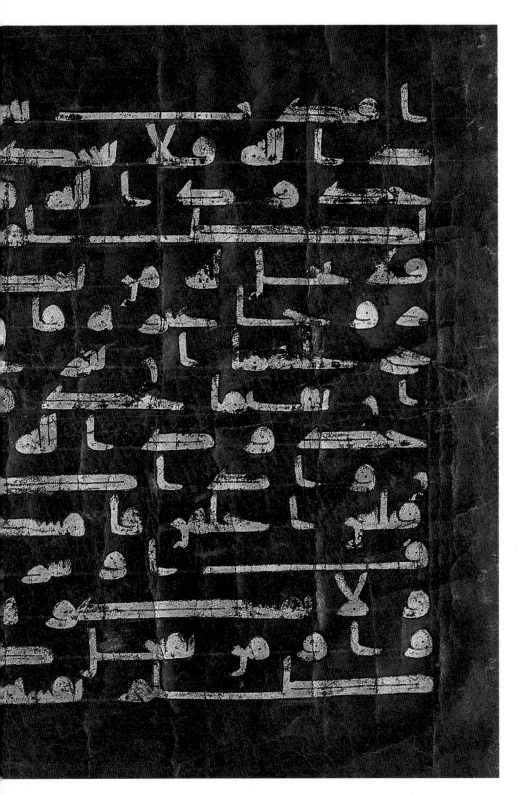

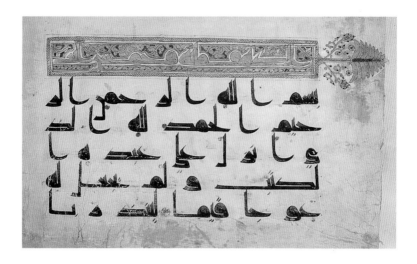

verses, and an inscribed medallion indicates the end of ten. Marginal medallions in some manuscripts repeated the divisions within the text and also indicate where the fourteen prostrations (Arabic *sajda*) prescribed in the Koran should be done. The earliest koranic manuscripts (see 34) do not seem to have had titles at the beginning of each chapter, but decorated horizontal bands were used to fill out the last line of the chapters at a relatively early date. It was no great step to add horizontal decorative bands to introduce new chapters, and by the ninth century a title and verse-count were included in these headings. These titles were often written in a smaller script and different colour of ink to show that they were not part of the received text. The horizontal bands commonly ended in palmettes (fantastic leaf-like forms) which spilled into the outer margins (38). This marginal decoration also gave rise to more elaborate decorative schemes that

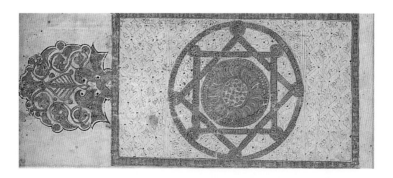

spread over two facing pages, usually at the beginning or end of a single or multi-volume manuscript, using geometricized vegetal motifs, often with lavish gold and colour (39).

Parchment manuscripts of the Koran were either kept as loose sheets in boxes or bound as volumes with leather covers. A set of bound volumes might also be kept in a box or stored flat on shelves in a library (see 26). As Arabic is read from right to left, the spine would be on the right, the opposite of a book in the West, and the title was often written along the spine. Islamic bindings often had an envelope flap on the front, or fore-edge, to protect and contain the text. Since the text was normally only

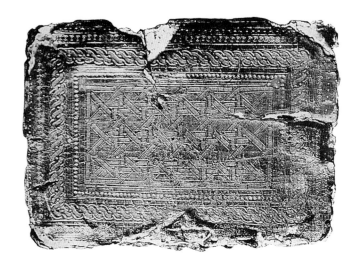

38
Above left
Right-hand page from manuscript of the Koran, 6 lines of text per page, showing chapter heading from *Surat al-Kahf* ('The Cave'), Chapter 18, 9th or 10th century. Inks and gold on parchment; 18.5×26 cm, 7¼×10¼ in. Chester Beatty Library, Dublin

39
Below left
Left-hand frontispiece from a manuscript of the Koran, 9th or 10th century. Gold on parchment; 12×28.5 cm, 4¾×11¼ in. Chester Beatty Library, Dublin

40 Right
Tooled leather binding from a manuscript of the Koran, 9th century. 13.8×20.5 cm, 5½×8 in. Library of the Great Mosque, Kairouan

loosely sewn to the binding, many covers became detached from their books, and it is therefore difficult to date surviving examples of covers. The earliest bindings to have survived are thought to be those preserved in the library of the Great Mosque of Kairouan in Tunisia. The typical early binding is of leather glued to pasteboard with flaps at the top and bottom, but not along the fore-edge. The decoration, which has been blind-tooled, or worked in the damp leather with stamps and burnishers, consists of a single oblong panel filled with a twisted band of ornament (or an inscription) surrounded by a wide border (40). Different designs were sometimes used for front and back covers.

The centrality of the Koran led to the promotion of the Arabic language from a regional idiom to the *lingua franca* of an empire. During the Prophet's lifetime, Arabic had been spoken by only a relatively small number of people in the region to the east and southeast of the Mediterranean Sea. Within three centuries, it had replaced such older languages as Latin, Greek, Syriac and Persian to become the language of religion, government, commerce, literature and science from the Iberian peninsula across the southern and eastern shores of the Mediterranean, Iraq and Iran to western Central Asia.

How widespread Islam, Arabic and the Arabic script were is shown by tombstones (41) from Spain, North Africa, Egypt, Syria and Iran, all inscribed in Arabic. It seems likely that a larger percentage of Muslims were literate than were their contemporaries in medieval Europe, since reading the Koran was an essential part of the faith. The predominance of Arabic, however, did not mean that all the old languages of the Near East and Mediterranean region disappeared. Most people were fluent, if not literate, in several languages, and many foreign words thereby entered Arabic. Persian, an Indo-European language in the same family as English or German, came to be written in the Arabic script in the eleventh century and still is; Turkish was written in the Arabic script from the fifteenth century until the early twentieth.

41
Tombstone
for Yaqub ibn
Abdallah,
Egypt,
858. Marble;
54.3×41.7 cm,
21¹⁄₃×16⁵⁄₈ in.
British
Museum,
London

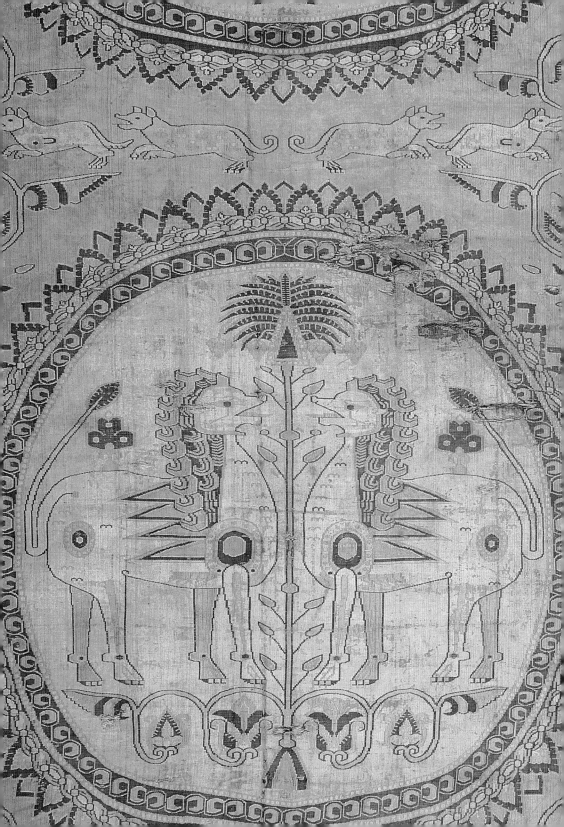

Textiles permeated life in the hot and arid lands where Islam flour-
ished. Everyone needed clothing for protection against the harsh
sun and to provide warmth in cold desert nights and the brief –
and sometimes wet – winter. Fashions came and went, but dress
and its accessories have always been constant markers of social
status. In the Islamic lands, dress distinguished not only men from
women and rich from poor, but also nomads from city dwellers,
and Muslims from non-Muslims. It was also used to make count-
less other social and religious distinctions: green turbans were
worn by the descendants of the Prophet Muhammad, and a
turban with twelve folds could indicate allegiance to the Twelfth
Shiite Imam. A coarse cloak of wool (*suf* in Arabic) was often
worn by mystics, whose very personal approach to religion was
becoming increasingly important alongside the communal prac-
tice of Islam, and they became known as Sufis.

Within this vast region two basic types of garment prevailed: in
Arabia and the Mediterranean lands, people wore loose flowing
robes made from lengths of cloth draped like togas on the body
or sewn together with little tailoring; in Iran and Central Asia, by
contrast, people wore garments fitted to the body and limbs;
pieces to make trousers and shirts were cut from lengths of cloth
and carefully sewn together. Over time the geographical range of
these two types overlapped, so that flowing robes came to be
worn in Iran and tailored garments in Egypt. Everywhere men
wore the turban, nicknamed the 'Crown of the Arabs'. Women
sometimes wore veils in public, but veiling was never mandated,
and the specific area the veil concealed, the status it indicated
(married, freeborn, etc.), and the age at which it was donned
varied widely. Among some groups, such as the Tuareg of North
Africa, men – but not women – wore veils.

42
Zandaniji textile
with roundels
enclosing
facing lions
around a
central palm
tree (detail),
Central Asia,
c.8th century.
Silk compound
twill;
89×85 cm,
35×33¹⁄₂ in.
Musée
Historique de
Lorraine, Nancy

Textiles were also used to cover and define spaces. As in the West, rugs were spread on floors and curtains and other hangings hung on walls. In most of the region, wood was (and still is) very scarce, and furniture in the Western sense of beds, chests, and tables and chairs was largely unknown. Many of these functions were filled by textiles, which also served as storage sacks, cushions and spreads. An early example is a hanging woven of coloured wool and undyed linen (43). Its geometric patterns are similar to those found in the mosaics used as floors in early Islamic palaces, such as that at Khirbat al-Mafjar. Even stone mosaic pavements were conceived as carpets, for the beautiful mosaic in the *diwan* there (see 14) has tesserae set to imitate a fringe, showing that it was meant to look like an actual carpet.

Unlike western Europe, where furniture was developed to keep human activities elevated from a generally cold and damp floor, life in most of the Islamic lands could be and was lived on the ground where it was cool in summer; a rug or mat was sufficient to keep down dust and provide warmth during the brief cold season. Textiles have the further advantage of being easily stowable when not in use. The use of textiles, which are portable, rather than heavy furniture – which is not, and which led in the West to the functional division of living space into specific areas for eating, sleeping or sitting – meant that a single space in a house could be used in many ways, depending on how the textiles were spread. For example, a typical communal living space would have a carpet to define the seating area, with cushions for support. For dining, the same carpet would be spread with a washable cloth, and diners would sit on the floor and serve themselves off communal trays, sometimes elevated on a low stand; when it was time for sleeping, the carpet would be spread with rugs and covers.

43
Woven hanging, Egypt or Palestine (detail), c.8th century. Coloured wool and undyed linen; 84×105 cm, 33×41¹/₃ in. David Collection, Copenhagen

Textiles were used by all members of society. They were particularly important for nomads, who made not only clothing and furniture from them, but also the sacks in which they carried goods and their shelter itself. Tents – portable structures with rigid supports sustaining a fabric covering – have been used as shelter

by the nomads of the Middle East and Central Asia since time immemorial. Two basic types of tent are used in the region. The typical tent in the Middle East has poles supporting a woven covering secured by ropes; the typical tent in Central Asia is a self-supporting wooden lattice covered with felts. The space within either type could be partitioned into men's and women's zones with textile hangings. As nomad groups entered the mainstream of medieval Islamic society, nomadic tent types were adapted for royal use by increasing their size and the splendour of the fabric coverings, and some rulers, such as the great Mongol conqueror Timur (Tamerlane), erected veritable tent cities for their court.

The central role of textiles in Islam from the very beginning is underscored by the veil (known in Arabic as the *kiswa*) that covers the Kaaba in Mecca (see 4). Although not mentioned in the Koran, the veil seems to have been draped over the Kaaba even in pre-Islamic times, and after the coming of Islam a new veil made in Yemen or Egypt was sent to Mecca. Supplying the veil was a great honour, and rulers fought for the right to do so, since it soon became a sign of sovereignty. Today the veil is a black cloth with bands of inscriptions from the Koran woven in gold thread, but in the past it could be of virtually any colour, including white, green or even red. In Muhammad's time one veil was apparently hung on top of another, for during the caliphate of Umar (r.634–44) the Kaaba threatened to collapse from the weight of all the coverings draped over it. The origins and meaning of the veil are shrouded in obscurity, but it may represent a vestige of the sacred tent – like the Israelites' tent for the Ark of the Covenant (2 Sam. 6:17) – in which God dwelled.

The connection of specific textiles with the Kaaba extends to the special clothes worn by the pilgrim in Mecca. Men don a garment made of two pieces of white seamless cloth: a wide loincloth that falls to the knees and a shawl draped around the upper half of his chest; his head must remain bare, although he is permitted to carry a parasol. No special garment is prescribed for women, although it is customary to cover the arms and legs, and

nowadays women wear veils. Either sandals or low shoes complete the outfit. The pilgrimage costume is kept simple and nondescript to symbolize the pilgrim's separation from the world and his equality with all other Muslims before God.

Luxurious textiles were well known in seventh-century Arabia, for the Koran speaks in several places of the sumptuous fabrics to be enjoyed by the virtuous in Paradise. Their garments will be of silk (Koran 22.23 and 35.33), and they will recline on carpets lined with rich brocade (55.54). This association of silk with Paradise apparently led all schools of Islamic law to forbid men in this world to wear silken garments next to the skin, although the schools of law differ about almost every other detail concerning silk. For example, some schools of law permit textiles of silk mixed with another fibre; some allow silk cushions and prayer mats, or silk outer garments that do not touch the skin. All these rules, however, seem to apply only to men.

Figured fabrics are also mentioned in the hadith, the traditions about the Prophet's life and deeds that comprise the second most important source of information about the early years of Islam. The hadith were transmitted orally for several generations before being written down in the eighth century; they often elaborate the circumstances under which obscure passages in the Koran were revealed. As the Prophet is considered the model Muslim, they also provide an example for every Muslim to follow. According to one such tradition, preserved in the collection made by a famous traditionalist named Bukhari (d.870), when Muhammad found that his wife Aisha had hung up a curtain decorated with figures of animals or birds, he is said to have exclaimed that those who imitate God's creative acts would be severely punished on Judgement Day. He was quite satisfied, however, when his wife cut up the offending fabric and made it into cushion covers. Although this tradition is usually cited to show that the Prophet was opposed to representations that might lead to idolatry, it also shows that fancy fabrics, undoubtedly imported, could be found in his household. Another tradition, concerning the rebuilding of the

44
Muhammad Placing the Black Stone in his Cloak from Rashid al-Din's *Jami al-Tawarikh* (*Universal History*), copied and illustrated at Tabriz, 1315. 13×26 cm, 5⅛×10¼ in. University Library, Edinburgh

Kaaba in Muhammad's youth, shows how textiles were used to confer honour. Workmen were about to put the Black Stone, a venerated black meteorite believed to belong to the original structure, back in place, when a quarrel broke out about who would have the honour of laying this most sacred relic in position. The Meccans finally agreed to let the first passer-by be the one. At that moment Muhammad arrived; he gently placed the stone in his cloak, giving a corner to the head of each tribe to carry (44).

The Prophet's cloak appears in many stories. According to one tradition, Muhammad went out one morning wearing his figured

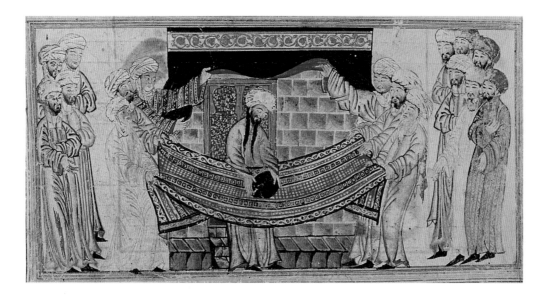

black cloak. He first encountered his daughter Fatima, then his son-in-law Ali, then his grandsons Hasan and Husayn. He took them all under his cloak, hugged them and said: 'People of the House, God only desires to put away from you abomination and to cleanse you' (Koran 33.32). Shiites in particular interpreted this incident as demonstrating the right of the Prophet's family to lead the Muslim community. According to another tradition, the Prophet gave his cloak (*burda* in Arabic) to his companion Kaab ibn Zuhayr as a reward for a poem he wrote. The Umayyad caliph Muawiya bought the cloak from the poet's son, and it was kept in the treasury of the Abbasid caliphs in Baghdad until the Mongols

conquered the city in 1258. Although some say the *burda* was burned, others claim that it was saved, for it eventually appeared as a relic in the treasury of the Ottoman sultans in Istanbul. The cloak was immortalized by the thirteenth-century poet al-Busiri, after he was miraculously cured when the Prophet appeared to him and threw the mantle over the poet's shoulders, as he had once done to the poet Kaab. Busiri's ode to the *burda* became the most renowned poem in Arabic, for the ode was supposed to convey the mantle's blessing to all who heard it.

Four fibres were used for textiles in the Islamic lands: two – wool and linen – were native to the Mediterranean region; and the other two – cotton and silk – were introduced from Asia. The most versatile fibre – and therefore the most important – was wool, made from the undercoat of sheep and sometimes goats and camels. The fleece is sheared from the animal, cleaned, carded, combed and spun into long threads, which can then be woven into fabrics. Most wool-bearing mammals, particularly sheep, are raised by nomadic herdsmen who search seasonally for pasture between mountains and lowlands. When nomadism expanded at the expense of agriculture in the period immediately before the rise of Islam, the raising of wool-bearing animals was encouraged, and woollen fabrics came to be produced in almost all Islamic lands, although some regions were particularly noted for them. The interest in animal husbandry led to the introduction of improved breeds. For example, the Merino sheep, known since the eighth century in the eastern Islamic lands, slowly grazed its way to Spain, where it eventually replaced the indigenous breeds because its fleece was finer. Wool is the only one of the four fibres associated with nomads, although farmers and city dwellers also enjoyed the benefits of sheep: their droppings fertilized the fields, their milk was made into cheese, their flesh provided meat, and their skins provided leather for shoes and bookbindings.

The other three fibres are associated with settled populations, as their production depends on agriculture. Linen – the strongest, but also the most difficult and labour-intensive fibre to prepare –

is made from the flax plant. The stalks are dried, fermented in warm water, and then dried again before pounding, combing, and spinning into threads. Flax can be grown in many places, but large quantities of fresh water are required to transform the raw flax into linen fibre. In Egypt and Mesopotamia, where the great rivers provided such water, linen was produced from prehistoric times. Linen fibres, which naturally rotate to the left, are best spun counter clockwise to produce an S-twist, so called because the characteristic slant visible when closely examining a thread resembles the middle of the letter S. This S-twist, which was a natural consequence of spinning linen, became a characteristic of all fibres spun in Egypt. Elsewhere, however, fibres are spun with a clockwise or Z-twist. This peculiarity of Egyptian spinning was already noted in the fifth century BC by the Greek historian Herodotus. As the linen fibres are grey-brown, the cloth has to be bleached, and the strong Egyptian sun was again an asset in making the fabric white. Egypt was the major centre of linen production in medieval times, although linen fabrics were also produced in Syria, Mesopotamia, Sicily, North Africa and Spain. Linen is versatile, being fine enough for veils and handkerchiefs, yet strong enough for ropes and hawsers. It is, however, difficult to dye, and so coloured decoration had to be added using other fibres.

Cotton, like linen, is produced from a plant fibre that is harvested and spun. The cotton plant needs a hot and humid climate to grow. Where rainfall is insufficient, irrigation can supply the necessary moisture for growth, but it is easier to spin cotton where the climate is damp. Cotton is native to India, but was introduced into Central Asia as early as the first century AD, where it was cultivated in the large oases irrigated by the great rivers. It soon spread westward, and in Islamic times, Iraq, Syria and Yemen became major centres of cotton production. Although today Egypt is famous for its cotton, it was actually not grown there until relatively recently. Like linen, cotton is versatile and can be used for a range of fabrics, from the finest gauzes to thick, absorbent fabrics comparable to wool. Unlike linen, cotton needs to be glazed or starched to provide a smooth surface.

The fourth fibre, and by far the most expensive, was silk, a lustrous elastic fibre produced by silkworms when they spin their cocoons. The cocoons are unravelled, and the fine filament (sometimes as much as 1,200 m or 1,300 yards in a single cocoon) reeled and twisted with many others into an extremely strong thread, which can then be woven. As silkworms feed on the leaves of white mulberry trees, the production of silk (sericulture) is limited to temperate regions where the white mulberry can be cultivated. Silk was discovered in China in the Neolithic period (Late Stone Age), and its production remained a jealously guarded imperial monopoly for 2,000 years. By the last centuries BC, silk threads and silk textiles were shipped overland along the Silk Road through Central Asia, Iran and the Fertile Crescent to the Mediterranean. The secret of sericulture was smuggled from China into Central Asia, India, and eventually Persia. In the time of the Byzantine emperor Justinian I (r.527–65), two itinerant monks are said to have hidden silkworm eggs and mulberry seeds in their hollow walking sticks and smuggled them from Central Asia to Constantinople, the capital of the empire. Silk manufacturing in the Byzantine Empire, as in China, became a state monopoly, with Syria its major centre of production, and under the Muslims, who conquered Syria in the seventh century, silk production increased dramatically. Sericulture was introduced to Spain by the early ninth century and to Sicily by the late eleventh or early twelfth century. In the early medieval period, silk was one of the three or four most important commodities of intercontinental trade, and silk and silk textiles were the most important export from the Muslim world until the early nineteenth century. Gradually, sericulture was transferred from the Islamic lands to western Europe, where, in the fourteenth century, the weavers of the Italian city of Lucca broke the Muslim monopoly on the production of silk cloth.

In addition to these four primary fibres and many secondary ones, such as hemp, textiles were made from combinations of fibres. The delicate, light fabric known as mulham ('half-silk'), for example, combines fine, raw silk floss with heavier cotton. Egyptian linens often had colourful woollen or silk bands woven into the

fabric, and Mesopotamian cottons were often embroidered in bright silk. Woollen rugs might be knotted on cotton for added strength. As some fibres were only produced in certain regions, fibres, threads and fabrics were traded extensively. For example, a great annual cloth market came to be held in Jiddah, the port of Mecca, at the time of the pilgrimage, where Egyptian linens were traded for Indian cottons. In the early medieval period silk was one of the main commodities of trade between East and West, where it was valued on a par with gold. The production of the raw materials and finished textiles, and their transport from one region to another, were a driving force in medieval Islamic economies comparable, say, to the automobile industry of modern times.

The primary fibres were rendered all the more versatile by dyeing, and vivid colours were a major characteristic of medieval textiles, although exposure to light has often dimmed their original intensity. A broad spectrum of dyes was available locally, but the demand for dyes was so great that more had to be imported. Most dyes were extracted from plants. For example, saffron from crocuses gives a vivid yellow, the root of a herb called madder a strong red, and the leaves of the indigo plant a bright blue. A few dyes are mineral based. Verdigris from copper, for instance, gives a vivid green, but it eventually corrodes the fibre to which it is applied. A few other dyes come from insects, such as kermes, cochineal and lac, which all produce vibrant reds. The most luxurious silks were woven with gold and silver threads, made by wrapping a silk thread with gold or silver leaf. Like fibres and textiles, dyes were traded widely throughout the Muslim lands, as were many other substances used in textile production. Chemicals to fix dyes (mordants) were needed to make the colours in the fibre permanent. Alkalai, for example, helped fix the colour of saffron. Sumac and gall nuts were used as both dyes and mordants, particularly for cotton. Other products connected with the textile trade included bleaches, nitre and quicklime for degreasing wool, and starches for finishing and glazing. The clay known as fuller's earth was used to make woollen textiles soft and fluffy.

Most textiles are woven on a loom – a frame strung with parallel threads, called warps. The weaver inserts another set of threads, known as wefts, perpendicular to and alternately over and under one or more warps. In plain weave both warps and wefts show on the surface of the finished fabric; in other weaves, only the warps or only the wefts may show. When the fabric has reached a sufficient length, the weaver ties the threads at the top to make a finished edge that will not unravel. The woven fabric is usually a long rectangle that can be used whole or cut into pieces and sewn. The width of the textile between the selvages – the finished edges at either side – depends on the width of the loom.

Two types of looms were used in the Islamic lands. Nomads generally used horizontal looms that could be folded up and moved; only relatively narrow strips could be woven on them, so when wide fabrics were needed, they were often made up of several narrow strips sewn together. Settled populations generally used stationary vertical looms that were difficult to move but could produce wider textiles. The fineness of the finished fabric depended on the choice of fibres, the thickness of the threads, and the quality of the weave. Sturdy fabrics for tents and sacks were woven of coarse wool and goathair; fine fabrics for veils and shawls were woven of silk and cashmere – the underbelly hair of Kashmir goats.

45
Carpet
depicting a
stylized
quadruped
reportedly
found at Fustat
(Old Cairo),
Iran,
8th century.
Wool pile;
89 × 166 cm,
35 × 65⅓ in.
The Fine Arts
Museums of
San Francisco

Textiles were also produced using other techniques. The textile most closely associated with the Middle East is the pile carpet, in which additional threads, usually wool or silk, were knotted into a woven substratum to form a furry surface. The oldest surviving example, discovered nearly intact in a frozen grave at Pazyryk in Siberia, may date from as early as the fifth century BC, but virtually nothing else survives to document the development of this craft until later Islamic times. One of the rare pieces to survive from early Islamic times is a wool carpet (45) discovered in the 1920s in the ruins of Fustat (Old Cairo). Like the Pazyryk carpet and many later examples, its design has a pattern in the middle surrounded by one or more borders. Worked in six colours, the Fustat carpet has a stylized four-legged animal with sharp claws, probably a lion, in the centre. Although the carpet was found in Egypt, the Z-spun woollen warps and wefts suggest that it was not made there, where S-spinning is traditional. It may have been imported to Egypt from Iran or central Asia. Other types of rugs had extra, or supplemental, wefts to make a pattern and increase the thickness and strength of the fabric. Another important technique used was felting, in which wool fibres are matted together into a fabric by the application of pressure, heat and moisture. The nomads of Central Asia may have invented felt; they used it long before spinning and weaving were developed, and it remained particularly popular in that area, where it was developed into a fine art.

Although most fabric woven in the Islamic lands for everyday use was plain, people appreciated decorated fabric and were willing to pay a high price to get it. Decoration could be added before weaving by dyeing the individual threads; this is how striped and checked fabrics were woven. One speciality weave is ikat, in which the warp and sometimes weft threads are tie-dyed to create patterns when woven; it was produced particularly in Central Asia and in Yemen, where it had been introduced across the Indian Ocean from India. A series of spectacular cotton fabrics was made at Sanaa, the capital of Yemen, and other cities in the ninth and tenth centuries. Portions of the natural-toned

46
Cotton two-colour ikat with gilded inscription, Yemen, 10th century. 79×45 cm, 31×17¾ in. Museum of Fine Arts, Boston

cotton warps were dyed blue and brown before weaving; when woven with natural cotton wefts, the characteristic variegated stripes appear. Some Yemeni ikats were also decorated with embroidery; others were painted in gold with inscriptions blessing the owner (46).

Decoration could also be added to textiles during weaving. In tapestry weaving, for example, mosaic-like patterns are created by using discontinuous wefts, that is, wefts that go back and forth around only a few warps to create a small coloured area. As in pre-Islamic times, bands and medallions with animals, birds and inscriptions tapestry-woven in bright colours were added to decorate plain linens (47). The typical dress of Egyptian Muslims, for example, was a loose linen robe woven in the form of a cross with tapestry-woven bands on either side of the neck opening and across the top of the sleeves. No cutting was needed before making the piece into a garment.

Compound weaves, in which two or more sets of warps and/or wefts are used simultaneously, show how sophisticated textile technology was in the Islamic lands in early times. These compound weaves allow complex all-over figural patterns in several colours to be produced. A silk band of compound twill with undyed silk warps and two colours of silk weft (48) exemplifies a class of two-coloured silks woven as trimmings for tunics. Many were found in Egyptian graves, especially at Akhmim in

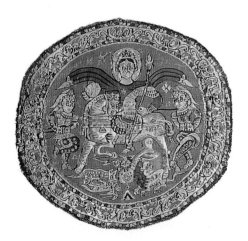

47
Tapestry woven medallion showing *The Victorious Emperor*, Egypt, 8th century. Wool and linen; 25.4×22.9 cm, 10×9 in. Victoria and Albert Museum, London

Upper Egypt. Some pieces bear Greek or Coptic names, showing that they were made for the Christian market. Others, identical in style, have Arabic inscriptions. The inscription on this piece makes no sense, suggesting that the weaver did not know how to write Arabic, a likely possibility in this period of cultural change after the Muslims conquered Egypt.

Decoration could also be added to textiles after weaving. Either the entire piece or only parts of it could be dyed or, as in batik, 'resist-dyed', that is, parts of the design are first coated with wax to keep them free of dye. Designs could also be painted or block-printed on the fabric. Finally, decoration could be embroidered, or sewn, in various coloured threads onto the finished fabric, usually linen or cotton, or appliquéd, that is, pieces of one textile are cut up and sewn in patches on to another to form a pattern.

By far the most common kind of embroidered decoration in the early Islamic period was a long band inscribed with the ruler's name and other information, such as the place and date of manufacture. Known as tiraz, from the Persian word for embroidery, these fabrics were made in state workshops to be distributed by the ruler to his court. Normally the ruler gave out cloth for winter and summer garments. The earliest surviving fragment of a tiraz is a compound twill silk with red warp and four colours of weft (49). According to the inscription embroidered in yellow silk, the piece was made in the 'tiraz of Ifriqiya', meaning the state workshop in what is now Tunisia, during the 'reign of Marwan', probably Marwan II (r.744–50), the last Umayyad caliph.

The tiraz system expanded under the Abbasid caliphs, who established factories in Central Asia, Mesopotamia and Egypt to provide seasonal clothing for their enormous retinues. Among the clothing left in the estate of the caliph Harun al-Rashid (d.809) were 8,000 coats, half of them lined with sable or other fur, the other half lined with figured cloth; 10,000 shirts and tunics; 10,000 caftans; 2,000 pairs of drawers; 4,000 turbans; 1,000

48
Band with design of running figures, trees, birds and animals and an inscription apparently in Arabic, Syria, 8th or 9th century. Silk; 56×9 cm, 22×3½ in. Victoria and Albert Museum, London

hooded cloaks; 1,000 outer wraps; and 5,000 kerchiefs. In addition to the clothing, furnishings included 1,000 Armenian carpets, 4,000 draperies, 5,000 cushions, 5,000 pillows, 1,500 silk pile carpets, 100 silk spreads, 1,000 silk cushions, 300 carpets from Maysan, 1,000 carpets from Darabjird, 1,000 brocade cushions, 1,000 cushions of striped silk; 1,000 pure silk drapes; 300 brocade drapes, 500 carpets and 1,000 cushions from Tabaristan, 1,000 small bolsters, and 1,000 pillows!

Most early tiraz pieces that survive, however, are relatively plain fabrics with simple embroidered bands. For example, one fabric made in Iran in 896 for the caliph named al-Mutadid (50), is of yellow mulham. At the top, an inscription is embroidered in red silk using chain and blanket stitches. At the bottom the inscription has been marked with a small toothed wheel, like the one dressmakers use today, but not yet stitched. The softness of the cloth meant that the fabric had to be glazed before decoration. The marks are in the glaze, which made it easier to use the marking wheel.

When embroidery was introduced to the western Islamic lands, a new technique had to be developed, as linen, the fabric commonly available there, did not need to be glazed and it was therefore impossible to draw a fine inscription on the unglazed surface. A linen textile (51) with the name of the caliph al-Mutamid, the factory at Alexandria in Egypt, and the date 272 (885–6 AD) inscribed on it, shows how the Eastern technique of embroidery was adapted to linen and other Mediterranean fibres. A decorative band of blue lozenges with yellow borders and a blue inscription are worked in couching and stem-stitch. The stiffness of the linen allowed the embroiderer to count threads, scaling the design so that it was not necessary to draw it on the fabric beforehand.

Like all manufactured goods before the Industrial Revolution, textiles were expensive. They were also fragile. The result was that they were often quite literally worn to shreds. Many of the surviving tiraz may have been used as winding sheets. Islamic law requires that bodies be buried in a plain white shroud, and some

49
Two pieces from a silk textile embroidered with the name of the caliph Marwan, Syria, mid-7th century. 30.3×50.7 and 15×22 cm, 12×20 and 6×7¾ in. Victoria and Albert Museum, London

50
Yellow tiraz embroidered in red silk for the caliph al-Mutadid (detail), Iran, 896. Mulham (silk and cotton); 15×66 cm, 6×26 in. Textile Museum, Washington, DC

51
White linen tiraz embroidered in blue and yellow silk for the caliph al-Mutamid, Alexandria, 885–6. 19×26 cm, 7½×10¼ in. Textile Museum, Washington, DC

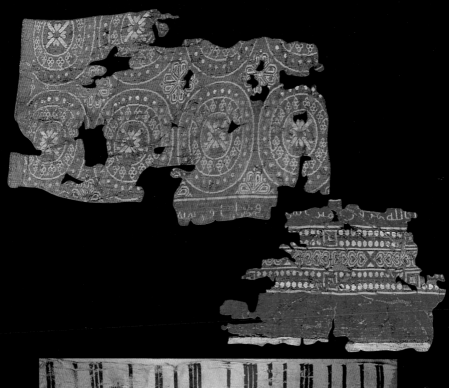

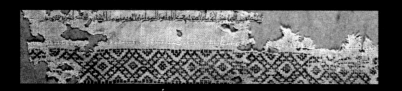

pious Muslims chose to be buried in the seamless white garments they had worn on the pilgrimage, others in the white robes of honour they had been given. Rags, particularly linen ones, were collected by ragmen, for recycling into paper, which – like silk – had been introduced into the Islamic lands from China and Central Asia sometime in the eighth century.

Except for those rare pieces that have a date written on them, textiles are difficult to localize and date; they are rarely made in single examples, since they lend themselves to repeat production. Once a design was established and looms set up to weave it, a pattern could be repeated indefinitely with only slight changes. This method of production was true of village and nomadic fabrics, where patterns were passed by example from generation to generation. It was also true of textiles made in factories in cities, where designs were maintained for years. The high cost of textiles meant that after they became damaged or worn, they were often cut up and reused rather than being discarded. The facings or lining of a cloak, for example, might be fifty years older than the outer part of the garment. Burial sites and archaeological evidence can establish the date after which a piece was not used, but the textile may have been made years before the date it was used or reused, especially

if it was used for a shroud. Hence this kind of evidence cannot be taken as the date that the textile was made.

Despite their importance in medieval Islamic society, relatively few textiles still exist. Some were buried and those in particularly dry ground survived, as they did in Egypt and other regions where it seldom rains. Most excavated pieces are plain fabrics, with little decoration. A notable exception is the fur-lined silk caftan (52–3) excavated between 1969 and 1975 in a cemetery at Moshchevaya Balka, an extremely remote site in the northern Caucasus mountains. It comes from the tomb of a local prince, who was buried in the eighth or ninth century, judging from the Byzantine coins found in his grave. The emerald-green long-sleeved robe, wrapped to the left and closed with gold buckles, is decorated with rows of medallions, each enclosing a yellow simurgh, a mythical lion-headed bird from Persian legend. Silks in other patterns were used for the facings and binding of the robe; apparently this wide range of precious fabrics was available to an obscure ruler in a remote region because it lay on the northern branch of the Silk Road that connected China and Central Asia to Byzantium and the West. It is likely that such opulent silks were imported into Syria, for murals at the Umayyad palace of Khirbat al-Mafjar reproduce comparable textile designs showing simurghs framed by linked circles or roundels (54).

Similar sumptuous fabrics have also been preserved in European church treasuries, where they were used to wrap the relics of saints. These textiles were acquired by pilgrims or carried over long distances and represent the finest that money could buy. Many European words for fine textiles are also derived from Arabic and Persian terms and placenames. For example, atlas is still the name for a rich satin, the word damask derives from Damascus, muslin from Mosul, and organdy from Urgench in Central Asia. Mohair comes from the Arabic word *mukhayyir* ('choice, select'), and taffeta comes from *taftan*, the Persian verb 'to spin'.

A silk textile found in the church treasury at Huy in Belgium

52–53
Far left
Silk caftan lined with fur, discovered in a grave at Moshchevaya Balka in the northern Caucasus mountains, Central Asia, 8th or 9th century.
h.1.39 m,
4 ft 6¾ in.
Hermitage, St Petersburg
Above left
Detail of 52 showing design of simurghs in roundels

54
Below left
Reconstruction drawing of a mural showing simurghs in roundels from the Umayyad palace at Khirbat al-Mafjar, near Jericho, c.740

provided the key to localizing and dating a group of these brightly coloured Islamic silk textiles decorated with roundels, enclosing paired birds and other motifs. The piece was included among the relics of St Domitian (who died in the sixth century, was canonized in the eighth, and whose relics were assembled in the twelfth). A note on the back in Soghdian script states that the cloth was made at Zandana, near Bukhara, in Central Asia. The writing is similar to other inscriptions discovered at the Soghdian citadel of Mount Mug in Central Asia, which was destroyed by the invading Arabs in 722. Therefore the textile can be dated to the late seventh or the eighth century, when Islam was first brought to Central Asia. Another example of this Zandaniji ('from Zandana') type is the Lion Silk (see 42), associated with the relics of a saint named Amon in the cathedral of Toul, possibly when they were moved in 820. A masterpiece of large-scale patterning, though now very faded, it has large medallions containing stylized lions facing each other across a central palm tree, worked on a beige warp in six colours.

This wide range of evidence, from texts to excavated materials, shows how textiles were involved in virtually every aspect of life. Extending the metaphor from the Kaaba, the draped shrine holy to all Muslims, one scholar recently referred to Muslim society as 'the draped universe of Islam'. Not only did textiles define status and space, but they also served, in an age before picture books, as the primary means by which artistic ideas were transmitted from one place to another.

Discovering the use of fire to transform materials extracted from the earth into pottery, glass and metal utensils began an important stage in the rise of civilization in the Near East, and the manufacture of ceramics, glass and metalwares continued to be characteristic of Islamic lands until modern times. Ceramics were used for storage, cooking and serving food; glass for lighting, for storing and serving foods and for keeping perfumes; metalwares for weapons, tools and utensils as well as jewellery and coins. In Islamic times these techniques of craft production were transformed into major artistic vehicles, and the 'decorative arts' show a concern for transforming the accoutrements of ordinary life into works of great beauty. Unlike Christianity, where vessels of silver and gold were used in church liturgy, Islam required no such luxury objects in the mosque. Objects that survive are merely more expensive versions of objects used in daily life.

The making and use of ceramics characterize all the great cultures of the ancient Near East and Mediterranean region. Most of the great centres of Near Eastern civilization were located along rivers and therefore had a virtually unlimited supply of clay, sand and water, the raw materials from which earthenware ceramics are made. Ceramics were first made of clay, an extremely fine earth found naturally along riverbanks where it is deposited by rivers. Later, an artificial body was sometimes made from sand, quartz and other materials finely ground together. In both cases the material for the object is dried, sifted and mixed with water into a firm paste so that it can be shaped. Techniques used include building the object up by modelling or using coils and slabs; moulding – pressing the paste or pouring liquified clay into a mould of some other material; and throwing – shaping a lump of paste with the hands while it is rapidly spinning on a potter's wheel. The shaped object is then left to dry, most conveniently in the sun. The object

55
Cosmetic bottle in the form of a dromedary with a pack on its back, eastern Mediterranean, 8th–9th century. Tooled and free-blown glass with trailed thread decoration; h.12 cm, 4¾ in. Metropolitan Museum of Art, New York

is then baked or 'fired' in an oven known as a kiln at a temperature high enough so that it will no longer soften in water. In a land where wood is relatively scarce, fuel consisted of dried dung, brush or other waste material. Although the basic materials are cheap, the cost of fuel adds to the price.

Glassmaking is also an ancient industry in Egypt, Syria and Mesopotamia; Syria in fact remained the major centre of glassmaking in the Mediterranean lands until competition from Venice began in the thirteenth century. Like pottery, glass is made by treating common materials with heat, in this case fusing together sand and woody ashes with lime (from ground up seashells) supplied by the sand. The raw materials are heated and melted in a pot, then cooled. The resultant 'frit' is crushed and mixed with waste glass and melted again. Metallic oxides are added to make the glass colourless, give it a distinct tone, or make it opaque. The hot glass is then shaped by blowing or moulding. It can then be decorated, either while still hot or when cooled.

The Islamic lands also inherited a long tradition of metallurgy: gold, silver, lead, mercury, copper and iron were among the most important metals mined and worked throughout the region. Apart from gold, which was often panned from rivers, ores were usually mined from the earth and smelted locally, for it was too expensive to carry heavy ores any substantial distance. One exception was tin, which was not available in the region and had to be imported at great expense from as far away as Sumatra, Spain or Cornwall in England. The production of a particular mine was limited by the continued availability not only of ore but also of fuel: in an arid climate when the scant supplies of fuel available locally were exhausted, the mine would have to be closed until sufficient vegetation could grow again. This meant that mines were often worked only for short periods at a time. Gold and silver were used for jewellery and coins; iron and steel for weapons and armour; bronze and brass – alloys of copper with tin and zinc – for the widest variety of household and everyday uses. The copper souk, or market, remains a fixture of virtually every Near Eastern bazaar,

56
Unglazed earthenware ewer with applied and incised decoration, Iraq, c.early 8th century. h.35 cm, 13¾ in. Metropolitan Museum of Art, New York

even today. The difficulty of extracting ore and the high cost of fuel made metalwares expensive; their durability and relative ease of repair, however, made them worth the price.

Earthenware vessels have been used for millennia in the Near East for carrying and storing water. This is particularly important where water is relatively scarce and access to it is centralized at the village well or riverbank. Earthenware vessels, which represent the most common type of pottery, are particularly suitable for this function because they are slightly porous; water quickly evaporates from their surface in a hot and dry climate, thereby cooling the vessel and its contents. Earthenware water jars have been made in all sizes, from enormous stationary storage jars for a house or a mosque to small portable ones for serving. Although the simplest – and cheapest – are plain, many have some sort of decoration, which is carved and scratched or added in moist clay to the surface of the unfired piece. As pottery is easy to break but difficult to destroy, innumerable fragments (called shards by archaeologists) of this ware, which was in daily use throughout the region, have been found.

An earthenware ewer with applied and incised decoration (56) shows both casualness and sophistication in its execution. The potter threw the water jug on a wheel and pinched the soft clay lip to form a spout. He added a handle and pierced several loops which could be strung with cords for carrying. He decorated it by adding bits of moist clay and scratching and cutting the leather-hard surface. The design, representing a tree flanked by ibexes and birds, can be traced back for millennia in the art of the ancient Near East, although the specific and somewhat rough style of execution suggests that the piece was produced in eighth-century Iraq. Such a stylized tree of life would be appropriate decoration for a vessel used to serve water.

The porousness of earthenware vessels, which made them so suitable for holding and cooling water, made them equally unsuitable for other liquids, such as oils, which could turn rancid from prolonged exposure to air. At an early date potters discovered

that a ceramic object could be covered with a thin glassy layer, or glaze, that would render it impermeable to liquids. Two different approaches to glazing were found in the region: alkaline glazes and lead glazes. Alkaline glazes, used since ancient times in both Egypt and the Near East, are close to glass. This is no surprise since the crafts of pottery and glassmaking have often been closely allied, and techniques discovered for one medium were often applied to another. Alkaline glazes are made from a mixture of ground quartz and alkali (from the Arabic *al-qali;* either soda [sodium carbonate] or potash [potassium carbonate], both made from plant ash), and sometimes salt. They are extremely transparent and can be made opaque and can be coloured with copper or iron. One problem is that they tend to degrade and turn iridescent. They adhere well to an artificial ceramic body, but not to an earthenware body and often crack unless sand is added to the clay, which tends to coarsen the body, making it more difficult to shape a delicate object. The other type of glaze, developed at more or less the same time in the Roman Empire and in China, is based on the use of red lead to lower the temperature at which the mixture turns to glass.

Whichever kind of glaze is used, the raw material for the glaze is ground finely and mixed with water. The earthenware object, which may have been already fired, is then dipped into the liquid glaze or painted with it; the object is then dried and fired again. Care has to be taken that the glazed objects do not stick together in the kiln so the base, or foot, is normally left unglazed, and stacked pieces are separated by tripods with no glaze whose imprints can often be seen on the finished surface.

In addition to waterproofing, glazes have the advantage that they can give the ceramic object a colour different from that of the clay from which it is made. Unlike alkaline glaze, lead glaze can be coloured easily to give a uniform tint, but designs worked in two or more colours tend to run together or smudge. Copper oxide, which produces a turquoise blue colour in an alkaline glaze, gives green in a lead glaze; rust in a lead glaze normally gives yellow or

orange; cobalt gives blue; and manganese gives purple or black. Transparent glazes enhance rather than conceal the ceramic surface but it is often desirable to hide the drab ceramic body on which glazes are applied. There are two ways to do this: a slip (a thin layer of coloured clay, often white to provide a reflective surface) can be added between the glaze and the body, or the glaze can be made opaque in some way. Slips had long been applied to colour the surface, but they do not make it impervious to liquid. The great discovery of potters in the Islamic lands was to use tin oxide in alkaline or lead-based glazes to give them an opaque, creamy-white appearance.

A condiment dish with a shiny green and yellow glaze (57) represents the legacy of the Roman tradition of moulded relief-ware and lead glazing into Islamic times. Small earthenware vessels and oil lamps had been moulded for centuries throughout the Roman Empire, but this example has an Arabic inscription that shows it was made in Islamic times. It is signed by Abu Nasr, a distinctively Islamic name, who came from Basra, a city in Iraq founded by Muslims in the seventh century. The inscription further states that he made the dish in Egypt. Other examples of

this type of finely moulded ware, with or without a lead glaze, have been ascribed to Iraq and Iran in the eighth and ninth centuries, suggesting that potters carried techniques of producing moulded objects with them as they moved from Syria and Egypt to look for jobs in the new centres of power established by the Abbasids in the eastern Islamic lands. In this way traditional Mediterranean techniques were brought eastwards where they were combined with the new approaches to design that were emerging under the powerful Abbasid caliphate.

The Abbasid court, the richest and most powerful in the world, admired the beautiful and the exotic and had the money to buy it. According to contemporary texts, they held Chinese pottery in particular esteem. For example, Ali ibn Isa, the governor of the province of Khurasan, sent the caliph Harun al-Rashid (r.786–809) a present of twenty pieces of Chinese imperial porcelain, 'the likes of which had never been seen before', along with 2,000 other pieces of porcelain. The majority were Chinese wares made specifically for export, but the twenty pieces must have been the special type made for the imperial household. Chinese wares were available throughout the Abbasid Empire, for they have been found in excavations at such sites as Samarra, the Abbasid capital in Iraq, and Siraf, a seaport on the Persian Gulf. Chinese ceramics found there include white and green-and-grey glazed stoneware and porcelain. It seems likely that most of these Chinese wares reached the Near East by sea across the Indian Ocean and up the Persian Gulf, although it is possible that others were carried by caravan along the Silk Road. Near Eastern potters were deeply impressed by the whiteness, strength and elegance of the Chinese imports, which had artificial bodies made from special clays and minerals fired at high temperatures to create a particularly thin and hard substance. Although they were unable to copy Chinese wares because they lacked both the materials and the know-how, craftsmen in the Islamic lands did learn how to refine local clays to produce a cream-coloured earthenware which they shaped and decorated in imitation of the Chinese wares.

57
Moulded
earthenware
condiment dish
with green and
yellow lead
glaze, inscribed
'the work of
Abu Nasr of
Basra in Egypt',
9th century.
w.15 cm, 6 in.
British
Museum,
London

One example of an Islamic version of Chinese wares is a flat earthenware bowl painted in cobalt blue on an opaque white glaze (58). The low and open shape derives from Chinese models, but because he lacked the fine white clay of China, the potter had to hide the local clay body with an opaque white glaze. It was long thought that this type of pottery had a lead glaze made opaque with expensive imported tin, but new techniques for examining old objects show that in many cases it is an alkaline glaze, modified and rendered opaque by firing it incompletely and leaving some particles of quartz in suspension. Traditional glazing techniques were thus continued in the eastern Islamic lands at the same time that new ones were imported.

Chinese potters would have considered the shape and glaze suffi-cient aesthetic treatment for a luxury piece, but potters in the Islamic lands, like artisans in other media, preferred several layers of decoration, including colour, texture and pattern. This fondness for elaborate surfaces is one of the most characteristic and persis-

tent features of Islamic art. In this case the potter 'stained', or painted in the glaze with an oxide of cobalt to give a blue design when fired. In other examples the opaque glaze is also stained with an oxide of copper to give green, an effect that has been compared to 'ink on snow'. On the interior of this bowl four sprays of leaves surround a central block of three lines of text which reads, 'Blessing to the owner; the work of Muhammad the …' (the last word is illegible). In addition to the name of the artisan or workshop, the formula shows that the piece was made for sale on the open market; had it been a specific commission, the individual receiving blessings would have been named. There is no decoration on the exterior, so the piece was obviously meant to be seen from above. Assuming that the dish was meant to be filled with some sort of food, the decoration could only be revealed when the food had been eaten. This type of ware is the first example of blue designs on a white background, a combination that became very popular in later times as it bounced back and forth between China, the Islamic lands and Europe.

Writing is used on this dish as decoration as well as information. The spread of Islam had given the Arabic script a profound appeal, and it was used to decorate a wide variety of objects at all levels of patronage. Because the inscriptions were usually well-known formulas, this also led to the ornamental transformation of letters themselves and, as in the case of the second part of the artisan's name on this dish, it is sometimes difficult or even impossible for us to read the words.

Another common type of glazed pottery from this period (59) has a creamy ground decorated with finely incised lines as well as broad splashes of green (from copper), ochre (from iron) and sometimes brown (from manganese). The potter used a thin layer of white slip to conceal the earthenware body and better display the glaze. The shiny transparent glaze is lead-based, so different colours tend to run together; the potter has taken advantage of this limitation to develop a distinctive type of decoration known as splashware. It is often thought to imitate Chinese splashed

58
Earthenware
bowl painted
in blue on
an opaque
white glaze,
Mesopotamia,
9th century.
diam. 24 cm,
9¹₂ in.
Staatliches
Museum für
Volkerkunde,
Munich

wares of the Tang period that had been imported into the Near East, but no well-authenticated piece of Chinese origin has yet been discovered in the Near East, and the Chinese type seems to have been reserved for imperial tombs. It is probable therefore that the two types were independent discoveries. The two levels of decoration – incising and colour – on the interior of the bowl have little if any relation to each other, but show another characteristic and persistent feature of decoration in Islamic art – the use of designs on several levels at the same time.

Perhaps the most impressive achievement of potters in this period was the development of ceramics that have decoration painted over the glaze in what is known as 'lustre' because of the shiny metallic sheen on the surface. The manufacture of these lustrewares was extremely complex and required several stages. Like other ceramics, the object was made, fired, glazed with a lead glaze made opaque by adding tin, and then fired again. For lustre ceramics, yet another stage was required: the design was then painted in oxides of silver or copper and fired a third time in a special, smoky kiln. The carefully regulated heat (about 600 °C) was just sufficient to soften the glaze; the oxygen-free atmosphere 'robbed' oxygen from the metallic oxides, leaving a thin film of metal on the surface of the glaze. The construction of a special kiln, the expense of the additional materials, the extra fuel required, and the difficulty of controlling all the possible variables

59
Earthenware dish covered with a white slip, incised and glazed, excavated at Nishapur, Iran, 10th century. diam. 26 cm, 10¼ in. Metropolitan Museum of Art, New York

60
Glass beaker,
free-blown
and painted in
three colours
of lustre,
eastern
Mediterranean,
8th-9th century.
h.11 cm, 4⅓ in.
Metropolitan
Museum of Art,
New York

made these ceramics the acme of the potter's art. The freedom
allowed by the technique of painting with a brush on a glassy
smooth glaze also made these ceramics the most painterly and
complex in design.

The lustre technique seems to have been developed by glass
makers in Egypt and Syria. The earliest dated example is a broken
beaker inscribed with the name of an Egyptian governor who
served for only a month in 773. The inscription on another piece
states that it was made in Damascus, probably in the eighth
century. One of the rare examples of a complete piece is a beaker
(60) decorated in three colours (ochre, orange and brown). Just
below the lip is an Arabic inscription, which no one has yet been
able to decipher; below is a design of alternating circular and
arched panels, each containing an abstracted vegetal motif.

Comparable plant motifs adorn a small ceramic bowl decorated
with a central stalk and paired leaves drawn in four colours of
lustre (61). The basic design is quite simple, but it has been elabo-
rated with many different patterns – spots, herringbones, blots,

peacock's eyes, etc. – that cover as much of the surface as possible. This approach to design is comparable to that found on the stucco decoration of contemporary buildings (see 25), where motifs from nature were increasingly abstracted into patterns that covered the surface like wallpaper. The design of another lustreware dish (62), discovered in the course of the 1911–13 German excavations at Samarra, is caught somewhere between a representational and an abstract design: the central circle is transformed into the body of a bird by palmettes forming wings and springing from the bird's head; the bird holds another sprig in its mouth. As on the palmette dish, the empty spaces have been filled with patterns, although a narrow undecorated or 'contour' band effectively separates the main motif from the background and prevents visual confusion. Nevertheless, the ambiguity – whether this is a bird or a plant – is intentional, and this element of design is another hallmark of the decorative arts in Islam.

The effect of lustre decoration has often been likened to that of polished metalware, particularly that of gold and silver plate. It is often claimed that lustrewares allowed diners to enjoy the pleasures of eating off gold or silver without having to suffer the moral consequences, for Islam frowned on the use of precious metals for personal adornment or plate. The Koran warns those who hoard gold and silver in this world that they will meet with a painful punishment in the next, while the righteous will eat from platters and drink from cups of gold. According to the traditions, the Prophet forbade the use of gold and silver vessels: 'He who drinks from a silver vessel will have hell-fire gurgling in his belly.' Nevertheless, this prohibition, like that against silk, was rarely observed, and many texts describe the gold and silver vessels used by the caliphs and others.

In all eras the intrinsic value of gold and silver makes plate a ready supply of currency when money is needed. To pay the troops, for example, plate can be broken, melted, and quickly minted into coin. Therefore it is no surprise that little gold or silver plate has

61
Above left
Earthenware
dish with
vegetal
decoration
painted in
four colours
of lustre, Iraq,
mid-9th
century.
diam. 19 cm,
7$\frac{1}{2}$ in.
Metropolitan
Museum of
Art, New York

62
Below left
Earthenware
dish painted in
lustre with the
abstracted
design of a
bird, excavated
at Samarra,
9th century.
diam. 27 cm,
10$\frac{5}{8}$ in.
Museum für
Islamische
Kunst, Berlin

survived from the early Islamic period, as there were always hungry and angry troops demanding to be paid. The few pieces that have survived are not the ones used at court, but come from hoards that were buried for protection in remote locations. One example is a silver dish (63), said to have been found near Erevan in Armenia, which represents a type of dish showing royal hunting scenes that had been made in Sasanian Iran and that continued to be produced after the Muslim conquest. Eastern Iran and Central Asia were the most important sources of silver in the Near East, and silver plate became an important status symbol. Many of these dishes were sent to rulers and allies abroad to impress the recipient with the valour and prowess of the donor. Some had scenes worked in very high relief, heightened by gilding the figures to set them off from the silver ground. Early examples of the type can be dated by the specific crowns worn by the ruler. After the fifth century AD, however, the representation of the king becomes increasingly unrealistic, and this trend continued into Islamic times.

This dish with the hunting scene can be dated to the seventh or eighth century. In contrast to most Sasanian dishes, the relief on this piece is flat and low, the outlines and details are strongly emphasized, the rendering of costumes and other motifs is conventionalized, and the background rather than the figures is gilded. The artist is presumably depicting a popular story about the Sasanian king Bahram V (r.420–38), known as Bahram Gur ('Wild Ass'), who was remembered for his prowess in hunting. The artist neglected to show the weapons with which the hero is killing the boars and lions that fall beneath his horse's hoofs, and he has inappropriately added a winged figure bearing a necklace – taken from a scene of royal investiture – to the hunt. This dish was not intended to impress the recipient with the prowess of the person depicted, but rather to recall a well-known episode from Persian legend that had survived into Islamic times.

Pre-Islamic motifs continued to be used in increasingly stylized designs, as seen on an octagonal silver dish (64) decorated with

63
Dish with representation of a king hunting boars and lions, Iran, 7th-8th century. Gilt silver; diam. 19 cm, 7½ in. Museum für Islamische Kunst, Berlin

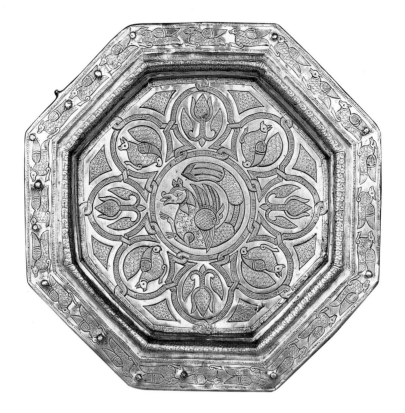

mythical lion-headed birds called simurghs, and datable to the ninth or tenth century. Like the earlier dish showing Bahram Gur hunting, the design on this dish has been marked with a sharp tool in a process known as chasing, and hammered from the front and back before it was partially gilded. The octagonal shape was not particularly suitable to beaten and chased silver, so crude metal strips had to be added on the outside to support the rim. Unlike the hunting dish, where the surface is used as space for representing a single scene, the design on the simurgh dish does not tell a story about the simurgh, but simply shows a pattern of interlaced bands forming circular compartments. Many of the compartments are filled with simurghs or blossoms, quite similar to those on the glass beaker (60) and a band of simurghs runs counterclockwise around the rim. The design looks like the textile pattern used on the caftan found at Moshchevaya Balka (52–3), and represents a new approach to decoration that was evolving in the early Islamic period.

In the pre-Islamic period, specific designs had been used for different materials – one design was appropriate for textiles, another for metalwares, still others for architectural decoration or for glassware – and there was little transfer of designs from one medium to another. One of the hallmarks of Islamic art, in contrast, is the transfer of motifs and techniques of decoration: a textile design might reappear on metalware or ceramics and an architectural motif on glassware, despite the enormous differences in scale. There are many possible reasons for this, and although some of these tendencies can already be detected in the arts produced immediately before the Islamic conquest, it seems likely that this development is also connected to the emergence of a new Islamic society. Old institutions, such as the Zoroastrian priesthood, no longer existed, and new Islamic institutions had no reason to see any significance attached to specific types of objects or representations. Artisans were thus free, and even encouraged, to combine old motifs in new and unpredictable ways. Even the most pious opponent of idolatry could not condemn a representation of a simurgh on a plate, as everyone knew that lion-headed birds existed solely in the imagination.

Only the rich could afford silver and gold; others could own objects made of copper alloys, so they were far more common, although still expensive. Many of these objects were thought to have been made of bronze, technically an alloy of copper with tin, an imported and expensive material, but technical analysis of early Islamic metalwares shows that many are actually made of brass, which is copper alloyed with zinc and other metals. Lead was added to make the alloy easier to cast, but it also made it more brittle and less suitable for hammering or turning on a lathe, so only small amounts were added to brass intended for those processes. The alloy sometimes contains a small amount of tin, but in most cases the tin content is so small that it was probably accidental.

A cast incense-burner (65) exemplifies the brass used in early Islamic times. Each of the three sections – the top half with five

64
Dish with
geometric
design
enclosing
simurghs, Iran,
9th-10th
century.
Gilt silver;
diam. 36 cm,
14⅜ in.
Museum für
Islamische
Kunst, Berlin

domes surmounted by eagles, the bottom half with four legs ending in paws or claws, and the long handle ending in a crouched antelope or gazelle – was cast in a separate mould, and the body and handle are slightly different in composition. When the casting was released from the mould, holes in the cold metal were made or accentuated by filing and drilling, and the surface was engraved or chased to add floral and geometric decoration. As this piece weighs over 4 kg (9 lbs), it is much too heavy to be swung or jerked as censers were in Christendom. Islamic incense-burners are usually meant to stay in place, although this one was equipped with a long handle so it could be moved when hot and it had legs to keep it off flammable surfaces.

65
Incense-burner
in the form of
a pavilion,
Egypt or Iran,
8th-9th century.
Cast brass;
h. 32·5 cm,
12¾ in.
Freer Gallery
of Art,
Washington,
DC

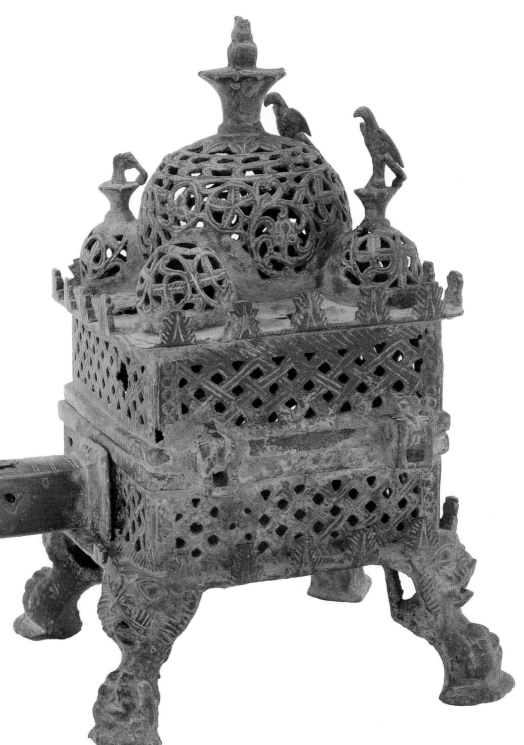

The incense, typically a fragrant wood called aloes, sometimes mixed with frankincense and ambergris, was burned in a shallow dish inside the burner, and the smoke escaped through the holes. Incense did not have the liturgical significance that it had in Christendom, where it was widely used to convey honour or sacrifice and accompany prayer. In the Islamic lands it was used to perfume the air and people. According to the historian al-Masudi, the caliph al-Mamun (r.813–33) met weekly with learned men; the guests were offered an incense-burner to perfume themselves before entering the caliph's presence. In nineteenth-century Egypt, a servant would present the incense-burner to the master or guest, who would waft the smoke towards his face with his right hand.

Incense-burners were made in a variety of shapes, but the unusual form of this incense-burner, with its multiple domes, is unrelated to metalware prototypes, and its design probably derived from architecture. Suggestions have ranged from Buddhist stupas of Central Asia to Byzantine Christian churches, but whatever the actual source, this object shows how designs were transferred from one medium to another. The piece has been attributed to Egypt because in style it resembles Egyptian objects, but metallurgical analysis shows that its composition is comparable to other brasses attributed to Iran.

Copper alloy ewers were also popular. Unlike unglazed earthenware, brass could not keep the contents cool, but it did have the advantage of sturdiness so it would not shatter when dropped. Ewers were used not only to serve drinking water but also to pour water over the hands when washing before a meal. The wash water was collected in a basin, and ewers and basins were often made as a matching set, although they have rarely survived together. The diner, who sat on the ground perhaps in front of a low table, would eat with the fingers of his right hand (the left hand was reserved for personal hygiene). Food was served communally on large dishes or trays, and the practice of sharing food made diners careful to observe the rules of etiquette.

Many early Islamic ewers have a spherical (66) or pear-shaped body, with a bird spout and a pierced tubular neck to filter the water; in the absence of spigots, vessels were filled by submerging them in a pool of water. The example illustrated here, one of a group of six cast brass ewers, has decoration in high and low relief, including a row of arches engraved on the body that bears no relationship to the round body or to the bird spout. Traces of inlaid and pierced decoration add to the confusion, an arbitrary mishmash of motifs and techniques characteristic of early Islamic wares in several media. This group of six ewers was conventionally attributed to mid-eighth-century Egypt, because this ewer was discovered in Egypt only 600 m (½ mile) from the reported burial site of the last Umayyad caliph Marwan II (r.744–50). This story is typical of the romantic associations many Islamic objects have acquired, but there is absolutely no historical or archaeological reason to connect this ewer with the Umayyad caliph, and its date and attribution should rest on comparison with other pieces.

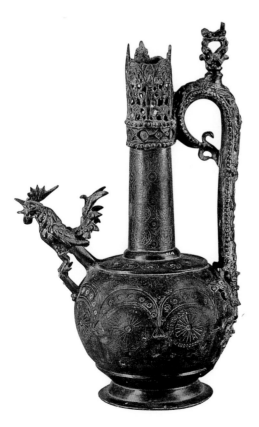

66
Ewer found at Abu Sir al-Malaq in the Fayyum, Egypt. Cast and engraved brass; h.41 cm, 16⅛ in. Museum of Islamic Art, Cairo

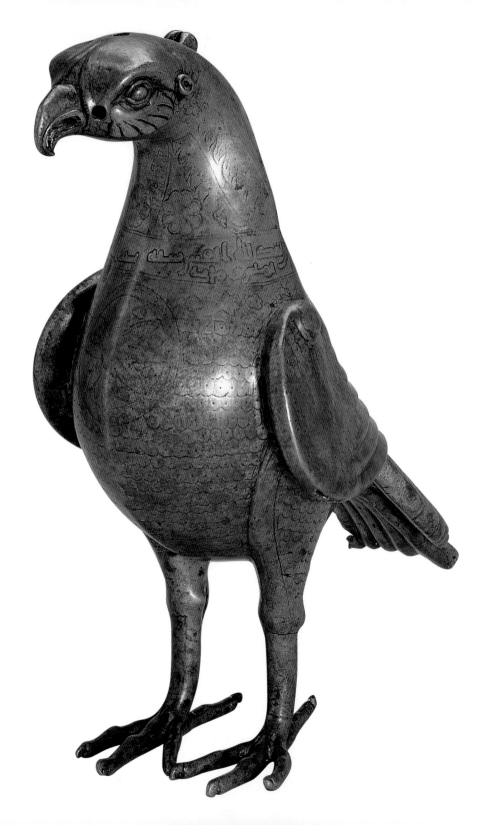

Some of the most distinctive early Islamic ewers take the form of animals or birds, like the one shown here (67). Apart from a few reliefs at Umayyad sites, these ewers were about as close as Islamic art ever came to sculpture in the round, and the utilitarian function of the object would exclude it from any suspicion of idolatry. In this ewer holes on either side of the beak serve as a spout; in other examples a handle on the back of the neck helps in pouring. The ewer is made of brass with traces of silver and copper inlay in a variety of patterns. Some, such as the scales meant to represent feathers on the body, bear some resemblance to reality, but others, such as the medallion on the breast and the rosettes on the throat, are quite arbitrary and applied like a patterned textile cover. An inscribed collar gives the name of the maker, Sulayman, and the date 180 (corresponding to the year 796–7 AD). As one of the few signed and dated pieces in existence, this ewer is important for establishing a general date for these early ewers. The inscription also gives the name of the city where the piece was made, but unfortunately the word is unreadable. Another ewer, in Tblisi in Georgia, is signed by a craftsmen from Basra, and so some of these pieces must have been made in Iraq, the centre of the caliphate.

As in metalwares, glasswares made in this early period exemplify the elaboration of pre-Islamic techniques and motifs. One popular type of object was a small bottle used to hold unguents, perfumes and cosmetics; it was made by folding a hot glass tube in half. Fancier pieces contained double or quadruple tubes, which were elaborately decorated with trailed threads of molten glass and many handles. Glassmakers in early Islamic times used a Roman prototype which they developed by setting the tubes or bottles on the back of glass pack animals (see 55); these dromedary flasks show the virtuosity and playfulness of the craftsmen in whose hands the practical function of the piece is almost obscured.

Because of the fragility of glass, examples from medieval times are very rare, and most of them are found in the relative security of church treasuries, so they can be dated only on stylistic

67
Ewer in the form of a bird, made by Sulayman, 796–7. Cast brass inlaid with silver and copper; h.38 cm, 15 in. Hermitage, St Petersburg

grounds because they are so removed from their place of origin. Excavated pieces, in contrast, are usually in fragments, but they can provide relatively secure dates because of evidence found with them. An incomplete dish of deep blue glass (68), for example, found at Nishapur in Iran was excavated from a level dating to the early ninth century. The design was engraved or scratched with a hard point and despite the simple technique, the effect is wonderful. The division of the surface into compartments, each filled with its own geometric or vegetal design, is similar to the decoration found on Abbasid lustre dishes (61–2), and it is likely that this precious object was imported to Nishapur from some other place of production.

Wheel cutting was another glass technique that was expanded in Islamic times. Long used to shape hardstones and rock crystal, the technique used a revolving abrasive wheel to cut away the surface and create a pattern that stands in relief. The glassmaker began with a solid glass block or blank with thick walls from which the finished object was laboriously cut. The glass could be colourless and transparent, but to achieve special effects, glasscutters used blanks made in the cameo technique, in which patches or a layer of glass of one colour were applied to an object of a different colour. For this bottle (69) the vessel had to be

68 Below
Blue glass dish (restored) with engraved decoration, excavated at Nishapur, Iran, early 9th century. diam. 28 cm, 11 in. Metropolitan Museum of Art, New York

69 Right
Glass bottle with relief-cut decoration (neck restored), Iran or Iraq, 9th-10th century. Clear glass with green overlay; h.15 cm, 5⅞ in. David Collection, Copenhagen

completely covered with an overlay by inflating it into a cup made from glass of the second colour. Most of the outer green layer was cut away, leaving the design of confronted birds flanking a palmette in relief on a colourless ground. The piece can be dated to the ninth century because it looks like a type of ornament used at Samarra at that time, where vegetal motifs were similarly transformed into reciprocal abstract patterns (see 6).

Special effects could also be achieved by using coloured glass blanks. The exceptional bowl illustrated here was made from opaque turquoise glass (70). The lobed shape is known from several other examples, but the colour is unique. Each of the

70
Relief-cut bowl of turquoise glass, Iran or Iraq, 9th-10th century, decorated with 11th-century Byzantine enamels in a 15th-century European setting of gilt-silver, diam. 19 cm, 7½ in. Treasury of St Mark's, Venice

five lobes contains the schematic representation in low relief of a running hare enclosed in a panel. The designs are further enhanced by engraved lines. An inscription on the foot has been read as the word 'Khurasan', the name of the province in north-eastern Iran where turquoise is mined, but why the name should be there remains a mystery. The bowl, which can be dated to the ninth or tenth century, was always regarded as special, perhaps because turquoise was thought to have curative powers. The bowl reached St Mark's Cathedral in Venice by 1204 and was mounted in a silver-gilt setting embellished with Byzantine enamels and preserved as a relic in the treasury.

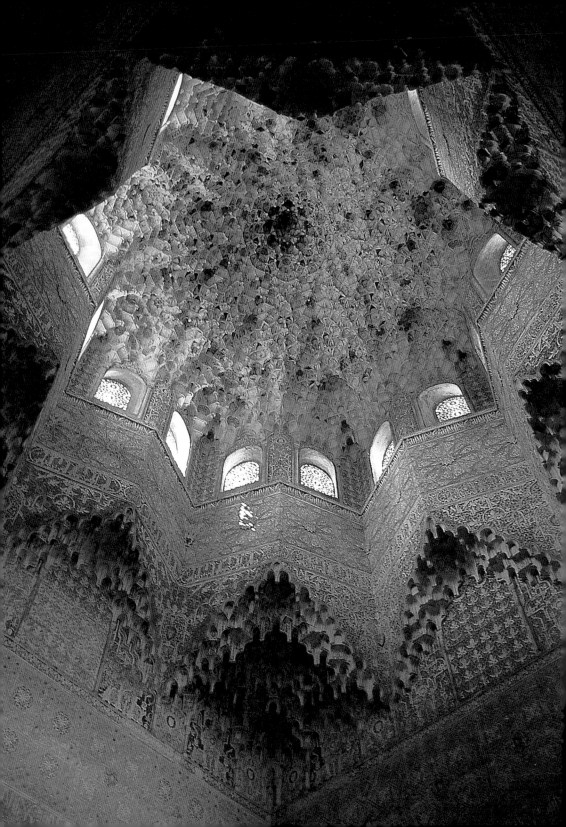

The middle period, roughly 900 to 1500, is sandwiched between those of great powers. The unified caliphates of the early period enjoyed universal authority, and the great empires of the late period ruled large regions for centuries. By contrast, the rulers of the middle period controlled relatively small areas with constantly changing borders. Even the greatest conquerers of the period were unable to hold their territories for long. Perhaps the major political problem in this period was how governments derived legitimacy and the right to rule. The Abbasid caliphs continued to rule from Baghdad in name until 1258, but regional governors began to declare their independence several centuries earlier, as in Egypt, where the Tulunid governor had been virtually free of Abbasid authority from 868.

During this period the fringes and then the centre of the Abbasid Empire unravelled. In the east, for example, the Samanids, a Persian family of landowners who had governed Transoxiana for the Abbasids throughout the ninth century, increasingly set their own course, particularly after they defeated their Saffarid rivals in 900. At the other end of the empire were the Umayyads of Spain, a branch of the old caliphal family who had ruled Syria in the seventh and eighth centuries. At first, the Spanish Umayyads were too far away to be of much trouble to the Abbasids, but in the tenth century they proclaimed themselves the rightful caliphs, as did *their* rivals, the Fatimids, a Shiite dynasty in North Africa and Egypt. Both caliphates were active in international politics, particularly with the Byzantines, in attempts to outflank the Abbasids. To Abbasid eyes, the Fatimid claim was more serious and closer to home, particularly since other Shiite dynasties had risen to power in Iran at the same time. Elsewhere, other types of reformist religious movements emerged, fuelled by perceived failures of Islamic orthodoxy. The Almoravids and Almohads,

reforming Berber dynasties that successively flourished in Morocco and Spain from the eleventh to the thirteenth century, fought fiercely but ultimately unsuccessfully against the growth of the Christian kingdoms of northern Spain, who completed their reconquest of the peninsula in 1492.

For centuries there had been an uneasy truce along the frontier between the Muslim lands and the Byzantine Empire in northern Syria and Anatolia, with each side conducting periodic raids that brought little result. The situation changed dramatically in the eleventh century. With the defeat of the Byzantines at the Battle of Manzikert in 1071, Anatolia was opened to Muslim settlement. Some two decades later, the Pope called for a European crusade to oust the infidels from the Holy Land. With the eastern Mediterranean lands in political disarray, the knights of the First Crusade were able to take Jerusalem in 1099 and establish several Christian kingdoms in Syria.

These challenges at home and abroad led the Abbasids to seek alliances with various strongmen. Some were Kurds from northern Mesopotamia; most were Turks, peoples from the Central Asian steppes who spoke Turkish. For centuries, Turks had been brought to the central Islamic lands to serve as slave (*mamluk* in Arabic) soldiers in the Abbasid armies, but increasingly they took power for themselves. The most important Turkish group was the Saljuqs (r.1038–1194), who carved out an empire extending from Afghanistan and Central Asia to Syria. Invested by the Abbasid caliphs with such grandiose secular titles as *sultan* ('power'), they developed a hierarchical state supported by an extensive Turkish army and Persian bureaucracy. The egalitarian ideal of early Islam, where all shed previous identities to enter into God's commonwealth, was shattered by rising ethnic tensions between the locals and the foreigners who came to rule over them. The fragmentation of this period can be seen most clearly in the walling of towns and construction of citadels in an attempt to provide security in troubled times.

Islam, too, faced challenges and underwent changes during the middle period. Shiite missionaries were able to convert large numbers of people because so many Muslims were disaffected with the status quo and believed that a descendant of the Prophet Muhammad would be the only one able to usher in an era of justice and prosperity for all. To counter the success of the Shiite missionaries, the orthodox Sunnis developed new institutions. The chief weapon in their arsenal was the *madrasa,* a theological college – often erected by the ruler – in which the orthodox religious sciences were taught. Another approach to rejuvenating Islam was the mystical path, known as Sufism from the coarse woollen (*suf*) cloaks worn by adherents. Although a current of personal mysticism had always existed in Islam, in the middle period mysticism was institutionalized and mystics were organized into orders housed in separate buildings, which might also be erected by the ruler. In these ways the government was able to control religious education and bring potentially disruptive elements into line.

The thirteenth century marked a watershed in Islamic history, when the Mongols, forest peoples from Central Asia who spoke Mongolian, invaded the Islamic lands. They were followers of Genghis Khan, one of the greatest conquerors of all times. Proclaimed chief of all Mongol peoples in 1206, he and his armies vanquished most of Eurasia from the China Sea to the banks of the Dnepr River in the Ukraine. His descendants ruled Mongolia and northern China as the Yüan dynasty, southern Russia as the Golden Horde, Central Asia as the Chaghatayids, and the eastern Islamic lands as the Ilkhans. Initially shamanists, who believed that priest-doctors (shamans) were able to control the unseen world of gods, demons and ancestral spirits, the Ilkhans soon adopted Islam and became staunch defenders of Persianate culture. Ilkhanid expansion in Syria was checked by the Mamluks, a self-perpetuating junta of military rulers in Egypt and Syria. With the fall of Baghdad to the Ilkhans in 1258, the Mamluk capital at Cairo emerged as the centre of Arab-Islamic culture.

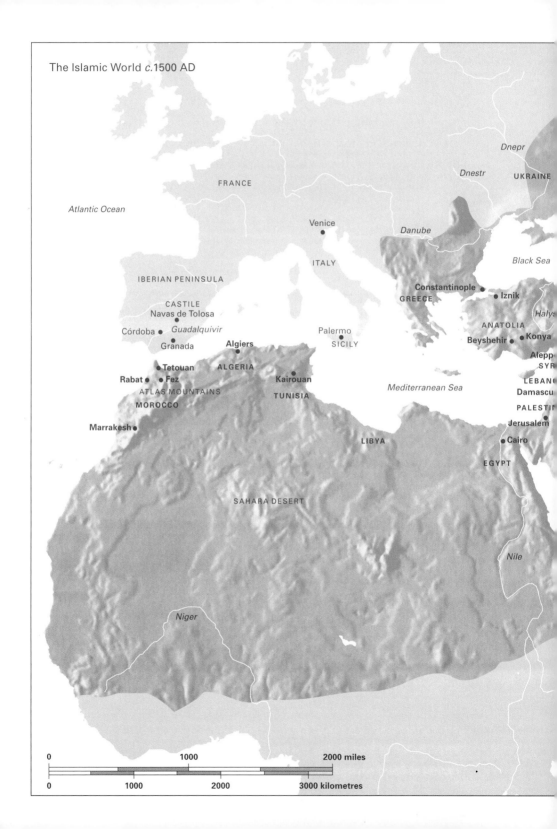

The Islamic World *c.*1500 AD

Dnepr

Dnestr UKRAINE

FRANCE

Atlantic Ocean

Venice

Danube

Black Sea

ITALY

IBERIAN PENINSULA

Constantinople
GREECE Iznik

Halys

ANATOLIA

CASTILE
Navas de Tolosa

Córdoba *Guadalquivir*

Palermo
SICILY

Beyshehir Konya

Granada Algiers

Alepp
SYR

Tetouan ALGERIA

Kairouan

LEBAN
Damascu

Rabat Fez

ATLAS MOUNTAINS

TUNISIA

Mediterranean Sea

PALESTIN

MOROCCO

Jerusalem

Marrakesh

Cairo

LIBYA

EGYPT

SAHARA DESERT

Nile

Niger

0	1000	2000 miles

0	1000	2000	3000 kilometres

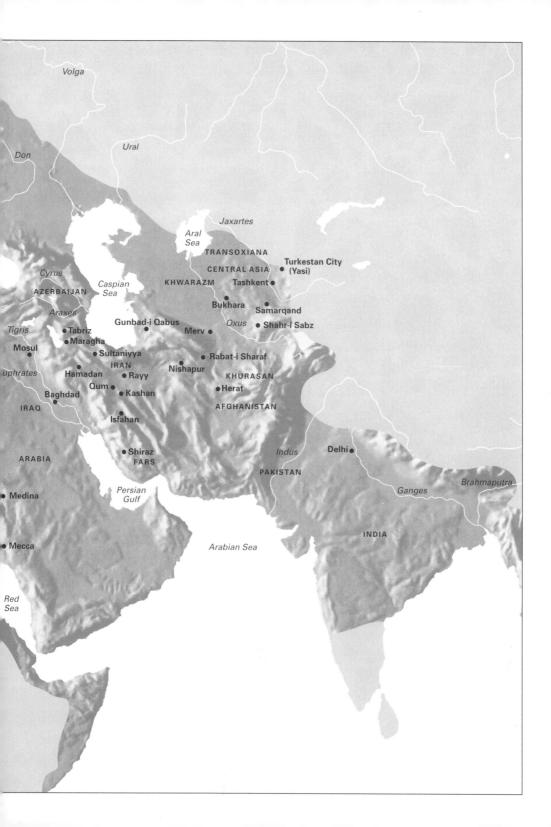

This shift in power and the close relations between the Ilkhans and the Mongols ruling in China meant that Far Eastern ideas and artistic motifs were brought to the Islamic lands. The apogee of Ilkhan power lasted less than a century, but in 1370 another great Mongol conqueror, Timur (known in the West as Tamerlane, from *Timur-leng,* 'Timur the lame'), forged a second Mongol empire in the Islamic lands. Although Timurid power was equally evanescent, their centres of art and culture in Central Asia, western Afghanistan and eastern Iran set the artistic taste for much of the Islamic lands. The Mamluks, for example, incorporated Timurid decorative motifs in their art, as did the emerging Ottoman rulers in western Anatolia.

The momentous shift of power in the Islamic lands from the Fertile Crescent, where it had developed, to new centres in Iran and Central Asia was accompanied in the later Middle Ages by the growth of cities and commerce in Europe. As a result, Islamic North Africa and Spain became increasingly isolated from developments in the central and eastern Islamic lands on the one hand and in Christian Europe on the other. This isolation was only exacerbated by the Portuguese discovery of a sea route around Africa in the fifteenth century and the Spanish discovery of the New World in 1492, which made North Africa an obstacle that could easily be circumvented. By the end of the middle period, the global economy had shifted away from its traditional Mediterranean centre to a new focus on long-distance trade directly with India, the Far East and the Americas.

The proliferation of centres meant that no single style of art or architecture predominated as the Abbasid style had in the early period. Regional styles became more important, and it is easy to distinguish the Islamic architecture of Spain and North Africa from that of Iran and Central Asia, or the lustrewares of Spain from those of Iran. Nevertheless, several artistic features were adopted throughout the Islamic lands, showing that superficial diversities did not totally obscure the underlying unities. The minaret, the tall tower attached to the mosque, became ubiquitous as a symbol of

73
Alhambra palace, Granada. Twelve-sided star-pattern tiles in the Hall of the Ambassadors, early 14th century

the presence of Islam. *Muqarnas*, the tiered niche-like ornament often likened to stalactites, was quickly adopted from Spain to Afghanistan and remained a standard feature of architectural decoration, used almost exclusively for Islamic buildings. Finally, the arabesque, the distinctive decorative motif based on such natural forms as stems, leaves and tendrils, but rearranged in infinite geometric patterns, became a hallmark of Islamic art and architectural ornament. Specific meanings have been proposed for all of these features, but given their widespread adoption among such divergent peoples, it is likely that these forms and motifs held different meanings for different viewers in different contexts.

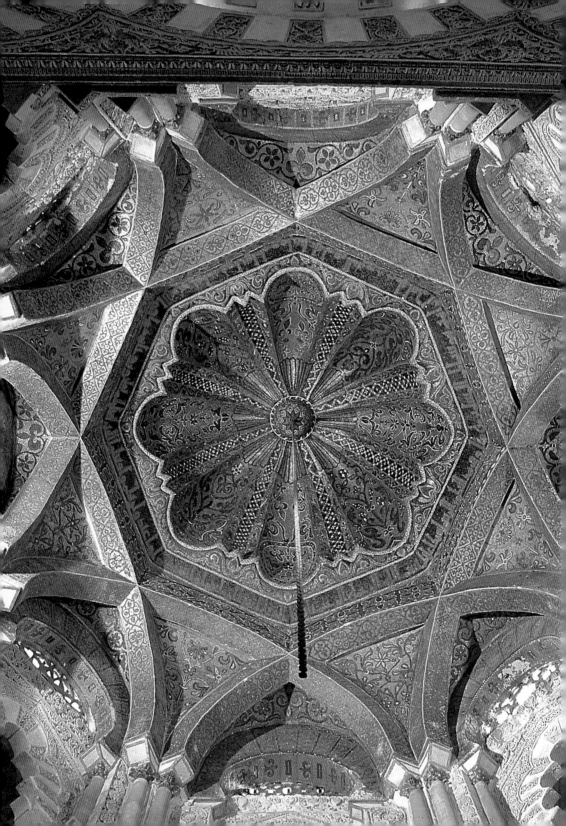

When the power of the Abbasid caliphate began to break up
around the year 900, distinct regional styles of architecture –
and other arts – began to supplant the widespread Abbasid
styles. These regional styles made use of local materials and
traditional techniques of construction. Distinct styles emerged
in Spain and North Africa, Egypt and Syria, Arabia, Anatolia,
Iran and Central Asia, and India. Nevertheless the legacy of the
Abbasid caliphate was strong, and several building types
remained standard in the different regions. The most important,
of course, was the hypostyle congregational mosque, which
could be expanded or modified to meet the changing needs of
the growing Muslim community.

One of the best examples showing how a mosque developed
in the medieval period is the congregational mosque in Córdoba,
the capital of Muslim Spain located on the Guadalquivir River.
Muslims had arrived there in 711 and made it the provincial
capital a few years later. The congregational mosque was begun
in 784–5 by Abd al-Rahman I (r.756–88), the sole member of the
Umayyad family in Syria to escape massacre by the Abbasids in
750. After a dramatic flight across North Africa, he arrived in
Córdoba six years later. He spent some three decades
consolidating his power, and only in his last years did he have
the opportunity to begin the mosque, completed in 786–7. The
building (75), like most congregational mosques of the early
period, had an open courtyard leading to a hypostyle prayer hall.
Its most distinctive feature was the inventive double-tiered
system of columns and arches supporting the wooden roof.
This was probably designed to make the most of the materials at
hand, for the Visigothic buildings erected in the region before the
Islamic conquest had short stubby columns which were reused in
the Muslim building. By stacking two short columns on top of

74
The
congregational
mosque,
Córdoba.
Mosaics in the
central dome of
the *maqsura*,
965

D B A A C

10 m

N

each other, the designers of the mosque could achieve the necessary height, although they needed to add intermediate arches to stiffen the unstable construction.

In the ninth and tenth centuries, the mosque at Córdoba was repeatedly enlarged and embellished. The two-tiered scheme of the first construction was maintained in all the later phases, not for reasons of cost or available materials but to maintain the original design. These renovations culminated when the Umayyad caliph al-Hakam II (r.961–76) expanded the prayer hall, adding a dome over the entrance at the centre of the addition and domes in front and on either side of the new *mihrab*. These areas were distinguished by elaborate screens of intersecting cusped arches (76), a design developed from the two-tiered support system of the original building. The screened area near the *mihrab* was a *maqsura* reserved for the ruler and connected to the palace by a passageway in the *qibla* wall. This *maqsura* was not meant to protect the caliph from harm, but seems to have emphasized the great pomp and ceremony with which the Umayyad caliph surrounded himself.

The *maqsura* is elaborately decorated with carved marbles and gold glass mosaic (74). Although mosaic was an expensive technique used extensively to decorate medieval Byzantine churches, the Umayyad caliphs of Córdoba chose to use it in their mosque because they associated it with the great monuments built some 250 years earlier by their predecessors, the Umayyad caliphs of Syria. The Umayyads of Spain doubtlessly wanted their mosque to equal in splendour works of their ancestors such as the Dome of the Rock in Jerusalem (8–10) and the Great Mosque of Damascus (11, 13). In order to do so, they had to seek the necessary workmen and materials from abroad. Arabic histories say that al-Hakam sent an ambassador to the Byzantine emperor in Constantinople, requesting him to send a workman to decorate the mosque. The emperor complied, and the ambassador returned with a master-craftsman and a gift of 320 *qintars* (approximately 16,000 kg, 35,000 pounds) of mosaic cubes. The caliph provided

75
Plan of the congregational mosque at Córdoba showing original mosque of 785(A) and successive expansions in 852(B), 950(C), 961–76(D), 987(E)

76 Overleaf
Congregational mosque, Córdoba, 965.
Maqsura screen

the master with a house, and the mosaic decoration was completed in June 965, according to an inscription.

The hypostyle mosque was also the type favoured for construction in areas newly conquered by Islam. While the type may have had some symbolic associations with the early years of Islam, it also had great practical flexibility, as the nature of the support could be varied to suit the materials available and local techniques of construction. For example, the congregational mosque at Beyshehir in Turkey is a hypostyle mosque with wooden columns supporting a wooden roof (77). Constructed in 1299 by the local Eshrefoglu ruler Suleyman Bey (r.1296–1301), the rectangular mosque has stone walls and a richly carved portal. The main interest of the mosque is its interior, where forty-seven slender wooden columns support horizontal wooden beams on which rests the wooden roof. Most of Anatolia is a high plateau, with cold and snowy winters. The mountain forests provided timber for the mosque, but the severe climate meant that the large open courtyard of warmer and drier lands was inappropriate here; instead only the central space was left open with a pool below to catch rainwater for ablution and to provide light.
A raised platform in the right corner provided the ruler with a private place for prayer, somewhat like the screened enclosure at Córdoba, but far less elaborate.

The Quwwat al-Islam ('Might of Islam') Mosque, the first mosque built in Delhi after the Islamic conquest of India, shows another adaptation of the hypostyle type (78). Begun in the 1190s on the remains of a Hindu temple, the building has a large open courtyard surrounded by halls supported by columns reused from ancient temples. The structure was placed on a raised platform, a feature borrowed from temples to separate a sacred space from the profane ground, and like them had staircases leading up to it. The warm Indian climate meant that the building was largely open to the elements. As at Córdoba, the available columns were not tall enough to create a lofty space, so two or even three temple columns were superimposed to gain the necessary height.

77
Eshrefoglu mosque, Beyshehir, 1299. Interior

78
Quwwat al-Islam Mosque, Delhi, begun 1190s. View of courtyard

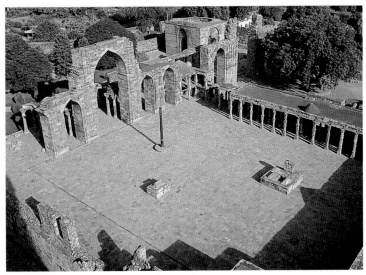

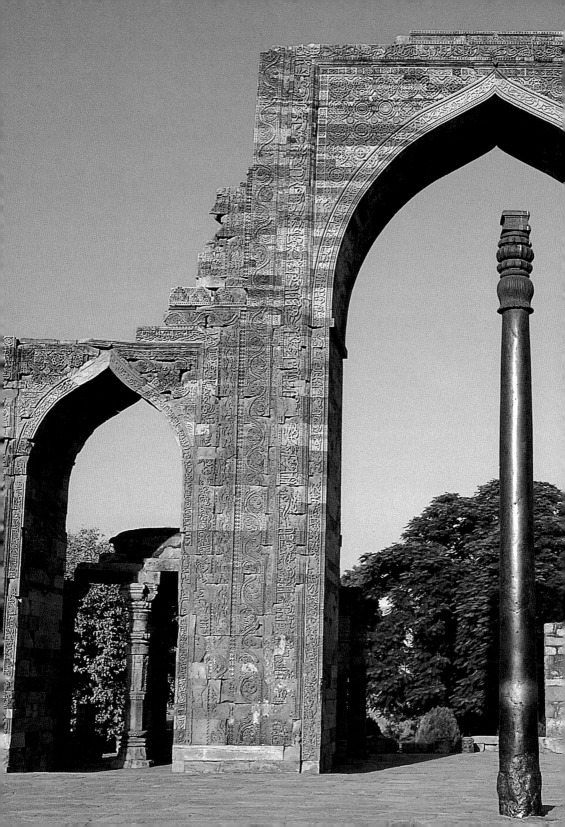

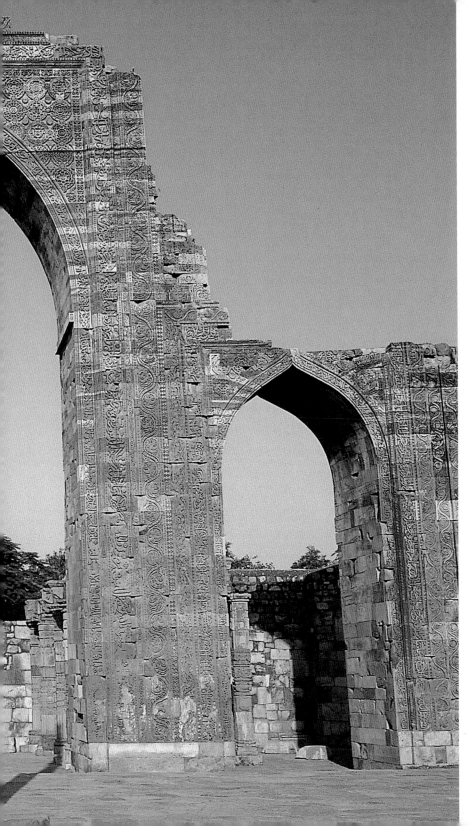

79
Screen of
corbelled
arches added
to the Quwwat
al-Islam
Mosque, Delhi,
by Qutb al-Din
Aybak, 1198.
The iron pillar
in the centre
was taken from
a temple
dedicated to
Vishnu in the
4th century AD
and erected as
a trophy in the
mosque

The columns supported beams which in turn supported a flat roof, the traditional technique of construction in India. Buildings there were constructed with posts and beams, as Indian builders were unfamiliar with construction using arches and vaults.

This original mosque in Delhi was obviously unsatisfactory because it was quickly changed. It seems that it did not 'look' Islamic enough. By the end of the twelfth century the hallmark of Islamic architecture in the eastern Islamic lands had become the use of arches and domes, so in 1198 Qutb al-Din Aybak, the ruler of Delhi, ordered an arched screen added to the courtyard in front of the prayer hall (79). It consists of a larger and taller central arch flanked by pairs of lower and narrower arches. As the local masons did not know how to build true arches, they had to imitate them with corbelling, in which each course of stones is projected out a bit from the one below until they meet in the middle. A corbelled structure, however, cannot support any weight, so it could not be crowned with a dome. The Aybak Screen only serves to hide what lay behind and is richly decorated with naturalistic vines and calligraphy. This decoration, presumably carved by native masons, shows another adaptation of traditional local techniques to the needs of new Islamic patrons, for Hindu and Jain architecture before the Muslim conquest is known for its exuberant figural sculpture that depicted the activities of innumerable gods and goddesses with multiple arms and legs. Muslims found this idolatry horrific, so offending images were defaced on reused materials, and purely vegetal and geometric ornament was carved on new construction.

As at Córdoba, the mosque at Delhi was insufficient to meet either the size of the rapidly growing Muslim population of the city or the pretensions of the local rulers, who also saw public architecture as a fitting symbol of their expanding power. The Qutb Minar (80), a huge sandstone minaret, was begun just outside the mosque in 1199, although it was not completed until 1368. Comprising superimposed flanged and cylindrical shafts separated by balconies and decorated with inscriptions, the

80
Minaret known as the Qutb Minar added to the Quwwat al-Islam Mosque, Delhi, begun 1199

72.5 m (238 ft) minaret was a fitting symbol of the might of Islam. Indeed, by the end of the twelfth century the minaret – a slender freestanding shaft – had become the universal symbol of Islam from the Atlantic to the Indian oceans. Minarets were often added to earlier mosques. They were less expensive than building a new mosque and were gratifyingly visible both from afar – where they indicated the presence of a town – or from nearby – where they indicated the location of the mosque. They served to advertise the presence of Islam at the same time as they demonstrated the piety of the founder.

Between 1210 and 1229 the Quwwat al-Islam Mosque was tripled in size by Aybak's son-in-law Iltutmish, so that the great minaret now stood inside the courtyard. Nearly a century later, Ala al-Din Khalji (r.1296–1316) once again tripled the mosque, so that it measured an enormous 228 by 135 m (748×443 ft). To go with this gargantuan mosque, the patron ordered a second minaret constructed in the new courtyard. The base, which is twice the diameter of the Qutb Minar, shows that the tower was intended to be a stupendous 145 m (475 ft) high. Only the patron's death prevented this grandiose project from being completed, and the truncated stump remains an evocative reminder of overweening ambition.

The arched screen that Aybak added to the mosque in Delhi was designed to give it an 'Islamic' appearance, for he and his associates had come to northern India from Afghanistan, where they undoubtedly knew the arched and domed mosque type that had become standard in the lands of greater Iran. The development of this standard Iranian type can best be seen in the congregational mosque at Isfahan, the capital city of central Iran. Like mosques in many other cities, it underwent major renovations as the city grew in importance and size. The first mosque on the site was built in the late eighth century when Isfahan was a provincial capital in the Abbasid caliphate. In 840–1 this relatively small mud-brick building was replaced by a larger hypostyle structure with a large central court surrounded by halls

with baked brick columns supporting a flat roof. Towards the end of the tenth century, when Isfahan became the capital of the Buyid family of soldiers who had taken the Abbasid caliphs under their 'protection', the mosque was given a distinctive new look. Much as Aybak was later to do when he added his screen to the Delhi mosque, the Buyids added a row of columns around the court. This type of renovation shows that the most important aspect of the building was no longer its exterior, but the view from the courtyard. It had the further advantage that the patron got a lot for his money: it was far cheaper to add a row of columns than to build a new mosque from scratch.

The major transformation of the congregational mosque at Isfahan took place under the Saljuq dynasty. As opposed to the Buyids, whose power was relatively limited and short-lived, the Saljuqs were a major power in the eastern Islamic lands, with a hierarchical state supported by an extensive Turkish army and Persian bureaucracy. Isfahan was a capital in an empire stretching from Central Asia to Syria. The first Saljuq work in the mosque in Isfahan was to change the relatively egalitarian space of the hypostyle building by tearing down twenty-four columns in front of the *mihrab* at the south end and inserting a freestanding domed chamber there. This work was ordered about 1086–7 by Nizam al-Mulk, who was the Persian chief minister, or vizier, to the sultan Malikshah (r.1072–92). The domed chamber was intended as a giant *maqsura* for the sultan and his court. The work was inspired because the sultan had just returned from Damascus, where he had ordered repairs to the Umayyad Mosque, including the great dome over the *maqsura,* and the dome at Isfahan is a Persian interpretation of a Syrian idea.

It is unlikely that the patron brought a Syrian builder with him, because the materials and techniques of construction available at Isfahan were so different from those used in Damascus. In the days before photographs and drawings of buildings, the vizier had to describe to his Persian workmen what the Syrian building looked like. In the medieval world, architectural ideas and forms

– such as *maqsuras* and domes – were readily transferable from one place to another, but materials and techniques of construction, such as stone and timber in Syria and brick in Iran, tended to stay fairly close to home. Thus two buildings that look very different to us today may have been intended by their patrons and builders to look like each other.

Nizam al-Mulk's arch-rival at court, the wily Taj al-Mulk, was not to be outdone. Two years later he ordered another domed chamber built to the north of the mosque (81). It shares many of the same formal elements as the south dome, but is considered to be more elegant, because the various parts have been integrated vertically into a harmonious composition reminiscent of Gothic architecture in Europe. Indeed, the north domed chamber is often called the masterpiece of medieval Persian architecture. The purpose of this unique building, however, is a mystery, and we know of no other examples of mosques with domed chambers added to the north side. Although beautiful, the north domed chamber is therefore peripheral to the development of the typical Iranian mosque.

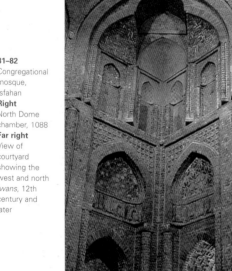

81–82
Congregational mosque, Isfahan
Right
North Dome chamber, 1088
Far right
View of courtyard showing the west and north *iwans*, 12th century and later

By contrast, the south dome in front of the *mihrab* became a standard element in mosque design in Iran. Tearing down part of a hypostyle structure to insert a freestanding domed chamber made the hypostyle structure unstable, as it was not originally connected to the dome, and the visual effect of a massive dome stuck in the middle of a low hall must have been jarring. At any event, the south domed chamber was soon connected to the rest of the mosque. Furthermore, the columns between the courtyard and the dome were torn down and replaced by a barrel-vaulted space open at one end, known as an *iwan* (82). The *iwan* had been a hallmark of Persian architecture since pre-Islamic times, when it was used in palaces to lead from the courtyard to the place where the ruler sat. *Iwans* had also been used in Umayyad and Abbasid palaces, but only in Saljuq times were they introduced to mosques. To complement this *iwan* in the centre of the south, or *qibla,* side of the mosque, three other *iwans* were built at the centres of the other three sides of the courtyard (83). This work may have been done after the great fire that destroyed much of the mosque in 1121–2.

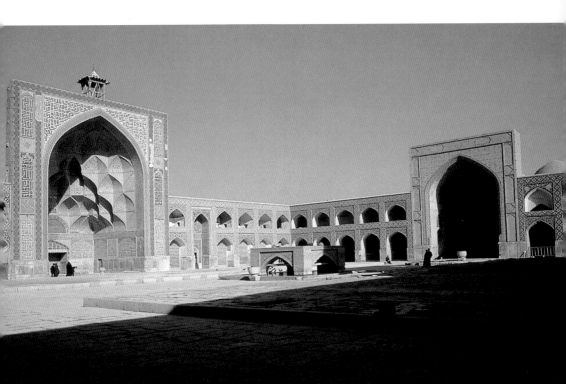

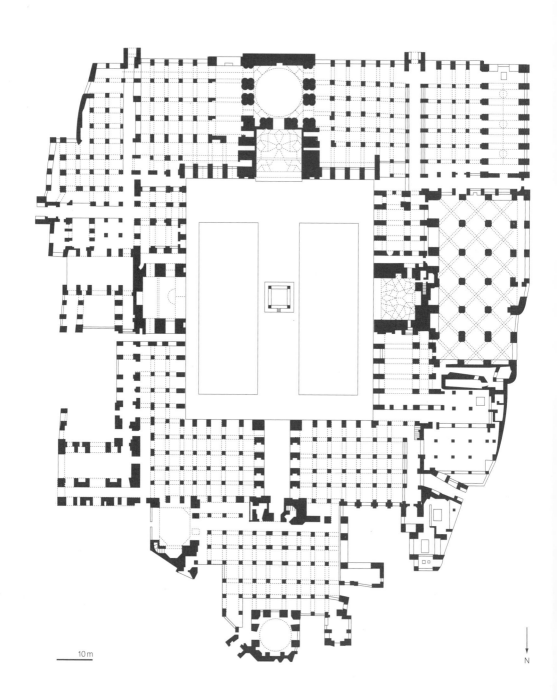

10 m

N

By the first half of the twelfth century, the congregational mosque of Isfahan had all the features of what was to become the standard type of Iranian mosque – a courtyard with an *iwan* in the middle of each of its four sides and a dome over the *mihrab* at the end of the *qibla iwan*. The exterior of this type of building blended imperceptibly into the surrounding city, except at the entrances which were marked by decorated portals. The typical building in Western architecture is like a box best seen from the exterior; in contrast, the four-*iwan* building is best seen from the centre of the internal courtyard. The germ of this idea was present in the Umayyad Mosque of Damascus, where the courtyard façade was elaborately decorated, while the exterior was left somewhat plain. The idea is taken one step further at Isfahan, where the exterior of the building can hardly be said to exist. Since the exterior was so unimportant, it was possible to expand the building in any direction; the only constant feature was the courtyard and the *iwans*.

83
Congregational
mosque,
Isfahan. Plan
showing
amorphous
exterior

The four-*iwan* plan is suitable to the Iranian climate, which is often warm or hot, occasionally cool, and rarely wet. The *qibla iwan,* which is most often used for prayer, opens to the north and remains shaded and cool all day. The west, north and east *iwans* get morning, noon and afternoon light respectively and can be used for the variety of activities appropriate to a mosque, such as teaching, study or rest, when the light and temperature suited. Furthermore, the angle of the sun in the sky changes with the seasons. In summer, when the sun is high, light cannot penetrate the deep *iwans,* so they remain shaded and cool. In winter, the low sun enters the *iwans* to provide light and warmth, and the deep recesses are protected from the winter wind. The four-*iwan* plan has no inherent orientation, but in mosques the *iwan* on the *qibla* side is always made larger and more important, a status underscored by the addition of the large dome at its end. Upon entering the courtyard, the worshipper immediately knows the direction of prayer, even without seeing the *mihrab.*

Although domes had not been used in Iranian mosques before the Saljuq period, the sophisticated construction of the two in the

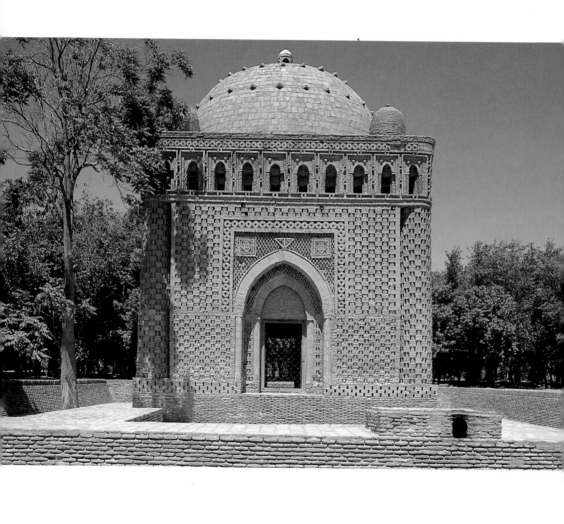

mosque at Isfahan shows that there had already been a long tradition of building domes in Iran. Domes were used mainly to cover tombs. The Prophet Muhammad had been opposed to any commemoration of the dead with elaborate tombs and had insisted that he be buried directly in the earth with only a simple winding sheet in an unmarked grave. Islamic orthodoxy, however, soon accommodated the more elaborate burial customs of pre-Islamic times. In Egypt, for example, funerary traditions went back to the times of the Pharoahs, who had been buried in pyramids amid veritable cities of the dead. The Christian Mediterranean lands also inherited the Greco-Roman tradition of imperial mausolea (named after the Greek king Mausolos who had a particularly elaborate tomb) as well as that of martyria, buildings commemorating martyrs to the faith. Already in early Islamic times, some graves were marked with a simple tombstone or covering, and even the Prophet's grave in Medina came to be surrounded by a wooden screen and eventually crowned with a dome. Despite official distaste for the custom of visiting graves, including those of the descendants of the Prophet and other pious individuals, many people did so to venerate the memory of the deceased, and the simple burial was often embellished with such signs of honour as grilles, tombstones, tomb-covers and even small buildings. Nevertheless, official policy continued to frown on such practices, and even such important individuals as the caliphs themselves were buried simply at first. By the end of the ninth century, however, the Abbasid caliphs seem to have adopted the practice of burial in a dynastic mausoleum, and their governors and rivals soon followed suit.

One of the earliest such tombs to survive anywhere in the Islamic lands is the Samanid tomb at Bukhara (84). The Samanids (r.819–1005), descended from an old Persian noble family, had served as governors for the Abbasids in western Central Asia. Ismail ibn Ahmad (r.892–907), the most successful member of the family, came to control much of the land between Baghdad and India, although he always acknowledged the caliph's suzerainty. Popular tradition ascribes the mausoleum in Bukhara to

Ismail, but it is more likely to be a family tomb erected after his death. Constructed and decorated of baked brick, it is a small cube with sloped walls supporting a central dome with little domes at the corners. Despite the simple forms, the interior and exterior are elaborately decorated with patterns worked in the creamy-coloured brick (85). The quality and harmony of construction and decoration show that this building, the first of its type to survive, could not have been the first to have been built. Already by the early tenth century there must have been a long tradition of building ornate domed structures in the greater Iranian world.

The domed cube was the most popular form for tombs, but it was not the only one, and a striking series of tomb towers survives from the eleventh century in northern Iran. The most

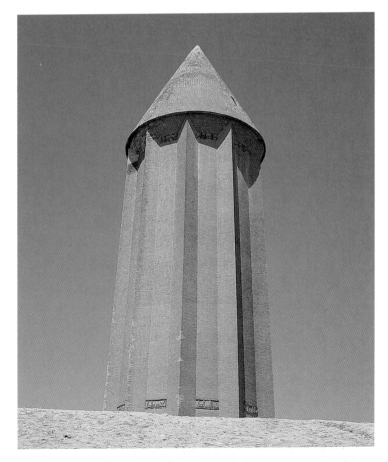

85 Left
Tomb of the Samanids, Bukhara, 920s. Detail of brickwork

86 Right
Gunbad-i Qabus, Gurgan, 1006–7

extraordinary is the Gunbad-i Qabus (86), a 52 m (170 ft) brick tower built by Qabus ibn Wushmgir (r.978–1012), the ruler of the local Ziyarid dynasty. The tower, raised an additional 10 m (30 ft) by an artifical hill that makes it look even taller, dominates the surrounding plain by its soaring verticality and simple form of a flanged cylinder topped by a conical cap. The plain exterior is broken only by two identical inscriptions which encircle the tower and state that Qabus himself ordered the tomb in 1006–7. The tall form and prominent location led one later author to write that Qabus' body was not interred but enclosed in a glass coffin suspended from long chains attached to the dome.

Qabus was a relatively minor figure in the great scheme of things, but his dramatic tomb served its purpose, and we remember him mainly because of it. Most rulers chose to perpetuate their names with elaborate tombs. Consequently tombs got bigger and bigger, and the one built for the Mongol Ilkhan ruler of Iran, Uljaytu (r.1306–13), is one of the largest ever erected (87). Uljaytu's capital was the city of Sultaniyya (literally, 'the imperial'), which the Ilkhans founded in the steppe in northwestern Iran. The site is now a dusty, mud-brick village, and it boggles the mind to imagine that it was once the bustling capital of an enormous empire. The Venetian merchant Marco Polo (1254–1324), who passed through northwestern Iran *en route* to visit China, left a glowing account of the busy commercial life in Iran, where the bazaars overflowed with bales of Chinese brocade, spices from India, silk from the Caspian, cotton from Shiraz, and pearls and mother-of-pearl from the Gulf. Under the Pax Mongolica, Eurasia from the Danube to the North China Sea was united in a vast trading network, the likes of which had never been seen.

Uljaytu's mausoleum is a fitting tribute to the vast Mongol empire. Standing 50 m (160 ft) high, the baked-brick building is covered by a blue-tiled dome visible from afar. The dome was ringed by eight slender minarets, the stubs of which can still be seen. To the south, or *qibla* side, lies a rectangular hall used as a

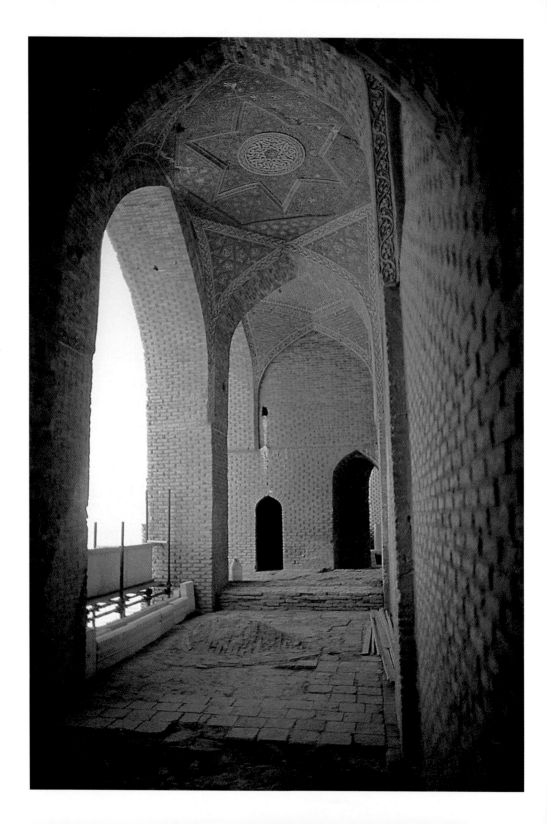

mosque where prayers might be said for the sultan's soul. The octagonal building contains a great single space, 25 m (80 ft) across, with deep recesses in each wall and a continuous gallery from which one could look down. A second gallery on the exterior encircles the building below the base of the dome and provides a splendid view over the surrounding plain. Much of the outside was covered with glazed tiles, which added glittering colour to an already splendid structure. More protected areas, such as the undersides of the gallery vaults (88), were also enriched with colour, here carved and painted plaster. Each of the twenty-four vaults displays a different geometric pattern, and many of these patterns are strikingly similar to those used in con-temporary manuscripts (see 107), suggesting that the artisans for both media took their inspiration from pattern books.

During the middle period, particularly in Iran, colour was increasingly used to define and distinguish parts of buildings. Glazed tiles became more common, covered larger surfaces, and used more colours. At the tomb of the Samanids, for example, the aesthetic effect was achieved largely by the careful manipulation of light and shadow over the surface. This approach changed from the eleventh century onwards, when colour was introduced by inserting glazed earthenware pieces – usually turquoise blue – between bricks to enliven walls. By the fourteenth century the ratio of glazed to unglazed had shifted, as whole expanses were covered in mosaics of glazed ceramic pieces, which had been cut to shape with a chisel and bedded in mortar. (These are technically quite different from the glass mosaics of Damascus and Córdoba.) The cornice at the tomb of Uljaytu shows three colours of tile – turquoise blue, dark blue and white – against the buff brick, and soon this palette was enriched with green, yellow ochre and purple-black. As the colour range and surface area increased, designs became freer, and geometric patterns gave way to floral motifs.

Many rulers sought to immortalize themselves by constructing fancy mausoleums for their remains, but some also devoted

their energies to the immortalization of other notables, particularly holy men, thereby hoping to gain God's blessing in this world and the next. Timur (r.1370–1405), the founder of the second Mongol dynasty to rule over much of the Islamic lands, was one of the greatest conquerors in history. After defeating the Golden Horde, the Mongol dynasty that had ruled the steppes of Russia, he used the prodigious booty he amassed to build a massive tomb over the grave of Ahmad Yasavi (d.1166), a Sufi leader who had been responsible for converting the Turks of Central Asia to Islam. During the middle period mysticism evolved from a solitary pursuit to a communal

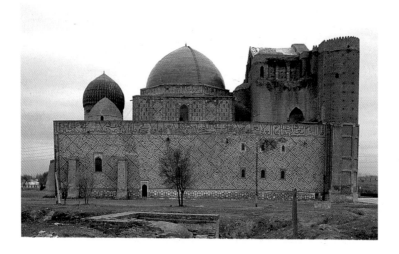

89–91
Shrine of
Ahmad Yasavi,
Turkestan,
1398
Left
Exterior
Opposite
Interior vaults

activity, with mystics organized into groups that followed the teachings of an elder, often known as a *shaykh*. They often lived communally in a building called a *khankah*, which might be indistinguishable in form from a *madrasa*. Ahmad had founded an order of mystics at an oasis known as Yasi (now Turkestan City in Kazakhstan), located on the trade route north from Tash-kent. After his death his tomb became a focus of pilgrimage for the Turks of Central Asia and the Volga. Timur, an opportunist in religion as well as other matters, wanted to cultivate the Sufi orders and hence had this immense tomb complex con-structed (89).

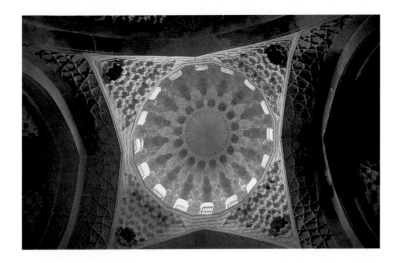

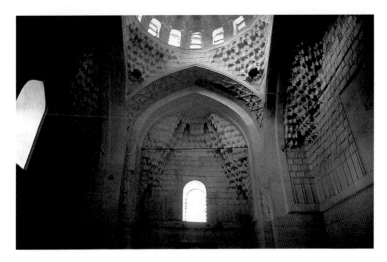

A bulky block, the building rises dramatically above the steppe.
The main entrance, a huge *iwan* flanked by towers, beckons the
visitor into the central square room, covered by a blue-tiled dome.
The room, used for Sufi gatherings, houses a huge basin from
which water was served to pilgrims. Subsidiary service rooms,
including a mosque, kitchen, bath, library, meditation rooms and
domitories, fill the sides of the building, but the focus of the
shrine is a small domed chamber behind the central room. This
chamber, which stands over the saint's tomb, is covered by a
melon-shaped dome with blue tiles. Inside it has a stunning vault
decorated with *muqarnas,* also used in other vaults (90–91).

Muqarnas, sometimes likened to stalactites, had been developed since the late tenth century as a means of decorating buildings in the Islamic lands. Consisting of tiers of niche-like elements that project out from the row below, *muqarnas* was applied to supporting elements inside domes, such as squinches in the corners, and to dividing elements between different parts on the exterior of buildings, as on tombs or minarets. Already at the Gunbad-i Qabus, a few tiers of *muqarnas* decorate the half vault over the portal, and the walls and dome at Sultaniyya are separated by a cornice of three tiers of *muqarnas* covered by tile mosaic. By the eleventh century, *muqarnas* elements were used to cover the entire inside surface of vaults. In Iran, these often covered the tombs of holy men. While the earliest *muqarnas* may have had a structural role, they increasingly became a purely decorative element. Thus, at the tomb of Ahmad Yasavi, the decorative *muqarnas* vault is made of plaster suspended by wooden beams from the brick vault above it. Like the Arabic script, *muqarnas* was adopted by builders from Spain to Central Asia, and it became the most distinctive decorative feature of Islamic architecture, although its meaning differed from place to place. Unlike other decorative motifs, *muqarnas* was never applied to any medium other than architecture and such fittings as *minbars*.

The shrine of Ahmad Yasavi combined several different functions in a single building. There was space for gathering, prayer, teaching, cooking, reading and sleeping. It is an unusually compact and closed structure, probably due to the severe climate on the Kazakhstan steppe. There is, for example, no open courtyard; the great domed hall served the same function as a central organizing space. Indeed, the dimensions of the central hall generated all the other dimensions of the building. Unlike the great mosque of Isfahan, the shrine at Turkestan is also a building meant to be seen from all sides and from a great distance, because the exterior walls are decorated and the different parts of the building are carefully composed. This measured arrangement was undoubtedly made possible by the site, for unlimited land

92
Ribat Sharaf,
Iran, 1114 and
later. View
of second
courtyard

was readily available, although the remote location meant that it must have been expensive and difficult to procure materials for construction, such as wood for scaffolding, fuel to fire the kilns, or minerals to make glazes. In contrast, men and materials for the mosque at Isfahan would have been readily available in the capital city, although land would have been at a premium and the building might be expanded only when an adjacent property became available. For such an urban structure as a congregational mosque, the four-*iwan* plan with its internal focus was eminently suitable.

The four-*iwan* plan was sufficiently adaptable that it was used in many places for the many types of buildings that were developed in the medieval period. These ranged from schools to caravanserais (medieval motels for caravans) to palaces, and the popularity of the plan meant that it was soon adopted far beyond the confines of its traditional home in Iran. A good example is the ruined caravanserai known as Ribat Sharaf, built in 1114 in the steppe between Nishapur and Merv near the present northern border of Iran (92). The site lies on the ancient Silk Road which had become one of the most important highways connecting the

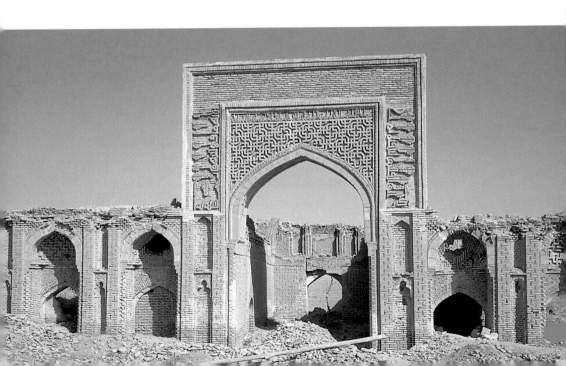

eastern Islamic lands with the centre, and large quantities of goods, including precious luxuries, foodstuffs and herds, were moved along the caravan network. In antiquity goods had been transported overland by wagon, but in the centuries before the rise of Islam the pack camel replaced the wagon as the primary means of moving goods long distances overland, and wheeled vehicles remained virtually unknown throughout the Islamic lands until the twentieth century. Camels could carry heavy burdens for several days from station to station across a largely waterless steppe, and a network of caravanserais – ideally some 40 km (25 miles) apart – was constructed to provide merchants with a secure place to rest and water their animals and spend the night.

The caravanserai known as Ribat Sharaf was probably built by Sharaf al-Din ibn Tahir, governor of the province of Khurasan, from whom the building gets its name. It was designed to protect caravans from maurauding Turks, but after they sacked it, the building was remodelled as a palace for Princess Turkan Khatun, wife of the Saljuq sultan Sanjar (r.1118–57), who had his capital at Merv. Just as at the shrine of Ahmad Yasavi, the open countryside provided enough space for a regular exterior, although the building's function meant that there was only one door that could be closed and guarded. The rectangular building has two interior courtyards, the larger one behind the smaller but each with four *iwans* flanked by single rooms and suites. The remains of staircases and the heavy construction in baked brick indicate that the building had at least one upper storey. A huge subterranean cistern opposite the entrance provided fresh water throughout the year in an arid plain where the only other water was brackish. The courtyards provided merchants with a place to stable their animals; the rooms provided spaces in which to unload wares and to sleep. At the far end of the complex the central *iwan* and dome are flanked by two larger suites of rooms, which were remodelled for the princess's use. Remains of fancy decoration in carved and painted plaster show how easy it was to transform a utilitarian caravanserai into a luxury palace, since the four-*iwan* plan was so flexible.

The four-*iwan* plan also became popular for the specialized religious institutions that developed in the middle period, such as theological colleges and convents for Sufis. The flexibility of the plan made it appropriate for use in such buildings, where space had to be provided for communal gathering and private study or rest, and the popularity of such institutions insured the spread of the four-*iwan* plan to many regions. From the earliest years of Islam, the mosque – in addition to its primary role as a place of communal prayer – had also functioned as a centre of instruction and learning. Religious scholars might choose a particular corner of a congregational mosque as their 'own', regularly going there to study books in the mosque library or instruct others who might come to the mosque to study. As the religious sciences developed and certain scholars became noted for a particular speciality, students might come from great distances to hear the lectures of a particular professor. Congregational mosques could provide lodging for the occasional ascetic or wayfarer, but not regular accommodation for students and teachers. As early as the tenth century, independent lodgings were established near mosques, and these soon became essential for students, who might spend several years studying with a particular teacher. The first institutions devoted exclusively to teaching jurisprudence and housing students were founded in the eleventh century. Known as *madrasas* (from the Arabic word meaning 'a place of study'), they were often maintained by an endowment of income-producing property, such as land or buildings, which would support the teachers and students and pay for repairs to the building.

The Saljuq vizier Nizam al-Mulk was an enthusiastic founder of *madrasas* in such Saljuq metropolises as Baghdad, Nishapur, Mosul, Herat and Merv, for the *madrasa* was a primary weapon in the orthodox arsenal to counter the spread of heterodox Shiism. Shiism had attracted large numbers of adherents in the tenth and eleventh centuries, primarily by taking advantage of widespread dissatisfaction with the status quo. The *madrasa* spread throughout the region and throughout northern Mesopotamia,

Syria and Palestine, and after the conquest of Anatolia from the Byzantines, the institution became a primary means of introducing Islam there. The Ayyubids, who supplanted the Shiite Fatimid dynasty in Egypt, and their successors, the Mamluk sultans (r.1250–1517), built an extraordinary number of *madrasas*. Not only was the *madrasa* seen as a means of countering heterodox beliefs, but it was also a way of piously perpetuating the founder's name and beliefs. A *madrasa* often incorporated the founder's tomb, and the complex was established as a charitable endowment. In this way, the founder hoped to perpetuate his name and family fortune, for by law, property endowed to institutions founded for charitable purposes was safe from state confiscation. In unsettled times, when rulers fell like dominoes, charitable foundations were a hedge against seizure of property, and the deed of endowment could specify that the founder or his descendants be appointed as trustee.

The situation in North Africa was slightly different, since the legal system followed there did not allow the founder to appoint himself the administrator of a charitable endowment. Hence most *madrasas* in North Africa were sponsored by the government, for only the ruler could afford to spend such large sums to enhance his reign and realm. *Madrasas* were introduced to Fez under the Marinids (r.1196–1549), a Berber dynasty that wanted to counter the heterodox policies of their predecessors. One of the finest is the Attarin *madrasa* (1323–5), located in the heart of Fez across a narrow street from one of the city's two congregational mosques. The *madrasa* takes its name 'Perfumers' from the nearby market for perfumes (*attar*, from which the English word attar comes). In the traditional Islamic city, such precious goods as spices, perfumes, silks and jewellery were sold in specialized markets, which are often clustered around the congregational mosque and could be locked up at night. Across the street from the Attarin *madrasa* was a caravanserai for merchants from the city of Tetuan; the fees they paid for lodging and storage provided for the upkeep of the *madrasa*.

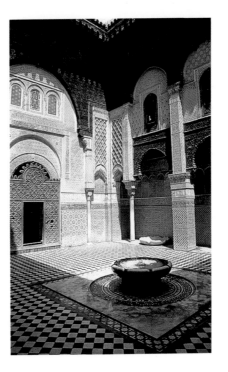

93
Attarin
madrasa, Fez,
Morocco,
1323–5. View
of courtyard

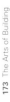

Like other Marinid *madrasas,* the Attarin is largely hidden from
the street. A single decorated door leads from the bustling bazaar
to the calm oasis of the courtyard (93) where students would
gather for study. A fountain and basin in the centre provided
running water for ablution and to create white noise to mask the
urban hubbub. Narrow colonnades along the sides of the court
provide shade, and a hall at the far end served for instruction and
prayer. From the hallway, a passage leads to a large latrine, and a
stairway leads to rooms for fifty or sixty students and faculty on
the upper floor overlooking the court.

The interior of the building is totally enveloped in a web of
intricate decoration. Glazed tiles cover the floor and lower walls,
carved plaster covers the middle part of the walls, and wood on
the upper part of the walls supports the roof. Although these
materials are used throughout the Islamic lands, the distinctive
combination and types of patterns are typical of the region. The
lavish use of cedar was made possible by the extensive forests
on the slopes of the Atlas Mountains. Each medium has its own
geometric, vegetal or written decoration, but all of them are

intricately worked on several planes. This intricacy is often seen as a characteristic feature of Islamic art. Ibn Khaldun, the great fourteenth-century philosopher and historian who spent his formative years in the service of the Marinid sultan at Fez, remarked in his masterpiece, *An Introduction to History,* that

The crafts and sciences are the result of man's ability to think, through which he is distinguished from the animals ... The sciences and crafts come after the necessities. The susceptibility of the crafts to refinement, and the quality of the purposes they are to serve in view of the demands made by luxury and wealth, then correspond to the civilization of a given country.

Thus, the complexity of design and execution of the Attarin *madrasa* and of much Islamic art in this period was a sign of civilized life.

The centre of civilization in the Arab world, in the wake of the Mongol conquest of Iran and the eastern Islamic lands in the mid-thirteenth century, shifted from Baghdad to Cairo, which became the largest city in the Islamic lands. It was the capital of the Mamluk sultans, who were originally Turkish slaves. Their precarious sultanate, where succession was a deathly game of king of the mountain, and the ethnic distinction between the sultans and the populace encouraged the sultans to enter into a social pact whereby in return for the right to rule, they would lavishly endow complexes to provide social services to the community. These stone buildings, erected during the patron's brief tenure, usually included his tomb accompanied by a *madrasa*, hospice for Sufis, dispensary for drinking water, hospital and elementary school. The endowment provided generous stipends for staff and students, as well as money for upkeep. Religious scholars might complain that monumental tombs were unseemly for pious Muslims because such buildings glorified the dead, but the social services and employment they provided assuaged most compunctions that the orthodox might have. In the bustling heart of Cairo, as in Fez, land was expensive and difficult to get, so buildings were wedged into narrow and

irregular plots squeezed into the cityscape. Cairene architects learned to make the most of these difficult parcels. They placed tombs in prominent locations facing the street where passers-by could say prayers in memory of the founders. They sited minarets and domes to dominate the street and skyline, thereby drawing attention to the buildings and their founders.

The largest of these funerary complexes (covering about one hectare or two acres) is the one built by Hasan, a relatively

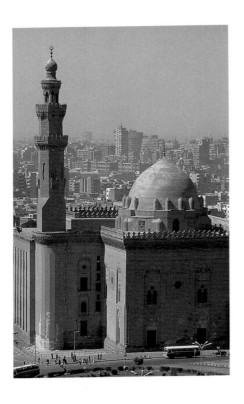

94
Funerary
complex of
Sultan Hasan,
Cairo, 1356

insignificant Mamluk sultan who is remembered not for his meagre political achievements but for his monumental building in the heart of Cairo. The complex occupies an enormous and prominent site on the parade ground at the foot of the citadel. This site allowed the building, unlike almost all others in Cairo, to be freestanding, with the founder's tomb on the southeast projecting toward the parade ground (94). The portal opens to the street that ran from the parade ground to the busy commerical centre of the city. Its soaring height is emphasized by the stunning

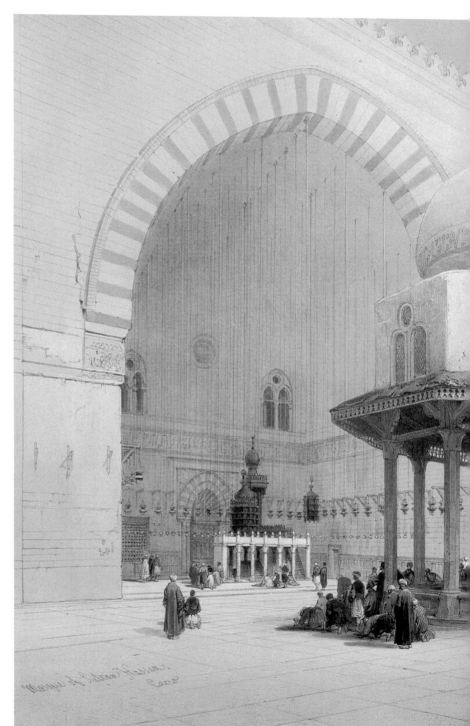

95
David Roberts,
Lithograph
showing
courtyard of
the funerary
complex of
Sultan Hasan
as it appeared
in the 19th
century

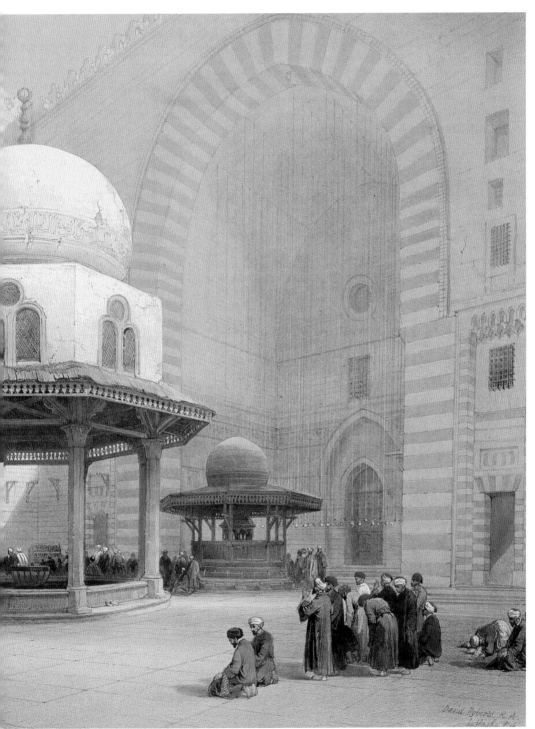

David Roberts, R.A.

muqarnas shell over the doorway, which would have been even more dramatic when crowned by the two tall minarets that were planned to balance the two that rise over the tomb. One of the minarets over the doorway collapsed soon after building, killing 200 orphans studying in a nearby school. This was taken as a bad omen, and the idea of minarets over the doorway was abandoned. The sultan was assassinated a month later.

From the portal, a series of passageways leads to the courtyard with four *iwans* (95). The largest, on the *qibla* (here southeast), served as a congregational mosque and has a stone *minbar* for sermons to the right of the gorgeous marble *mihrab.* The founder's tomb was designed to lie beyond the *qibla iwan*, so that all the prayers directed at the *mihrab* in the congregational mosque would have then passed over his grave. Hasan, however, was not buried there, for his body was never recovered after his assassination, and the tomb houses only the remains of his two young sons. In the centre of the court is a large pavilion for ablutions, and in each of the corners between the *iwans* is a doorway leading to a multistorey *madrasa,* each with its own internal courtyard, teaching hall and rooms for 100 students. Most *madrasas* were dedicated to only one or two schools of law; this complex is a rare example of a *madrasa* dedicated to the four most important schools of Islamic law. The complex also housed an orphanage, a hospital, a covered bazaar with shops, a water tower, baths and kitchens. Its gigantic scale attests to the grandiose delusions of this minor sultan. The Egyptian economy suffered from the sultan's mismanagement as well as from the effects of the Black Death, which had begun to decimate the population in 1347–8. The plague, however, may have aided Hasan's schemes, for according to Islamic law, the estates of those who died intestate reverted to the state, thereby swelling the sultan's coffers.

Although unfinished at the patron's untimely death, the complex of Hasan epitomizes the Mamluk style. The walls of finely cut and carved limestone follow the street pattern and integrate the

building into the cityscape. Parts of the interior, particularly the mosque and the tomb, are panelled with thin slices of coloured marble columns arranged in decorative patterns. The panelling is surmounted by an inscription band elegantly carved in plaster and decorated with scrolls and lotus blossoms, motifs also seen in contemporary books and ultimately derived from Chinese designs. Under the Pax Mongolica, Chinese motifs became popular in Iran and from there passed to other regions. The political rivalry between the Mamluks and the Ilkhans did not prevent the transfer of artistic ideas between the two powers. The furnishings endowed to Hasan's complex were equally elaborate. The superb doors, made of wood plated with bronze and inlaid with gold and silver, as well as the bronze chandelier, were so fine that they were confiscated by a fifteenth-century sultan to decorate his own tomb. The splendours of Hasan's complex would have been revealed at night by hundreds of glass oil lamps suspended by chains from the ceilings; some fifty lamps bearing the sultan's name still survive.

While Hasan had the money and power to obtain a prime site at the foot of the citadel for his tomb, most Cairenes were buried in large cemeteries on the southern and eastern edges of the city (96). Over the centuries this area had developed as a veritable city of the dead. Pious individuals gathered around the tombs of notables, including Imam al-Shafi, founder of the Shafiite school of law, and descendants of the Prophet's family. By the middle of the Mamluk period, many sultans and their families chose to build their funerary complexes in the cemeteries, since land was increasingly scarce (and expensive) in the city centre.

Similar developments took place in other cities, such as Samarqand, where many members of the Timurid dynasty were buried to the northeast of the city. The large cemetery there was known as the Shah-i Zinda or 'Living King', as it grew around the tomb of a companion of the Prophet who had been martyred nearby in early Islamic times. A *madrasa* was erected there in the

eleventh century, and in the fourteenth century the tombs, simple domed cubes covered with glittering tiles, were laid out along a narrow street leading to the city. Many housed the graves of Timurid princesses, for throughout the Islamic lands women were particularly encouraged to express their piety by visiting cemeteries while men prayed at the congregational mosque. Like Sufi convents, cemeteries became the place of popular religious practices that often contrasted sharply with the official Islam of the congregational mosques and *madrasas.*

The first caliphs, as Muhammad's successors, had participated actively in religious affairs, but increasingly religious affairs became the domain of a distinct class of religious specialists, known as the *ulema*, and the caliphs had less and less to do with the day-to-day practice of Islam. While they maintained the fiction that they continued to wield power, the caliphs were forced to hand over the actual running of affairs to a range of sultans, *amirs, atabegs*, governors and other strongmen. At first they carved out domains within the caliphate, but gradually these became independent entities, particularly after the Abbasid caliphate was overthrown in 1258 by the Mongols. At the same time, these independent rulers became more involved in the affairs of their neighbours so that in the middle period citadels, fortresses and palaces became important symbols of dynastic power. The rise of independent principalities, incursions by nomadic Bedouin, Turks and Berbers from the fringes of the Islamic lands, and the call for the First Crusade in 1095 all led to the fortification of many cities, particularly those in the eastern Mediterranean region. Damascus, Jerusalem and Cairo were all walled, but some of the most spectacular to survive are the fortifications at Aleppo (97).

Long an important trading centre in northern Syria, Aleppo became a strong and prosperous city-state under dynasties of Turks and Kurds, the Zangids and the Ayyubids. Since time immemorial, the major feature of the city has been a truncated conical mound, or tell, on which an impregnable citadel was

96
Southern
cemetery of
Cairo with
small graves in
front of the
Sultaniyya
tomb, 1350s

97
Citadel of
Aleppo, Syria,
13th century
and later

erected. A moat surrounds the paved slope to protect the
citadel itself, which housed palaces, mosques, shrines and
barracks. A steep bridge led from a protecting tower across the
moat to the bent entrance whose twisted passage forced
invaders to turn sideways and expose their vulnerable flank.
The bent entrance, which impeded the progress of attackers and
exposed them to the missiles of the defenders, was perfected
during this period. Another innovation was machicolation,
openings in upper walls or over gates from which missiles,
boiling oil or molten lead could be dropped on attackers. The
Crusaders, who captured Jerusalem in 1099, were so impressed
with the new military hardware that they brought these novelties
back to Europe where they incorporated them in their castles and
fortifications. As in many other cities, the Aleppo citadel stands
astride the city walls, controlling not only attacks from without
but also insurrections from within. This siting reflects the ethnic

tensions between rulers and ruled in the medieval period, where foreign masters – Turks, Kurds, Berbers or Mongols – held sway over a population largely of Arabs and Persians.

Similar ethnic tensions emerged in Spain after the collapse of the Umayyad caliphate in the eleventh century and the emergence of the Christian kingdoms in the north. The Zirids, a Berber dynasty who emigrated to Spain from North Africa to fill the power vacuum, fortified the city of Granada and erected a citadel above the city on a low spur of the Sierra Nevada range. Like the citadel of Aleppo, it both protected and dominated the city. Under succeeding dynasties, particularly under the Nasrids (r.1230–1492) who made Granada their capital, the fortress was enlarged until it became a veritable city in itself, with palaces, mosques, baths, tombs, gardens and quarters for artisans. The walls and towers (98) are a distinctive reddish tone that has given the complex its name, the Alhambra, from the Arabic word for red.

The Alhambra is the best example of an Islamic palace to survive from the middle period. In general, palaces were built of less durable materials than mosques or tombs, which were meant to last forever. Most palaces were destroyed or abandoned by succeeding rulers, who saw no reason to maintain the works of those they had vanquished. The Alhambra, in contrast, was consciously preserved as a curiosity and as a symbol of victory by the Christian kings of Aragon and Castile, who completed the reconquest of Spain in 1492 by expelling the Muslims and Jews.

Although the Alhambra is the finest example to survive, it was by no means the most important Islamic palace in its own time. The Nasrids were a relatively minor power at the western fringe of the Islamic world at a time when the Mediterranean was beginning to wane in importance. Timur, by contrast, was far wealthier and his palaces far more splendid, to judge from the fragmentary remains of the gargantuan portal of his palace at Shahr-i Sabz in Central Asia. Even Timur's tent palaces, huge pavilions of bejewelled gold cloth set in verdant gardens watered by streams, were more magnificent. It is also difficult to extract the Alhambra from the myths created about it in the early nineteenth century when European and American Romantics, in search of a relatively safe thrill, discovered its ruins inhabited by gypsies. The American novelist Washington Irving, for example, wrote: 'The peculiar charm of this old dreamy palace is its power of calling up vague reveries and picturings of the past, and thus clothing naked realities with the illusions of the memory and the imagination.' All the names of parts of the complex, whether in Spanish or English, are modern conventions which perpetuate the romantic stereotypes of one of the most popular tourist attractions in Europe.

Looking from the outside at the rough jumble of towers and walls that encloses the Alhambra, one would never imagine the order and delicacy inside. In contrast, the careful arrangement of windows and doors on the ouside of the Renaissance palace inserted into the Alhambra by the Holy Roman Emperor

Charles V (r.1516–56) shows exactly what lies inside it. The Alhambra complex comprises two adjoining palaces connected to the Generalife, a summer palace set in gardens on an adjacent slope. The first palace, known as the Palace of the Myrtles after the shrubs planted in the courtyard, now leads to the second, the Palace of the Lions after the fountain in its courtyard which is supported on twelve stone lions (99). Both palaces are arranged around courtyards with porches and alternating long and square rooms, but the two were originally separate and served different functions. The Palace of the Myrtles, a grand version of a typical urban house, was the place of official reception, while the Palace of the Lions, based on a grand country house, was for private pleasure. It is rarely clear from the forms or decoration how a particular room was used, apart from obvious exceptions such as the bath. As in all Islamic domestic architecture whatever the scale, the function of a room could be altered by changing the furnishings.

One of the most distinctive and attractive features of the Alhambra is the commingling of outside and inside. A court- yard is open to the sky but is inside a building; a porch is covered on three sides but opens to the courtyard. This ambiguity was enhanced by the use of water to connect interior with exterior. Water was carried by aqueducts from the surrounding hills and piped into buildings, where it flowed from fountains through an elaborate system of channels in the floor. The sound of flowing water everywhere further blurred the distinction between inside and out. Vistas also brought outside and inside together: many rooms had windows or loggias designed to command an exten- sive outlook and from which one could gaze out on gardens or the city below.

This magnificent ensemble was lavishly decorated inside and outside with humble materials, such as glazed tile (see 73), carved plaster (see 71) and carved or joined wood. These same materials and techniques were used throughout Spain and North Africa, as for example, at the Attarin *madrasa* in Fez (93), and this distinctive

98 Overleaf
Alhambra
palace,
Granada,
13th century
and later

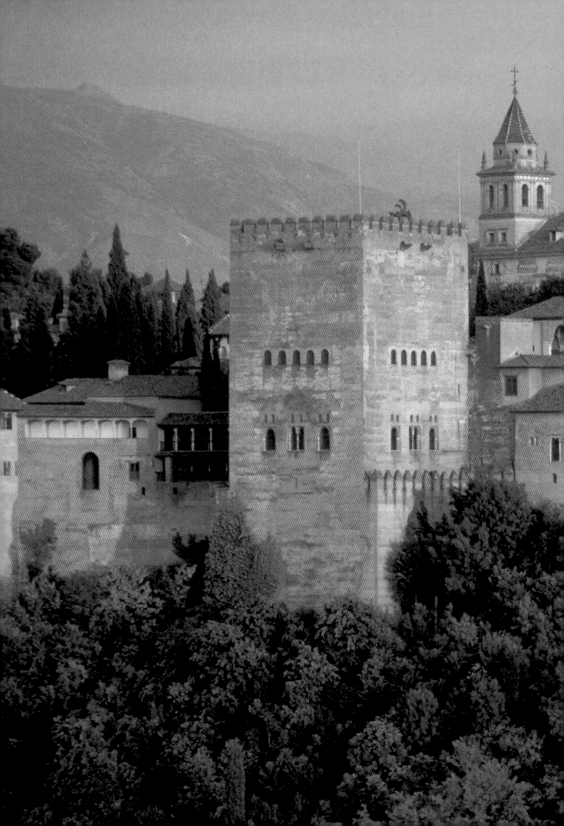

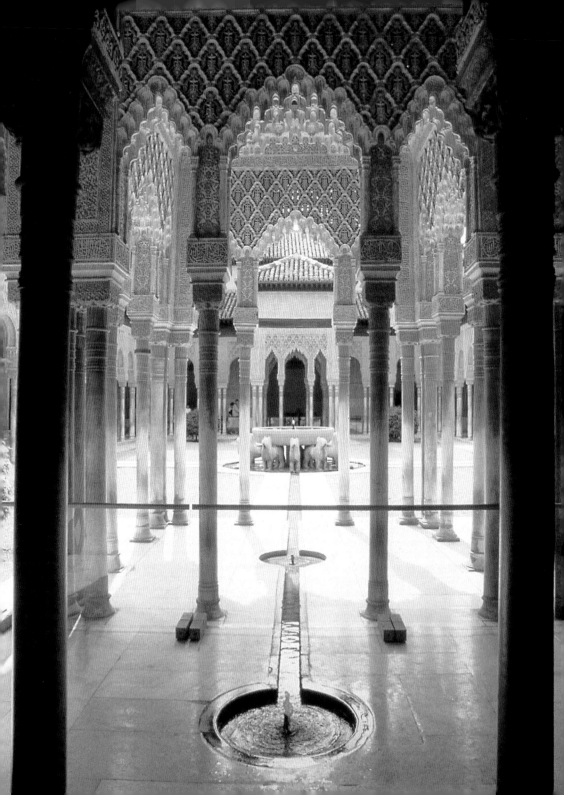

style of decoration has come to be known as Hispano-Moresque. As in Morocco, there was much wood with which to make ceilings. The Hall of the Ambassadors has a wooden ceiling made of thousands of pieces of wood joined together in a representation of the seven heavens, an appropriate canopy for the ruler's audience hall. Elsewhere in the Islamic lands wood was relatively scarce, and joinery techniques had evolved to make the most of a precious resource. Wood was joined and inlaid with ivory and other materials to decorate chests, *minbars,* and the like. The use of such a delicate technique to cover an entire ceiling shows the generous resources available to the Nasrid rulers.

Perhaps the most magnificent ceilings at the Alhambra are the two plaster vaults suspended over rooms in the Palace of the Lions (71, 100). *Muqarnas,* which was used in the eastern Islamic lands over the tombs of holy men, was used here like wood to symbolize the dome of heaven. As sunlight passed from window to window in the drum of the vault, the movement of shadows would create the effect of a rotating starry sky. This metaphor was driven home by verses commissioned from the fourteenth-century court poet Ibn Zamrak and inscribed on the walls of the rooms below:

And how many arches rise up in its vault supported by columns which at night are embellished by light!

You would think that they are the heavenly spheres whose orbits revolve, overshadowing the pillar of dawn when it barely begins to appear after having passed through the night.

This opulent setting was made all the more splendid when furnished with rich silk hangings, soft carpets and glittering ceramics.

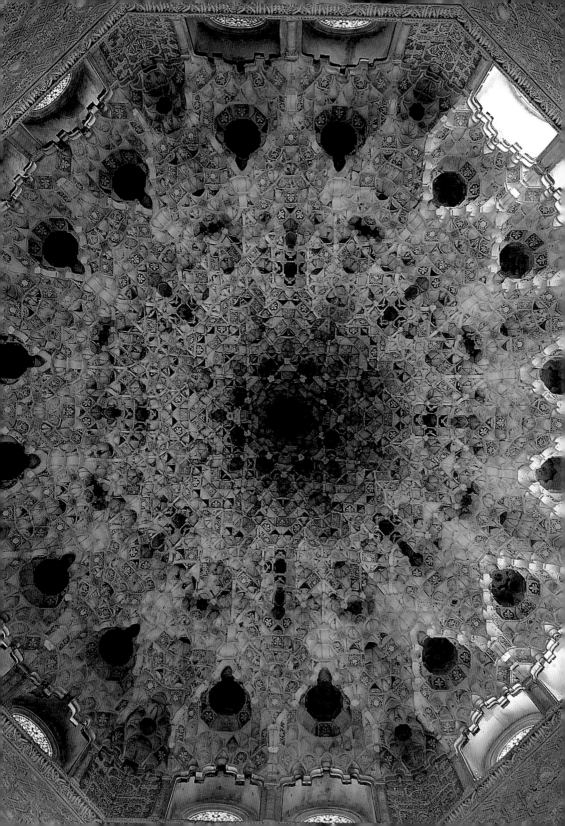

Penmen and Painters The Arts of the Book

The arts of the Islamic book – calligraphy, illumination, illustration and binding – came of age in the middle period, and luxury books are some of the most characteristic examples of Islamic art produced in this period. This came about from two major developments: paper became common, replacing parchment as the major medium for writing, and rounded scripts were regularized and perfected so that they replaced the angular scripts of the previous period. Books became major vehicles for artistic expression, and the artists who produced them, notably calligraphers and painters, enjoyed high status and their workshops were often sponsored by princes and their courts.

In the earlier period, manuscripts of the Koran seem to have been the most common type of book produced and embellished, but in this period a wide range of books were produced for a broad spectrum of patrons. These continued to include, of course, manuscripts of the Koran, which every Muslim wanted to read, but scientific works, histories, romances, epic and lyric poetry were also copied in fine hands and embellished with beautiful illustrations. Most were made for sale on the open market, and cities boasted special souks where books were bought and sold. The congregational mosque of Marrakesh in Morocco is known as the Kutubiyya, or Booksellers' Mosque, after the adjacent market. Some of the most luxurious books were specific commissions made at the order of a particular prince and signed by the calligrapher and decorator. These signed and dated works provide a framework for understanding the many other books that are unsigned and undated.

Papermaking had been introduced to the Islamic lands from China in the eighth century. It has been said that Chinese papermakers were among the prisoners captured in a battle fought near Samarqand between the Chinese and the Muslims in 751, and the

101
The constellation Andromeda, from a copy of al-Sufi's *Book of the Fixed Stars*, 1009. Ink and colour on paper; 26.3 × 18.2 cm, 10$\frac{1}{3}$ × 17$\frac{1}{8}$ in. Bodleian Library, Oxford

technique of papermaking – in which cellulose pulp extracted from any of several plants is first suspended in water, caught on a fine screen, and then dried into flexible sheets – slowly spread westward. Within fifty years the chancellery in Baghdad was using paper for documents. Writing in ink on paper, unlike parchment, could not easily be erased, and therefore paper had the advantage that it was difficult to alter what was written on it. Papermaking spread quickly to Egypt and eventually to Sicily and Spain, but it was several centuries before paper supplanted parchment for copies of the Koran, probably because of the conservative nature of this art and its practitioners. In the western Islamic lands parchment continued to be used for manuscripts of the Koran throughout this period.

The introduction of paper spurred a conceptual revolution whose consequences have barely been explored. Although paper was never as cheap as it has become today, it was far less expensive than parchment and therefore more people could afford to buy books. Paper is thinner than parchment, so more pages could be enclosed within a single volume. At first, paper was made in relatively small sheets that were pasted together, but by the beginning of the fourteenth century very large sheets – as much as a metre (3 ft) across – were available. These large sheets meant that calligraphers and artists had more space on which to work. Paintings became more complicated, giving the artist greater opportunities to depict space or emotion. The increased availability of paper, particularly after 1250, encouraged people to develop systems of representation, such as architectural plans and drawings. This in turn allowed the easy transfer of artistic ideas and motifs over great distances, from one medium to another, and in a different scale in ways that had been difficult, if not impossible, in the previous period.

Rounded styles of Arabic handwriting had long been used for correspondence and documents alongside the formal angular scripts used for inscriptions and manuscripts of the Koran. Around the year 900, Ibn Muqla, who was a secretary and vizier at the

Abbasid court in Baghdad, developed a system of proportioned writing. It was based on the diamond-shaped dot formed when the nib of a reed pen was pressed against a piece of paper. Ibn Muqla calculated the length of *alif*, the first letter of the Arabic alphabet and a straight vertical line, in dots and then extrapolated the size and shape of all other letters from the *alif*. According to tradition, the first script to be regularized was known as *muhaqqaq* ('accurate', 'well-organized' or 'ideal'), where the *alif* was nine dots high. Eventually six round hands, comprising three pairs of big and little scripts and known collectively as the Six Pens, became the standard repertory of every calligrapher from this time on.

No examples of Ibn Muqla's work are known to have survived, but he taught his art to several followers, including his daughter, who was in turn the teacher of the most important calligrapher of his day, Ali ibn Hilal, known as Ibn al-Bawwab ('son of the doorman'). Ibn al-Bawwab began his career as a housepainter but soon turned his attentions to calligraphy, in which he added elegance to the system developed by his predecessor. Ibn al-Bawwab gained the notice of the Buyid ruler of Shiraz, who appointed him librarian. It is said that the library contained a thirty-volume manuscript of the Koran penned by Ibn Muqla, but one volume was missing. The ruler asked Ibn al-Bawwab to make a replacement for the lost volume, and the calligrapher was so successful that that the ruler was unable to distinguish the replacement from the original. Ibn al-Bawwab reportedly knew the Koran by heart and copied it sixty-four times. Only one of these copies is known to survive (102), and it is a milestone in many ways.

The Ibn al-Bawwab Koran is a small volume (17.5 × 13.5 cm, 7 × 5⅓ in) of 286 brownish paper folios. Each text page has fifteen lines of round script written with a straight cut reed pen to produce letters of uniform thickness. The brown ink is discreetly enhanced with blue and gold. Chapter headings and five double pages of illumination and tables at both the beginning and end of the book

بِسْمِ اللَّهِ الرَّحْمَٰنِ الرَّحِيمِ

الْحَمْدُ لِلَّهِ رَبِّ الْعَالَمِينَ الرَّحْمَٰنِ الرَّحِيمِ مَالِكِ يَوْمِ الدِّينِ إِيَّاكَ نَعْبُدُ وَإِيَّاكَ نَسْتَعِينُ اهْدِنَا الصِّرَاطَ الْمُسْتَقِيمَ صِرَاطَ الَّذِينَ أَنْعَمْتَ عَلَيْهِمْ غَيْرِ الْمَغْضُوبِ عَلَيْهِمْ وَلَا الضَّالِّينَ

بِسْمِ اللَّهِ الرَّحْمَٰنِ الرَّحِيمِ

الم ذَٰلِكَ الْكِتَابُ لَا رَيْبَ فِيهِ هُدًى لِّلْمُتَّقِينَ الَّذِينَ يُؤْمِنُونَ بِالْغَيْبِ وَيُقِيمُونَ الصَّلَاةَ وَمِمَّا رَزَقْنَاهُمْ يُنفِقُونَ وَالَّذِينَ يُؤْمِنُونَ بِمَا أُنزِلَ إِلَيْكَ وَمَا أُنزِلَ مِن قَبْلِكَ وَبِالْآخِرَةِ هُمْ يُوقِنُونَ أُولَٰئِكَ عَلَىٰ هُدًى مِّن رَّبِّهِمْ وَأُولَٰئِكَ هُمُ الْمُفْلِحُونَ

are enriched with white, green and red. The combination of graceful script and delicate ornament make this manuscript a masterpiece, which Ibn al-Bawwab signed in a colophon at the end. It states that Ali ibn Hilal wrote this manuscript at Baghdad in 1000–1001. Surprisingly, this manuscript was apparently made for sale on the market, as the colophon mentions no patron. We can assume therefore that there must have been a fair market for such fancy books by noted calligraphers; otherwise Ibn al-Bawwab would not have spent so much time preparing it.

Manuscripts of the Koran might be illuminated with pages or panels of carpet-like decoration but God's word was never illustrated with pictures. Pictures were used, however, in other kinds of manuscripts, particularly scientific and technical works where the picture was a necessary adjunct to explain what was discussed in the text. In the ninth century the Abbasid caliphs sponsored a revival of Classical learning, and many scientific texts, including Ptolemy's treatise on the stars and Dioskorides's herbal, were translated from Greek into Arabic. As the Classical models had been illustrated, it is likely that the Arabic copies were illustrated as well, although the earliest copies have not survived. Illustrations to a manuscript of al-Sufi's *Book of the Fixed Stars,* a revision of Ptolemy's catalogue of the stars and constellations, show how the Classical models were transformed in Islamic times. The constellation Andromeda, for example, was represented in Classical times by a nude woman chained to rocks, but in this manuscript dated 1009 (101) she has lost her setting and been transformed into a dancing girl with fluttering draperies. Similarly, male constellations, such as Sagittarius, wear turbans or hats. Once established, these new models were repeatedly copied. In the same way, illustrations to the Arabic translation of Dioskorides's book about the medicinal uses of herbs were copied from drawings rather than being drawn from life. Although this work continued to form the basis of Islamic pharmacology, the increased abstraction of the drawings meant that it was difficult, if not impossible, to recognize a plant from the drawing.

102
Right-hand page from a Koran, copied at Baghdad, by Ibn al-Bawwab, 1000–1001. Brown ink, colour and gold on paper; 17.5×13.5 cm, 7×5¹⁄₃ in. Chester Beatty Library, Dublin

New kinds of texts also came to be illustrated, showing that the taste for illustrated books had broadened and that more people wanted to read and enjoy them. One of the most unusual is the *Maqamat* ('Assemblies') of al-Hariri (1054–1122), which wittily recounts the fifty adventures of a rogue named Abu Zayd of Saruj as told by the merchant al-Harith. Its linguistic inventiveness and punning style made it immensely popular among the educated bourgeoisie of the Arab lands, but the verbal pyrotechnics of the text did not lend themselves easily to illustration. Nevertheless, the work was repeatedly illustrated, and eleven illustrated copies produced before 1350 have survived. The illustrations emphasize another aspect of the text – Abu Zayd's adventures across the contemporary Islamic world, and the paintings thereby provide rare glimpses of daily life in medieval times.

The most famous manuscript of the *Maqamat*, copied and illustrated by Yahya al-Wasiti at Baghdad in 1237, has particularly creative scenes. The one shown (103), for example, illustrates the forty-third adventure, in which the two main characters encounter a man outside a village. Abu Zayd asks the man whether the villagers would appreciate his literary talents, to which the man gives a long and witty 'No'. Al-Wasiti could not give visual expression to the man's witty reply, but he could elaborate the setting. In the foreground, the two main characters on camelback talk with the man on the left. A pool from which animals drink separates the foreground from the bustling village in the background. Under the domed arcades of a market a variety of people engage in daily activities. Some haggle, others wait for customers and a figure on the right spins yarn. Two fowl search for food on the roofs. On the left is a mosque with a blue-tiled dome and minaret decorated with inscriptions. In contrast to scientific illustrations, this image tells us less about the text than about the economic and social life in a contemporary town. It, like the hundred other paintings in the manuscript (see 26), provides an open window into medieval Islamic life.

103
Village scene from a manuscript of al-Hariri's *Maqamat*, copied and illustrated at Baghdad by Yahya al-Wasiti, 1237.
Ink and colour on paper;
35×26 cm,
14¹₂×11 in (page).
Bibliothèque Nationale, Paris

The unusually specific colophon in this copy of the *Maqamat* mentions no patron, so it, like most other manuscripts of the text, was probably made for sale on the market to a well-educated and well-heeled buyer. This flowering of urban culture in Baghdad in the mid-thirteenth century, however, was overshadowed after the Mongol invasions as new centres emerged where different types of manuscripts were produced for new classes of patrons. Illustrated manuscripts continued to be made in Baghdad after the supposed 'destruction' of the city by the Mongols in 1258, but after this date Iran becomes increasingly important as the creative centre for the arts of the book.

The most important region in the late thirteenth and early fourteenth centuries was northwest Iran where the Ilkhanid rulers had their capitals. Scientific works were produced at Maragha, where Hulagu established in 1259 an impressive observatory directed by the noted astronomer Nasir al-Din Tusi. Astronomy and astrology were extremely important to the early Mongol rulers of Iran, who maintained the shamanist beliefs of their ancestors, and the astronomical tables produced at Maragha were transmitted west where they were crucial in the revival of astronomy that took place in the Byzantine Empire and western Europe. As the Ilkhans became increasingly Persianized and converted to Islam, they adopted the languages, beliefs and customs of their subjects. Books such as the Arabic animal fables known as *Kalila and Dimna*, after the two jackals who figure in it, were translated into Persian, and a variety of works by many authors attempted to integrate the different systems of knowledge and belief in this heterogeneous society. The Ilkhanid ruler Uljaytu (r.1304–16), for example, was born to shamanist parents but baptized a Christian in infancy with the name Nicholas in honour of the current pope, with whom his father Arghun had negotiated. Uljaytu then became a Buddhist, but when his brother and predecessor Ghazan officially converted to Islam in 1296, Uljaytu became a Sunni Muslim, dallying in turn between the Hanafi and Shafii schools of law. He then became a Shiite Muslim.

This cosmopolitan world is epitomized in Rashid al-Din's *Universal History*. The author, born to a Jewish family in Hamadan *c.*1247, converted to Islam and became court physician and vizier, in which position he amassed extraordinary wealth and established charitable foundations in Tabriz, Hamadan and elsewhere. His great power incited the envy of others and eventually led to his execution in 1318. His four-volume *Universal History*, begun at Ghazan's request and completed under Uljaytu, contains sections on the Mongols, Turks, Chinese, Franks, Jews, Indians and the Islamic dynasties, derived from a wide range of sources. In the endowment deed of the foundation he established near Tabriz, the vizier stipulated that large-format copies of his collected works be produced yearly in both Persian and Arabic and distributed to the major cities of the realm, where they could be consulted. Of the copies produced in the author's lifetime, about half of one of the Arabic versions has survived. The manuscript comprises the histories of the ancient prophets, Muhammad and the caliphate, the rulers of Islamic Iran, the Chinese, the Indians and the Jews. The manuscript is remarkable for the format, style and profusion of its illustrations, which took their inspiration from a great variety of visual sources, ranging from Chinese scrolls to Italian panel paintings of the thirteenth century.

An image such as the *Birth of the Prophet Muhammad* (104) shows the range of historical and visual sources available in Iran under the Ilkhans. Like most of the illustrations in the manuscript (see 44), the scene occupies a broad strip on a large page. The image is divided into three parts. The centre shows the infant Muhammad cradled by two angels while his mother is attended by five mid-wives. On the right sits an aged figure with a staff, while on the left are four women, three standing and one huddled over a stick. None of these supporting characters figures prominently in the text, which concerns the date of the Prophet's birth.

Pictures of Muhammad are extremely rare in Islamic art; those in this manuscript are some of the first known and show that Ilkhan patrons did not share the inhibitions of other Muslims about

representing the Prophet. The idea for the scene came from Christian art, in which scenes from the life of Christ are common. In Christian theology, the Nativity of Christ, for example, represents the divine miracle of God's sending his son to save mankind, and scenes of it became ubiquitous in Christian art. The birth of the Prophet, by contrast, has no such theological

104
The Birth of the Prophet Muhammad, from Rashid al-Din's *Universal History*, copied at Tabriz, 1315. Ink and colour on paper; 24.5×9.4 cm, 9¾×3⅝ in (page). University Library, Edinburgh

significance for Muslims, as Muhammad was human, not divine, and early stories of his life focus on his actions, not his birth. There was no tradition in Islamic art for an image of Muhammad's birth, so the artist had to adapt a Christian model, probably a Byzantine panel painting or manuscript illustrating the Nativity. In the scene of the *Birth of the Prophet*, Muhammad's mother replaces the Virgin Mary, the Prophet's uncle replaces Joseph, and the three women on the left replace the Magi. The technique of the Rashid al-Din paintings, where line drawing is heightened with coloured washes, is not Byzantine but derives from Chinese paintings on handscrolls, which came to the Ilkhan court with the Mongols. These disparate elements and styles are juxtaposed a little uneasily in this seminal manuscript, but by the next generation all these features were integrated into a coherent whole.

Uljaytu's son and successor Abu Said was born and raised a Persian-speaking Muslim, and under his patronage the illustrated manuscript reached new heights. Indeed, a sixteenth-century commentator wrote that it was in this time that 'the veil was withdrawn from the face of Persian painting and the kind of

painting that we know now [*eg* in the sixteenth century] was created'. This new style can be seen in the great copy of the *Shahnama*, the Persian national epic that had been composed three centuries earlier by Firdawsi. The *Shahnama*, a long poem of 50,000 rhyming couplets, recounted the history of Iran from the creation of the world to the Islamic conquest and brought

105
Ardawan Captured by Ardashir, page detached from the Great Mongol *Shahnama*. Ink and colour on paper; 40×29 cm, 15³⁄₄×11³⁄₈ in. Arthur M. Sackler Gallery, Washington, DC

together legends and stories about the great kings and heroes of the past. The poem was transmitted orally at first; the earliest surviving manuscript dates from the mid-thirteenth century but it is not illustrated. The great Ilkhanid manuscript of the *Shahnama* was commissioned in two volumes of over 400 pages illustrated with 200 large pictures, but it has been dismembered, and only fifty-eight single paintings and a handful of text pages survive.

An image such as *Ardawan Captured by Ardashir* (105) attests to the mature and unified conception of this work. The narrow horizontal format of the Rashid al-Din illustration has been expanded to fill more than one-third of the written surface, itself even larger than in the earlier book. The Persian text was copied in six columns separated by narrow rulings. As in Arabic, one reads Persian from right to left; here each line on the page contains three of the poem's couplets. A box at the top of the painting gives the title of the scene below. The painting shows the defeated Ardawan, last of the Parthian kings, standing captive before the mounted Ardashir, first of the Sasanian kings, the glorious dynasty that ruled Iran for four centuries before the coming of Islam.

A deep pictorial space and a complex circular composition has replaced the additive three-part structure of the earlier painting. The placement of an anonymous soldier with his back towards us in the centre foreground is daring indeed and serves to involve the viewer in the action depicted. The figures seem to burst from the picture frame (notice the foot of the central soldier). To his right stands the bowed and defeated ruler, whose white humble garments reflect his dejection. He is juxtaposed to the ruddy-faced executioner, whose sword dangles over the victim's head. The major landscape element, the large tree in the background that is rendered in a Chinese style, has branches pointing to the new ruler dressed in royal blue and crowned in gold. The panoply of soldiers and attendants distinguished from each other by facial type and dress, especially hats, reflects the variety of people serving at the court of the Ilkhans. The specificity of the images

106
Right-hand text
page from a 30-
volume
manuscript of
the Koran,
copied by
Abdallah ibn
Muhammad ibn
Mahmud al-
Hamadani for
Sultan Uljaytu,
Hamadan,
1313.
Ink, colour and
gold on paper;
56×41 cm,
22×16⅛ in.
National
Library, Cairo

suggests that some if not all were chosen for illustration as allegories to contemporary events, for the Ilkhan rulers of Iran liked to see themselves as the latest in a distinguished series of rulers of this ancient land.

While all of the images in this manuscript are not of the same complexity or quality of conception, as a whole they reflect the integration of the traditional arts of calligraphy and illustration with the new artistic ideas brought by increased contact with East and West under the Pax Mongolica. The generous conception of the images in the Great Mongol *Shahnama* was due in part to the large size of the paper on which the book was written. These large sheets and the materials to decorate them were expensive and conveyed a sense of the wealth of the patron who was able to afford such expense. In addition to illustrated manuscripts, large

107
Right-hand
illuminated
page from a
30-volume
manuscript of
the Koran,
copied by
Abdallah ibn
Muhammad ibn
Mahmud al-
Hamadani for
Sultan Uljaytu
Hamadan,
1313.
Ink, colour and
gold on paper;
56×41 cm,
22×16⅛ in.
National
Library, Cairo

sheets were also used for copies of the Koran during this period.
One of the finest – and largest – is a thirty-volume manuscript
copied for Uljaytu at Hamadan in 1313 (106) by the calligrapher
Abdallah ibn Muhammad ibn Mahmud al-Hamadani.

Whereas Ibn al-Bawwab's manuscript was a single volume meant
to fit in a (large) pocket, this multi-volume manuscript was meant
for public reading in the mosque, where one volume would be
read each day of the month. Although the pages were folded from
a sheet measuring 56×82 cm (22×32 in), each side has only five
lines of majestic script in one of the six styles of writing codified a
generation earlier by the great Baghdadi calligrapher, Yaqut al-
Mustasimi (1221–98). The technique of writing in gold which was
outlined in black and marked with blue vowels was extremely
painstaking and laborious to produce, although the result is easy
to read, even at a distance. The extravagant use of materials
stands in sharp contrast to the dense, even cluttered, effect of Ibn
al-Bawwab's manuscript. The solemn splendour of the Ilkhanid
manuscript was enhanced by elaborate chapter titles, written in

white on a blue ground with gold decoration and marked by large ovals in the margin. The illuminated pages at the beginning of each volume are equally splendid (107), with carpet-like patterns of star polygons and infinite geometric repeats. The similarity of these patterns to those found in the vaults at Sultaniyya (88) show that artists were working from pattern books produced at some central location. These designs could be reproduced in various media to any scale. The new role of the pattern and pattern book shows that the designer had emerged as a new type of artist, and his role would only continue to grow in the following centuries.

As in Iran, large manuscripts of the Koran intended for public use in charitable foundations were endowed by the Mamluks of Egypt and Syria. One of the most famous of these manuscripts is a copy of the Koran completed in 1372 and endowed in 1376 by Sultan Shaban to the *madrasa* he established in Cairo. The extremely large (74×51 cm, 29⅛×20 in) single volume has 217 pages with thirteen lines to a page, except for the opening pages (108), which have script approximately twice the standard size. The calligrapher, the writing-master Ali ibn Muhammad al-Ashrafi, and the illuminator, Ibrahim from Amid in southeastern Anatolia, were justly proud of their collaboration and their names figure prominently in the colophons. The illuminator's palette was unusually wide: to the standard dark blue, gold, black and white, he added brown, light blue, green, orange, red and pink, a range of colour typical of Iranian work. This is not unusual, since Amid (now Diyarbekir in Turkey) was well within the Iranian cultural sphere.

With the collapse of the Ilkhan state in 1335, provincial centres became more important, and artists and writers were attracted to their modest courts. In the southern province of Fars, for example, the Inju family of governors for the Ilkhans became independent rulers, and their court became a major centre for the production of metalwares (see Chapter 8) and illustrated books in the mid-fourteenth century. Shiraz, the provincial capital, was known as

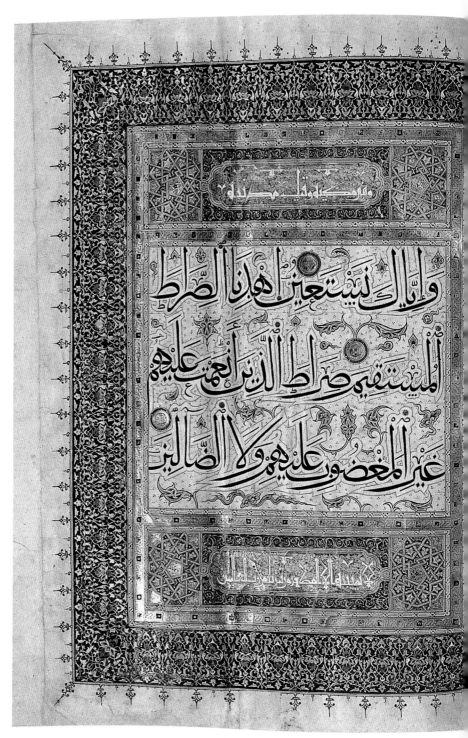

108
Opening pages
to a manuscript
of the Koran,
endowed by
Sultan Shaban
to his *madrasa*,
Cairo, 1376.
Ink, colour and
gold on paper;
74×51 cm,
29¹⁄₈×20 in
(each page).
National
Library, Cairo

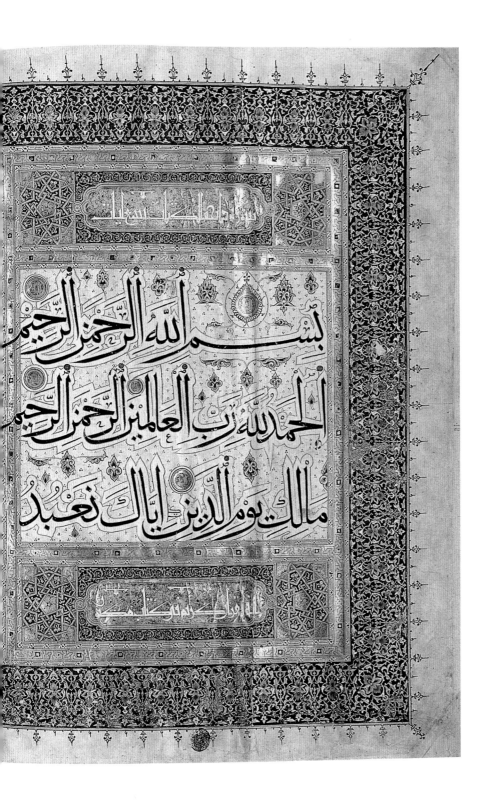

the city of nightingales and roses, and it had long been the home of poets, such as the pragmatic and witty Sadi (d.1292) and the lyric Hafiz (d.1390). The literary circle around these authors made the city a logical centre for manuscript production, and manuscripts produced there can be distinguished by their relatively coarse paper and hasty calligraphy. Unlike the large manuscripts produced for Ilkhan patrons, Shiraz manuscripts were produced commercially for a wide range of clients. Several copies of the *Shahnama*, for example were made there in the 1340s and 1350s, including one dated 1341, made for Qivam al-Din, the Inju vizier (109). The illustrations, such as this scene of the hero Bahram Gur slaying a dragon in India, appear vibrant and energetic to the modern eye, but the absence of such expensive pigments as gold and ultramarine blue indicates that these were less expensive books, as does the slapdash quality of the images.

Shiraz continued to be a centre for the commercial production of illustrated manuscripts for centuries, and many of these commercial products were exported in the fourteenth and fifteenth as far afield as India and Anatolia, where they inspired the creation of local styles of painting. Finer manuscripts were made at the court of the Jalayirids (1336–1432), who succeeded the Ilkhans in Iraq and Azerbaijan. The most famous manuscript is a copy of three poems by Khwaju Kirmani, copied by Mir Ali ibn Ilyas from Tabriz for Sultan Ahmad Jalayir at Baghdad in 1396. The manuscript originally had ten illustrations that are nearly full-page; the text on these pages has shrivelled to a small box containing a single couplet, and the illustration spills over the putative margins to fill the entire sheet. The figures are tiny dolls engulfed by expansive architectural settings or landscapes (110). The technical quality of these paintings is superb, with jewel-like pigments on rich creamy paper, but the emotionalism of the Great Mongol *Shahnama* has given way to a dreamy lyricism, in which birds sing and plants blossom in an eternal spring. One of the paintings is signed by Junayd of Baghdad, the first surviving (genuine) signature by a Persian painter, although calligraphers had signed their works for centuries. This signature indicates that

111
The Lion Attacks the Bull, from a copy of *Kalila and Dimna*, prepared for Prince Baysunghur at Herat, October 1429. Ink and colour on paper; 29×20 cm, 11⅜×7⅞ in. Topkapi Palace Library, Istanbul

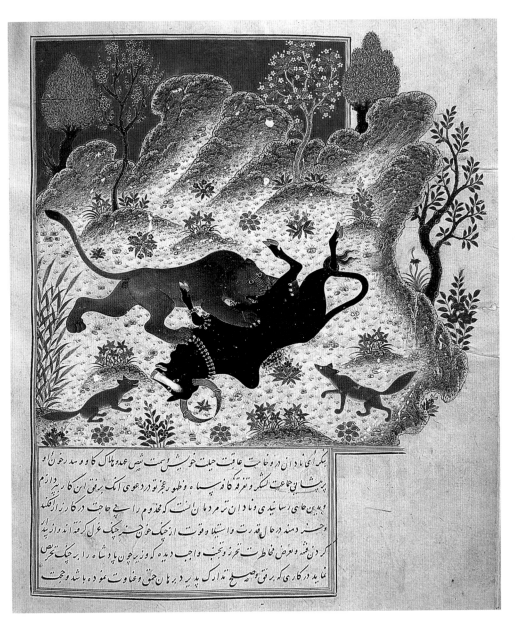

بلکه اکی ماداں در وخامت عاقت حیلت خویش سمت نمص عمده هلاک کاو و سد رخون کاو
پریشانی بجماعت لشکر و تفرقه کاو بسماه وطور غرفتو در دعوی اکنک بر یق این کار یذ دارم
وبدین حاسی رسانیدی وماداں ترمردماں است که مخذوم را پے حاجت در کار از الکند
وحنر دمند در حال قدرت واستیلا وقوت از حبک خون حنر حبک غزل کرفه اندو از پلار
کر دن جمله وعرض مخاطت نخرز و حب واجب دیده که وز بجون پادشاه را بر حبک تحرس
نا بید در کار ی که بر فی مصیح تدارک پد بر دبر ماں حقی وعناوت مو ده باشد وحمت

painters were growing in status among artists and that the arts of the book were increasingly important in Iranian art.

The new role of painters and the arts of the book can be seen in the fifteenth century at the court of the Timurid prince Baysunghur (1397–1433) in Herat. The grandson of Timur, Baysunghur served as governor there for his father Shahrukh from 1419 until his premature death from alcoholism. Baysunghur's library-workshop at Herat was headed by the famous calligrapher Jafar al-Tabrizi. At least twenty manuscripts – in addition to many drawings – are associated with Baysunghur's studio. Each shows the extraordinary taste of this discriminating bibliophile: the heavy creamy paper was specially prepared for the renowned calligraphers, and superb paintings and illuminations adorn the text, which was encased in elegant bindings of leather and cut and gilded paper. Each individual aspect was carefully planned to contribute to the creation of a total work of art.

A copy of the animal fables *Kalila and Dimna* transcribed by Shams al-Din Baysunghuri in October 1429 and decorated with twenty-five brilliant illustrations, epitomizes the classical style of Persian manuscript painting. The text belongs to a literary genre known as 'Mirrors for Princes', in which the stories were meant to gently instruct rulers in proper conduct. A fable such as *The Lion Attacks the Bull* tells how the lion, deceived by his inability to differentiate between illusion and reality and egged on by the deceitful jackal Dimna, attacks the bull without cause. The tale is meant to warn the ruler to look carefully before he leaps into action. The illustration (111) shows how the designer has integrated image and text: neither is subservient to the other, for both are conceived as an intertwined whole. The prose text is gracefully inscribed in six lines across the page, and above it the illustration grows into the right (outside) margin. The two jackals frame the central scene, which is staged as an elaborate ballet in a dreamlike landscape. The violence has been tamed – even the blood pouring from the bull falls in patterns – in this land of eternal make-believe.

112
Bihzad, *The Seduction of Yusuf*, from a copy of Sadi's *Bustan*, prepared for Sultan Husayn Mirza at Herat, 1488. Ink and colour on paper; 30×22 cm, 11⅞×8⅔ in. National Library, Cairo

Although the calligrapher of this manuscript signed his work, the painter did not, and few if any painters at Baysunghur's studio can be identified. This situation changed dramatically by the end of the century with the emergence of the most famous Persian painter, Bihzad. He worked at the court of Sultan Husayn Mirza (r.1470–1506) in Herat. The five illustrations to a copy of Sadi's *Bustan* ('Orchard'), transcribed for the sultan's library in 1488 by the most renowned calligrapher of the age, Sultan-Ali Mashhadi, provide the best evidence for Bihzad's style because all are signed. They all have jewel-like and carefully modulated colours; blues and greens predominate but are tempered by complementary warm colours, especially a bright orange.

The most brilliant of Bihzad's compositions is the *Seduction of Yusuf* (112) which elaborates the biblical and koranic story of Joseph and Potiphar's wife, known as Zulaykha. The incident was mentioned only briefly in Sadi's text of 200 years earlier, but it was recounted in detail by the mystical poet Jami, who worked at Husayn Bayqara's court. The text of Sadi's poem is inscribed in the cream-coloured panels at the top, middle and bottom of the page, and two couplets from Jami's poem are inscribed in white on blue around the arch in the centre of the painting. According to Jami, Zulaykha built a palace with seven splendid rooms decorated with erotic paintings of herself with Yusuf. She led the unwary Yusuf from room to room, locking doors behind her. When they reached the innermost chamber, she threw herself at Yusuf, but he fled from her grasp. The seven locked doors miraculously opened before him to enable his escape from the temptress. Bihzad illustrated the most dramatic moment of the story, when the desperate Zulaykha grabs for Yusuf.

Just as Jami's text is an allegory of the soul's search for divine love and beauty, Bihzad's image invites mystical contemplation. The splendid palace stands for the material world, the seven rooms represent the seven climes, and Yusuf's beauty is a metaphor for that of God. As there was no witness, Yusuf could have yielded to Zulaykha's passion, but he realized that God was

113–114
Copy of Rumi's *Masnavi*, prepared for Sultan Husayn Mirza at Herat, 1483.
25.8×17.5 cm, 10¹⁄₈×6⁷⁄₈ in.
Museum of Turkish and Islamic Art, Istanbul
Above
Outer binding with flap.
Varnished pigment and gold on pasteboard
Below
Inner binding.
Leather filigree

all-seeing and all-knowing. The seven locked doors, which lead the eye through the composition, can be opened only by God. This brilliant image transcends the literal requirements of the text and evokes the mystical themes prominent in contemporary literature and society.

The importance of mysticism in this period is demonstrated by another splendid manuscript prepared for Sultan Husayn Mirza in 1483, a copy of the *Masnavi* by the celebrated thirteenth-century mystic Jalal al-Din Rumi. A work of unbridled ecstatic vision, the 25,000-line poem epitomizes the mystical tradition of Persian poetry. Transcribed at the moment when Jami was composing his mystical verses, the Rumi manuscript has richly decorated pages encased in one of the most sumptuous bindings ever made, painted and varnished on the outside (113) and delicate leather cut-outs pasted over a blue ground on the inside (114). Like most Islamic bindings, it has a flap wrapping around the book, and the strip covering the opening is inscribed with the book's title. The design of delicate arabesques arranged in a carpet-like pattern is embossed and painted in gold and black. The inside of the cover, protected from wear, shows a fantastic scene of deer, monkeys, wild geese, foxes, and birds sitting in a tree, meticulously executed in delicate leather filigree discreetly enhanced with gold tooling. Both the fine materials and the labour-intensive techniques show the esteem in which Rumi's mystical poem was held and the importance of the arts of the book at Sultan Husayn Mirza's court.

The Timurid court at Herat was the most important centre for book production in the late fifteenth century, but the taste for luxury books was shared by many contemporary rulers in Iran and elsewhere. Fine manuscripts were one of the favourite possessions of princes; they were traded and given as gifts and sometimes taken as booty. An unusally well-documented copy of the *Khamsa* ('Quintet'), five romantic or didactic epics in 30,000 couplets by the twelfth-century poet Nizami, exemplifies how manuscripts were carried about in the fifteenth century. According to the detailed

115
Bahram Gur in the Yellow Pavilion from a copy of Nizami's *Khamsa* prepared for several 15th-century princes. Ink and colour on paper; 30×19.5 cm, 11⁷⁄₈×7²⁄₃ in. Topkapi Palace Library, Istanbul

colophon, the manuscript was begun by the calligrapher Azhar for the Timurid prince Abu'l-Qasim Babur (r.1449–57) at Herat, but the manuscript was unfinished when the prince died. After the Turkoman ruler Jahanshah sacked Herat in 1458, the manuscript passed to Jahanshah's son Pir Budaq, governor of Shiraz and then Baghdad. After his death it went to another ruler, Khalil Sultan, who commissioned the calligrapher Abd al-Rahman al-Khwarazmi to finish copying the text. Two artists, Shaykhi and Darvish Muhammad, were assigned to illustrate it. When Khalil Sultan died in 1478, the still-unfinished manuscript passed to his brother Yaqub (d.1490), who also died before the book was completed. The colophon ends, 'In accordance with the saying "Many a wish has turned to dust", none of the patrons was able to achieve his goal or drink in fulfilment from the goblet of completion', but finally the manuscript passed to Shah Ismail I (r.1501–24), founder of the Safavid dynasty, under whose patronage the last illustrations were added.

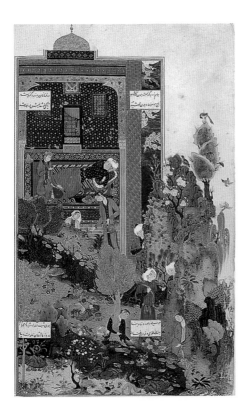

The beauty of Nizami's poetry made it one of the perennial favourites in Persian literature and one of the most popular texts for illustration from the fifteenth century onwards. The most intricate and mystical of the epics, *Haft Paykar* ('The Seven Portraits'), concerns the education of the Sasanian monarch Bahram Gur as the ideal king. It culminates in his visit to seven princesses, each of whom represents a different aspect of love (see frontispiece). Hundreds of illustrated copies are known, so this manuscript must have passed from hand to hand not because of its rarity but because of the beauty of its calligraphy, illumination and illustration. An image such as *Bahram Gur in the Yellow Pavilion* (115), painted during Sultan Yaqub's possession of the manuscript in Tabriz, is the work of Shaykhi, an artist from Herat who moved to the Turkoman court. The rich palette of colours and fantastic vegetation contrast sharply with the carefully modulated Herat style exemplified in the work of Bihzad. Nature has exuberantly burst from the constraints of the frame to engulf the nominal subject, the prince in the pavilion, in a dream of anthropomorphic rocks from which lollypop trees grow.

The flowering of the art of the book in fifteenth-century Iran was to continue into the sixteenth century and set a model for the arts of the book in the Ottoman and Mughal empires. The single specimen of the handmade book epitomized princely art in this period. These books were largely copied on paper, and the fine art of Islamic papermaking was adopted in Europe in the thirteenth century and then developed further, so that by the end of the period European paper was being imported into Egypt. The introduction of movable type in Europe in the mid-fifteenth century brought about the democratization of the book there, as books became cheaper and more accessible to a wider audience. By contrast, the high status of calligraphy as the major medium of Islamic art meant that it was centuries before printed books would be accepted in the Islamic lands, although block printing had been used for centuries to decorate textiles and leather.

The increased numbers of large textiles that survive from the middle period fill out the picture sketched by the fragmentary remains of the early centuries of Islam. Textiles continued to be the heavy industry of virtually all the Islamic lands, and the extensive trade in raw materials and finished goods provided the basis for most medieval economies. One of the most remarkable sources for information about the lively trade in textiles is a cache of documents found in the Geniza, or storeroom, uncovered when the Palestinian Synagogue in Old Cairo was torn down in 1889–90. The documents put there for safekeeping included letters, court records, deeds, orders of payment and trousseau lists from the tenth to the fifteenth centuries. Although produced by the Jewish community, they provide evidence for the bustling activities of all merchants involved in Mediterranean trade. Some strike an uncannily contemporary note, such as this passage from a long letter sent around the year 1000 by a Tunisian trader staying in Cairo to his cousin in Alexandria, from whom he ordered four robes for himself:

116
Silk curtain probably made for the Alhambra palace, Granada, 15th century. 4.38×2.72 m, 14 ft 4 in× 8 ft 11 in. Cleveland Museum of Art

When the Sicilian boats arrive, please buy me two narrow robes of excellent quality, costing about $2\frac{1}{2}$ dinars [the monthly income of a lower middle-class family was about 2 dinars], and two attractive robes worth about $1\frac{1}{2}$ dinars, and bring them with you. And my lord, if you depart before the arrival of the Sicilian boats, bring me two attractive robes which have some elegance, and give $2\frac{1}{2}$ dinars to Joseph for the purchase and forwarding of the two narrow robes, for I do not have anything to wear on weekdays.

The merchants of Cairo apparently emulated the dress codes of their rulers, the Fatimid caliphs (r.909–1171), whose splendid wardrobes outdid even those of the Abbasid caliphs of Baghdad. The Fatimid caliph al-Muizz (r.953–75), the first of his line to

rule in Egypt, created an institution in the palace called the House of Clothing, where all kinds of garments and cloth used to be cut. Every winter and summer courtiers and servants, their wives, and their children were given new suits according to their rank, everything from turbans to trousers and handkerchiefs. At one such investiture, al-Muizz gave away cloth worth more than 600,000 dinars. The amirs got *dabiqi* garments and turbans with gold borders, these two items worth 500 dinars, and the highest ranking amirs received necklaces, bracelets and ornamented swords. When hungry troops looted the caliphal treasuries in 1067, one eyewitness recorded that the looters brought out more than 100,000 pieces of cloth from the storerooms. The value of what was sold in fifteen days, quite apart from what was plundered or stolen, came to 30 million dinars.

One caliphal garment from the Fatimid period has survived remarkably intact. It is known paradoxically as the Veil of Ste Anne, because it was preserved as a relic in the Church of Ste Anne at Apt in France. As both the lord and bishop of Apt took part in the First Crusade in 1099, the cloth was probably brought from Egypt or Syria as plunder. A length of bleached linen woven in plain weave, it is decorated with three parallel bands of ornament tapestry-woven in coloured silk and gold thread, a standard Egyptian technique. In the centre are three medallions linked by a wide band of interlacing circles. Each medallion contains a pair of sphinxes sitting back to back and encircled by an inscription in angular script naming the patron (the Fatimid caliph al-Mustali r.1094–1101), and the supervisor of the work – his vizier al-Afdal, who is known for his lavish disbursement of textiles. The bands along either side are decorated with birds, animals and another inscription stating that the textile was woven in 1096 or 1097 (the last digit is not clear) at the royal factory of Damietta in the Nile Delta. This robe of honour was probably worn as an over-garment or mantle, with the decorated medallions falling down the wearer's back.

Other types of mantles and loose tunics were sewn together from narrower widths of cloth produced on simple vertical looms. These garments needed only a little stitching along the selvage or side to produce the type of robe seen in an illustration from a thirteenth-century manuscript purporting to show the first-century AD Greek physician Dioskorides and his pupil, although both are depicted wearing contemporary Muslim dress (117). Unlike the sages of Antiquity, who sat on chairs, this one sits on a low bench and his pupil kneels on a cushion; instead of togas, both wear turbans and robes decorated with arm bands. These arm bands sometimes had figural or non-figural ornament; at other times they bore inscriptions with the name of the ruler

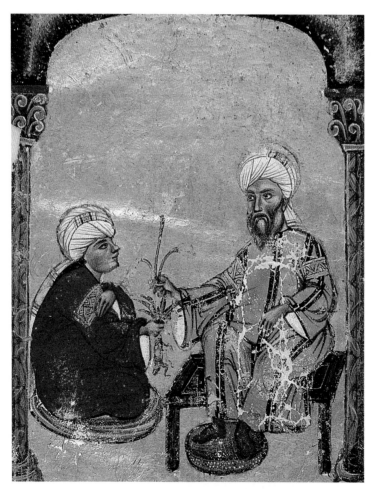

117
Dioskorides and a Student, from a manuscript of the Arabic translation of Dioskorides's *De Materia Medica*, copied in northern Iraq or Syria in 1229.
Ink, colour and gold on paper; 19×14 cm, 7¹₂×5¹₂ in.
Topkapi Palace Library, Istanbul

who bestowed the garment. Inscriptions might also mention the person for whom a textile was woven, the place, the date and the circumstances of manufacture. Inscriptions are consequently extremely important for dating and localizing textiles, thereby providing the basis for reconstructing the history of medieval Islamic textiles.

According to contemporary descriptions, the Fatimid caliphal treasuries also held stores of tents and upholstery and furnishing fabrics of unimaginable luxury and splendour. One tent was decorated with a picture of every beast in the world; it took

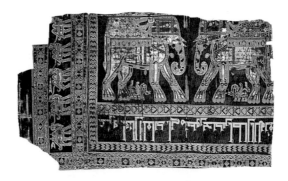

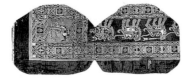

150 workers nine years to make and cost 30,000 dinars. There were elephant saddlecloths of red embroidered everywhere with gold except at the bottom where the elephants' thighs protruded. The accompanying howdahs had matched sets of cushions, pillows, carpets, seats, curtains and spreads of silk brocade. The fabrics were decorated with designs of elephants, wild beasts, horses, peacocks, birds and even humans in all manner of striking and wonderful forms and shapes.

Some idea of these fabulous medieval textiles can be gleaned from surviving pieces, such as the Shroud of St Josse (118). Like the Veil

of Ste Anne, it was preserved in a European church treasury. It now comprises two pieces – one large, one small – used to wrap the bones of St Josse in the abbey of St Josse-sur-Mer, near Caen in northern France. According to church records, the bones were wrapped with silk in 1134; the cloth was probably a gift from Etienne de Blois, the patron of the abbey who, along with his brothers Godefroy of Bouillon and Baudoin, was a commander of the First Crusade. The textile has a red warp and weft in seven colours: plum, yellow, ivory, sky blue, light brown, copper and golden brown, although the last three have faded to beige. The silk fabric is a weft-faced compound twill. This technique, known as samit or samite (from the Greek *hexamitos*, 'six-threads'), had developed in Iran in the first centuries after Christ.

Weaving rich silks with complex patterns was possible because of the introduction of the drawloom, which has an extremely complicated system of drawstrings that raise and lower the pattern warps. The drawloom seems to have been developed simultaneously in Syria and in China in the first centuries AD. It spread to Iran in pre-Islamic times and was eventually adopted in all the Islamic lands where silk was woven. The advantage of the drawloom is that fine strings replaced the older cumbersome system of shafts, used to raise and lower the warps and make a complicated pattern. As the drawstrings were much lighter than the heavy heddles, it was much easier and quicker to raise and lower them. Depending on the fineness and width of the fabric desired, several thousand drawstrings could be used simultaneously, for each string controlled one warp thread. Although the drawloom took a good while to set up and required two people – the weaver and the drawboy who sat above the loom and pulled the strings – to operate, it permitted larger quantities of finer fabrics to be woven with less effort. Most commonly, these were sumptuous patterned fabrics, often worked with gold thread.

The two pieces of the Shroud of St Josse come from different parts of the same length of fabric, which has been reconstructed

as a carpet-like pattern with borders surrounding a central field. Presumably other lengths of this fabric were woven, but none has survived. The border shows a train of two-humped, or Bactrian, camels, with a cock set in each corner. The rectangular field shows two facing elephants with dragons between their feet. An inscription underneath the elephants' feet, but written upside down, invokes 'glory and prosperity to the commander, Abu Mansur Bakhtikin, may God prolong his existence'. Although the textile bears no date or place of manufacture, the person named in the inscription can be identified as a Turkish commander in the province of Khurasan in northeastern Iran. He was arrested and executed on orders of his Samanid sovereign Abd al-Malik ibn Nuh in 961. The Iranian or Central Asian origin of the textile is confirmed by several elements of the design, including the cocks and flying scarves on the camels, motifs that had been used extensively in Sasanian art, as well as the dragons and Bactrian camels. Dragons are a Chinese motif, and Bactrian camels are indigenous to Central Asia. The textile had to have been made for Abu Mansur Bakhtikin when he was still alive, since the inscription asks for blessing on a living person. We can only guess how this cloth was used, but it would have made a magnificent saddlecloth.

A technically similar textile with an entirely different design is a weft-faced compound silk twill decorated with inscriptions (119). It has a blue warp and wefts of blue and yellow, with end bands in light green and cream-colour. Apart from the blue stripes, its decoration is limited to Arabic inscriptions. The larger invokes 'Glory and prosperity to the King of Kings, Baha al-Dawla, Light of the People, Strengthener of the Nation, Father of Victory, the son of Adud al-Dawla, Crown of the People, may his life be long.' The smaller inscription underneath reads: 'For the use of Abu Said, Zadanfarrukh ibn Azadmard, the Treasurer.' Baha al-Dawla was the Buyid ruler of Mesopotamia and parts of Iran from 989 to 1012; his principal centre of activity was Baghdad. Zadanfarrukh served as his ambassador in 1001, so it is very likely that the piece was made there then.

119
Blue silk cloth inscribed with name of Buyid ruler Baha al-Dawla, Baghdad, c.1000. 130×290 cm, 51¹⁄₈×114¹⁄₈ in. Textile Museum, Washington, DC

As well as dating and localizing the textile, the inscriptions shed light on the ways that contemporary Iranian society was changing. The Buyids were a clan of condottieri from the mountainous region in Iran south of the Caspian Sea. They 'liberated' western Iran and Iraq from the control of the Abbasids and reduced the caliph to a puppet, who was forced to grant them increasingly inflated titles, such as those used on this fabric. The name of the treasurer reveals his Persian heritage: his given name has an Arabic component, Abu Said, meaning 'father of happiness', showing that he was a Muslim. His Arabic name also has a Persian equivalent, Zadanfarrukh ('happy-born'), and as his father Azadmard ('chivalrous') has only a Persian name, Abu Said was probably a convert to Islam. The use of Persian names at this time parallels the increased importance of Persian language and literature in contemporary society. It was just at this time, for example, that the Persian poet Firdawsi (940–1025) compiled the *Shahnama*, or 'Book of Kings', which became the national epic of Iran. The Buyids revived titles and ceremonies

from ancient Iran to justify their right to rule and even claimed to be descendants of the Sasanians.

In contrast to the Shroud of St Josse, whose history can be documented from the twelfth century, the cloth naming Baha al-Dawla only appeared on the art market in December 1926, when a French dealer offered it to the Victoria and Albert Museum in London. It was too expensive for them, but it was bought the following year for the Textile Museum in Washington, DC. The dealer said that he had acquired the piece from a mysterious Mr Acheroff, who claimed to have had the concession to excavate a Buyid cemetery at the medieval site of Rayy, south of Tehran. Clandestine excavation of a tomb there in late 1924 and early 1925 had brought to light several medieval silks, which soon entered the art market, followed quickly by dozens of fakes made to capitalize on the discovery. Many of these textiles were acquired by major museums and private collectors, but their authenticity has always been the subject of controversy, because there was no way to determine which ones were genuine and which fake. Only with the development of carbon-14 dating has it been possible to prove that just a few of these textiles, mostly those that passed through the hands of Acheroff and his cronies, are genuine medieval pieces. Some of those purporting to be the oldest were actually made after 1945, because they show the presence of radioisotopes introduced into the atmosphere only after the detonation of the first atomic bombs.

Compound weaves were laborious to produce on drawlooms, and sometime around the year 1000 weavers developed a faster technique now known as lampas. Lampas fabrics, which have two sets of warps and wefts that create independent pattern and ground weaves, were easier to weave than compound weaves – those used for the Shroud of St Josse and the Buyid cloth – which have two sets of warps with different functions but only one set of wefts binding the warps into a fabric. A lampas fabric of silk and gold with paired falcons (120) exemplifies the complicated and fluid patterns woven in Iran at this time. The design on this

piece is a hybrid mixture of diverse elements: duodecagons enclose the paired birds and in between the twelve-sided medallions are dragons, very Chinese in style. The figures are woven in gold, which stands out against the black ground, and the falcons' eyes are highlighted in light blue. This textile has about sixty silk warps per centimetre, meaning that a loom width would have several thousand, each controlled by an individual drawstring. There are sixteen weft passes per centimetre, and the repeat is 34 cm (13½ in) long, meaning that the drawboy had to pull some one thousand different combinations of warp drawstrings for the weaver to complete one pattern! The technical characteristics of the weaving, particularly the use of extremely thin strips of gilded membrane for the gold thread, suggest that the fabric was woven in Central Asia. The Arabic inscription on the birds' wings, however, invokes 'Glory to our lord the just and sagacious sultan, Nasir...' It is thought to refer to the Mamluk sultan Nasir al-Din Muhammad, who ruled Egypt and Syria from 1294 to 1340. He is known to have received a camel caravan carrying 700 silks inscribed with his name from the Ilkhan sultan Abu Said when they concluded a truce in 1323, and this silk might have been part of this gift. The peregrinations of this splendid piece are not at all unusual. Precious textiles had long been a requisite part of diplomatic missions, but we can only imagine how this piece later found its way to Danzig (Gdańsk) where it was made into a cope, or long ecclesiastical cape, and preserved for centuries in the Marienkirche there.

The beauty and value of these fine silks woven on drawlooms in the eastern Islamic lands was quickly appreciated. In regions such as northern Europe, which had neither the raw materials nor the drawloom technology, the finished fabrics had to be imported from afar, but in Spain and Sicily, which were under Muslim domination, both the raw materials and the technology were available and fine silks were produced there. These industries spawned silk weaving centres in Christian Spain and Italy, which eventually equalled and sometimes surpassed their predecessors.

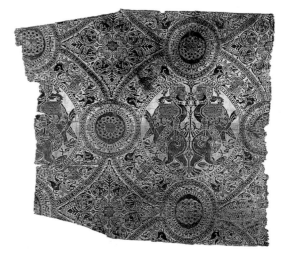

While some Spanish-Islamic silks were just inspired by originals made in the east, others skirted the fringes of honesty. A silk textile found in the tomb of San Pedro de Osma (d.1109) in the cathedral of Burgo de Osma in Spain, for example, has an inventive design of roundels containing harpies on the backs of lions facing each other (121). The borders of each roundel show a kneeling man holding two griffons, and the roundels are connected by smaller circles bearing an Arabic inscription that says 'This is among the things made at Baghdad, may God protect it!' While silks with this kind of design were undoubtedly woven at Baghdad, there is ample evidence to prove that this particular textile was woven in southern Spain in medieval times. The spelling in the inscription is peculiar to the western Islamic lands, as are the technique, a distinctive type of lampas weave, and the way the gold threads are joined. By the twelfth century Islamic Spain had become a centre of production for gorgeous gold brocades that were esteemed by Muslims and Christians alike. For example, a sumptuous silk and gold brocade naming Ali ibn Yusuf, the Almoravid ruler of North Africa and Spain from 1106 to 1142, was made up into a chasuble, or ecclesiastical mantle, for the Spanish saint Juan de Ortega (d.1163).

Sicily, which had been conquered from the Byzantines by Muslim armies over the course of the ninth century, was another centre renowned for its silk textiles, particularly after the island was taken by the Normans (who ruled there from 1061 to 1194). Despite their rough-and-tumble origins as a band of northern European adventurers, the Normans created a splendid court in Palermo where Byzantine, Islamic and Latin traditions were blended. Roger II Hauteville, King of Sicily from 1130 to 1154, became one of the greatest kings of Europe and made Sicily the leading maritime power in the Mediterranean. Endowed with an active and curious mind, Roger tolerated the various creeds, races and languages in his realm and drew around him a circle of scholars and distinguished men, including the Moroccan geographer al-Idrisi (1100–66). It was at Roger's court that al-Idrisi designed a celestial sphere and a disc-shaped map of the world, both made of

120 Far left
Cloth with a design of falcons and dragons used for a cope in the Marienkirche, Danzig. Central Asia, early 14th century. Silk and gold-wrapped thread; 71×22 cm, 28×8⅔ in. Kunstgewerbe Museum, Berlin

121 Left
Fragment from the Shroud of San Pedro de Osma, found in the church of Burgo de Osma, Spain, 12th century. Silk and gold-wrapped thread; 45×50 cm, 17¾×19¾ in. Museum of Fine Arts, Boston

solid silver, and composed his encyclopedic treatise, *The Book of Roger*, to explain them.

Roger's stupendous mantle (122) is the most famous textile made in Sicily and one of the most important medieval textiles anywhere. (Another important medieval embroidery, the Bayeux Tapestry, was also made for the Normans, and records the Norman conquest of Britain in 1066.) A huge semicircle of red silk, Roger's mantle is embroidered with gold thread and pearls in a design showing a central palm tree separating scenes of a lion attacking a camel. Along the hem is an Arabic inscription stating that it was made in the royal workshop at Palermo in 1133–4. When worn by the tall and powerful ruler, known for his fair hair and full beard, the robe would have been regal indeed: the tree would have run along the king's spine, the heads of the lions

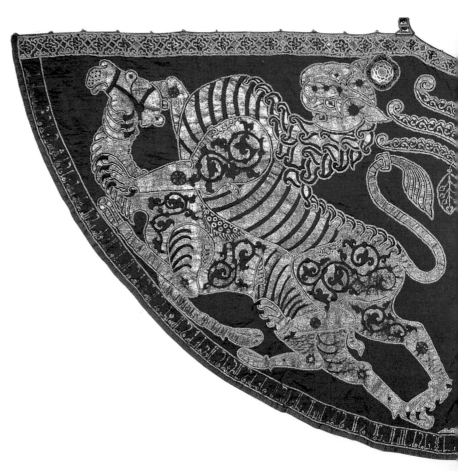

122
Mantle of
Roger II
Hauteville,
Palermo,
1133–4.
Red silk
embroidered
with gold
thread and
pearls;
diam. 3 m,
9 ft 10 in.
Kunst-
historisches
Museum,
Vienna

would have laid over his chest, and the defeated camels would have been pressed to the floor. The unusual design has been interpreted as a symbolic representation of the triumph of Christianity, symbolized by the lions, over Islam, symbolized by the camels, for not only did the Normans expel the Muslims from Sicily but they also conquered cities along the coast of North Africa. While there is no supporting evidence to confirm this interpretation, the garment was sufficiently striking that it was preserved and later used as the coronation mantle of the Holy Roman Emperors.

Fancy textiles were also used as banners and flags carried on pilgrimage and in battle. One such banner, preserved in the monastery of Las Huelgas at Burgos in Spain, is popularly known as the Las Navas de Tolosa Banner (123), because it is

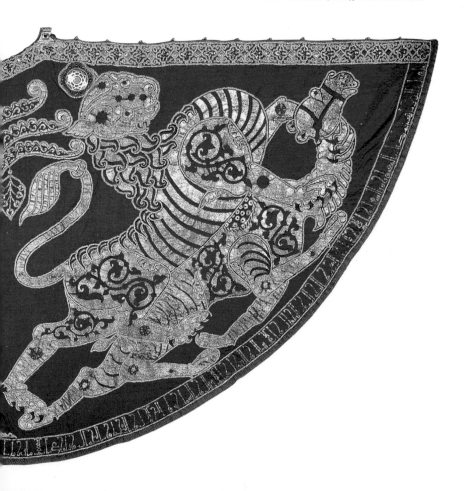

said to have been captured in 1212 at the decisive battle when the Almohad sultan al-Nasir was defeated by Alfonso VIII, King of Castile. It is more likely that the banner was a trophy won on campaign by King Ferdinand III (d.1252), who gave it to the monastery when he had it restored. A large rectangle of tapestry-woven silk with eight scallops across the bottom, the banner is worked in red, white, black, blue and green silk along with gilt parchment strips. It has a central square panel framed by inscriptions. In contrast to Roger's mantle, the imagery is strictly geometric and verbal: the quotations from the Koran promise Paradise to true believers and would have been appropriate to warriors on campaign, who are promised Paradise if they fall in battle.

Sumptuous textiles were meant to create an earthly paradise in the homes of the rich and powerful. One of the finest furnishing fabrics to survive from medieval Islamic times is an enormous silk curtain (see 116). It consists of two loom-width panels joined

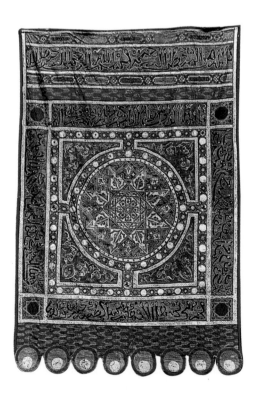

by a narrow central strip; each panel is decorated with three squares between elaborate borders at top and bottom. The curtain was woven in lampas weave on a drawloom in red and yellow, with details in dark blue, green and white. Cartouches along the central strip are inscribed in Arabic with the motto of the Nasrid dynasty: 'There is no victor save God.' This motto is carved in plaster and worked in tile all over the walls of the Alhambra palace in Granada (see 71, 99–100) so the curtain was probably made to hang there, where it would have further decorated the walls and kept down the drafts, just as woollen tapestries were used in contemporary northern Europe. The yellow silk replaced gold thread, for a letter dated 4 June 1414 to King Fernando I of Aragon mentions that Muslim weavers had ceased using gold, presumably because it was too expensive. In size and complexity this stunning piece has few if any rivals in medieval textiles. Its splendid condition gives an unusually vivid sense of the luxury and richness of Nasrid palace interiors.

Not only were walls enriched with textiles but so were floors, and the quintessential Islamic floor covering is the knotted carpet. Just like woven textiles, knotted carpets became more important in the middle period and many examples survive. These testify to the dissemination of the knotted carpet across the Islamic lands, although differences in techniques and designs show that there were many centres of production. There are, for example, several types of knots, depending whether the pile is tied symmetrically or asymmetrically around one or two warps, and the warps and wefts between the knots can be of wool, cotton, silk or a combination. It is only from this period that a continuous tradition of carpet making can be traced to modern times, not only through surviving carpet fragments, but also by representations in contemporary Italian paintings and Persian illustrated manuscripts which can show when a particular group of carpets was used.

In contrast to the isolated examples of the early period (*eg* 45), several groups of carpets can be identified in the middle period.

123
Las Navas de Tolosa Banner, Morocco or Spain, early 13th century. Silk, gold thread and gilt parchment; 3.30×2.20 m, 10 ft 10 in× 7 ft 3 in. Monastery of Las Huelgas, Burgos

124
Fragment of a
carpet found in
the Ala al-Din
Mosque,
Konya,
Anatolia,
early 14th
century.
Wool pile;
183×130 cm,
72×51 in.
Museum of
Turkish and
Islamic Art,
Istanbul

The earliest is known as the Konya type because some twenty
examples were discovered in 1903 in the Ala al-Din Mosque at
Konya in central Anatolia, where they had been hidden under
successive layers of carpets laid on the floor of the prayer hall.
The Konya carpets are relatively coarse and are knotted with
symmetrical knots in a limited range of strong colours, such as
medium and dark red, medium and dark blue, yellow, brown
and ivory. The typical piece (124) has a central field containing
staggered rows of small angular motifs while the contrasting
border has large stars or pseudo-inscriptions. The generous size
(the largest carpet measures 2.58×5.50 m, 8½×18 ft) suggests that
they were produced on a commercial scale. At first scholars
attributed them to the patronage of the Saljuq sultans, who
ruled Konya in the twelfth and thirteenth centuries, but the motifs
on some of the carpets are derived from the cloud pattern on
silks woven under the Yüan dynasty (1279–1368) in China, and
the group is now thought to date from the first half of the
fourteenth century.

The second group of carpets to survive from this period – animal
carpets – is slightly later in date. At least three survive: the
Berlin carpet, found in a church in central Italy in 1886; the Marby
Carpet, found in the Swedish village of Marby in 1925; and a third
(125) found in Tibet and acquired by the Metropolitan Museum of
Art in New York in 1990. Like the Konya carpets, the animal
carpets have symmetrical knots, but unlike them they are all
relatively small – measuring about 1×1½ m (3×5 ft) – and display

125
Above right
Animal carpet,
Anatolia,
14th century.
Wool pile;
153×126 m,
5 ft×4 ft 2 in.
Metropolitan
Museum of
Art, New York

126
Below right
Detail of an
animal carpet
shown in a
15th-century
Sienese
painting,
*The Marriage
of the Virgin.*
Tempera on
wood;
41×33 cm,
16⅛×13 in.
National
Gallery, London

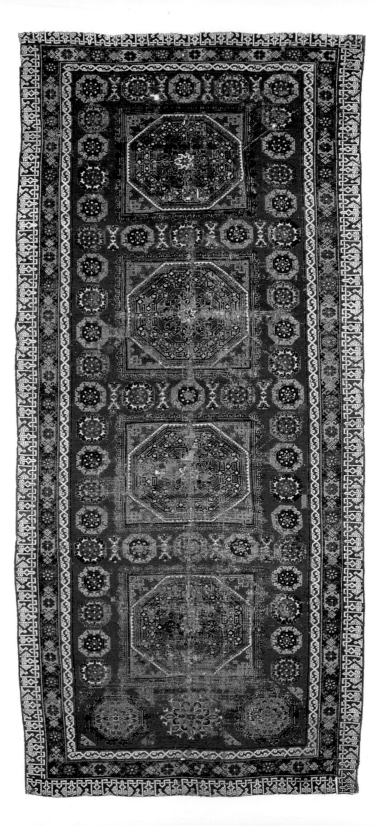

stylized animals within octagonal or square frames. They vary in colour. The New York carpet has a red ground with four blue dragons, each of which has three feet on the ground and one raised foreleg. Each dragon is decorated with another three-legged animal. The field is surrounded by a series of borders, the largest of which has blue octagons. The carpet has been attributed to the later fourteenth century, because a painting from early fifteenth-century Siena, *The Marriage of the Virgin* (126), shows a similar carpet, even down to the detail of the raised foreleg.

Animal carpets must have been made already in the early fourteenth century, as they are depicted under royal figures in two illustrations from the Great Mongol *Shahnama*, which was made in Tabriz *c.*1335. At this time, animal carpets must have been rare and reserved for kings. By the late fourteenth or early fifteenth century, more of them must have been made and exported to Europe, to judge from their appearances in Italian painting, or to Tibet, to judge from the history of the New York carpet. By contrast, Konya carpets are not depicted in Italian paintings and only a few fragments of them have been found outside Anatolia, so they seem to have been made for local use.

The same division between carpets made for export and those made for domestic consumption holds in the fifteenth century. One of the most distinctive types of Anatolian carpet produced

127 Left
Large-pattern Holbein carpet, Anatolia, late 15th century. Wool pile; 4.29×2 m. 12×6 ft 6 in. Museum für Islamische Kunst, Berlin

128 Below left
Hans Holbein the Younger, *The Ambassadors*, 1533. Oil on panel; 207×209.5 cm, 81¹₂× 82¹₂ in. National Gallery, London

129
Below right
Detail of 128 showing a Large-pattern Holbein carpet used as a tablecover

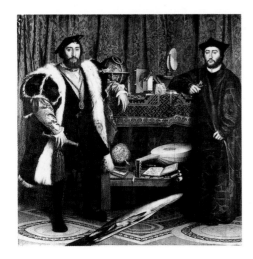

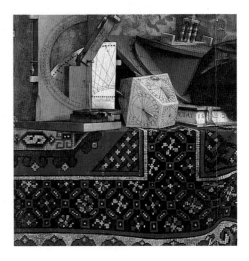

for export in the later fifteenth century is now known as Large-pattern Holbein carpets. The typical example (127) has a field containing several large octagons inscribed in square frames. The octagons are usually decorated with strapwork patterns and separated and enclosed by bands of smaller octagons. Several borders of varying width usually include an elegant band of pseudo-inscription in which the stems of the 'letters' appear to be twisted together. The carpet is knotted in brightly-coloured wool in a variety of colours, primarily brick-red with white, yellow, blue, green, brown and black. The carpets get their name because many are depicted in paintings by Hans Holbein the Younger (1497–1543), such as *The Ambassadors* of 1533 in the National Gallery, London (128–9), but they appear in European paintings dating from as early as the 1450s, where they are shown on floors under important people or as luxury table coverings.

Although Large-pattern Holbein carpets produced for export are relatively big, finer carpets of even greater size were produced for internal consumption in the period 1450–75. They are known as Ushak medallion carpets, from their place of manufacture – the town of Ushak in western Anatolia – and their typical design motif – a curvilinear medallion. They dwarf the Holbein carpets in size: the largest (130) is more than 7 m (23 ft) long. Their size shows that a lot of money was invested in the looms, materials and labour to produce them, and such large sums were available only to royal patrons. Knotted in red, white, yellow, blue and blue-black, a palette similar to that used in the Holbein carpets, the Ushak medallion carpets present an entirely different type of design in which arabesques are balanced by small-scale tendrils. These curving designs show that the weavers used paper patterns, or cartoons, to guide their work. In contrast, the weavers of the Holbein carpets would have knotted the geometric designs directly at the loom from memory. The introduction of paper cartoons, which were furnished by the court design studio, marks a great shift in the nature of artistic production and is another indication that Ushak medallion carpets were made for local rulers. They are not represented in European paintings for

130
Ushak medallion carpet, Anatolia, third quarter of the 15th century. Wool pile; l.7.23 m, 23 ft 8 in. Dar al-Athar al-Islamiyya, Kuwait, on loan from the al-Sabah Collection

another century, by which time the taste at local courts had moved to another type of carpet.

Carpets had long been produced at many centres in the eastern Mediterranean, and the place where a particular type of carpet was made is often a matter of spirited speculation. One of the most distinctive types is a group commonly known as 'Mamluk' after the Mamluk sultans of Egypt. The group comprises several dozen carpets sharing technique and design. They are knotted of wool on S-spun warps, the way fibres are traditionally spun in Egypt, and usually have red, blue and green knots, sometimes

with yellow and ivory. Like Holbein carpets, Mamluk carpets have designs based on one or more large octagons, but the total effect is quite different (131), with smaller octagons, hexagons, triangles, umbrella-shaped leaves, cypress trees and cups creating a dense kaleidoscopic effect. Although many sites of production have been proposed, Cairo is the most likely. Carpets were used in Cairo and made there by the fourteenth century. In 1474 the Venetian merchant Giuseppe Barbaro mentioned that the carpets produced in Cairo were inferior to those of Tabriz in Iran. Unfortunately, no contemporary Iranian carpets are known to survive, so we cannot tell whether Barbaro's judgement was justified.

Carpets were also woven in the Islamic lands of the western Mediterranean. Although carpet weaving is thought to be a quintessentially Islamic art, this region provides the best evidence for the widespread popularity of carpets among Jewish and Christian patrons. Queen Eleanor of Castile, the wife of the English king Edward I, for example, is known to have had Spanish carpets spread on the floor, and a remarkable group of fifteenth-century carpets is decorated with the coats-of-arms of Christian patrons. By this point Spain had become a major centre of carpet production, and more fifteenth-century rugs survive from Spain than from anywhere else. They are technically distinguished by a special type of knot tied around a single warp. In addition to the group with emblems of royal or noble families from Castile, there is a large group that imitates contemporary Anatolian designs, testifying to the high esteem in which the originals were held. The Spanish carpet illustrated here (132), for example, clearly copies the design of a Large-pattern Holbein from Anatolia and shares its vivid palette, although it is technically distinct. By the fifteenth century, because most of the Iberian peninsula had been taken by the Christians, the carpet-weaving industry in Spain was in the hands of the Mudejars, the Spanish term for Muslims living under Christian rule.

131
Mamluk carpet,
Egypt, c.1500.
Wool pile;
1.88×1.34 m,
6 ft 2 in×
4 ft 5 in.
Textile
Museum,
Washington,
DC

132 Overleaf
Wheel carpet,
Spain,
15th century.
Wool pile;
3.10×1.69 m.
9 ft 10 in×
5 ft 6 in.
Metropolitan
Museum of
Art, New York

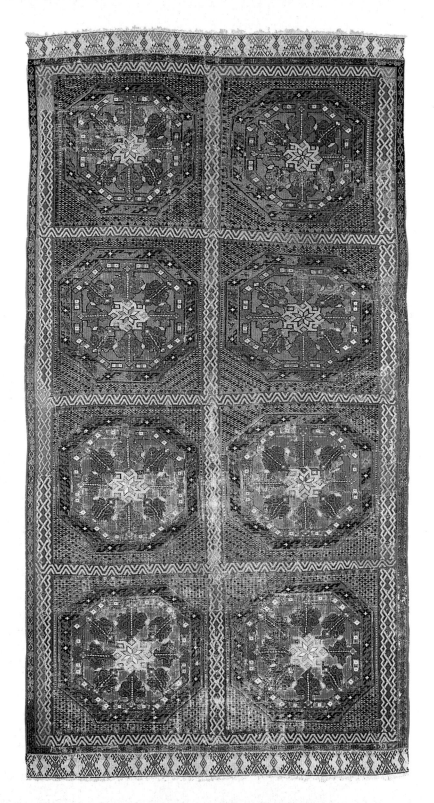

The arts of ceramics, metalware and glass were at their finest and most inventive during the middle period, particularly in Egypt, Syria and Iran, and these objects were often decorated with brightly-coloured figural scenes. In ceramics, the earthenwares of the early period were replaced by an artificial paste body, probably in imitation of Chinese porcelains, and these luxury ceramics were decorated in an extraordinary range of techniques, from overglaze painting in lustre and enamels to underglaze painting. In metalwares, colour was introduced through the use of inlays in different metals, and in glass, the best-known luxury vessels were decorated with gold and polychrome enamel. In the years before the illustrated book became such an important medium of pictorial representation, these and other decorative arts, especially carved ivory, were major vehicles for representation in Islamic art and provide evidence for the early development of the pictorial arts in the Islamic lands.

A deep bowl with flaring sides on a low base (133) shows how ceramic techniques and themes from the previous period were at first continued and refined. Made of buff-coloured earthenware covered with a fine white slip, painted in red and dark brown slips, and covered with a transparent colourless glaze, the bowl is notable for its size and fine interior decoration. The centre is filled with an abstracted plant motif which grows from a single stem and branches out into five leaves that encircle a stylized floral image, but the major decoration is a wide band of elegant angular script around the sides. The Arabic text begins after a small decorative motif at about 4 o'clock: 'Blessing to its owner', and continues after a small teardrop motif at 8 o'clock with the proverb: 'It is said that he who is content with his own opinion runs into danger.'

133
Earthenware
bowl painted in
brown and red
slips on white
under a
transparent
glaze, Iran,
10th century.
diam. 39 cm,
15¹₃ in.
Freer Gallery
of Art,
Washington,
DC

Each letter of the inscription is surrounded by a broad band reserved in the white of the slip ground, and the remaining ground is filled with spots and four-petalled flowers. Alternating red and black scallops encircle the rim, although there are two places where the alternation is inconsistent. In contrast to the extremely sophisticated and measured decoration of the inside, the outside of the bowl is sparsely decorated with sprays of leaves separated by feathered lines.

When the bowl was filled with food, the major decoration, like that on the ninth-century blue-and-white dish (see 58), would have been revealed only after the food was finished. Assuming that the bowl was intended to be held and appreciated with the stem of the plant at the bottom, closest to the viewer, then the most important part of the inscription, the blessing to the owner, is immediately legible below it. To read the following proverb the bowl must be turned completely around in a counterclockwise direction, thereby inviting the holder to handle and turn it. Unfortunately, most museums do not provide the facilities for doing so!

Other bowls and plates are decorated in the same way with similar aphorisms, such as 'Planning before work protects you from regret; patience is the key to comfort', or 'Knowledge is an ornament for the youth and intelligence is a crown of gold.' In contrast to the rather casual inscriptions on earlier ceramics (see 58), the inscriptions on these ceramics are thought out extremely carefully, and the script truly deserves to be called calligraphy, or 'beautiful writing'. All these earthenwares are attributed to the tenth century, when the Samanid dynasty controlled northeastern Iran and the adjacent region of Central Asia. This Persian dynasty is known for encouraging Persian language and literature; for example, the great poet Firdawsi began his classic *Shahnama* under their patronage. The inscriptions on these ceramics show nevertheless that there was also a clientele who knew the Arabic language well enough to appreciate having their dinnerware decorated with moralizing aphorisms written in Arabic. Persian was

coming to the fore as a popular language, but Arabic was still more appropriate for writing. The earliest Persian manuscript to survive dates only from the twelfth century.

Elsewhere in the Islamic lands potters expanded on traditional techniques in different ways, as in an earthenware bowl from eleventh-century Egypt showing on the interior a groom leading a giraffe (134). Made of a white and sandy clay covered with a milky white glaze, it was painted over the glaze in an olive-green lustre. The technology of lustreware had been developed in eighth-century Egypt and Syria for decorating glass (see 60) and was then taken to Iraq where it was applied to ceramics (see 61, 62) in the ninth and tenth centuries. With the renewed prosperity of Egypt under the Fatimids, who made Cairo their capital from 969 to 1171, the lustre technique was revived there. The traditional geometric and floral motifs used in the earlier period were expanded in Egypt to include a wide range of figural subjects, including rabbits, birds, riders and dancers. The groom on this

134
Earthenware
bowl painted
in olive green
lustre on a
milky white
glaze, Egypt,
11th century.
diam. 24 cm,
9½ in.
Benaki
Museum,
Athens

piece, for example, wears a short tunic tucked into his belt, ankleboots and a turban; he leads a spotted giraffe wearing a patterned saddlecloth. A tree on the right hints at the outdoor setting. The principal elements are set off by a narrow band reserved in white; the remaining ground is filled with small spirals. Because of the curve of bowl, the figures appear oddly fore-shortened in a photograph, but the line is fluid and assured, and the drawing shows an interest in naturalism, which is visible in other contemporary arts, such as carved ivory and wood.

The realism on Egyptian lustrewares and other arts from this period is totally at odds with the trend towards increased abstrac-tion seen in Iraqi ceramics of the tenth century. It is not clear why this new sense of realism developed in Egypt at this time, but it may have been due to a closer observation of everyday life, for the Fatimids were known to have encouraged the exact sciences. Many of the representations on Fatimid lustrewares continue types of images known from Classical times (the groom here looks like an acrobat), so it is more likely that a popular tradition of drawing had been maintained in Egypt and incorporated in the luxury arts at this time. Ceramics are rarely, if ever, mentioned in contemporary sources, suggesting that they were a popular rather than an aristocratic art, and the depictions on them show aspects of contemporary life not described in texts.

The descriptions of the Fatimid court treasures enumerate thou-sands of precious objects made from gold, silver, rock crystal, gemstones and other expensive materials. Most of these were melted down or refashioned when cash was needed or styles changed. One of the few Fatimid court objects to survive is a stunning ewer carved and drilled from a single piece of rock crys-tal (135). The pear-shaped body is decorated with a central vegetal motif flanked by seated leopards carved in low relief, enlivened with such details as engraved spots, while the inscription above invokes blessing on the Fatimid caliph al-Aziz, who ruled Egypt from 975 to 996. The handle, which is carved from the same piece, is surmounted by a small crouching figure of an ibex. In contrast

135
Rock crystal
ewer made for
the Fatimid
caliph al-Aziz
(r.975–96).
h.21 cm, 9¼ in.
Treasury of St
Mark's, Venice

to the lively realism of the lustre bowl, the leopards on this ewer
are static and stereotyped. They represent a long tradition in
the lands of the Near East of associating felines with royalty.
The raw rock crystal was imported from North and East Africa as
well as other remote places and was believed to prevent night-
mares. The manufacture of rock crystal objects reached a peak
during the early Fatimid period, and several pieces associated
with al-Aziz are known. Such precious items were among the
items looted by hungry troops from the caliph's treasuries in 1067.
The crystal object eventually reached Europe, where they were
collected by churches and rich individuals, who had gold and
silver mounts added.

None of the rock crystals is signed, and the names of the carvers,
who must have worked for the court, are unknown. Signatures

are somewhat more common on other types of objects made from precious materials, such as silver or ivory. A wooden box (136) with a pyramidal lid covered with hammered plaques of silver decorated with gilt and niello (a black alloy of sulphur, lead and silver) is signed inconspicuously by Badr and Tarif on the inside of the hasp. A large inscription, worked in niello that contrasts with the gold ground of the base of the lid, invokes blessings on al-Hakam II, the Umayyad caliph of Spain (r.961–76), and states that the box was among the things ordered for Abu Walid Hisham, his son and heir-apparent, under the direction of the official Jawdar. Since Hisham was only declared heir-apparent in 5 February 976 and succeeded his father on 1 October of the same year, the box can be dated precisely. The inscription further shows that it was a specific commission, perhaps to commemorate the prince's elevation to the status of heir-apparent. It is thought that boxes like these were used to hold small and precious materials, such as spices or jewels. Like many other objects of Islamic art, particularly luxury wares, the box gained a new function in Christian hands, for it is now in the treasury of the Cathedral of Gerona in Catalunya, a province in northern Spain. It probably passed into Christian hands quite soon after it was made, for during the civil war between Hisham's two periods of rule, Córdoba was raided in 1010 by Catalan mercenaries who were rewarded with the right to take all the booty they could. This box may have been one of the spoils of that battle.

Apart from the inscriptions, the major decoration on the box is a pattern of leaves enclosed in a vine that spirals in regular loops. The motif is strikingly similar to that found on the earthenware bowl (133) made at approximately the same time some 5,000 km (3,000 miles) away. It is extremely unlikely that the maker of one object knew the other, but the similarities can be explained by imagining a common source in the arts of the Abbasid court at Baghdad. Although the Umayyads of Spain challenged the Abbasids' political legitimacy, they nevertheless emulated their art and culture. For example, the musician Ziryab, an emigré from Baghdad, became the arbiter of fine taste in ninth-century

136
Casket made for the Umayyad heir-apparent Abu Walid Hisham, Spain, 976. Silver, decorated with gilding and black organic material; 27×38×24 cm, 10⅝×15×9½ in. Treasury Museum, Gerona Cathedral

Córdoba, setting the standards for dress, table manners, protocol and etiquette, even down to the coiffure of men and women.

One of the decorative inconsistencies of this box is the strap over the lid which is hammered from the same sheet of silver as the rest of the lid. This strap, which copies the metal straps that would have held wooden and ivory boxes together, is obviously useless on a silver box. This derivation of the silver box from ivory models is confirmed by several ivory caskets of the same shape made in Spain at this time. The finest is a large box in the Cathedral of Pamplona (137) made of nineteen plaques of ivory assembled with ivory pegs. Although the silver strap and lock are missing, it is clear where they were once placed. Ten eight-lobed medallions on the lid show paired animals, mythical beasts and hunters; ten bigger medallions on the sides of the box show princely scenes of feasting, jousting, music making, and a man defending himself with a sword and shield against attacking lions. The lid is inscribed with blessings on he who does good works, the chamberlain, Sayf al-Dawla Abd al-Malik ibn al-Mansur; the inscription adds that this is among the things ordered by the chief page, Zuhayr ibn Muhammad al-Amiri in 1004–5. The inside of the lid is inscribed 'the work of Faraj and his apprentices', of whom five – Misbah, Khayr, Ahmad Amiri, Saadah and Rashid – signed various parts of the decoration.

The ivory box was probably a gift made during the reign of Hisham II to celebrate the conquest of Leon by Abd al-Malik, the son of the famous vizier al-Mansur. For this great victory, the caliph awarded Abd al-Malik the title Sayf al-Dawla ('Sword of the State'), which is included prominently in the inscription. The patron is depicted in the medallion on the front right; he is seated on a throne supported by lions and flanked by attendants. The lively figural scenes carved in high relief on this box are typical of carved ivories produced in the second half of the tenth and early eleventh century at the court of the Umayyad caliphs of Córdoba. The number of signatures, however, is unusual and may be explained by the nature of the object, which was assembled from

many pieces worked separately, and its extraordinary quality. These multiple signatures show that it required many people to make such an intricate object. It seems likely that the scenes depicted, like the inscription, have specific meanings, although these are unclear to us today.

These carved ivories were extremely expensive and made only for the richest patrons. Virtually all ivory came from eastern and central Africa overland along the trans-Saharan routes to Egypt or North Africa. India, the only other place where elephants lived, produced only enough ivory for its own use. It is therefore not surprising that most medieval Islamic ivories were carved in regions close to the source: Egypt, North Africa, Spain and Sicily. The small bits of ivory left over were not wasted, but were inlaid in wooden objects, where the hard white of the ivory contrasted sharply with the dull browns and reds of wood. The extraordinary value of the large ivory box was obvious to Muslims and Christians alike, for after the fall of the caliphate it was kept for many centuries in the monastery of Leyre as a reliquary and eventually transferred to the treasury of the cathedral in Pamplona.

Most Islamic objects of precious silver and gold that remained in the Islamic lands were melted down when tastes changed or money was needed, but a remarkable number of objects made from cheaper copper alloys have survived from medieval times. Brass in particular was the medieval equivalent of high-quality plastic today: it was relatively cheap, durable, strong and easy to shape, although it was not particularly fashionable until the year 1100. It was particularly useful for large objects, such as lamp-stands and ewers, which might break if made of ceramic, and for functional objects, where the material was unimportant or where the strength and weight of metal was an advantage. After 1100 this humble material was transformed into a luxury ware by the addition of coloured inlays, so that the glittering surface resembled the gold and silver vessels appreciated by the wealthy.

One of the most extraordinary inlaid brass objects to survive is the Bobrinsky Bucket (138). Bought in Bukhara in 1885, it was

137
Casket made
for the
chamberlain
Abd al-Malik,
Spain, 1004–5.
Ivory,
24×38×24 cm,
$9\frac{1}{2}×15×9\frac{1}{2}$ in.
Museo de
Navarra,
Pamplona

later acquired by the Russian collector Count Bobrinsky from
whom it gets its name. Its round body is cast of brass and inlaid
in copper and silver with horizontal bands of alternately Arabic
inscriptions and figural scenes. The broad band at the top express-
ing good wishes to the owner is written in an unusual script, in
which the upper parts of the letters are formed from human
figures and some of the lower parts are formed from animals.
Below this band is a narrower one with scenes of entertainment,
such as drinking, music-making and playing such games as
backgammon, known in the medieval Islamic lands as *nard*. The
narrowest band in the middle has an elaborately knotted inscrip-
tion expressing good wishes. The fourth band shows scenes of
horsemen hunting and fighting. The lowest band is another
animated inscription bearing good wishes. The dedicatory inscrip-
tion, clearly written in Persian along the rim, states that the
bucket was ordered by Abd al-Rahman ibn Abdallah al-Rashidi,

inlaid by Muhammad ibn Abd al-Wahid, and designed by Masud ibn Ahmad, the engraver from Herat, for Rashid al-Din Azizi ibn Abu'l-Husayn al-Zanjani, a merchant who bore the titles 'pillar of the state', 'pride of the merchants' and 'ornament of the hajj and of the two shrines [Mecca and Medina]'. The bail handle, connected to the bucket by two loops, each formed by a fish and a leaping lion, is inscribed with the date Muharram 559 (corresponding to the date December 1163).

Although none of these individuals can otherwise be identified, this wealth of inscriptions tells much about the piece and contemporary society. First, the object, like the Pamplona casket, was made by two individuals who had specialized jobs within the workshop, one being responsible for executing the other's design. The bucket was a specific commission, apparently by a dependent (he bears the epithet Rashidi, 'of Rashid') for his master, Rashid al-Din, a merchant. The merchant's titles relating to the pilgrimage and the date of the commission, the first month of the Muslim year, together suggest that the bucket was intended as a New Year's gift after the merchant had performed the pilgrimage to Mecca, which he would have undertaken in the last month of the preceding year. Finally, the dedicatory inscription was written in Persian, showing that Persian was becoming increasingly accepted as a written language for everyday affairs. Arabic, still and forever the language of Islam, was used for the good wishes. The anthropomorphic inscriptions are extremely difficult to read, but the text is so banal – 'glory and prosperity and power and tranquility and happiness ... to its owner' – that any viewer could immediately guess its content. Important information that was meant to be read, such as the names of the donor, artisans and recipient, and the date, was conveyed in more legible scripts. This same hierarchy of scripts was used on the coinage, the most visible sign of a ruler's power, in the eastern Islamic lands. A ruler's name was often written in a flowing, legible cursive while the rest of the text was written in an old-fashioned angular script.

The function of the Bobrinsky Bucket is a puzzle. It was once called a 'kettle' or 'cauldron', but these are misnomers, for an inlaid object could not be used for cooking over a fire. Some scholars have hypothesized that the bucket was intended for carrying food or milk, but the copper interior would have had to have been tinned in order to avoid food poisoning from verdigris, corroded copper. Buckets and pails might be used to draw water from wells, but the luxurious decoration on this piece would have been subject to damage, and drinking water could have equally been tainted by verdigris. The most likely explanation is that the pail was intended to hold water for washing. Ritual ablution, which has been proposed by some scholars because of the recipient's pilgrimage titles, seems unlikely because of the figural imagery which would have been inappropriate for use in or near a mosque. Furthermore, theologians condemned the game of backgammon, a game of chance in contrast to chess which relied on skill, as the Devil's temptation, so the bucket was unlikely to have been used in a religious context. The bucket was probably

139
Harun al-Rashid and the Barber, from a manuscript of Nizami's *Khamsa* copied at Herat, 1494–5. British Library, London

used when bathing in a bathhouse, and indeed, representations of bathhouses from a later period in Herat show similar buckets used to pour water over the bather's body (139). The luxurious inlay meant that it was unlikely that the bucket would have been left in the bathhouse; rather it was an exquisite version of an everyday object made as a commemorative gift. In short, the Bobrinsky Bucket was a present for the man who had everything in 1163.

The Bobrinsky Bucket, a masterpiece of inlaid brass, was probably made in or near Herat, now in northwest Afghanistan. One of the artists is identified as an 'engraver from Herat', and according to contemporary sources, Herat was known for its fine metalwares. Inlaying was not the only technique perfected by craftsmen from Herat, to judge from a group of extraordinary hammered brass objects, such as ewers and candlesticks. The truncated conical candlestick illustrated (140) is decorated with seven horizontal bands, alternately broad and narrow. The broad bands have lions and hexagons hammered in high relief; the narrow bands have

140
Candlestick,
eastern Iran/
Afghanistan,
c.1200.
Hammered
brass inlaid with
copper, silver
and black
organic
material;
h.32 cm,
12⅝ in.
Dar al-Athar
al-Islamiyya,
Kuwait, on
loan from the
al-Sabah
Collection

141
White fritware bowl with carved decoration under a transparent colourless glaze, Iran, 12th century. diam. 18 cm, 7 in. Freer Gallery of Art, Washington, DC

inlaid arabesques and Arabic inscriptions with good wishes to an anonymous owner. The shoulder is further decorated with a row of ducks. The decoration was enhanced with copper and silver inlay. In contrast to the Bobrinsky Bucket, the function of this object – and others like it – is quite clear: it was set on the floor and held a large candle for interior lighting, whether in a house, mosque or tomb. Many such candlesticks can be seen in later Persian paintings, and other examples, although not of this type, are inscribed with verses celebrating the candlestick.

Quite apart from the intricacy and beauty of this candlestick, it is technically extraordinary, for – apart from the ducks – it was constructed from a single sheet of brass that was hammered from the front and the back. It has no seams at all and attests to the technical ability of the smith, who was able to transform a flat sheet into a large truncated conical base, ridged neck and faceted socket, all decorated with elements in high relief. There are several candlesticks and ewers made in the same way. One of the ewers is signed by an artist from Herat in 1182, and the whole group has been attributed to the province of Khurasan in north-east Iran and western Afghanistan in the late twelfth and early thirteenth centuries.

Metalware was only one of the media that underwent extraordinary technical transformation in the eastern Islamic lands during this period, for with the collapse of the Fatimid caliphate in Egypt in 1171, new centres, particularly in Iran, developed revolutionary

ceramic techniques to imitate Chinese porcelains. Potters, led by those in Iran, wanted to imitate finely-thrown, translucent Chinese porcelains decorated with subtle carving or moulding under a thin transparent glaze, but could not do so with their traditional heavy clay body covered with thick and opaque tin glazes. Instead, they devised another technique, also used in ancient Egypt, for making an artificial body material from ground quartz mixed with a small amount of white clay and ground glaze. This material, usually known as 'fritted' or 'stone-paste', was white and translucent (when thin) and could be covered with a thin, transparent alkaline glaze. This combination of materials allowed an extremely wide range of decorative techniques to be used.

Some ceramics, thought to date from the late twelfth century, copy Chinese models closely. A small flaring bowl (141), for example, shows what delicacy could be achieved with this new material. The shape, with extremely thin flaring walls, emulates the crisp, finely potted Dingware bowls made in the Song period in China, and the decoration, lightly incised and even pierced before being filled with the transparent glaze, is meant to imitate translucent and similarly pierced Chinese porcelains. The bowl is incised with two bands of continuous scrolls, each containing a single leaf. The use of a vegetal motif is similar to that on the Chinese models, but the regularized arabesques on the Iranian bowl are very different in effect from the free naturalism on the Chinese wares, where loosely-drawn flowers fill the entire interior surface. The origin of the Iranian style of arabesque is clear when this bowl is compared to the floral motif on the slip-decorated earthenware bowl of some two centuries earlier (133).

The introduction of this new ceramic body was followed within fifty years by a burst of creative energy unparalleled until the rise of Wedgwood and Staffordshire pottery in eighteenth-century England. The extraordinary range of decorative techniques used includes wares decorated with monochrome glazes, wares incised and carved before glazing, wares decorated with moulded and

applied ornament, and wares painted under and over the glaze. The most expensive were the wares in which the design was painted on an already glazed and fired object because these over-glaze painted wares required a second firing. There are two types of overglaze painted wares: lustrewares and enamelled wares.

Lustrewares continued to account for the majority of luxury wares, and in addition to the traditional bowls, plates and jars, new types were introduced such as figurines, stands, and most importantly, large expanses of wall tiles. Like Fatimid lustrewares, the Iranian lustrewares were decorated in one colour of lustre. Only one centre of production has been identified – the city of Kashan in central Iran – on the basis of potters' signatures, and many of the potters were related. The names of some seventeen potters are recorded, and at least two families of potters, that of Abu Tahir and al-Husayn, can be established over several generations. The al-Husayn family, for example, can be traced through eight generations from a certain Hibat-Allah al-Husayn, who may have lived in Egypt or Mesopotamia around 974. His great-grandson

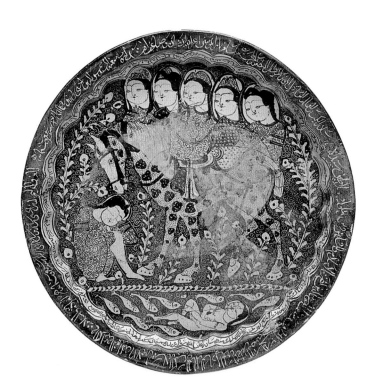

Abu'l-Hasan ibn Muhammad ibn Yahya ibn Hibat-Allah al-Husayn, made tiles in 1118 for the tomb of the eighth Imam at Mashhad in Iran, and in the early fourteenth century, Abu'l-Hasan's great-great grandson, Abu'l-Qasim, wrote a treatise on the art of ceramics in which many of the techniques for making these fancy ceramics are described.

A large scalloped plate (142) shows how the new alkaline glaze on a fritted body allowed the artist free rein in painting elaborate and expressive designs on the surface of the glaze. Most of the bottom of the plate is decorated with a large scene of a horse with his groom sleeping in front of his head; five other figures stand behind the horse. At the bottom is a small aquatic scene of a naked woman with fish swimming around her. The narrow rim and sides are filled on both exterior and interior with long inscriptions written in Arabic and Persian. The unusually detailed drawing suggests that the image depicts a specific story or event, but the words inscribed on the plate do not provide an explanation for it, as they ask for

Everlasting glory, happiness, safety, favour and grace to the amir, the great marshal, the wise, the just, the one assisted by God, the victori-ous, the vanquisher, the warrior, the wager of holy war, sword of kings and religion, aid to Islam and the Muslims, lord of Kings and sultans, lord of Princes… the sword of the Commander of the Faithful, may God render his victories mighty and double his power. Work of the sayyid Shams al-Din al-Hasani Abu Zayd in the month of Jumada II of the year 607 of the hegira [corresponding to December 1210].

The other inscriptions are greeting-card doggerel of the order: 'Roses are red, violets are blue…'

Although the inscription around the rim does not explain the scene depicted, it does provide much information about the milieu in which the plate was created. It was clearly made as a specific commission for a particular individual who, although his personal names are missing, is identifiable as a member of a distinctive and powerful class in society. Other important people commissioned sets of lustre tiles, such as the great-grandson of sultan Sanjar's

142
Scalloped plate painted in lustre over a transparent glaze, Kashan, Iran, December, 1210.
diam. 35 cm, 13¾ in.
Freer Gallery of Art, Washington, DC

vizier, who commissioned tiles for the cenotaph of Fatima at Qumm in 1206. The potter of the Freer plate was the most famous potter from medieval Kashan. He was also a sayyid, or direct descendant of the Prophet Muhammad through his grandson al-Hasan, and had a title Shams al-Din ('Sun of the Faith') for his name, both indicating his elevated social status. A century later, the potter Abu'l-Qasim who wrote the treatise on ceramics, also came from an important family. One of his brothers was a noted historian who wrote a history of the Ilkhan sultan Uljaytu; another was an important mystic at the hospice in the central Iranian town of Natanz. The specificity of the inscription on the Freer plate suggests that the image was also specific, and similarly ordered by the patron, so it is all the more intriguing that no convincing explanation of its meaning has yet been proposed.

The Freer plate was produced in a mould with twenty-nine scallops, and unusually, several other ceramics produced from the same mould with twenty-nine scallops are known. They must have been made in the same workshop, if not by the hand of Abu Zayd himself. One in the Victoria and Albert Museum in London dated three years earlier than the Freer plate, shows a rider on a spotted horse. Another in the Gardner Museum in Boston shows two lovers facing each other, while a fragmentary plate in the Islamic Museum in Berlin shows a pair of genies above three young riders. The other plate from this mould (current whereabouts unknown) is not overglaze painted in lustre but decorated in the simpler technique of underglaze painting, with black arabesques painted under the turquoise blue glaze. As all the plates were produced from the same mould, this turquoise plate shows that Abu Zayd's shop produced different qualities of ware; undoubtedly the turquoise plate is an example of everyday ware, while the lustre plates are the 'fine china' of the day. The Freer plate may have been one of a set of dishes, and the meaning of its complex design might be clearer if more of the set were known. Similarly, it would be difficult to reconstruct the game of chess if one had only a single knight.

143
Fritware beaker painted in polychrome over a transparent glaze, Iran, early 13th century. h.12 cm, 4¾ in. Freer Gallery of Art, Washington, DC

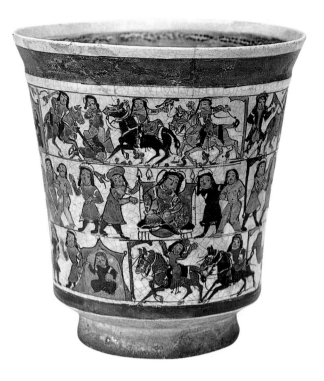

The second type of luxury ceramic developed in Iran in the twelfth century was enamelled, or painted over the glaze in several colours and occasionally gold before being fired a second time at a relatively low temperature. The technique is often known as minai, from the Persian word for 'enamel'. Like lustreware, many of the enamelled pieces are bowls, often bearing depictions of enthroned figures and legendary scenes of hunting. An unusual beaker (143) provides the clearest evidence that some scenes decorating ceramics were meant to tell a tale. It illustrates the ancient love story of the Iranian hero Bizhan and the Turanian princess Manizha, known best from its telling in Firdawsi's *Shahnama*. Depicted here in comic-book style with twelve scenes arranged in three tiers of small linked panels (144), the tale concerns Bizhan, who accidentally meets the beautiful Manizha while hunting. The lovers tryst and are discovered; Bizhan is captured and imprisoned in a pit, which is sealed with a boulder. Manizha then entreats the hero Rustam to rescue her lover and while she looks on, Rustam lifts the great boulder and releases the prisoner.

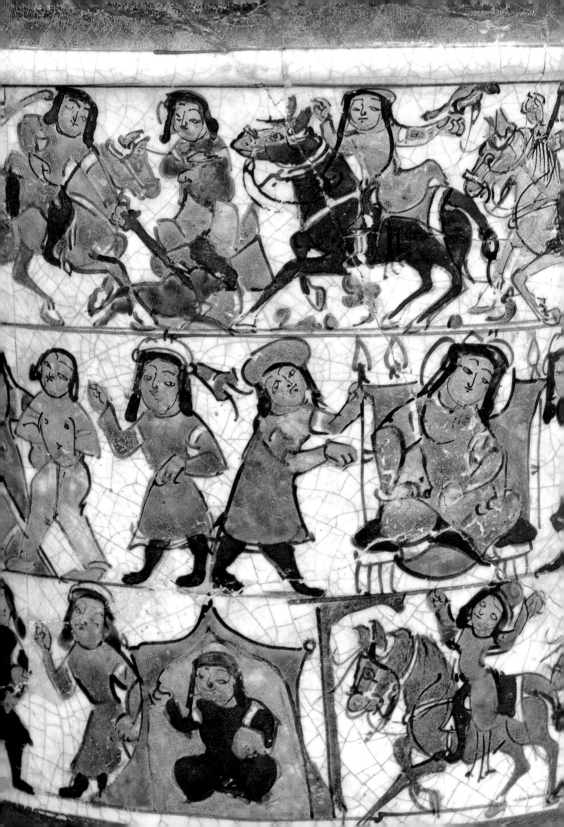

Slight differences between the story of Bizhan as told in the *Shahnama* and as depicted on the beaker suggest that the artist relied on another version of the text. The rectangular format of the scenes has suggested to some that the artist may have based his images on illustrated manuscripts. No illustrated manuscripts from thirteenth-century Iran have survived, but they are known to have existed. It has also been suggested that the scenes on the beaker were copied from wall paintings in palaces. As with manuscripts, no narrative murals survive, but they too are known from texts. Whatever the ultimate source, the beaker, like the epigraphic bowl (133), had to be turned in the viewer's hands to be appreciated. Although it bears no inscription with the patron's name, one can easily imagine that it was made for a rich person to use at drinking-parties. (Despite the koranic prohibition of alcoholic beverages, wine continued to be made and appreciated in Iran and other regions.) Epic poetry was still recited from memory rather than read from a book, so the Freer beaker may well have served as a mnemonic device for the reciter: the bard could use the scenes to reconstruct the entire heroic tale.

These developments in the eastern Islamic lands were cut short in the thirteenth century by the Mongol invasions, which began with the conquests of Khwarazm in 1219–20 and of Transoxiana in 1220. Traditional artistic centres were sacked, Herat twice in the 1220s, Kashan in 1224. It is unlikely that commercial and artistic activity ceased entirely, as was once thought, but undoubtedly there were fewer patrons for luxury works of art, and new centres attracted the best artists. Mosul, a prosperous city on the banks of the Tigris River in northern Iraq, grew in prosperity from the second half of the twelfth century. With strong trading links to the east, it flourished in relative security, seemingly safe from the Mongols on the east and the Crusaders on the west. Under the patronage of Badr al-Din Lulu, initially vizier (1210–22) to the Zangid rulers and then independent ruler of the city (1222–59) almost until the Mongols sacked it in 1261, the arts flourished there, including illustrated manuscripts and inlaid metalwares. It is thought that the local metalware industry took on a new life

144
Detail of 143

in the thirteenth century when objects and perhaps even crafts-
men from the eastern Islamic lands arrived in the city, and the art
of inlaid brass reached unsurpassed heights there.

One of the finest pieces of the period, and the only one known to
have been made in Mosul, is the Blacas Ewer (145), acquired by
the British Museum in 1866 from the Duc de Blacas. Made of
hammered sheet brass, the ewer has a faceted pear-shaped body,
tall neck and long spout (now missing). As on the Herat candle-
stick, the decoration is arranged in horizontal bands, alternately
epigraphic and figural, but the figural bands are more prominent
and contain a wider range of more varied motifs. According to an
inscription around the neck, the ewer was decorated by Shuja ibn
Mana of Mosul in the month of Rajab 649 (corresponding to the
date April 1232) in Mosul. The other inscriptions offer standard
blessings and good wishes to an anonymous owner. The major
focus of the decoration is the figural scenes, arranged in several
series of lobed medallions around the body and neck. The medal-
lions alternate with smaller medallions and are set against a
background of geometric patterns composed of interlocking
T-, I-, or Y-shapes; both designs are based on contemporary textile
patterns (*eg* 121) not surprisingly since Mosul was renowned for
its textiles, most notably *mosulin* (whence muslin), the cloth of
silk and gold seen there by Marco Polo.

The medallions on the Blacas Ewer show figures engaged in
scenes of hunting, battle, court and everyday life, such as a lady
with an attendant riding in a camel litter. Other scenes are drawn
from popular stories, such as that showing the Persian king
Bahram Gur hunting with the beautiful slave-girl Azada, who
plays her harp. This story is known not only from the *Shahnama*
but was depicted on contemporary metalwares and ceramics. The
narrow figural band on the widest part of the body was probably
intended to be an animated inscription, but the figures have so
overwhelmed the letter shapes that the words are entirely illegi-
ble. Some examples of contemporary metalwork have decoration
representing specific astrological or symbolic programmes, such

145
Ewer,
Mosul,
1232.
Hammered
brass inlaid
with silver
and copper;
h.30 cm,
11¾ in.
British
Museum,
London

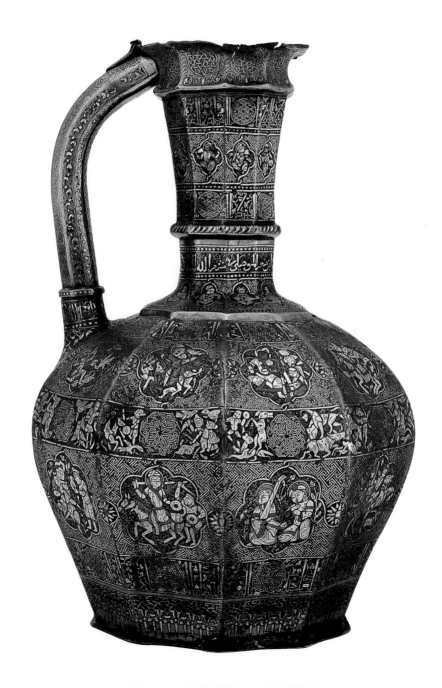

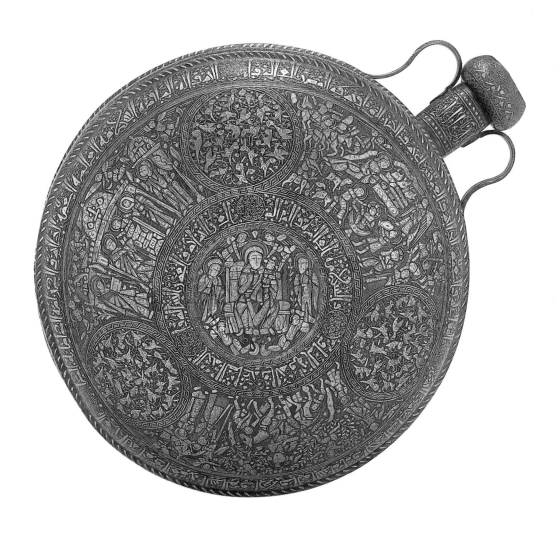

as signs of the zodiac or the kingly cycle of feasting and hunting. The scenes on the Blacas ewer, in contrast, do not appear to belong to a specific programme and show the varied pleasures of the contemporary life of the rich and powerful, presumably the class for whom this anonymous ewer was made. Like the Bobrinsky Bucket, the Blacas Ewer is a practical object transformed into a luxury item: ewers were used to pour water over the hands before dining, and the waste water was caught in a basin (*eg* 148). The five surviving inlaid brasses made for Badr al-Din Lulu, for example, are the appurtenances of his luxurious life – large and small trays, a basin, a candlestick and a box.

The popularity of the Mosul style of metalware is indicated by the twenty known craftsmen who bear the epithet *al-mawsili* (from Mosul). Their names show the complexity of the industry, with craftsmen beginning as pupils or hired men before becoming masters themselves. The achievement of Mosul metalworkers lies not only in the superb decoration of objects but also in their fabrication, for these artisans seem to have invented the technique of spinning a disc of metal against a chuck, or form, rotating at high speed on a spinning lathe. As the technique requires a considerable amount of force, it was only possible with the invention of a new type of lathe, and was probably developed to speed up production of sheet brass objects to meet increased demand. Although the technique was suitable only for regular, concentric forms, it would have reduced the time required to manufacture a candlestick base, for example, from over an hour to just a few minutes.

This new technique was used to fabricate parts of a large brass canteen (146–7) made in seven sections, which were then soldered together. A conical socket on the flat back allowed the piece to be fitted onto a post and turned by the handles until the contents, filtered through the strainer in the mouth, poured out. Its size and weight (5 kg or 11 lb, when empty, nearly 30 kg or 66 lb, when full) meant that a single person would have had difficulty hoisting it. The shape derives from pilgrim flasks of pre-Islamic

146–7
Canteen, Syria, mid-13th century. Hammered brass inlaid with silver and black organic material; diam. 37 cm, 14½ in. Freer Gallery of Art, Washington, DC
Above
Front side showing enthroned madonna
Below
Back side showing conical socket

times and unglazed canteens from the Islamic period, but the style and technique of decoration show that it was made in the thirteenth century in Syria, where the Mosul techniques of inlaying the brass surface with silver and a black organic material were appreciated by Muslim and Christian patrons alike. Indeed, the organization of the decoration with linked medallions follows the style established in Mosul, as do the inscriptions around the centre and along the shoulder, which offer the standard range of good wishes in Arabic. The figural scenes, however, are unusual, for Christian themes predominate. The central medallion shows a picture of the enthroned Madonna and Christ child; it is surrounded by three scenes from the life of Christ: the Nativity, the Presentation in the Temple, and the Entry into Jerusalem. The middle band, as on the Blacas Ewer, bears an illegible animated inscription in which the letters have been transformed so completely into revellers that the specific verbal content has been lost, although the general content of such inscriptions – good wishes – would have been understood. The lowest band on the side has thirty medallions of musicians or drinkers alternating with a scene of a hawk attacking a bird. The underside is decorated with an arcade of twenty-five pointed arches, each enclosing a haloed figure, including an angel, a warrior saint and a praying figure. The central ring shows nine armed horsemen galloping counterclockwise.

This canteen is the most famous of a diverse group of eighteen objects with Christian scenes. Some, of rather poor quality, were made for local Christians in Syria or Iraq, while others were designed for Muslim patrons. The D'Arenburg Basin, also in Washington, is a splendid object decorated with an arcade of Christian figures and small cusped roundels with scenes from Christ's life, although it was made for the Ayyubid sultan of Syria and Egypt, al-Malik al-Salih (r.1240–58). Still others were probably made for the Crusader nobility, who had settled in coastal Syria and Palestine following the First Crusade and the conquest of Jerusalem in 1099. These unsophisticated knights from Europe were seduced by the luxuries that graced even the

148
Basin known as the Baptistère of Saint Louis, Egypt or Syria, c.1300. Brass inlaid with gold and silver; diam. 50.2 cm, 19¾ in, Musée du Louvre, Paris

most modest Muslim courts. Political and religious differences did not get in the way of the shared interests of the rich and powerful. The Crusaders developed a nouveau-riche taste for exotic objects with delicate engraving and glittering silver inlay of Arabic inscriptions, Christian scenes and secular pleasures. Objects such as the Freer Canteen would have been made for such clients and taken back to Europe as souvenirs of the Holy Land, perhaps to be used later as reliquaries. This canteen, for example, was in the collection of the Italian prince Filippo Andrea Doria when it was discovered in 1845, and its pristine condition suggests that it was always a treasured object.

The Ayyubids were unable to oust the Crusaders from the Holy Land, but their Mamluk successors not only checked the Mongol advance into Syria but also defeated the remaining Crusader states along the Mediterranean coast. The Mamluk court in Cairo became a great centre of patronage, and metalworkers from Mosul moved there to seek new patrons. One of the finest inlaid metalwares produced for the Mamluks is a large basin known as

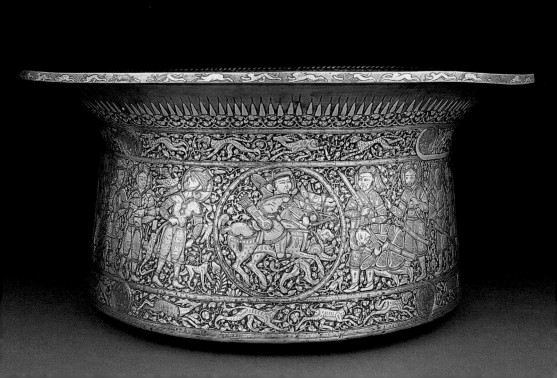

the Baptistère of Saint Louis (148). Like the Freer Canteen, it was taken to Europe at an early date, although its name is apocryphal: it can have no connection with Saint Louis IX of France, who died well before it was made, and its first recorded use for baptism was in the seventeenth century.

Like earlier metalwares, the Baptistère is decorated with horizontal bands of roundels alternating with panels. Unlike them, it has no inscription bands, and the decoration, which covers most of the inside and outside, comprises extraordinarily detailed and superbly executed figural compositions. On the outside the friezes show running animals, the roundels show mounted figures and the panels show groups of standing figures. The figures can be divided into two groups on the basis of their dress and facial features: some are huntsmen and servants, others are sword-bearing figures with Mongolian features. The decoration on the inside shows enthroned figures, hunting and battle scenes and a fantastic fishpond on the base. The superb workmanship and precise detail make this the masterpiece of Mamluk metalwork, and the artist Muhammad ibn al-Zayn was justly proud of his work, for he signed it in six different places: one formal signature under the rim and five more informal signatures hidden on representations of metal objects and thrones within the scenes.

Muhammad ibn al-Zayn signed himself a master, and his work clearly developed from the Syrian style of the thirteenth century, yet his career and dates are unknown. The basin bears no date or dedication to a specific patron, but it is too fine and too specific to have been made for sale on the open market. Some scholars have tried to identify individual people or the events depicted in the scenes, but it is more likely that the images substitute for the inscriptions on contemporary metalwork that give the names, titles and attributes of the patron. These inscriptions, which invoke glory and prosperity on the owner, are paralleled by the scenes of the good Mamluk life on Ibn al-Zayn's basin and represent the culmination of the figural style that had been developing for several centuries on inlaid metalwares. The Baptistère was

probably made around 1300, and its decoration represents the final stage in this tradition. Henceforth, for reasons that are still unexplained, figural decoration became less important or disappeared altogether, to be replaced by inscriptions and arabesques.

This change in taste is also apparent in enamelled glasswares produced in the Mamluk lands, for there was a long tradition of manufacturing richly coloured glass in Egypt and Syria (see 60). Under the Ayyubids and Mamluks decoration was outlined in red enamel, filled with white, yellow, green, blue, purple and pink, and then fired at a low temperature, the same technique used in the production of enamelled ceramics. These luxury wares were highly esteemed both at home and abroad, for they have been preserved in European church treasuries, and some are even said to have been found in China. Shapes included goblets, bottles, flasks, vials, vases, bowls and basins, but lamps are best known, probably because so many were made to light the funerary complexes erected by the Mamluk sultans and their amirs. Despite the fragility of these lamps, they were still used in the nineteenth century, to judge from David Roberts's views of Cairo (see 95).

149
Mosque lamp made for Sayf al-Din Tuquztimur, Egypt, 1340. Glass with enamelled decoration; h.33 cm, 13 in. British Museum, London

The typical lamp (149) has a wide and flaring neck, bulbous body with six applied handles, and prominent foot. A small glass container for water and oil with a floating wick would have been inserted inside the lamp, and the lamp itself would have been suspended by chains from the ceiling. The lamps are often decorated with bold inscriptions. On this example made for the amir Tuquztimur, who was cup-bearer to the sultan al-Nasir Muhammad, the neck is inscribed with the so-called 'Light Verse' (Koran 24:35) written in a tall cursive script:

God is the Light of the heavens and the earth;
the likeness of His Light is as a wick-holder
[wherein is a light
(the light in a glass
the glass as it were a glittering star)]

Tuquztimur's name and titles are inscribed around the body of the lamp in a thick cursive script in reserve against a blue ground. When the lamp was lit, the amir's name and titles would have glowed with divine light, a stunning visual realization of the beautiful koranic metaphor inscribed above.

As self-made men, the Mamluks were extremely conscious of their status. Their daily life was punctuated by elaborate ceremonial, and an individual's rank was immediately visible in his dress. Many of the wares produced for the Mamluks were also marked with prominent emblems of ownership: sultans had epigraphic emblems, but amirs bore pictorial emblems, often called blazons. That of the pious and gentle Tuquztimur, depicted on the neck of his lamp, was a tear-drop shaped shield bearing an eagle with outstretched wings, with a bar above and a cup below, indicating his rank as cup-bearer.

In contrast to the fine metal- and glasswares produced for the Mamluks, ceramics were of lesser quality, probably because fine Chinese porcelains were easily available by sea. Nevertheless, Mamluk potters did adopt the new ceramic techniques that had developed in Iran, particularly the new artificial body and the new

150
Fritware dish underglaze-painted in cobalt blue, Iznik, c.1480. diam. 45 cm, 17¾ in. Gemeentemuseum, The Hague

technique of underglaze painting. While luxury overglaze-painted ceramics, whether enamelled or lustred, were some of the finest products of the ceramic industry in twelfth- and thirteenth-century Iran, the most significant invention for the future history of ceramics in the Islamic lands – as well as in China and Europe – had been underglaze painting. Because of the fine and white artificial body, which provided an ideal surface for painting, and the alkaline glaze, which did not cause the pigments to run during firing, potters were able to paint directly on the body material, which was then covered by a layer of transparent glaze. Not only was this technique much cheaper than the double-fired lustre and enamel techniques but the underglaze decoration was also more durable, for low-fired overglaze painting was easily abraded from the ceramic surface.

Designs were often painted in black or cobalt blue under a turquoise or colourless glaze. Cobalt was mined near Kashan in Iran, where it was refined and combined with other materials to make the pigment used for underglaze painting. In the fourteenth century, when the Pax Mongolica made trade between Iran and China easy, refined cobalt was also exported to China. From the second quarter of the fourteenth century, Chinese potters transformed their traditional white porcelains by adding underglaze painting in cobalt blue. These blue-and-white porcelains were themselves almost immediately exported in large quantities throughout Asia, to the Islamic lands, and eventually to Europe. By the end of the fourteenth century, for example, Chinese blue-and-white porcelains were so popular that knockoffs were being made in Syria, Egypt and Iran, and, by the fifteenth century, in the emerging Ottoman Empire.

Perhaps the finest of these Islamic blue-and-white ceramics is a group exemplified by a large deep dish decorated in blue and white and datable c.1480 (150). While few Islamic ceramics of the fourteenth and fifteenth centuries were of a comparable quality to the Kashan wares of the thirteenth century, these blue-and-white pieces are of an unusually high technical standard and are often

quite large, measuring over 40 cm (16 in) in diameter. Making a large bowl or plate was far more difficult than making a small one because of the difficulties in controlling the materials and firing. The hard and dense body of this dish has been covered with a brilliant white slip, and delicate arabesques and floral scrolls were painted under a colourless glaze in cobalt blue, often with the design left white in reserve against the blue background. As fragments of this ware have been discovered at Iznik, a city in western Anatolia known earlier and later for its ceramics, it is assumed that this type of ceramic was made there. The hard white body gives the impression of porcelain, and the shapes and designs on the exteriors of some dishes, with peony scrolls in blue on white, are also somewhat Chinese in flavour. The designs on the interiors, however, are quite similar to those found on bookbindings and illumination produced in contemporary Iran (see 113). They probably all came from a common source, most likely the court workshop where designs that could be used on all media were produced.

This new attitude towards design was accompanied by new types of design. The old reliance on inscriptions and figural decoration was replaced by a new delight in the arabesque, the quintessential decorative theme in Islamic art. Vegetal motifs had been trained into geometric shapes throughout the history of Islamic art, but these arabesque motifs had usually been subsidiary to other decorative themes, particularly inscriptions. Although many of the finest works of the middle period have figural decoration, the real story in this period was the development of the arabesque, which would come to dominate the decorative arts in the later period.

The late period, like the early one, is one of great powers in the Islamic lands. The myriad local dynasties of the middle period were subsumed by several empires, of which the most important were the Ottomans, the Sharifs of Morocco, the Safavids and the Mughals. They derived their legitimacy in two ways: the Sharifs and Safavids traced their descent from the Prophet Muhammad and derived their power from that lineage, whereas the Ottomans and the Mughals were the descendants of long lineages of great Turkish conquerors and derived their political legitimacy from that heritage. Each of these dynasties ruled for centuries, but in face of the rising economic power of Europe, the shifting centre of the world economy from the Mediterranean to the Americas and the Far East, and the growth of European colonialism, their reigns were of varying length.

151
Taj Mahal, Agra
1631–47. Detail
of marble
panelling

The Ottoman dynasty (r.1281–1924) lasted the longest. They had been one of the local dynasties of the middle period, but they grew in power in the fifteenth century to become masters of the Mediterranean and Middle East. In 1453 the Ottoman sultan Mehmed II took Constantinople, the capital of the Byzantine Empire, which was renamed Istanbul. This conquest of a city coveted by Islam since the seventh century gained him unprecedented kudos among Muslims, and he attempted to complete his mission of establishing the rule of Islam over all the lands once held by the Roman Empire. He conducted an incessant series of campaigns against Venice and Hungary, and his successors Selim (r.1512–20) conquered Syria, Egypt and Arabia, and Suleyman (r.1520–66) extended the empire into Mesopotamia and Europe to the walls of Vienna. Corsairs brought Ottoman rule to Algeria and Tunisia. From this heyday in the sixteenth century, Ottoman power waned and the empire shrank, but the Ottoman sultans continued to rule from Istanbul until the end of World War I.

Ottoman expansion in northwest Africa was checked by the Sharifs (r.1511–), two parallel lines of rulers each descended from the Prophet Muhammad. The Sadians and Alawis emerged in the fertile oasis valleys south of the Atlas Mountains to rule the old imperial cities of Morocco. Although they ran up against the expansionist aims of the Ottomans on the east and the Europeans on the north, the Sharifs were briefly able to extend their influence south across the Sahara into West Africa. Although France and Spain eventually established protectorates in Morocco, the Alawi line regained the throne following the declaration of Moroccan independence in 1956 and still rules today.

The Ottomans' great rival on the east was the Safavid dynasty of Iran (r.1501–1732). The Safavid state was a theocracy, for the dynasty traced its descent from Ali ibn Abu Talib, the son-in-law and successor to the Prophet Muhammad, and claimed semi-divine status as reincarnations of the Shiite imams. The Safavids imposed Shiism, which had enjoyed sporadic importance in earlier times, as the state religion, and thus distinguished themselves from their Sunni neighbours to the west and east. Under the Safavids, Iran acquired the sense of national identity that has survived to the present day. The Safavids' immediate rivals on the northeast were various lines of Uzbek Turks who supplanted the Timurids in Central Asia and ruled from such cities as Samarqand, Bukhara and Khiva.

Far more powerful were the Mughals (r.1526–1857), descendants of a Timurid princeling who fled Central Asia to establish a foothold in northern India in the early sixteenth century. After some difficulty, his descendants established a line that controlled all of northern India, including present-day Pakistan, India and Bangladesh. They were, without question, the richest of the Islamic superpowers of the later period. The Mughals themselves were pious Muslims and established Islamic institutions through-out their realm, but unlike the other Islamic lands, at no time was Islam the religion of a majority of the Indian population.

152
Sultan-Muhammad,
The Court of the Gayumars
(detail of 181), from the copy of the *Shahnama* prepared for Shah Tahmasp, Tabriz, 1525–35. Ink, colour and gold on paper; 34×23 cm, 13⅓×9 in. Prince Sadruddin Aga Khan, Geneva

153 Overleaf
Map of the Islamic lands c.1700

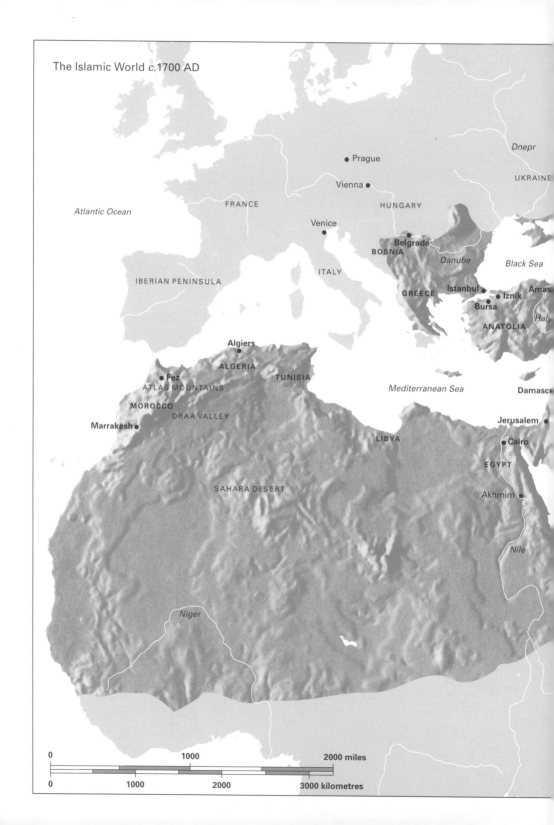

The Islamic World *c.*1700 AD

Atlantic Ocean

Prague

Vienna

FRANCE

HUNGARY

Dnepr

UKRAINE

Venice

Belgrade

BOSNIA

Danube

Black Sea

ITALY

IBERIAN PENINSULA

GREECE

Istanbul

Iznik

Amas

Bursa

Haly

ANATOLIA

Algiers

ALGERIA

TUNISIA

Fez

ATLAS MOUNTAINS

Mediterranean Sea

Damasc

MOROCCO

DRAA VALLEY

Marrakesh

Jerusalem

LIBYA

Cairo

EGYPT

SAHARA DESERT

Akhmim

Nile

Niger

0		1000		2000 miles

0	1000	2000	3000 kilometres

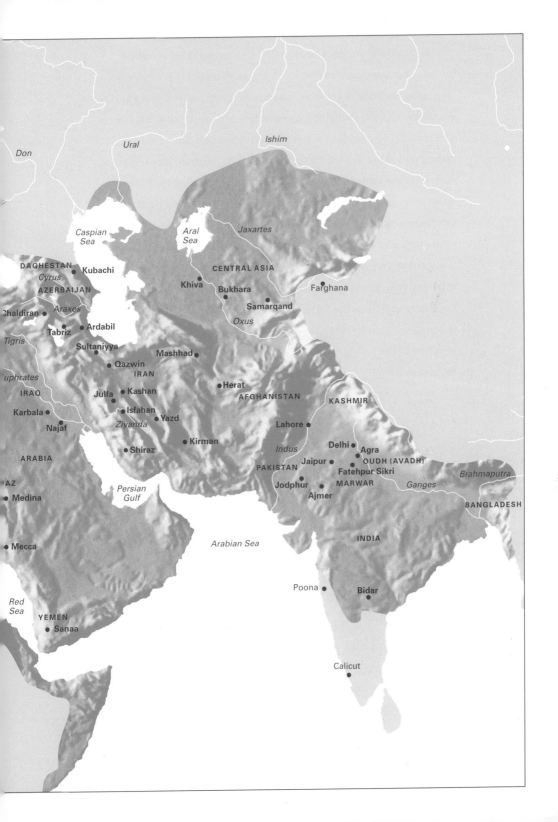

Don
Ural
Ishim

Caspian
Sea

Aral
Sea

Jaxartes

CENTRAL ASIA

DAGHESTAN ● Kubachi
Cyrus
AZERBAIJAN
Khiva ● ● Bukhara
Farghana
Chaldiran ● Araxes ● Samarqand
● Tabriz ● Ardabil
Oxus
Tigris
● Sultaniyya ● Mashhad
uphrates ● Qazwin
IRAQ IRAN ● Herat
● Julfa ● Kashan AFGHANISTAN KASHMIR
Karbala ● ● Isfahan
Najaf ● Ziyanda ● Yazd Lahore ●
Indus Delhi ● ● Agra
ARABIA ● Kirman ● Jaipur OUDH (AVADH)
● Shiraz PAKISTAN ● Fatehpur Sikri Brahmaputra
AZ Persian ● Jodphur MARWAR Ganges
● Medina Gulf ● Ajmer BANGLADESH

● Mecca
Arabian Sea INDIA

Red
Sea ● Poona ● Bidar
YEMEN
● Sanaa

● Calicut

The Sharifs were somewhat apart from the other dynasties of the later period, not only because of their geographic isolation but also because they maintained Arabic as a court and literary language. Elsewhere, Persian was the language of the court and literature, and Persian culture of the Timurid period was held up as a model to be followed. The shared artistic language enabled artists and ideas to move from one court to another. Nevertheless, each of these dynasties created a distinct style of art that set it apart from contemporaries and rivals, and these dynastic styles can be seen in many works of art executed in all media. Earlier rulers had also commissioned many fine works of art, but many were destroyed or refashioned to fit changing tastes. In contrast, the relatively late date has meant that many more works of art have survived from the later period. This large amount of evidence is supplemented by documentary evidence, whether from the archives of the rulers themselves or from the reports of the many European travellers who visited the region in this period.

Imperial rulers in the later period used the arts of building to enhance their imperial image at their capitals, and immense domed mosques and tombs proclaimed from afar the spiritual and temporal powers of these great Islamic dynasties. With advances in communication and architectural representation, these imperial styles were readily transmitted to the provinces, so that Ottoman-style mosques in Egypt and North Africa or Mughal-style mosques throughout the Indian subcontinent affirmed the temporal strength and boundaries of the realm.

On 30 May 1453, the day after the Ottomans conquered the Byzantine capital of Constantinople, Mehmed the Conqueror ordered the great Byzantine imperial church of Hagia Sophia (Holy Wisdom) to be transformed into the city's congregational mosque. This act entailed few architectural changes – eventually figural mosaics were covered with whitewash and minarets built – but it had great symbolic importance. The church, which had been built by the Byzantine emperor Justinian in the sixth century and was famed for its immense dome buttressed by cascades of half domes, was one of the marvels of Christian antiquity. By transforming the church into a place of Muslim worship, Mehmed signalled to all that Islam had finally succeeded in its century-old aim of conquering Constantinople. Although the city continued to be known officially as Qustantiniyya (the Arabic and Turkish version of Constantinople), it was popularly known as Istanbul.

More practically, Mehmed needed to repopulate the metropolis that had suffered centuries of decline and to revitalize its economic institutions. To do so, he initiated a vast building programme, at the centre of which was a large congregational mosque and surrounding dependencies. Mehmed ordered work to begin on the complex on 21 February 1463; it took seven years to

complete. The site, a vast, almost square, area on the fourth of Istanbul's seven hills, had been occupied by an important church, destroyed by the Ottomans, where the Byzantine emperors were buried. At the centre of the complex was an enormous square court containing a domed mosque with a court in front and a garden with tombs for the founder and his wife at the back. This central unit was flanked by charitable foundations – four large and eight subsidiary *madrasas*, or theological colleges, a small primary school, a library, a hospice for Sufis, a hospital and residences – and establishments that provided income for the upkeep of the foundation, such as a caravanserai with rooms for merchants, baths for men and women, a great covered market with 280 shops, a saddlers' market with 110 shops, a horse-market, stables and workshops for stirrup makers and farriers. In an era of almost constant campaigns, this district would have been thronged with soldiers seeking supplies. Much of Mehmed's complex was levelled in a great earthquake of 22 May 1766, but it can be reconstructed from early drawings, such as the great panoramic view of the city made by the German artist Melchior Lorch in 1559 (155).

Previous Ottoman sultans had built this type of complex that combined educational, social and commercial functions at Bursa, their earlier capital in western Anatolia, but Mehmet's complex was new in its careful organization and hierarchy. The Sufi hospice was relegated to a peripheral position, reflecting the declining role of the Sufi shaykhs. The number of *madrasas* and their central position shows the increased importance of the *ulema*, the class of learned scholars, in the post-conquest Ottoman state. In addition to its function as a religious and educational centre for Muslims in their new capital, Mehmed's complex was integrated into a wider economic web, for half of its income derived from outside the city and brought the wealth of the country side into the capital. In 1489 and 1490, for example, the income of the complex amounted to some one and a half million silver coins. It derived from twelve baths in the capital, as well as the poll tax on non-Muslims there. Additional money came from taxes on fifty villages in Thrace and rents. Approximately 60 per cent of the income went for salaries to the 383 employees (102 at the mosque, 168 at the *madrasas*, 45 at the hospice, 30 at the hospital, 21 agents and clerks to collect revenues, and 17 builders and workmen), and additional payments were made to poor scholars, their children and disabled soldiers. Another 30 per cent of the income was spent on food: 3,300 loaves of bread and two meals were distributed to 1,117 individuals daily. The remainder supported the hospital and paid for repairs.

155
Melchior
Lorch, *The
mosque of
Mehmed as
seen in a
panoramic view
of Istanbul*,
1559.
Sepia on paper.
University
Library, Leiden

Mehmed's complex provided a model for the one built a century later by his most illustrious successor, Suleyman (r. 1520–66), on a large sloping site overlooking the Golden Horn (156). Work began in July 1550 and, as at Mehmed's complex, continued for over seven years. The site was terraced to provide foundations for a congregational mosque, two mausoleums, six *madrasas*, a Koran school, a hospital, a hostel, a public kitchen, a caravanserai, a bath and rows of small shops. Suleyman, known in English as 'the Magnificent' because of the splendour of his court, is known in Turkish as *Kanuni*, or law-giver because Islamic law and Ottoman administration were harmonized during his reign. His purpose is

clear from the endowment deed to his complex, which says that it was built 'to elevate matters of religion and religious sciences in order to strengthen the mechanisms of worldly sovereignty and to reach happiness in the afterworld'.

Fortunately the accounts from the construction of the Suleymaniye complex survive, for they provide an unusual insight into the details of how materials and craftsmen were assembled from all over the empire. Most of the documents are concerned with how to acquire fancy stones, particularly four huge columns of red granite for the mosque. The accounts also record purchases of glazed tiles from Iznik, lapis lazuli for blue pigment, other colours, gold coin for gilding, gold foil, gold leaf, mercury, ostrich eggs, tin, timber, planks, sandarac resin and petroleum thinner. There were 3,523 workers, half Christians and half Muslims. When the complex was finished, it had a staff of 748 (almost twice the number at Mehmed's foundation), and their stipends accounted for nearly one million silver coins. The annual income of the complex was over five million silver coins, of which four-fifths was derived from taxes on villages in the European part of the empire.

The Suleymaniye complex presents an impression of an imposing pyramidal mass of domed units punctuated by the four slender

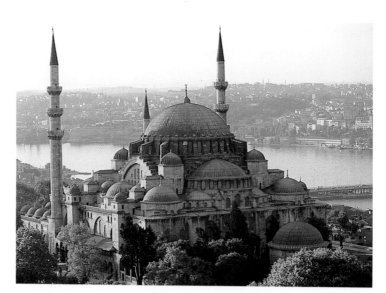

156–157
The Suleymaniye complex, Istanbul 1550–7
Left
General view
Right
Plan

minarets of the mosque, which stands at its centre. The great Ottoman architect Sinan (d.1588) exploited the sloping site, by terracing the supporting institutions such as shops and caravanserais into the hillside and relaxing the absolute symmetry of earlier complexes so that the complex was integrated into the city. As at Mehmed's complex, the mosque (157) stands in the middle of a huge walled enclosure, with a courtyard in front and a garden cemetery at the back, where the sultan and his wife were later buried. The charitable institutions, all buildings with courtyards surrounded by arcades and small rooms, are arranged around the perimeter wall that encloses the mosque. Sinan based the design of the mosque, with a great dome buttressed by two half-domes, on the great Byzantine church of Hagia Sophia, but he opened the nave and screened aisles of the church to form a single space, interrupted only by the four massive piers that support the central dome and the two great columns on either side (158). Such a clear and uninterrupted space was appropriate to Islamic worship, where the community of Muslims prayed together in parallel rows.

The exterior composition of grey lead-covered domes and white stone walls, lightened only by arched openings of windows and

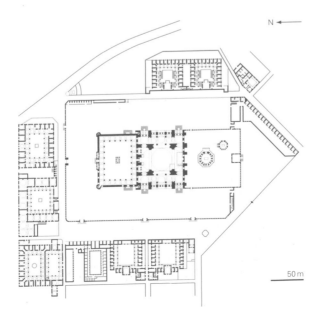

N ←———

50 m

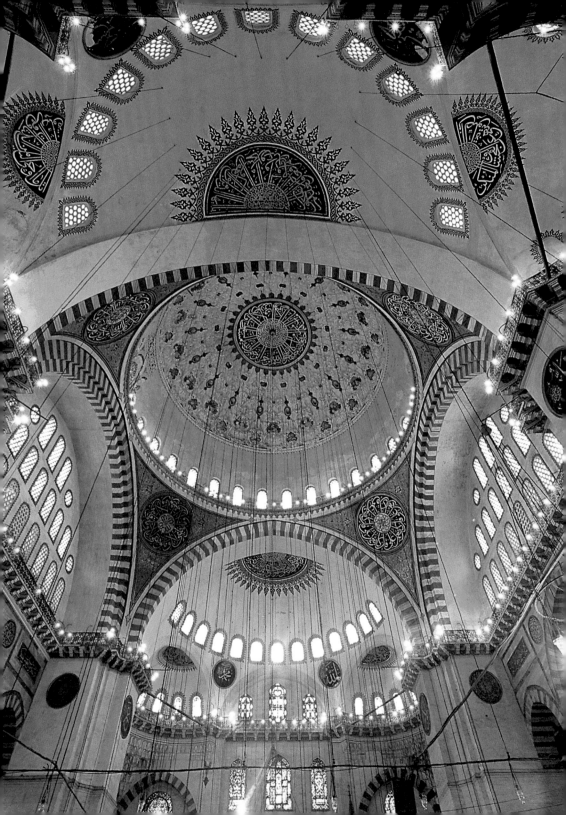

arcades and punctuated by slender minarets, epitomizes the classical Ottoman style of architecture. The ornament on the interior of the mosque was kept to a minimum, although the *qibla* wall was discreetly decorated with underglaze-painted tiles. These tiles were made in factories at Iznik, which had produced crockery since the late fifteenth century and now could produce the large expanses of tiles that were becoming popular in Istanbul. Underglaze painting allowed for great freedom in drawing, fully exploited in intricate vegetal and epigraphic designs.

Such tiles can be seen best in the small mosque built by Sinan for the grand vizier Rustem Pasha. Born in Bosnia *c.*1500, he became a general in the Ottoman army and married the sultan's daughter in 1539. Five years later he was appointed grand vizier because of his great financial skill, but was dismissed in 1553 after a court intrigue. Following two years of voluntary 'retirement' with his wife, Rustem was reinstated as grand vizier, a post he held until his death in 1561. His vast wealth allowed him to sponsor many pious foundations, among them a mosque located in a bustling market area just below Suleyman's complex. The domed mosque was built above a row of shops and a warehouse, which provided

158
The mosque of the Suleymaniye complex, Istanbul, 1550–7. Interior

159
Tiles along the *qibla* wall, mosque of Rustem Pasha, Istanbul, *c.*1561

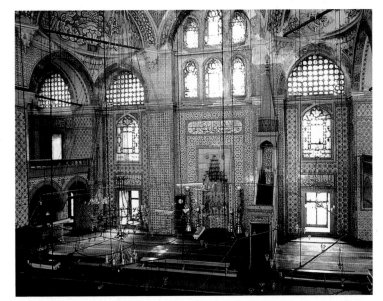

both physical and financial support for the mosque and raised the building so that it would appear more monumental than it was. The most notable feature of the mosque is the tiling that covers the walls, piers, *mihrab* and *minbar* in a jungle of stylized flowers and leaves painted on a white slip in black, purple, dark blue, turquoise blue and red under a transparent glaze (159). The tiles include both large compositions spread over many tiles designed to fit specific surfaces and mass-produced tiles cut to fit the walls on which they were installed. The designs show elongated leaves with jagged edges, flowers, and leaves of a type depicted on many other arts, including textiles (see 200–2).

160
Plan of Isfahan showing Abbas's extension to the city at the beginning of the 17th century

Just as the Ottomans had taken advantage of their new capital Istanbul to create monumental buildings that symbolized the power and prestige of their dynasty, so did their rivals, the Safavids in Iran. A Shiite dynasty flanked by Sunni neighbours, the Safavids were constantly harassed on both frontiers. On the east, they held their own against the Uzbek Turks, although frontier towns such as Herat and Mashhad frequently changed hands. On the west, they were less successful against the Ottomans, who trounced them at the Battle of Chaldiran outside Tabriz in 1514, and the constant threat of Ottoman incursions forced the Safavids to move their capital away from the frontier. In 1555 they abandoned Tabriz in favour of Qazvin, some 450 km (280 miles) to the southeast. In the 1590s the most powerful ruler of the dynasty, Abbas I (r.1588–1629), again transferred the capital, this time to Isfahan, the old Saljuq capital, in the centre of the country.

Moving the capital from the insecure borderlands to the centre of the country was part of a deliberate policy to consolidate Safavid religious and political authority, develop state capitalism, and establish Safavid Iran as a world economic and diplomatic power. During the sixteenth century Safavid legitimacy and prestige had been threatened not only by external invasions but also by internal squabbles for the throne. The major Shiite shrines at Najaf and Karbala in Iraq had fallen into Ottoman hands, and in

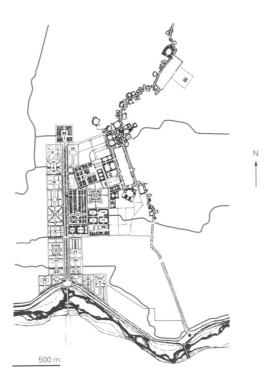

1589 the Sunni Uzbeks took the city of Mashhad, home of the great shrine to the eighth Shiite Imam, Reza. Abbas's decision to build a new capital was meant to add lustre to a declining power and erase the stain on Safavid honour. His act also had economic motivations, and Abbas's capital was the centre of a network of caravanserais established throughout the country to foster trade. The Armenians living in Julfa, a town on the Araxes River in Azerbaijan, were forcibly relocated to New Julfa, a new suburb to the south of Isfahan, and their monopoly of the silk trade became a major source of revenue for the Safavid state.

Abbas's urban programme entailed relocating the commercial, religious and political centre of Isfahan south towards the Ziyanda River (160). The old focus of the city had been a large open area, or maidan, near the congregational mosque. Abbas ordered a new maidan, called Naqsh-i Jahan, 'Design of the World', for it was intended to symbolize Isfahan's position at the centre of the world. The two maidans were connected by a bazaar 2 km (1¼ miles) long, underscoring the role of trade in

the new city. A spacious vaulted passage flanked by shops (161), the bazaar is punctuated by domed intersections that give access to more than 100 service structures, including caravanserais, baths, *madrasas*, shrines and small mosques. At the south end of the meandering medieval bazaar, Abbas ordered a group of royal structures laid out in a grid aligned to the new maidan. These comprised a royal market for fine textiles, the mint, a hospital, a bath and several caravanserais, the largest of which housed 140 cloth merchants on the ground floor and jewellers, goldsmiths and engravers on the upper storey. The royal bazaar opened onto the maidan through an elaborate double-storey portal with galleries that once housed the royal music pavilion. Faded murals on the portal depict Abbas's victories over the Uzbeks and show the image he wished to project as potentate and restorer of the country.

The maidan was the heart of Abbas's new city (162). An elongated rectangle covering eight hectares, it was far larger than contemporary European plazas, such as St Mark's in Venice. The maidan was originally designed for state ceremonies and sports, but within a few years it was redeveloped for commercial purposes by lining the perimeter with a two-storey arcade of shops. These shops were let at low rents to attract reluctant merchants from the old city centre. The new maidan astonished foreign travellers, who left glowing accounts of its huge size, architectural homogeneity and bustling life. The vast space was filled with stalls of merchants, craftsmen, barbers and entertainers, but could be cleared for military reviews, drill by the shah's personal militia, archery contests, polo matches and festivals. At night it was illuminated by 50,000 earthenware lamps hung from thin poles in front of the buildings. The long, modular façades, originally decorated with polychrome glazed tiles, are broken only by the monumental entrances to four buildings – the bazaar on the north, the Shah Mosque on the south, the mosque of Shaykh Lutfallah on the east, and the entrance to the palace precinct on the west.

161
The bazaar,
Isfahan. Interior

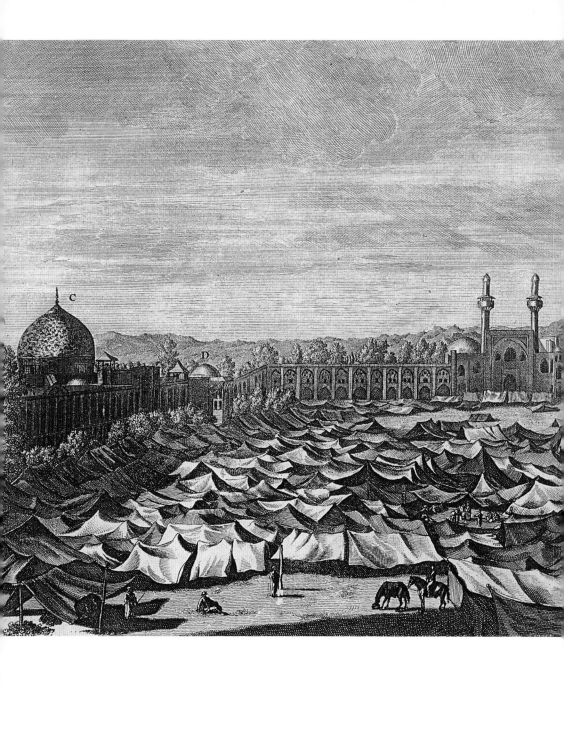

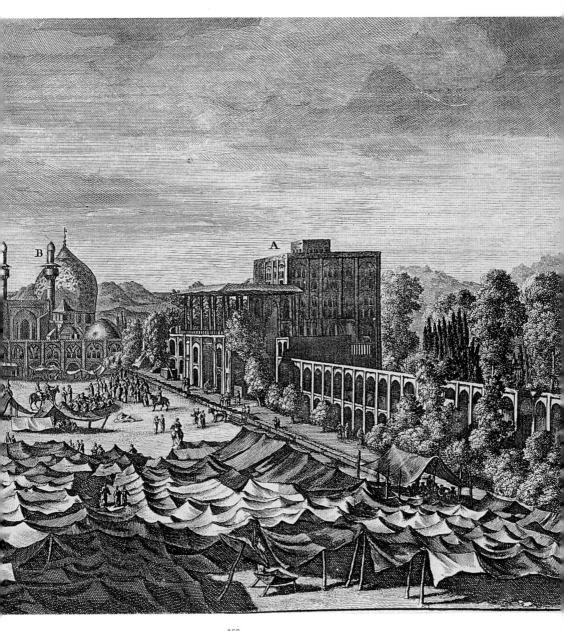

162
Cornelius de Bruin,
The Royal Maidan, Isfahan,
from the North,
engraving in *Travels into*
Moscovy, Persia and Part
of the East Indies, 1737.
This shows Abbas's new
maidan 100 years after it was
built. Illustrated from right to
left are the Ali Qapu or
'Sublime Porte' (A), the Shah
Mosque (B), and the Mosque
of Shaykh Lutfallah (C)

On the south, opposite the entrance to the bazaar, is the monumental Shah Mosque, which was designed to replace the old congregational mosque as the centre of public worship in the city. Like the bazaar, the Shah Mosque has a large, two-storey entrance facing the maidan. The portal is aligned with the maidan, but the remainder of the building is set at a 45 degree angle to face Mecca. Begun in the spring of 1611, construction of this large mosque took twenty years, and the marble panelling was only installed in 1638. Like Ottoman complexes in Istanbul, the Shah Mosque was supported by the revenues from agricultural and commercial properties in and around the city, and both the building and its generous endowment were another aspect of Abbas's plan to shift the commercial and religious centre away from the old maidan. The new maidan's two great portals, opening onto the bazaar on the north and the Shah Mosque on the south, mark the economic and religious foundations of Abbas's new order.

The Shah Mosque follows the typical Iranian plan – a central courtyard with an *iwan*, or vaulted hall open at one end, in the middle of each of its four sides and a dome over the *mihrab* at the end of the *qibla iwan* (163–4). The same plan had been used for the old congregational mosque in Isfahan (see 83), but the Shah Mosque shows several important differences. In the back corners are large *madrasas* consisting of courtyards surrounded by arcades. As with Ottoman complexes in Istanbul, the Shah Mosque was designed to keep a watchful eye on education. The plan of the Shah Mosque shows an extraordinary concern for symmetry and regularity, possible because it was the result of a single campaign when virtually unlimited space was available in this newly developed area.

The Shah Mosque is also remarkable for its colourful decoration. The walls are covered at the bottom with marble panelling, above which all vertical surfaces, both inside and out, are clad in polychrome glazed tile. The fanciest decoration is on the entrance portal (see 154 and 165), which is covered with a mosaic of many

163–165
Shah Mosque,
Isfahan,
1611–66
Above right
Aerial view
Below right
Qibla iwan
and sanctuary
Overleaf
Detail of tile
mosaic on
portal

coloured pieces cut from larger tiles and fitted together to form complex patterns. Tile mosaic had been used since the fourteenth century to decorate brick buildings, as at the tomb of Uljaytu at Sultaniyya (see 87), but here the surface area covered has increased substantially, more colours are used, and the patterns are far more complex and curvilinear. The portal, for instance, is decorated with seven colours of tile forming long inscriptions with white letters set against a dark blue ground, glittering tiers of *muqarnas*, or niche-like elements, cascading from the sunburst at the apex of the semi-dome, and large carpet-like panels flanking the doorway. Most of the rest of the mosque is decorated with tiles of poorer quality, probably because money was short and the spaces to be covered vast. These multicoloured glazed tiles are done in the *cuerda seca* technique, in which large tiles

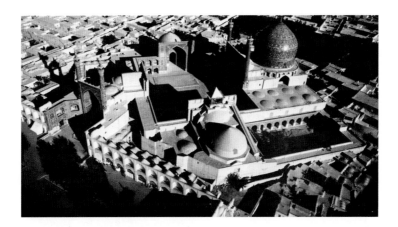

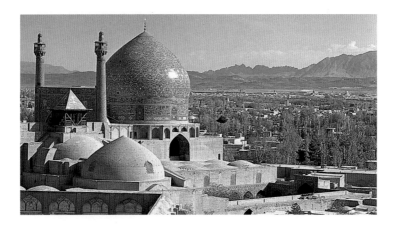

were painted with different colours of glaze. To prevent the glazes from running together during firing, they were separated by a greasy substance mixed with manganese that left a matt black line between the colours after firing. The *cuerda seca* technique is much faster than tile mosaic, but the colours are not as brilliant because they are all fired at one temperature.

The mosque of Shaykh Lutfallah, built between 1603 and 1619 on the east side of the maidan, is unique among Safavid mosques. Comprising a single domed room surrounded by service areas, it lacks the standard accoutrements of mosques, such as a courtyard, side galleries, *iwans* or minarets. Its form belongs to the long-established Iranian tradition of large-domed mausoleums, known since the tenth-century tomb of the Samanids at Bukhara (see 84), but its inscriptions call the building a mosque. It takes its name from Shaykh Lutfallah Maysi al-Amili, a distinguished scholar and teacher who came to Isfahan at Abbas's request and took up residence on the site, but the mosque only came to have this name following the shaykh's death in 1622–3, and he does not seem to have played any part in its construction. Although the building is often considered to have been a royal chapel, there is no evidence that this sort of building existed in Safavid times, and its original function remains something of a mystery.

The interior is probably the most perfectly balanced space in Persian architecture (166), and the impact of the vast glowing room, heightened after passing from the glaring sunlight through a long gloomy passageway, is overwhelming. Tiers of ogival medallions descend from the sunburst at the apex and swell in size with the curve of the dome. Windows around the drum are fitted with double ceramic grilles in arabesque patterns that allow flickering light to reach the interior and play over the tiled surfaces below. Walls and corners are outlined by light-blue cable mouldings and framed by magnificent inscription bands in white on a dark-blue ground that spring from the floor. The vertical integration creates an unusual sense of spaciousness and

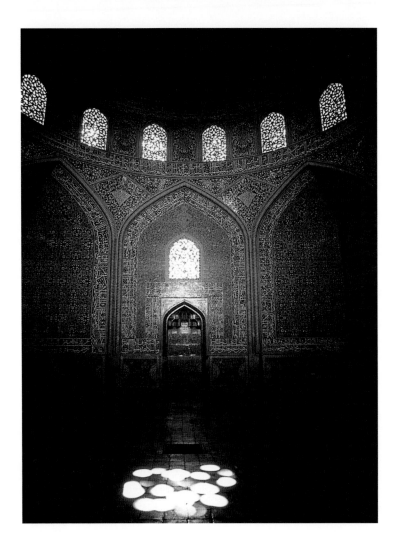

166
Mosque of
Shaykh
Lutfallah,
Isfahan,
1603–19.
Interior

167 Overleaf
Si-o Se Pol,
Isfahan,
1602

harmony and may have been inspired by a local model, for the
only other example of a similarly integrated interior in Iranian
architecture is the north dome added to the congregational
mosque in Isfahan in 1088 (see 81), another domed unit whose
original function and audience are also unclear.

On the west side of the maidan opposite the mosque of Shaykh
Lutfallah is the Ali Qapu or 'Sublime Porte' (168). Begun by Abbas
as a modest entranceway to the royal gardens, it was repeatedly
modified and extended upwards as it evolved into an audience
hall and then an official tribune from which to watch parades and
games held on the maidan. The columned porch provided an

elevated reviewing stand for royalty and guests, and the ingenuity and playfulness of the court architects can be seen in the way they lifted an earth-bound verandah two storeys above the ground. This playfulness is matched by the decoration on the interior (169), in which fantastic plaster vaults suspended from the ceilings are pierced in the shapes of the Chinese porcelains and Persian lustrewares that the Safavid rulers assiduously collected. Walls in some rooms were richly painted with mildly erotic scenes showing the languid youths popularized in small paintings and drawings made for albums (see 189).

The garden precinct behind the Ali Qapu was dotted with small palaces and pavilions. It extended as far as the Chahar Bagh, or 'Four [-fold] garden', an elegant boulevard that stretched some 4 km (2½ miles) down to the river. Flanked by the palaces of the nobles, who were encouraged by Abbas to add fine buildings to his new capital, the avenue was divided by a central canal with fountains and cascades and planted with flowers and trees. The avenue is an enormous realization in three dimensions of the garden carpets made in Abbas's royal factories (for a later one, see 195). The southern end of the Chahar Bagh passes over the Si-o Se Pol, or Bridge of Thirty-three [Arches], erected in 1602 by Allahvardi Khan, favourite and generalissimo of Abbas (167). The bridge has several pavilions at which pedestrians could stop and enjoy a splendid view of the river. Like the Chahar Bagh itself, the bridge combined aesthetics with practicality, for it linked the city to New Julfa, the Armenian quarter, and to the great royal pleasance and hunting ground on the slopes beyond.

168
Ali Qapu,
Isfahan,
1597–1660

In the sixteenth century the Safavids' major rivals on the east were the Shibanid family of Uzbeks, and although the two dynasties were fierce political rivals, their architecture shares many similarities, probably because both based their buildings on those erected by the Timurids in the fifteenth century. Just like the Ottomans and Safavids, the Shibanids set out to leave their mark by creating a splendid new capital, and the city of Bukhara replaced Samarqand as the political and religious centre of

Transoxiana. In the first half of the sixteenth century, the city walls were rebuilt, and several building ensembles were erected or restored. In the second half of the sixteenth century, a branch of the Shibanid family sponsored two large-scale urban projects in Bukhara: a major east-west thoroughfare and a north-south artery. Like Abbas's work in Isfahan, these developments show how art and commerce were intertwined.

The east-west thoroughfare ran through Bukhara from the Registan, an important retail district below the citadel, westward for 5 km (3 miles) beyond the city walls to the Chahar Bakr shrine complex. Enlarged at this time with a mosque, *madrasa*, and hospice for Sufis, the site served as the family cemetery for the Juybari family of Sufi shaykhs, who endowed the shrine with the income from several parcels of land, a village and two gristmills west of Bukhara. Even into Soviet times, the income supporting the *madrasa* was still substantial. The thoroughfare aided the development of a residential and cultural district in the southwest section of Bukhara, and the city walls had to be extended. The north-south artery cut through the centre of Bukhara between 1562 and 1587 had three covered markets. The northern one, the Goldsmiths' Dome, was, despite its name, a retail emporium for textiles. Some 350 m (½ mile) to the south is the Hatsellers' Dome

169
Ali Qapu,
Isfahan,
1597–1660.
Detail of the
vaults in the
music room

170
Hatsellers'
Dome,
Bukhara,
1582–7

(170); another 150 m (¹⁄₁₀ mile) further south is the Moneychangers'
Dome. These retail markets were surrounded by caravanserais
and warehouses that supported huge *madrasas*, some housing
several hundred students.

Central Asia under the Uzbeks was a major centre of orthodox
learning, but its location at the fringes of the Islamic lands meant
that it was increasingly isolated, particularly after the sixteenth
century when the international caravan trade through Central Asia
declined. With economic stagnation, art and architecture became
increasingly repetitive as forms became fossilized. The same thing

occurred at the opposite end of the Islamic lands under the
Sharifan dynasties of Morocco. They were descended from
Arabian emigrés who traced their lineage to the Prophet
Muhammad and who had settled in the oasis valleys south of the
High Atlas mountains. In the sixteenth century the Sadian family
expanded their influence from the Draa valley over all the cities
of Morocco. Their primary capital was Marrakesh, undoubtedly
because it was closest to their power base, and the finest example
of their architecture is the Ben Yusuf *madrasa* there. The largest
madrasa in the region, it was built by Abdallah al-Ghalib in 1564–5
but takes its name from a nearby mosque erected in the twelfth

century. The *madrasa* is a large square arranged around a spacious courtyard with a large rectangular pool (171). On the side opposite the entrance stands the rectangular prayer hall, while the sides of the building contain more than 100 cells for students and teachers arranged on two floors. The *madrasa's* symmetry, regularity and spaciousness are unusual, for by this date most large foundations had to be wedged into a dense urban fabric. The building is enveloped in a web of exuberant decoration in tile mosaic, carved stucco, and carved and painted wood, but the arrangement of tiled dadoes and inscription bands, stuccoed walls and wooden cornices is uncannily similar to examples made two centuries earlier in the region (see 93). The Ben Yusuf *madrasa* is one of the most charming in Morocco, but on close inspection the individual elements are somewhat sterile and monotonous, particularly when compared to fourteenth-century models. As in Central Asia, economic stagnation blocked artistic innovation in North Africa in the later period, with old formulas repeated time and time again. The traditional role of North Africa as an entrepôt for European trade with sub-Saharan Africa and the East was usurped by the European discovery of direct sea routes around Africa to the East. Furthermore, the discovery of the Americas shifted the traditional European focus away from the Mediterranean Sea to the Atlantic Ocean.

The Portuguese navigator Vasco da Gama dropped anchor in Calicut harbour on the west coast of India in 1498. Ottoman expansion in the eastern Mediterranean had blocked caravan routes, and Europeans were in search of a direct route to procure the riches of the east, namely spices, dyes and textiles. Many of these were available in India, where many crops, ranging from rice to cotton, were easily raised in this well-watered subtropical land. By far the greatest power on the Indian subcontinent was the Mughal dynasty (r.1526–1858), the greatest, richest, and longest-lasting Muslim dynasty to rule India. Their wealth dwarfed that of their contemporaries in the Islamic lands and enabled them to build enormous cities and monuments that projected their power over a diverse population of Muslims, Hindus and Jains.

171
Ben Yusuf
madrasa,
Marrakesh,
1564–5. View
of courtyard

Descended from the Timurid dynasty of Iran and Central Asia and their Mongol predecessors (whence the name Mughal), the Mughals drew upon Timurid models and artists for their art and architecture. These were combined with indigenous materials and techniques of construction to create a new and distinctive style. This style was seen in the capitals that these peripatetic monarchs established at Delhi, Agra, Lahore and elsewhere to control their vast empire. The constant movement of the Mughal court was designed not only to squash any possibility of internal revolt but also to project the unlimited power of the monarch.

One of the best examples of this Mughal style is the city of Fatehpur Sikri, the new capital founded in 1571 by the emperor Akbar 40 km (25 miles) west of Agra in the midst of a vast plain overlooking a large lake, now dry. Fifty years earlier, Akbar's grandfather Babur, a minor Timurid princeling who fled Farghana to seek his fortune in India, had constructed a garden and pavilion at the site, near the town of Sikri. In 1568 the Sufi shaykh Salim Chishti, who lived nearby, presciently predicted that Akbar would soon have three sons; to commemorate the event Akbar ordered the construction of a new city known as Fathabad (City of Victory), a Persian name which was soon supplanted in popular usage by the Indianized form Fatehpur Sikri. Construction was largely finished within a decade, but the emperor seldom returned to this city, probably because he had to deal with military and political problems elsewhere.

Most of Fatehpur Sikri can be dated to the fourteen years when it was Akbar's principal residence. Like Safavid Isfahan, Fatehpur Sikri was planned and built in a relatively short time under a single patron. Its plan is marked by a unity of design based on proportional modules and ratios; its construction is unified by the fine red sandstone quarried on the nearby ridge and used for the buildings throughout. The city, extending from the old town of Sikri to the hermitage where Salim Chishti lived, is protected by 11 km (7 miles) of stone walls with parapets and gateways. The settlement once spread 20 km (12 miles) beyond

172
Buland
Darvaza,
Fatehpur Sikri,
India, 1573–4.
Gateway to the
congregational
mosque

the walls to encompass imperial gardens, resthouses, residences, and a drinking and gambling zone.

The largest building in the city is the congregational mosque, a huge rectangular structure set on top of the ridge. Like earlier Indian mosques, the building is further raised on a high platform. A vast courtyard surrounded by arcades contains the tomb of Salim Chishti. Like all saints' tombs in this period, it was built of white marble and is immediately distinguishable from all the other buildings at the site. Opposite it along the south wall stands the Buland Darvaza, the 'Lofty Gate' that served as the main entrance to the mosque from the city (172). The royal quarters, with both public and private spaces, were set to the northeast of the mosque and contained several palaces arranged around large courtyards. While the religious buildings at the site use the traditional Islamic architectural vocabulary of arches and domes, these secular buildings use trabeate construction (173), the system of stone posts and beams that was traditional to

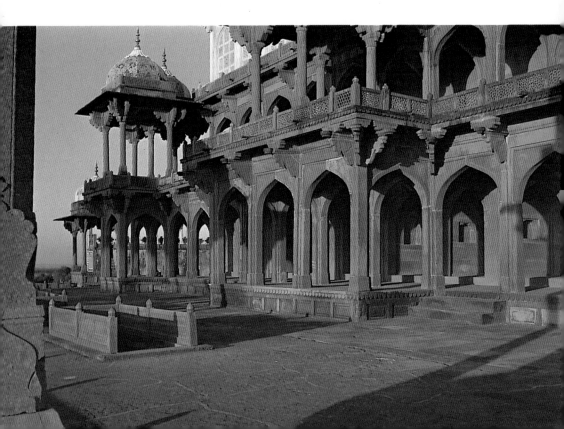

architecture in India. To judge from contemporary representations of palaces in illustrated books, the severe lines would have been softened by cloth awnings and screens, and brightly coloured tents may have been erected in the courtyards.

Akbar was buried outside of Agra in a mausoleum set in the midst of a vast garden enclosed by a high wall and divided by water channels. This arrangement, which had already been used for his father Humayun who was buried at Delhi, became standard for Mughal emperors. By far the most famous example, and indeed one of the landmarks of world architecture, is the Taj Mahal (174), the tomb that Akbar's grandson Shah Jahan built in memory of his favourite wife Mumtaz Mahal. Work on the tomb began soon after Mumtaz Mahal's unexpected death in 1631, and the building was completed by 1647. The tomb is set in a large garden divided by water channels, but unlike earlier examples, the tomb was placed not at the centre of the garden but at one end overlooking the Jumna River to increase the visual impact from the monumental gateway at the opposite end of the garden. The tomb and the high platform on which it is set are built of highly-polished white marble, for by this point marble – which is harder and more difficult to cut – had replaced the soft sandstone originally used for imperial structures. The octagonal shape of the domed tomb, framed by four minarets, derives not only from the long Iranian tradition of octagonal mausoleums (see 87) but also from the Iranian tradition of garden pavilions. Known as Hasht Bihisht, or 'Eight Paradises', these pavilions had four blocks of rooms arranged around a central space. The main effect of the Taj Mahal derives from its form, for the decoration is extremely restrained, being limited to panels of inscriptions and flowering plants (see 151). The decoration drives home the message implicit in the building's form and location that the tomb represents the Throne of God above the gardens of Paradise on the Day of Judgement, an image ultimately derived from the description of Paradise in the Koran. In contrast, the motif of a flowering plant growing naturally from a stem in the ground was foreign to the Islamic tradition of arabesque. The motif copies engraved

173
The Panj
Mahal,
Fatehpur Sikri,
India, late 16th
century

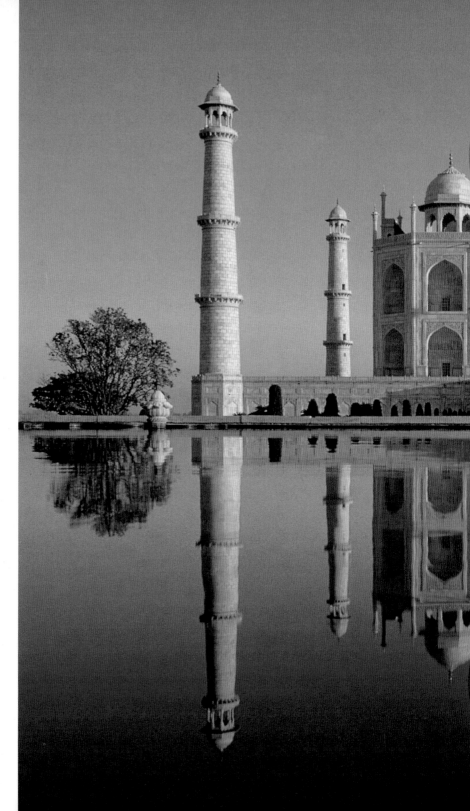

174
The Taj Mahal,
Agra, 1631–47

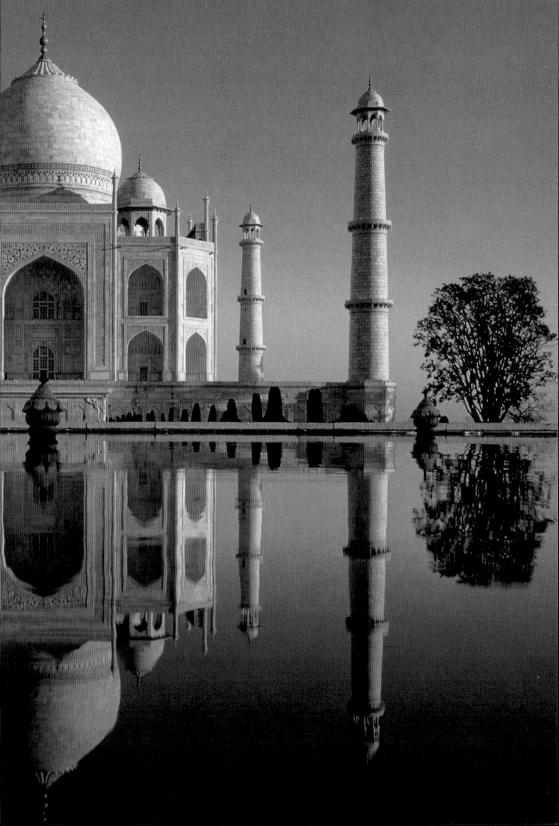

illustrations found in European herbals that were brought by Jesuit missionaries to India in the early seventeenth century. From this time the motif became ubiquitous in all the arts produced for the Mughals (see 207).

In many ways the Taj Mahal represents the end, rather than the beginning, of a tradition. The emperor Awrangzeb, the son of Shah Jahan and Mumtaz Mahal, adhered to orthodox tradition that condemned the use of elaborate tombs, being buried in a grave marked only by a simple stone. The rise of European power in India left few of Awrangzeb's successors the means or the opportunity to erect elaborate tombs. Apart from the mausoleum erected at Delhi in the eighteenth century by the nawab of Oudh, the Taj Mahal spawned few successors in India. The glowing reports and engravings of Europeans, however, made it a familiar image in the west, where it was reproduced on everything from Staffordshire crockery to wallpaper and inspired such Oriental fantasies as the Royal Pavilion at Brighton.

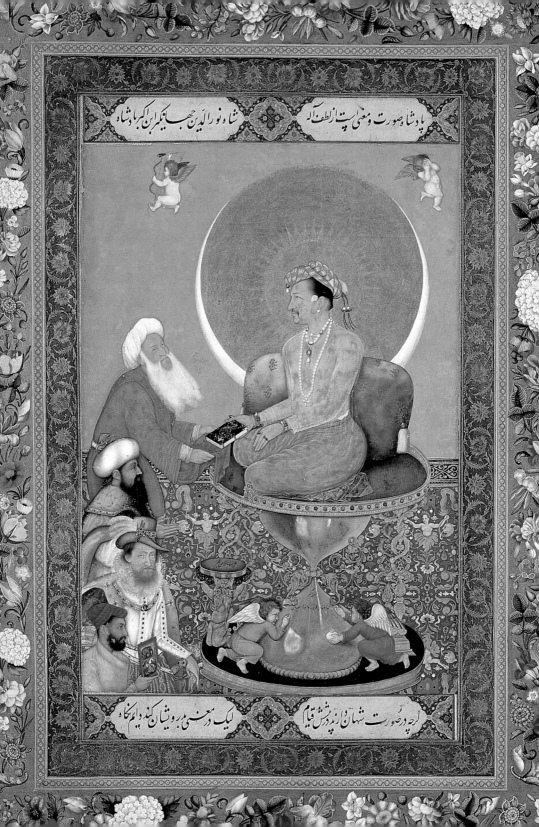

The Persian style of book that had been developed by the
Timurid princes in the fifteenth century was not only continued
by the Safavid rulers of Iran in the sixteenth and seventeenth
centuries, but also adopted by the Ottoman court to the west
and Mughal court to the east, where Persian language and culture
was deeply appreciated. The book as the work of art was slowly
replaced by the single page of calligraphy, drawing or painting,
intended to be collected in albums. This altered format reflected
not only a change in patronage, but also the increased recognition
of the achievement of the individual artist, and it is only from this
period that the careers of artists can be reconstructed with some
certainty. The representational arts were also affected by the
availability of Western images, which brought to the Islamic
lands such new techniques as cast shadows, vanishing-point
perspective. and oil painting on canvas.

The most common type of manuscript copied in the Islamic lands
remained the Koran, and manuscripts continued to be produced
in the time-honoured tradition, following the styles of calligraphy
codified and perfected by the great masters of the middle period.
The Ottoman calligrapher Shaykh Hamdullah, for example,
wrote in a clear cursive script (177) in the tradition of the great
thirteenth-century master, Yaqut al-Mustasimi. Shaykh Hamdullah
taught calligraphy in Amasya, where the young Ottoman prince
Bayezid had been sent as governor. When Bayezid became
sultan in 1481, he brought his teacher to Istanbul and assigned
him a studio in the palace. Shaykh Hamdullah became the major
calligrapher of the age and is said to have revised the six scripts
that had been canonized by Yaqut.

In this age of imperial studios, early specimens of calligraphy were
prized as exemplars, and manuscripts of the Koran that had been

175
Bichitr,
Jahangir
Presenting a
Book to a Sufi,
India,
*c.*1615–20.
Ink and colour
on paper;
28 × 18 cm,
11 × 7 in.
Freer Gallery
of Art,
Washington,
DC

176
Opening
double-page to
a manuscript
of the Koran
copied by Yaqut
al-Mustasimi
1282–3 and
refurbished in
the mid-16th
century in
Istanbul.
Ink and colour
on paper;
34×23 cm,
15¹⁄₃×9 in
(each page).
Topkapi Palace
Library, Istanbul

177
Left half of the
opening
double-page to
a manuscript of
the Koran
copied by
Shaykh
Hamdullah,
Istanbul
1491.
Ink and colour
on paper;
16×11 cm,
6¹⁄₄×4¹⁄₄ in.
Topkapi Palace
Library, Istanbul

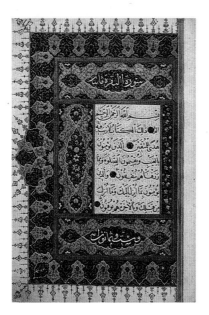

copied by Yaqut or one of his followers were often refurbished.
For example, a fragment of the Koran bearing the purported
signature of Yaqut al-Mustasimi and the date 1282–3 was
refurbished in the mid-sixteenth century (176). The brownish
pages of calligraphy were mounted within larger white margins;
the three lines of script were enclosed by cloud panels filled with
arabesques, and the borders were embellished with gold and
blue flowers and scrolls. These prized manuscripts were often
presented from one monarch to another in a ritualized system
of gift-giving where the recipient remained beholden to the donor
until he could present a more magnificent gift in exchange. The
Safavid shah Tahmasp sent several embassies to the Ottoman
sultan Suleyman; among the gifts presented were Koran
manuscripts by famous masters. This fragment, which shows
stylistic features characteristic of both Safavid and Ottoman
illumination, might have been one of the gifts sent from Tabriz
to Istanbul, where it would have been mounted and rebound.

In the new Ottoman capital, many manuscripts of the Koran and
other religious texts were needed to supply the great foundations
established there by the sultans. A magnificent walnut box (178)
made by a certain Ahmad ibn Hasan in 1505–6 was probably

commissioned by Sultan Bayezid for his mosque in Istanbul that was completed in that year. The hexagonal box with a hinged lid surmounted by a twelve-sided pyramid and carved ebony and ivory finial is the earliest example of a distinct Ottoman style of woodwork and one of the finest pieces extant. The exterior is encrusted with ivory panels bearing koranic inscriptions; the interior is inlaid in fine woods, ivory and gilt brass. The chest is divided into thirty compartments to hold a multi-volume Koran of oblong format, quite different from contemporary manuscripts, which were normally vertical in format and bound in a single volume. The particular manuscript of the Koran for which this chest was intended has not yet been identified, but the oblong and multi-volume format suggests that the box was intended to hold an early kufic Koran that Bayezid had had restored. The similarity of the decoration on the Koran chest to both ivory

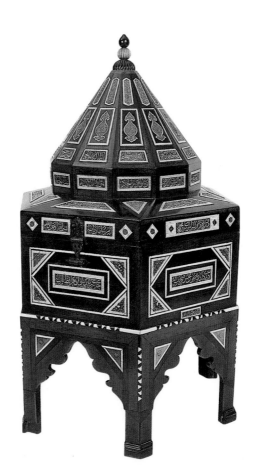

178
Hexagonal
box for a
manuscript
of the Koran,
Istanbul,
1505–6.
Walnut inlaid
with ivory and
coloured wood;
h.82 cm,
32¹⁄₃ in.
diam. 56 cm,
22 in.
Museum of
Turkish and
Islamic Art,
Istanbul

179
Double-page
frontispiece to
a calligraphic
album by
Ahmed
Karahisari,
Istanbul,
c.1550.
Ink, gold and
colour on
paper;
50×35 cm,
19²⁄₃×13³⁄₄ in
(each page).
Museum of
Turkish and
Islamic Art,
Istanbul

carving in late Mamluk Egypt and contemporary inlaid wood from northern Italy is no surprise, for the court at Istanbul attracted artisans from all over the eastern Mediterranean lands.

A double-page frontispiece (179) from a calligraphic album of koranic quotations, *hadith*, prayers and extracts from the *Qasidat al-Burda*, the poem about the Prophet's mantle, also shows how Ottoman artists drew on many sources. It was penned by the most famous calligrapher of the sixteenth century, Ahmed Karahisari (1469–1556), who is known for his use of 'chain' script, in which the letters are joined as though the pen had never been lifted from the page. This frontispiece displays two different examples of this script: on the right is the *basmala*, or invocation to God, sandwiched between examples of a script often known as Square Kufic, in which the curves of all letters have been transformed into right angles. The upper block has the words 'Praise God' written four times, while the lower block contains the entire text of chapter 112 from the Koran. On the left is a pious phrase, 'Praise to the Successor of Praise', chosen more for its symmetry and calligraphic potential than its meaning. Both text and script resemble works made for the libraries of the late Mamluk sultans in Cairo. When the Ottomans

took Cairo in 1517, many of these works were taken as booty to Topkapi Palace in Istanbul, where they served as models for artists in the employ of the court. This frontispiece juxtaposes two extremes of the calligrapher's art: the chain script shows how a master calligrapher could exercise total control over the flowing line, while the square script shows how he could ingeniously fit a complicated text into a rigid grid without leaving any extraneous spaces.

Court workshops were not the only centres of manuscript production in the Islamic lands, and the city of Shiraz in southwest Iran continued to be a centre for commercial production in the later period. A visitor in the sixteenth century described small family businesses where fathers, sons and even daughters participated as scribes, painters and binders. He said that such workshops could easily produce a thousand books a year. Most of the calligraphers were anonymous, but one exception is Ruzbihan Muhammad who was the most famous scribe-illuminator of sixteenth-century Shiraz. He worked there from 1514 to 1547, to judge from the manuscripts he signed, and apparently learned his art from his father, who was also a famous scribe. Ruzbihan Muhammad made at least one manuscript at a shrine, showing that shrines could also be centres of manuscript production, along with commercial establishments, royal courts and libraries. His finest work is a manuscript of the Koran copied in a combination of scripts written in many colours on different backgrounds (180). The illumination on the opening pages with the text of the Fatiha, the first short chapter of the Koran, show finely executed details. There is a very similar frontispiece in the Sackler Gallery in Washington, DC, which has been detached from another manuscript. The size and composition are the same, but the details, such as the colours and spacing of words, are different, suggesting that the artist used templates for his general compositions but executed the details freehand.

Although illustrated manuscripts were produced commercially in Shiraz and other centres, the finest illustrated manuscripts were

produced in the workshops maintained by the great royal courts. The one at Tabriz sponsored by the Safavid ruler Tahmasp I (r.1524–76) was the most important in the early sixteenth century. As at Istanbul, artists from all over the realm were brought to the capital to forge a new dynastic style that combined the traditions of papermaking, calligraphy, illumination, ruling, painting and binding. The two most important sources for this new style were the refined tradition associated with Bihzad (see 112) and his school in Herat and the wilder tradition associated with the Turkoman courts in Tabriz (see 115). Under Tahmasp's patronage, these divergent strands were

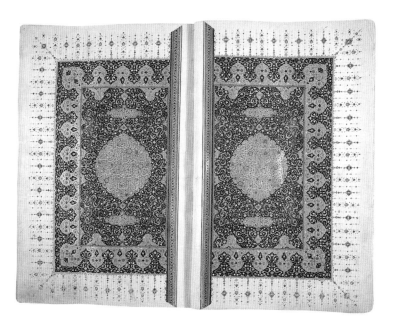

woven together to produce a harmonious and unified style that is considered the apogee of the arts of the Islamic book.

The biggest project carried out under Tahmasp was a monumental two-volume copy of the *Shahnama*; its 742 pages contained 258 illustrations executed over a decade by many artists whose talents ranged from brilliant to plodding. The large format and great number of illustrations in the manuscript were unusual in its time, since most other copies of the Persian national epic were smaller and had far fewer illustrations. This new format was

apparently inspired by the model of the Great Mongol *Shahnama* (see 105) that had been made at Tabriz some two centuries earlier and kept in the court library there. Only one painting in the Safavid manuscript, *King Ardashir and his slave-girl Gulnar* on folio 516b, is dated (1527–8). It depicts the founder of the Sasanian dynasty cuddling his beloved concubine under a quilt; the romantic illustration may well allude to the fourteen-year-old Tahmasp's first comparable experience that year. In 1567–8, after Tahmasp had tired of the arts, he used this valuable manuscript to enhance his prestige by presenting it to the Ottoman sultan Selim II. For centuries it remained virtually unopened in the Ottoman imperial collection. By 1903 it had entered the collection of Baron Edmond de Rothschild, whose family sold it in 1959 to an American collector, Arthur Houghton. The manuscript was then dismembered and individual pages sold at auction. In 1994 after Houghton's death, his heirs swapped the remains of the manuscript – comprising 501 text pages, 118 paintings and the binding – for a painting of a nude woman by the Dutch-born American painter Willem de Kooning that the Iranian government found offensive. So, after 450 years, much of this magnificent manuscript has finally returned to its country of origin.

The most brilliant painting in the manuscript, *The Court of Gayumars* (152, 181), is considered by many to be the greatest painting from a Persian manuscript. It depicts the first king of Iran, the benevolent Gayumars who ruled from a mountaintop. During his reign mankind learned how to prepare food and clothe themselves in leopard skins; in his presence wild animals became meek as lambs. At the apex of the composition stands the king; he looks mournfully down at his seated son Siyamak, who will be killed in battle with the black demon. Opposite Siyamak on the left stands Gayumars's grandson, the willowy Prince Hushang, who will revenge his father's death and save the Iranian throne. Before them, the members of Gayumars's retinue gather in a circle in a fantastic landscape against a gold sky. This image, like that of the young Ardashir, may allude to contemporary events, and the young Tahmasp may have seen himself as Hushang, for the young

Safavid ruler had reestablished the dynasty's authority after the devastating defeat at the hands of the Ottomans at Chaldiran in 1514.

Already in the sixteenth century, this painting was recognized for its greatness. In 1544 Dust Muhammad, the Safavid painter, chronicler and librarian, who himself added one painting to this manuscript, enumerated the artists working at Tahmasp's studio:

First is the rarity of the age, Master Nizamuddin Sultan-Muhammad, who has developed depiction to such a degree that, although it has a thousand eyes, the celestial sphere has not seen his like. Among his creations, depicted in His Majesty's Shahnama is a scene of people wearing leopard skins: it is such that the lion-hearted of the jungle of depiction and the leopards and crocodiles of the workshop of ornamentation quail at the fangs of his pen and bend their necks before the awesomeness of his pictures.

Despite the florid prose typical of Safavid historical writing, this detailed description makes it certain that Sultan-Muhammad painted this very picture.

Although the *Shahnama* was the biggest project carried out in Tahmasp's court workshop, it was not the only one. Luxury copies of many of the classics of Persian literature were also produced for the ruler. One of the finest to survive is a copy of Nizami's *Khamsa* penned at Tabriz by the famous scribe Shah Mahmud of Nishapur between 1539 and 1543. One-third smaller than the *Shahnama*, the volume was still lavishly illuminated and illustrated with full-page pictures. The wide margins are enhanced with drawings executed in gold touched with silver showing animals cavorting in windblown landscapes. The illustrations are more uniform in conception, execution and finish than those in the *Shahnama*, showing that this was a more manageable project. The paintings were executed separately and pasted into spaces left for them in the text. At least fourteen were done in the sixteenth century and three others added a century later when the manuscript was refurbished.

181
Sultan-Muhammad,
The Court of Gayumars,
from the copy of the *Shahnama* prepared for Shah Tahmasp, Tabriz, 1525–35.
Ink, colour and gold on paper; 34×23 cm, 13¹⁄₃×9 in.
Prince Sadruddin Aga Khan, Geneva

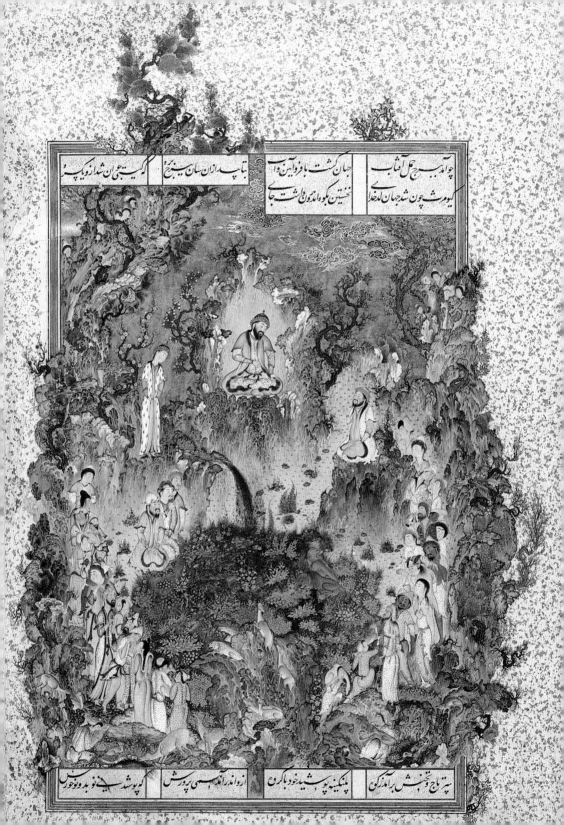

One of the most memorable images in this manuscript depicts the *Miraj*, or the ascent of the Prophet to Heaven. The event, which had been alluded to in the Koran (17.1), took on a life of its own in the hands of mystics and poets who lovingly elaborated its details. Here, the few lines in Nizami's text have been transformed into a radiant vision of faith and glory (182). The Prophet Muhammad, dressed in green and veiled in white, blazes in a huge flaming halo against a starry blue sky, where curling white clouds obscure a haloed golden moon. Buraq, the human-headed steed who bears him through the seven heavens to the Divine Presence, is led by the angel Gabriel, crowned with a smaller flaming halo. The Prophet is surrounded by angels bearing splendid golden vessels and a book, presumably the Koran. This painting is a fitting culmination to the art of the illustrated book in Safavid Iran, for soon after this manuscript was completed Tahmasp wearied of calligraphy and painting, and many of the finest artists were forced to seek employment elsewhere, whether at princely courts in Iran or at Mughal courts in northern India.

Firdawsi's *Shahnama* and Nizami's *Khamsa* were among the most popular texts to be illustrated in Iran, for rulers and others enjoyed reading about the exploits of their illustrious predecessors. The five romantic epics of the *Khamsa* were also popular tales with wide appeal. Since Persian was the court language in Ottoman Turkey and Mughal India, Persian literature was also appreciated there, and such works served as models for book production abroad. The subjects were changed, however, to suit local patrons who were not rulers of Iran. In Ottoman Turkey, for example, the sultans might have appreciated the literary qualities of Firdawsi's work but would have had little interest in its historical aspects. They had their court historian, known as the 'master of the *Shahnama*', compose new epics modelled on Firdawsi's original but extolling the exploits of the reigning Ottoman sultan and his ancestors.

The most important and largest of these Ottoman epics was a five-volume history of the Ottoman dynasty by the historian Arifi.

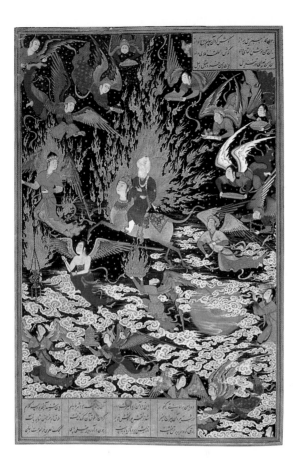

182
Ascension of the Prophet Muhammad, from the copy of Nizami's *Khamsa* prepared for Shah Tahmasp, Tabriz, c.1540. Ink, colour and gold on paper; 28 × 19 cm, 11 × 7½ in. British Library, London

Born to a Persian family, he probably came to the Ottoman court after 1517 and was eventually appointed court historian and given a studio where he supervised the calligraphers and five painters employed on this project. The first volume dealt with the Creation and the early prophets; the second, the rise of Islam; the third, earlier Turkish rulers; the fourth, the foundation of the Ottoman Empire; and the fifth, the reign of the ruling sultan Suleyman the Magnificent who commissioned the work. Only three of the original volumes have survived, of which the presentation copy of the fifth volume is particularly magnificent. Known as the *Suleymannama* ('History of Suleyman'), it was finely calligraphed in 1558 on 617 pages of gold-speckled and polished paper, with exquisite illumination and sixty-nine large illustrations, of which four are double-page.

The double-page illustration depicting the Ottoman siege of Belgrade in 1521 (183–4) is particularly interesting because it shows how Ottoman artists adapted and changed Persian models for their book illustrations. The left page, which shows the Ottoman camp of tents, is clearly derived from Persian models. The space has been rendered as a flat, vertical plane rising above a stream which meanders across the bottom of the two pages. The brightly coloured tents are rendered in profile and set one behind the other in overlapping planes. The central and largest

183–184
The Siege of Belgrade, Double page illustration from a manuscript of Arifi's *Suleyman-nama,* Istanbul, 1558. Ink and colour on paper; 36.5×25.4 cm, 14³⁄₈×10 in (each page). Topkapi Palace Library, Istanbul

figure is the sultan, who is enthroned in front of a royal canopy and surrounded by rows of retainers. The costumes, however, show that this is an Ottoman painting, for the figures wear large white turbans or fez-like caps. In contrast, the scene on the right-hand page, which shows the besieged Hungarian city, is derived from European models, for different techniques are used to depict space and the defenders of the city. The buildings are shown in three dimensions with shading, the figures make broad gestures that contrast with the static Ottomans, and the colours are much

more subdued than the brilliant ones used on the left. While these differences may have been intended to contrast the calm of the Ottoman camp with the panic of the city's defenders, they also show that Ottoman painters, much like Ilkhanid painters two centuries earlier in Iran, were still in the process of creating a unified style out of disparate elements that had been brought from both east and west.

The double-page format, which had been used sparingly – mostly for frontispieces – in Persian books, became especially popular in Ottoman book painting, because the large space gave more scope for portraying costumes and settings in greater detail. This illustration is still anchored in the text, for couplets appear in the upper right and lower left corners of each page, but the trend is unmistakable: the image was becoming increasingly independent of the text. The *Suleymannama* paintings also show the Ottoman interest in depicting topography and relatively recent events rather than the activities of long-dead heroes.

Ottoman interest in topography was undoubtedly spurred by their territorial ambitions, for they were clearly intent on conquering the former lands of the Roman Empire and reestablishing it under their rule. They had already expanded from Anatolia into Europe in the late fourteenth century, and by 1517 had taken all of Syria, Egypt and Arabia. Iraq and most of North Africa were soon incorporated into the empire, while Ottoman troops were besieging European capitals and the Ottoman navy was fighting in the Mediterranean. Although the Ottomans had no desire to conquer the New World, which had just been 'discovered' by the Spanish and Portuguese, Ottoman interest in global geography is shown by a parchment map of the world by Piri Reis, a captain in the Ottoman navy. The right half, which depicted Eurasia, China and the Indies is now lost, probably because it was used at sea by Ottoman navies operating in the Indian Ocean. Only the left half (185) which shows Brittany, the Iberian Peninsula and West Africa along its right side and the outline of the Americas along its left, has survived. The author claims to have consulted a wide range of

**185
Piri Reis,**
Map of the
Atlantic Ocean,
1513.
Ink and colour
on parchment;
90 × 63 cm,
35⅜ × 24⅜ in.
Topkapi Palace
Library, Istanbul

sources, including four Portuguese maps and a Spanish slave
who had sailed with Columbus on his three voyages to the New
World. This map, which is dated 1513, only twenty-one years
after Columbus's first voyage, has great historical importance
since none of Columbus's maps is known to have survived. While
the land masses are depicted with uncanny accuracy, they are
populated with a range of fantastic creatures and legendary
vignettes, including one scene in the upper right showing sailors
lighting a fire on an island that they quickly discover to be the
back of a whale! Ottoman interest in cartography was felt in the
court studios, where artists incorporated topographical details in
their book illustrations.

Artists in Mughal India also adapted Persian traditions of book
painting, as well as other arts of the book, to meet the needs and
tastes of new patrons. Palm-leaf books had long been made in
India for Hindu, Jain and Buddhist texts. The arts of the Islamic
book had been practised in northern India since Muslims had
established sultanates there in the twelfth century, but due to the
damp climate and successive invasions, only a few manuscripts of
the Koran and of literary works survive from the Sultanate period.
The arts of the book in India were reinvigorated in the mid-

sixteenth century by the Persian artists who had left Safavid Iran after Tahmasp's interest in painting and calligraphy waned. A great flowering of Indian book painting took place under the emperor Akbar (r.1556–1605), when the imperial studio, which followed his peripatetic court, swelled to more than a hundred artists. The manuscripts they produced were as splendid as those that had been made earlier in Iran and represent the apogee of book production under the Mughals.

The emperor's taste was catholic, ranging from the classics of Persian literature to the *Mahabharata*, the great Hindu epic, which he ordered translated from Sanskrit into Persian. The Mughal emperors greatly enjoyed Persian literature, and their library included many of the finest manuscripts from the Timurid royal library in Herat. Like the Ottoman sultan Suleyman, the Mughal emperor Akbar ordered chronicles of the lives and deeds of his ancestors and himself. Each of these grand historical manuscripts had as many as 500 pages with some 150 full-page illustrations. To keep up with the demand for illustrations, teamwork was required, and we know that different artists were responsible for such specialties as outlines, colour, finishing and faces. The illustrations in these manuscripts provide an invaluable pictorial record of recent military campaigns, court ceremonies and the personal exploits of the emperor. For example, a picture of *The Construction of Fatehpur Sikri* (186) from the *Akbarnama*, which tells the history of Akbar's reign, shows stonemasons and labourers at work on the Elephant Gate in the emperor's new capital. Wooden scaffolding still supports the arch of the gateway, but the waterworks at the left are already in working order.

The emperor Akbar also commissioned new manuscripts of several classics of Persian literature. Exquisitely calligraphed on thick creamy paper, these manuscripts are embellished with paintings, illumination, marginal decoration and painted-and-varnished covers. The texts include Nizami's *Khamsa* and Jami's *Baharistan* ('Abode of spring'), as well as the *Khamsa* of Amir Khusraw Dihlavi (1253–1325), the greatest Persian poet of India.

186
The Constructruction of Fatehpur Sikri, from the first copy of the *Akbarnama*, India, c.1586–7. Ink and colour on paper; 38×24 cm, 15×9⅜ in. Victoria and Albert Museum, London

The poet, who was descended from a Turkish family, became a courtier to the sultans of Delhi (hence his epithet Dihlavi, meaning 'of Delhi') as well as a Sufi shaykh in the Chishtiyya order. His most famous work, the *Khamsa*, or 'Quintet' was composed between 1298 and 1302 in frank imitation of Nizami's twelfth-century poem. It became a particular favourite in India.

A small but exquisite copy of this text prepared at Lahore in 1597–8, presumably for the emperor himself, once had twenty-nine illustrations, of which eight have been detached. One image (187) retells Nizami's story of an Arab youth named Qays who is driven mad (*majnun*) by his love for the beautiful Layla. Emaciated and dressed in rags, he wanders among the wild beasts where he is visited by his grieving father. This story of unrequited love, equivalent to *Romeo and Juliet*, was a perennial favourite. The hero is shown here kneeling before his father, surrounded by animals in a rocky landscape, and the muted tonalities emphasize the feeling of dignified sorrow. As in the Ottoman Empire, Mughal artists modified what they had learned from Persian painting to suit their own needs and tastes: distinctly Indian features here include the loving rendition of animals, the fantastic landscape and the European-inspired depiction of an Indian palace in the distant background.

European prints and representations were available in India following the establishment of European trading colonies along the Indian coast in the sixteenth century, and Mughal artists were quick to incorporate European techniques of shading and atmospheric perspective into their work, as well as to copy European prints and drawings they saw. The interest was reciprocal, and Mughal works were brought to Europe where artists such as Rembrandt made copies of Mughal paintings they collected. In 1600 the East India Company was granted a charter, and from that time the English became frequent visitors at the Mughal court.

Illustrated manuscripts had never been popular in the western Islamic lands, probably because of religious conservatism and the

187
Majnun Visited by His Father, from a manuscript of Amir Khusraw Dihlavi's *Khamsa,* Lahore, 1597–8. Ink and colour on paper; 28.5 × 19.5 cm, 11¼ × 7⅔ in (page). Walters Art Gallery, Baltimore

great distance from Iran, where illustrated books were particularly popular. Manuscripts of the Koran remained the primary type of fancy book produced in North Africa, and even this tradition was unusually conservative. Koran manuscripts in North Africa continued to be copied in squarish parchment books long after vertical-format paper books had been adopted in the eastern Islamic lands. While the vertical format and the use of paper was eventually adopted for manuscripts of the Koran, a distinctive North African script – known as *maghribi* from the Arabic word for North Africa – was retained. Other Arabic scripts exploit the contrast between thick and thin lines, but the letters of *maghribi* script are of uniform thickness and characterized by swinging loops that descend from a horizontal baseline. These features can be seen in a manuscript of the Koran (188) copied in 1568 for the Sharifan sultan Abdallah ibn Muhammad, the man who ordered the Ben Yusuf *madrasa* in Marrakesh (see 171). The lavish use of gold to decorate pages at the opening and closing of the book and to mark the beginnings of chapters and ends of verses in the text

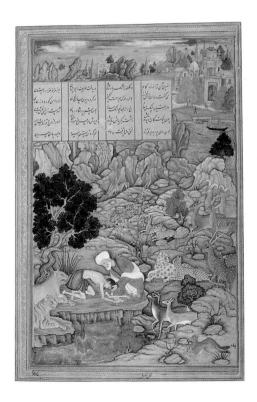

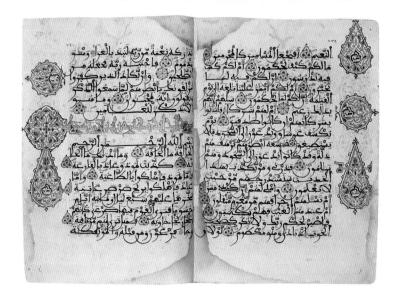

is another characteristic feature of luxury manuscripts from this region. Gold was readily available because it was traded for salt with Africa south of the Sahara, and indeed, Abdallah's greatest successor, his brother Ahmad al-Mansur (r.1578–1603), earned the epithet 'the golden' because he extended his power across the west of Africa into northern Nigeria. Not only did he gain control of the great salt pans in the Sahara but he also received enormous booty and tribute in gold, which financed his building projects at home.

In the seventeenth century the illustrated book became less important in Iran, India and the Ottoman Empire, where it had flourished in the sixteenth, as single-page works of art became increasingly popular everywhere. An illustrated book was an expensive art object that only the wealthiest could afford, but a single sheet was much cheaper and well within the means of a far larger clientele. These single pages included not only exquisitely calligraphed samples of the writer's art embellished with illumination, but also individual studies of flowers, animals and people. The first albums, which had been assembled in Iran in the fifteenth century, were like scrapbooks, with a jumble of pictures and texts from earlier works cut out and pasted together, but by the seventeenth century, royal collectors often had single sheets

mounted into albums with decorated borders that attempted to give some unity to a heterogeneous assortment of elements by different artists in different styles.

There are several explanations for the popularity of the single image. As book illustrations became increasingly large and complex, it was difficult if not impossible to paint them on the pages of the book itself. They were consequently painted on separate sheets which were later pasted into the book. The division of labour in manuscript production was accompanied by the emergence of distinct artistic personalities who had recognizable personal styles. Calligraphers had long enjoyed special status as artists in the Islamic lands, and their names and artistic genealogies can often be traced for centuries. It is only in the fourteenth century in Iran, however, that the names of painters are known for the first time, and it is only at the end of the fourteenth century that the names can be matched with surviving paintings. The careers of a few famous fifteenth- and sixteenth-century painters, such as Bihzad or Dust Muhammad, can begin to be delineated from their works and from notes about them in contemporary writing, but much of the information is anecdotal and even the basic facts of birth and death are often controversial. In this period artists rarely signed their paintings, and attribution – using details of style and technique to connect a given work with a given artist – remains the primary means of establishing the works of a particular artist. This situation changed dramatically in the seventeenth century: artists increasingly signed their works, they prided themselves on distinct personal styles, and the development of these styles can be traced through dozens of examples produced over decades of work.

All of these features can be seen in the work of Riza, often known as Riza Abbasi because he worked for the Safavid shah Abbas (r.1588–1629). The son of Ali Asghar, a Safavid court artist, Riza was born in 1565, probably at Kashan and died in 1635, probably at the capital Isfahan. He became active in the 1580s, when the country was in chaos under the ineffective Muhammad

189
Riza,
*Young Man in
a Blue Coat*,
Isfahan, *c.*1587.
Ink and colour
on paper;
13×7 cm,
5$\frac{1}{8}$×2$\frac{3}{4}$ in.
Harvard
University Art
Museums,
Cambridge,
Massachusetts

Khudabanda (r.1578–88) and artists could not rely on royal patrons. Artists had to seek other means of support and single-page portraits (189) became Riza's main source of income. Riza's early work is exemplified by his charming and sensitive depiction of a Young Man in a Blue Coat, with delicate lines and large expanses of bold colour. The loose ends of the turban and sash show a distinctive fluttering edge that became the artist's hallmark. Later in his life, Riza replaced the idealized courtly youths of his early period with more realistic depictions of workers, mystics and even nude women. This change in subject matter has often been attributed to a mid-life crisis, when he abandoned the company of courtiers and princes and began to associate with wrestlers and ne'er-do-wells.

190
Muin, *Tiger
Attacking a
Youth*, Isfahan,
8 February
1672.
Ink and colour
on paper;
14×21 cm,
5$\frac{1}{2}$×8$\frac{1}{4}$ in.
Museum of
Fine Arts,
Boston

Riza's most gifted pupil was Muin (c.1617–97), known by the epithet musavvir ('the painter'), who, like his teacher, is known for his single-page compositions. They are distinguished by brilliant

draughtsmanship and keenly observed details, as can be seen in a drawing in brown ink with red highlights showing a tiger attacking a youth (190). It has a long inscription explaining the circumstances surrounding its creation:

On Monday, the day of the feast of the blessed Ramadan of the year 1082 [corresponding to the date 1672 AD], the ambassador from Bukhara brought a tiger and a rhinoceros as gifts for his most exalted majesty Shah Sulayman. At one of the city gates known as Darvaza-Dawlat, the tiger jumped up suddenly and tore off half the face of a grocer's assistant, fifteen or sixteen years old, and he died within the hour. We heard about the grocer but did not see him. This was drawn in memory of it.

The unusually long inscription continues with many irrelevant but fascinating details about life in the Safavid capital at that time:

And in that year from the beginning of the second half of the honourable month of Shaban until now, the eighth day of Shawwal, there have been 18 heavy snowfalls of such magnitude that the trouble of shovelling snow has exasperated people. The price of most goods

has gone up, and firewood and kindling are still unobtainable. The cold was such that there are no glass bottles or rosewater bottles left. May God end it well. It is Monday the eighth of the month of Shawwal of the year 1082. Heavy snow is falling. We stayed at home because of the cold. It was drawn by Muin Musavvir.

Muin chose an unusual subject and he needed a long caption to explain it because it did not fit into the accepted categories of contemporary art. It is difficult to imagine who would have bought such a drawing, except for people who already appreciated Muin's special style. The long inscription also gives us the exact time, temperature and place of execution. Muin did the drawing on Monday 8 February 1672, when confined at home by an unusually long spell of cold weather. This cold spell may be related to the 'Little Ice Age' in northern Europe, when the Thames River froze solid and a fair was held on the ice in the winter of 1683–4. That the artist worked at home shows how seventeenth-century painters were increasingly independent of royal patrons and their court workshops.

In India the Mughal court, which remained far richer than the Safavids ever were, continued to be the major patron of the arts, although there too a taste for single-page works developed. The emperor Akbar, for example, commissioned portraits of his chief nobles which were bound into albums, and in the early seventeenth century his son, the emperor Jahangir, ordered several splendid albums compiled. They combined calligraphy with portraits, genre scenes, animal and flower studies, and foreign images – Persian and European paintings and European prints – as well as Mughal copies. Often the albums were arranged so that facing pages of calligraphy alternated with facing images, but all pages were mounted in similar borders painted in gold and colours.

A painting by the artist Bichitr (see 175) removed from a sumptuous album in St Petersburg shows the emperor Jahangir presenting a book to the aged Shaykh Husayn, superintendent of the shrine of Muin al-Din Chishti at Ajmer where Jahangir lived

The Great Empires 1500–1800 AD

from 1613 to 1616. In the lower left are small representations of a Ottoman sultan, King James I of England, and a Hindu who is holding a painting of himself bowing. This small figure seems to be a self-portrait of the painter, who was a well-known portraitist. His Indian name suggests that he was one of the many Hindus employed in the court workshop and responsible for developing the distinct Mughal style that synthesized Persian and Indian traditions of book illustration. The portrait of the Ottoman sultan derives not from a specific image by an Ottoman painter but rather from a European representation. The portrait of the English king is copied from a painting by John de Critz, which the English ambassador, Sir Thomas Roe, presented to the emperor, and such motifs as the putti, hourglass and halo are taken from other European images.

Whereas earlier Mughal paintings had recorded actual audiences and other contemporary events, paintings from the later part of Jahangir's reign were often allegorical, with portraits of majestic figures isolated against lavish symbols of their wealth and power. Bichitr's painting is a work of propaganda, meant to project an image of the emperor as one who has chosen the spiritual life over worldly power. It alludes to the mystical orders as a source of Mughal dynastic power. Another painting detached from the same album depicts an imaginary meeting between Jahangir and his rival, the Safavid ruler Abbas.

In the Ottoman Empire, painting never achieved the exalted status it acquired in Safavid Iran or in Mughal India, and in the seventeenth century the quality and quantity of illustrated manuscripts produced there declined, particularly after 1650 when imperial support for the court workshops waned. Calligraphy, however, was always prized, and Ottoman calligraphers retained the high status and achievements of their predecessors. The finest calligrapher of the seventeenth century was Hafiz Osman (1642–98). He earned a living by teaching calligraphy: money received from royal students allowed him to teach the poor one day a week. Known for his manuscripts of the Koran and

calligraphic specimens, he developed a seemingly simple style based on the principles of such past masters as Yaqut and Shaykh Hamdullah (see 176, 177). The clarity and elegance of his work can be seen in a calligraphic specimen (191), one of ten bound in an accordion-format album. Each page has a line of large script juxtaposed to-four lines of smaller script flanked by floral panels. The whole is framed by paper with marbled designs, a technique especially popular in the Ottoman Empire and often associated with the art of calligraphy; some masters were skilled in both. To make it, the marbler dropped oily colour on the surface of a watery bath and worked it with pointed tools and combs to create patterns. When the desired pattern was achieved, he delicately laid a sheet of paper on the surface of the bath and the paper absorbed the design. As the design was good for only one sheet, he had to start over each time, a time-consuming (and expensive) process. Marbled paper became fashionable for margins, endpapers, and even book covers. Designs became increasingly elaborate, and some masters were able to create such flowers as pansies, carnations, hyacinths, tulips and daisies.

The great invention that revolutionized book production in fifteenth-century Europe – printing with movable type – had no immediate impact on the Islamic lands. The Ottoman sultan

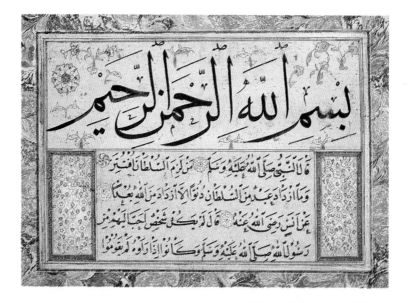

Mehmed II, himself a bibliophile, was deeply interested in European artists and techniques, and so it is all the more surprising that he did not sponsor the introduction of printing with movable type in his realm. Both practical and cultural factors may have played a role. It was difficult to design a typeface for the Arabic script, where letters are connected to each other and change shape according to their position in a word. In contrast to a fount of type for European languages, which normally contains about 275 characters or sorts (about 100 of which are italic letters, points and figures), a full Arabic fount might contain as many as 600 sorts to allow for all the possible letter shapes, ligatures and vocalizations. Given the high esteem in which calligraphy – especially writing the word of God – was held, the regimentation and mechanization that the Arabic script would have undergone in typesetting could have been seen as sacrilegious. Furthermore, the mass production of books might have challenged the learned class, who had an entrenched monopoly on intellectual authority. Thus, the early history of printed Arabic books took place in Europe.

The first book printed in Arabic is believed to be the Koran printed in Venice by Paganino de' Paganini in 1538. All examples were thought to have been destroyed by fire until 1987, when a single copy was discovered in a monastery library. Other early printed books were Arabic translations of Christian religious texts to be used by missionaries, as well as scientific works by such authors as the eleventh-century philosopher Avicenna (Ibn Sina) and the twelfth-century geographer al-Idrisi, who had long been known in the West.

191
Calligraphic *
specimen from
an album by
Hafiz Osman,
Istanbul,
1693–4.
Ink, colour and
gold on paper;
10×21 cm,
4×5$\frac{1}{2}$ in.
Museum für
Islamische
Kunst, Berlin

The first presses in the Islamic lands were run by Christian missionaries, but the first printing press run by a Muslim was established at Istanbul only in the early eighteenth century, when Ibrahim Müteferrika used copperplates to print engraved maps. He soon began to print books with Arabic type modelled on the typical Ottoman script of the period. His first book was an Arabic–Turkish dictionary printed in 1728; it was followed by

works on history, geography, language, government, navigation and chronology, sometimes illustrated with maps and engravings. The printing of the Koran and other religious texts was still forbidden in the Ottoman Empire, although two editions of the Koran were printed by Muslims at St Petersburg (1787) and Kazan (1803). Only with the introduction of lithography in the nineteenth century did it become possible to reproduce the flowing lines of a calligraphed text, and printed books began to be disseminated widely.

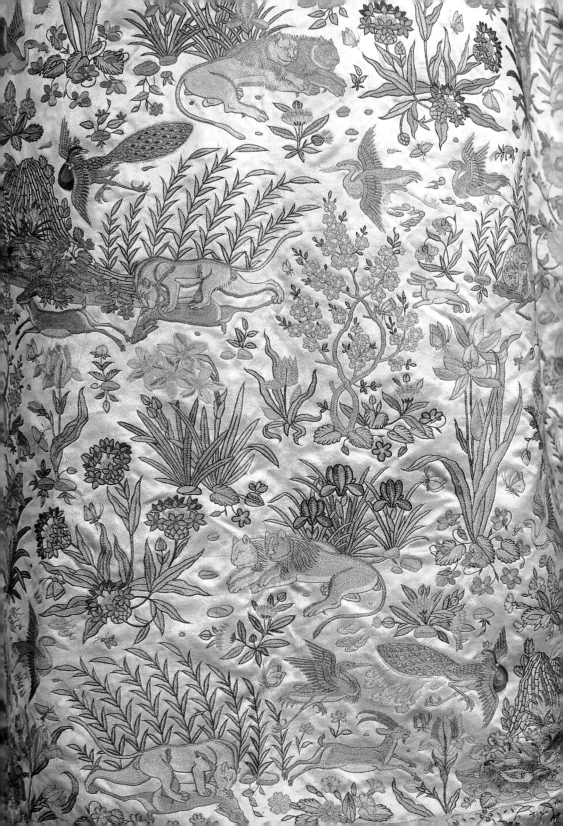

As in earlier centuries, the economies of the great empires were based on textile production and trade, and rulers subsidized and regulated the manufacture of luxury textiles for domestic consumption and export. Raw silk and silk velvets and brocades were major exports to Europe from Safavid Iran and the Ottoman Empire, as were the cottons of India before the Industrial Revolution. Although textiles remained fragile, the comparatively recent dates of production mean that relatively large quantities of them have survived. Fine knotted carpets, perhaps the most familiar of all Islamic arts in the West, were produced on commission for the court and for sale on the market. In Europe, knotted oriental carpets were a luxury affordable only to the wealthiest few, and in the eighteenth century changing tastes in European interior decoration meant that their earlier popularity declined. Comparatively few carpets were imported until the nineteenth century when they began to be appreciated once again and carpets sized to the dimensions of European rooms began to be produced for export on a commercial scale.

The earliest complete carpets known to have been made in Iran date to the sixteenth century, although illustrated manuscripts of the fourteenth and fifteenth centuries show that carpets had been used there for centuries. Judging from representations of carpets in manuscript paintings, geometric patterns had gradually been transformed into arabesques, in which blossoms and leafy scrolls surround medallions. The picture becomes much clearer in the sixteenth century, for approximately 1,500–2,000 carpets survive from the period of Safavid rule, although only five are precisely dated. As in the Ottoman Empire, weavers began to use paper patterns prepared by professional designers in court workshops, and designs – including representations of flowers, trees, animals and figures as well as calligraphy – were increasingly indebted to

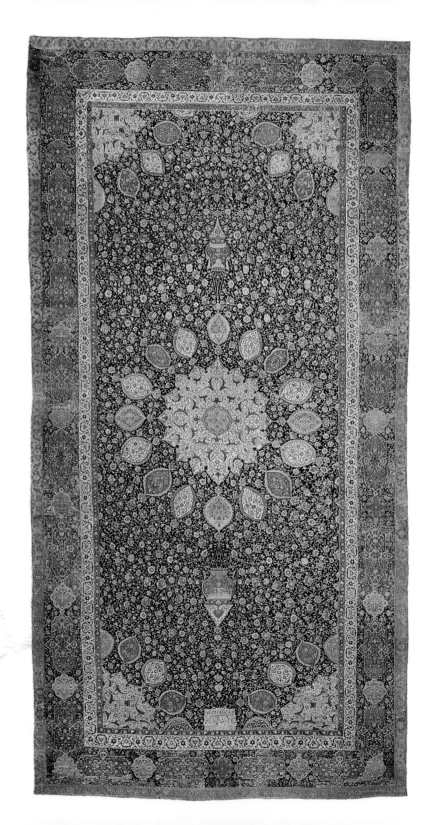

book illustrations. The use of fine silk for the warp, weft, and ultimately the pile, allowed the production of extremely detailed and flowing designs that transcend the rectilinear grid inherent to all woven textiles.

The large number of carpets to survive from Safavid Iran reflects a dramatic change in the nature of carpet production. The Safavid rulers changed carpet weaving from a nomadic and rural craft to a national industry. Tahmasp, for example, established royal factories for carpets and textiles in such major cities as Kashan, Isfahan and Kirman. These workshops produced not only luxury carpets for royal use and gifts but also carpets intended for export to India, the East Indies, the Ottoman Empire and Europe. These were an important source of state revenue. Abbas relocated the Armenians of the town of Julfa on the Araxes River in Azerbaijan to New Julfa, a new suburb of Isfahan; they had a monopoly on the silk trade.

The most famous carpets to survive from the sixteenth century are a pair of enormous carpets, a well-preserved one in London (193) and a patched one in Los Angeles, known as the Ardabil Carpets. It is said that they came from the shrine in that city where Shaykh Safi, the founder of the Safavid line, is buried. Both carpets have the same design knotted in ten colours of wool on silk warps and wefts, but they differ in the number and texture of their knots. The London carpet has some 25 million knots, and the Los Angeles carpet, when intact, would have had over 34 million. The two carpets were probably woven in different workshops supplied with the same pattern of a central sunburst surrounded by sixteen pendants, with a mosque lamp hanging at either end. The corners are filled with one-quarter of the central design. All these elements float over a deep blue ground strewn with arabesques. Both carpets are inscribed in a box with a couplet by the poet Hafiz:

I have no refuge in the world other than thy threshold
My head has no resting-place other than this gate

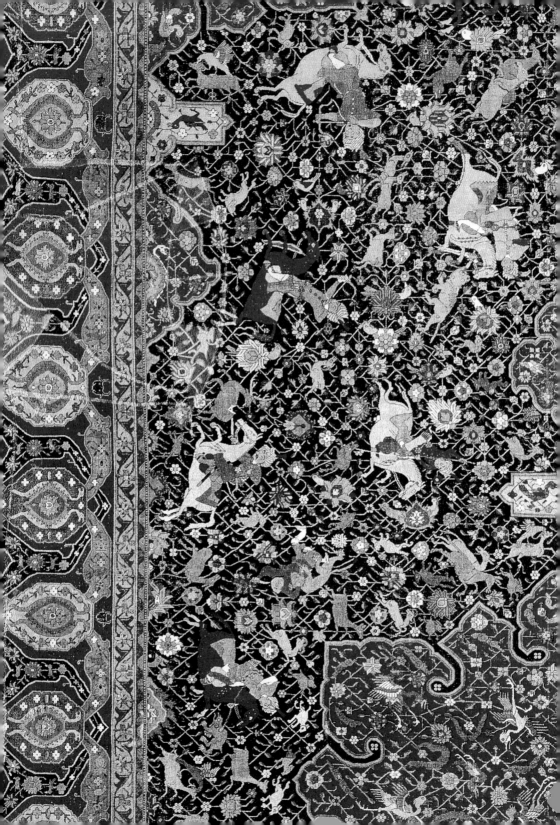

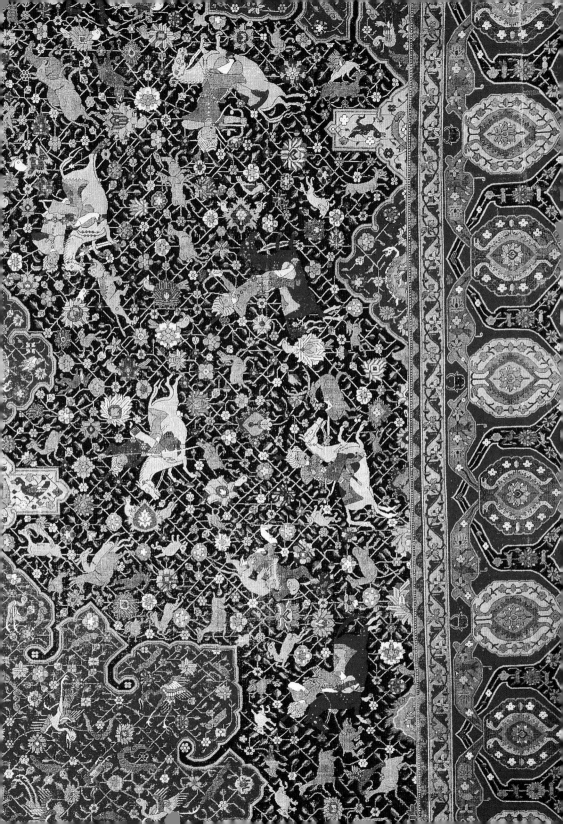

followed by the signature of the court servant, Maqsud of Kashan, and the date 1539–40. It is inconceivable that Maqsud alone tied the millions of knots; rather he was probably the designer responsible for preparing the paper cartoons from which these elegant carpets were woven.

Another contemporary carpet, also signed and dated, is similar in technique although only one-quarter the size of the Ardabil Carpets and very different in style (194). The design is knotted in many brilliant colours of wool on silk warps and cotton wefts. In contrast to the abstract flowing arabesques of the Ardabil Carpets, this carpet has figures set against a somewhat angular background. The central red medallion is filled with cranes; the deep blue ground is populated with scenes of hunters, both mounted and on foot, pursuing lions, deer and other animals. The hunters wear the distinctive turban wrapped around a tall red cap that was worn at the early Safavid court. As in the Ardabil Carpet, quarter-medallions fill the corners. An inscription in the centre of the carpet gives the name Ghiyath al-Din Jami, presumably the designer, and the date 949 (corresponding to the date 1542–3). The central location of the signature might suggest that the designer was boasting of his achievement, but this was hardly the case. The figural design shows that this carpet would have been inappropriate for a mosque. It would, however, have been suitable for a palace, particularly when the royal throne was set over the central star medallion. The designer's signature would then have been under the ruler's feet, a traditional indication of the maker's humility.

If this hunting carpet was meant for a throne, where were the Ardabil Carpets spread? There is no room large enough at the Ardabil shrine for the carpets in their present condition. But as they were refashioned in the nineteenth century, their present size is no hindrance to their use in the large hall at Ardabil. Such a site would have been appropriate since that shrine is known in Persian as the 'holy threshold', the term used in the quotation from Hafiz.

195
Wagner garden carpet, Central Iran, late 17th century. Woollen pile; 5.31×4.32 m, 17 ft 5 in× 14 ft 2 in. Burrell Collection, Glasgow

Another type of carpet woven from the Safavid period onwards is known as a garden carpet since its design shows a formal Persian garden divided by streams into rectangular beds. The most splendid example is a huge carpet that was discovered in 1937 in a sealed room in the palace of the Maharaja of Jaipur at the fortress-palace at Amber in India. According to a label on the lining, the carpet was inventoried at the fort on 29 August 1632, and so it must have been made before then. The design, worked in blues, greens, yellows and other vivid colours on a red wool ground, shows an elaborate garden with a large domed pavilion in the centre. Fish, ducks, turtles and dragons cavort in the waters, and the flower-beds are planted with cypresses, plane trees, fruit trees, date palms, lilies, roses and carnations. Pheasants perch on the trees, feed their young in nests, and sit on the grass. This garden carpet, unquestionably the finest and most sumptuous in existence, probably represents the kind of garden that was planted in Abbas's new capital at Isfahan (see Chapter 9). When the carpet was spread on the floor, the user sitting on it would have been surrounded by a verdant, refreshing garden. This conceit was so popular that the type was made repeatedly, albeit with stiffer drawing, until the nineteenth century (195).

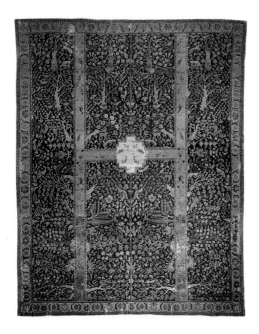

Like carpets, luxurious textiles were produced in state workshops and elsewhere in the Safavid Empire. According to Sir John Chardin, a Huguenot jeweller who left a multi-volume account of his travels to Iran in the 1660s, two-faced gold lampas and gold velvet were the most expensive fabrics in the world. To produce them, as many as six weavers would have worked simultaneously at the loom, using up to thirty bobbins to execute the intricate and vividly coloured patterns. According to Jean-Baptiste Tavernier, another European traveller to Iran, more people were engaged in silk weaving than in any other trade. The cities of Yazd and Kashan were particularly famous for their luxury silks.

Lampas fabrics had been woven for centuries in the Islamic lands, but under the Safavids in sixteenth-century Iran, large-scale figural designs woven in bright and vibrant colours became especially popular. Patterns included not only scenes from popular legends immortalized in the *Shahnama* and other poems but also scenes from contemporary life showing hunting and languid youths. As with carpets, professional draughtsmen provided the designs that were later executed by weavers of lampas and velvets. The main design was ingeniously reversed and repeated several times across the width of the fabric to create the impression of a continuous landscape background. A coat in Moscow

196
Coat, Iran, 16th century. Silk velvet with metalllic threads; l.1 m, 3 ft 3 in. State Armoury Museum, Moscow

197
Detail of 196

(196) made of a silk of great beauty is considered to be one of the finest textiles of all times. The cloth is woven in gold, silver and coloured silk (cream, beige, tan, yellow, crimson and green) on a pale blue ground. The design shows a figure hurling a rock at a dragon while a phoenix is perched nearby in a tree (197). The coat is constructed with a rectangular central section to which side pieces, underarm gussets and sleeves are sewn, but it is pieced together so skilfully that the pattern seems to flow seamlessly.

This design of a figure, sometimes identified as Alexander, hurling a rock at a dragon was apparently very popular in sixteenth-century Iran, for other versions are known in both lampas and velvet techniques. They were extremely prized, both at home and abroad. According to popular tradition, some tent decorations cut from this pattern were seized by the Ottoman sultan Suleyman the Magnificent during a raid into Iran. In the seventeenth century these same medallions were used to decorate the tent of an Ottoman grand vizier; this tent was captured at the siege of Vienna in 1683 by Prince Sanguszko of Poland, leader of the European defenders of the city. The medallions remained in the Sanguszko family until the 1920s, when a reversal of fortune forced them to sell some of their collection, and the medallions were eventually acquired by several museums.

Velvet became the most fashionable fabric in Abbas's reign. The earliest surviving velvets date from the sixteenth century, but the origins of this piled fabric are unknown and could be much older. Velvet's soft, short and dense pile is produced while weaving the fabric by looping extra warps over wires that are temporarily inserted like wefts. The looped warps are later cut and the wires removed, leaving the warp tufts as the pile. When looking at a velvet, the face shows the pile weave and the back shows the ground weave. Velvets can either be entirely covered with pile or have pile in only certain areas, a technique known as voided velvet, and the pile can have as many colours as there are colours of extra warps. Safavid voided velvets are extremely complex, with pile areas of many different colours and a satin ground

weave enlivened with yarns wrapped in metal foil that add shimmer to the areas with no pile.

Perhaps the finest early Safavid velvet to survive has a pattern of a leafy trellis forming hexagonal compartments with figures (198). Each compartment contains a princely figure, wearing the typical Safavid turban of the sixteenth century, on the right with a falcon on his wrist ready to pursue the flying duck on the left. A servant below the duck carries the game bag. The leafy trellis is embellished with lion masks and spotted snakes. The velvet is piled predominantly in deep red with accents of orange, yellow, green, two shades of blue, grey, and black against a silver metallic ground, now largely worn away. The colours vary in each compartment, adding to the splendid effect.

Safavid velvets were used for many purposes, ranging from tent decorations to clothing. One of the few complete garments to survive is a velvet coat (199) which was given in 1644 to Queen Christina of Sweden by the Russian Tsar, who acquired it by trade or gift with Safavid Iran. The coat, which crosses over the front to fasten under the right arm, has extremely long sleeves. It is made up of a gold-ground velvet with a pile pattern in many colours showing young dandies holding wine cups and ewers and wearing long coats decorated with leafy patterns. The pattern of alternating swaying plants and languid youths is drawn in a style similar to the languid youths in drawings by Riza (see 189) and his contemporaries. The coat represents a very Safavid conceit of wearing a coat made up of a fabric showing people wearing coats made up of similarly decorated fabrics, somewhat comparable to Bichitr's self-portrait in his painting of Jahangir (see 175).

In the Ottoman Empire, as in the Safavid, royal factories were established, often in the capital Istanbul, to produce silk textiles and carpets as well as other luxury goods for the court. Commercial factories in provincial centres such as Ushak, Bursa and Iznik also produced silk textiles and carpets, some of which were sold to the Ottoman court, while others were sold on the open market for use at home or abroad. Some pieces for the court

The Great Empires 1500–1800 AD

198 Above
Fragment of a figured cloth, Iran, mid-16th century.
Silk velvet;
77×67 cm,
30¹⁄₃×26¹⁄₃ in.
Cleveland Museum of Art

199 Right
Figured coat, Iran, early 17th century.
Silk velvet;
l.1.23 m, 4 ft.
Royal Armoury, Stockholm

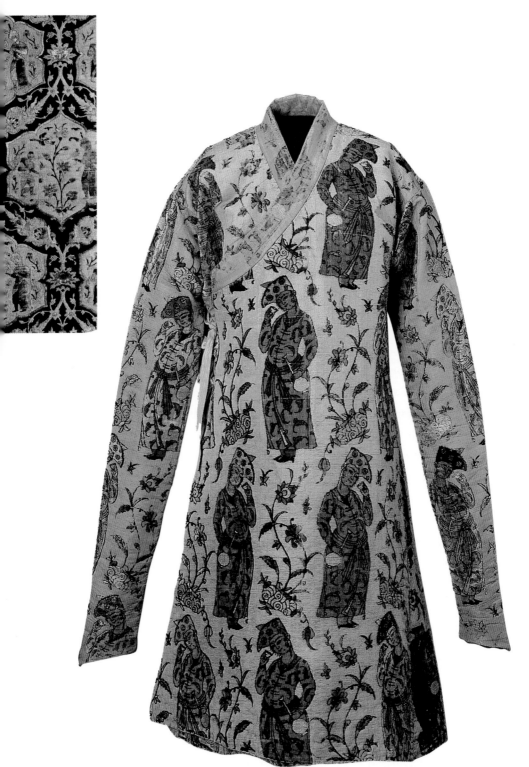

were made on commission from patterns prepared by court designers at the capital, but others were purchased from among ready-made examples. In this manner the fashions of the court at Istanbul were synthesized with popular tastes.

The designs distributed from the court workshops can be seen in the group dubbed Ottoman Court carpets. They all have designs made up of composite flowers set on delicate scrolls with long jagged leaves and known as the *saz* style, perhaps from the reed (*saz*) pen used for the drawing. This style is found in many different media, not only carpets and textiles (see below) but also ceramic tiles and vessels (see 211, 212). Designs in the *saz* style were prepared in the court studio, and paper cartoons disseminated to various workshops.

Ottoman Court carpets are woven in various materials and techniques. All of them have asymmetrical knots of cotton or wool, but the ground can be wool or silk and the yarn spun clockwise or counterclockwise. Some Ottoman Court carpets were produced in Cairo, including the largest and best preserved example of this type of carpet recently discovered in storage in the Pitti Palace in Florence. It has S-spun warps and wefts, a technique associated with Egypt, and it is described in Medici inventories as 'Cairino' or coming from Cairo. In 1623 it was brought as a gift to Grand Duke Ferdinand II by Admiral Da Verrazzano, possibly a descendant of the great Italian navigator who explored the Americas. Weavers in Cairo, who left to their own devices had woven carpets with geometric patterns (see 131), acquired the cartoons for floral designs popular at the Ottoman court and turned them into magnificent products, one of which was sold on the open market to a European.

Other Ottoman Court carpets were woven in Anatolia. In 1585 the Ottoman sultan Murad III ordered eleven carpet weavers to move from Cairo to Istanbul, bringing with them two tons of dyed wool. An Ottoman Court carpet in Vienna (200), with a silk warp and weft and white and light blue cotton in the woollen pile, is one of the finest. Previously in the Austrian royal collection at

200
Ottoman Court carpet in the *saz* style, Istanbul or Bursa, late 16th century. Wool and cotton pile on silk warps and wefts; 1.81×1.27 m, 6 ft×4 ft 2 in. Österreichisches Museum für Angewandte Kunst, Vienna

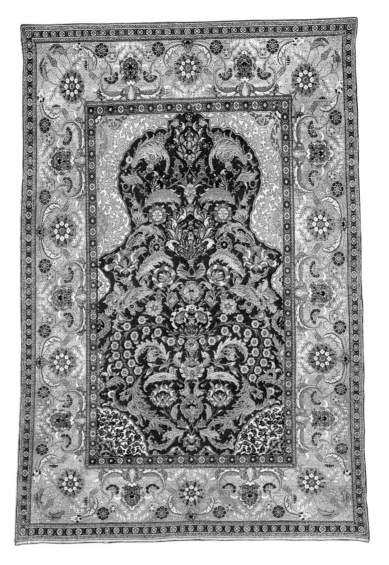

Schönbrunn Palace, it shows that Ottoman carpets, like their Safavid counterparts, were prized possessions of European nobility. The flowers are set in an arched niche with quarter medallions in the lower corners, a design similar to that found on large tiles used to decorate the Topkapi Palace in Istanbul (see 212), and so carpets with a silk warp are usually assigned to a site near Istanbul, possibly Bursa.

Another type of small carpet produced for the Ottoman court, possibly at Bursa, also has wide borders and arched niches, but instead of floral designs in the *saz* style, the field is filled with

columns, sometimes with a hanging lamp. When laid with the arched niche and lamp pointing in the direction of Mecca, they were used as prayer rugs. Six examples of the type are known, but the details differ. Some have single columns flanking the niche; in others (201) columns divide the field into three parts. A few have hexagonal domed buildings set in the panel above the niches. They show how a general design type could be easily be modified to produce numerous individual variants. These rugs, with silk warps and wefts, represent the finest Ottoman court production, but the design of a niche with columns became popular with commercial and village weavers and was repeated for centuries in rougher materials and greater degrees of simplification. The same design was used on rugs made as curtains for synagogues, where they were hung over the arch in which the Torah was kept, and they were sometimes inscribed in Hebrew.

Bursa was the main centre of the international silk trade. For centuries, silk thread produced in the Caspian provinces of Iran was transported by caravan across Anatolia to Bursa, where it was bought by Europeans, mainly Italians, to be woven in Europe. The Ottomans earned substantial revenues from the customs, taxes and brokerage fees levied from the Iranian and Italian merchants, but in the early sixteenth century imports were curtailed because of wars between the Ottomans and the Safavids. The Ottoman sultans then encouraged domestic silk production, and by the mid-seventeenth century the plains around Bursa teemed with mulberry trees, whose leaves fed the silkworms. By the eighteenth century Turkey rivalled Iran in exporting unwoven silk to Europe.

The sumptuous silk textiles made for the Ottoman court in the sixteenth century are exemplified by a magnificient ceremonial caftan (202), woven of silk and gilt-metal thread in seven colours (blue, brown, green, peach, red, white and gold) on a brown-black silk ground. The floral motifs in the *saz* style are similar to those found on tiles, particularly those used to decorate the mosque of Rustem Pasha in Istanbul (see 159), the Ottoman grand vizier in

201
Ottoman prayer rug with columns, Istanbul or Bursa, late 16th century. Wool and cotton pile on silk warps and wefts; 1.73×1.27 m, 5 ft 8 in× 4 ft 2 in. Metropolitan Museum of Art, New York

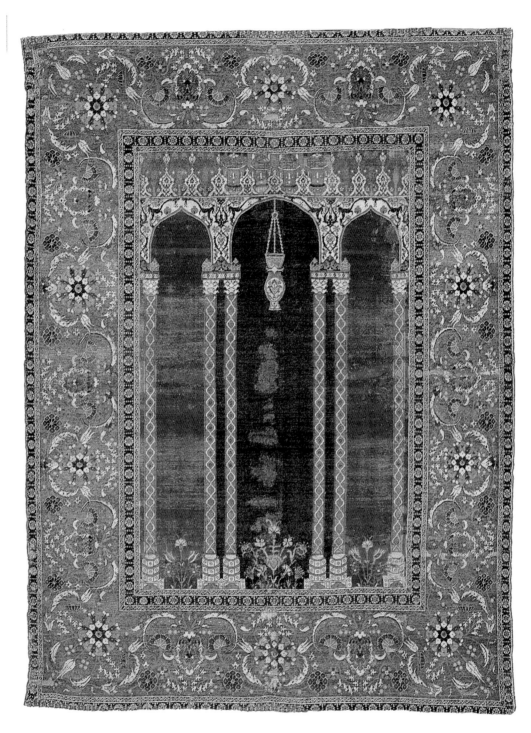

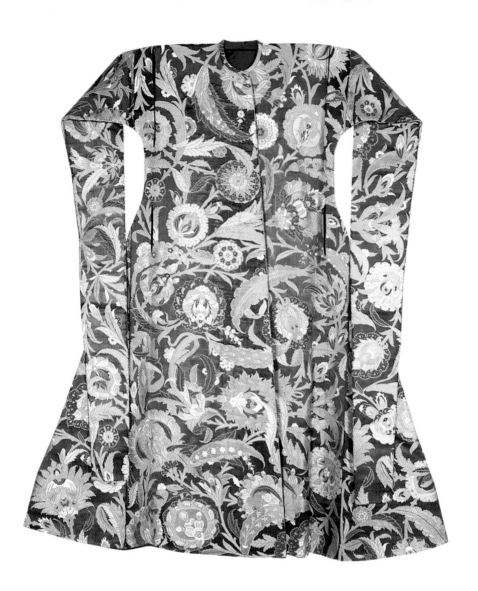

the mid-sixteenth century who encouraged the domestic production of luxury textiles to offset imports. The design of the silk must have been extraordinarily difficult to set up on the drawloom, for unlike almost all other Ottoman textiles, the layout does not repeat and the design is ever-changing. The caftan is typical of the outer robes worn at the Ottoman court: the wearer, probably Suleyman's son Bayezid (d.1562), passed his arms through slits at the shoulders, leaving the ankle-length sleeves to hang over the back. Like the Safavid silk coat (see 196), the design is carefully matched across the front opening, but there are no fastenings to keep the caftan closed, so the prince must have remained still while wearing it. European accounts of embassies to the Ottoman court reiterate that to enhance the aura of the sultan's power, the Ottoman rulers stood motionless while visitors were presented.

Ottoman wardrobes were enormous, and more than 2,500 items are preserved in the imperial stores at Topkapi Palace in Istanbul. In addition to more than 1,000 caftans, they include personal items such as shoes, belts, underwear and accessories as well as a large number of talismanic shirts (203). The shirts are made of modest materials, usually soft white cotton or linen and occasionally cream or pink silk. Their decoration, by contrast, is painstaking: they are elaborately painted in polychrome pigments, gold and silver with koranic verses, prayers and magic squares with digits and letters whose numerical values were used to predict the future. They required intricate preparation. Court astrologers determined the proper time of execution, and numerologists worked out the designs. One such shirt took three years to prepare. If worn as undergarments, the decoration would have enhanced the magical powers but the visual effect would have been obscured. They may have been worn over chain mail, for they are cut very loosely. Suleyman's wife Hürrem Sultan wrote to her husband who was on campaign describing how she had acquired the shirt that accompanied her letter. A holy man in Mecca had made it after seeing the Prophet Muhammad in a vision, and brought it to Istanbul. Hürrem sent the shirt to her

202 Above
Caftan,
Istanbul,
mid-16th
century.
Polychrome silk
and gilt-metal
thread;
h.1.47 m,
4 ft 9 in.
Topkapi Palace
Museum,
Istanbul

203 Below
Talismanic
shirt,
Istanbul,
mid-16th
century.
White linen
painted with
black, blue, red
and gold;
l.1.23 m, 4 ft.
Topkapi Palace
Museum,
Istanbul

husband, urging him to wear it for her sake, for it was inscribed with sacred names that would turn aside bullets. Most of the surviving shirts are inscribed with Koran 48, the chapter entitled 'Victory', and their surprisingly good condition suggests that they were not actually worn in battle, but may have been gifts intended to inspire victory, rather than deflect attack.

Like the Safavids, the Ottomans were famous for fancy silk velvets. Ottoman pieces generally use fewer colours than their Safavid counterparts and have floral and geometric, but never figural designs. They also show less variation in texture than Italian velvets, which have varying heights of pile contrasted to areas of uncut loops. Ottoman velvets are quite strong and able to withstand abrasion. They were used for caftans, horse trappings and book covers, but the largest number to survive were cushion covers intended to be placed on divans, often in pairs. They are identifiable by the row of lappets across the ends of the rectangular fabric, which usually measures about a metre (3 ft) long. Typically they were woven on cotton and silk wefts in deep red and ivory silk with gilt- or silver-wrapped metallic thread. Some also had green or pale blue thread.

One of the few pairs of velvet cushion covers that can be dated precisely was presented by Abdi Pasha of Algiers to King Frederick I of Sweden in 1731 (204). The design is organized in the traditional way established in the sixteenth century, with a central medallion and six lappets at either end, but new motifs are introduced, particularly tulips in the corners. These covers were woven in the so-called Tulip Period, when the taste for this flower reached a height under the Ottoman sultan Ahmed III (r.1703–30), and the tulip dominated the composition of both furnishing and dress fabrics as well as many other arts. The tulip, which grows wild in eastern Anatolia and the Iranian plateau, was assiduously cultivated at the Ottoman court, who ordered incredible quantites of bulbs for flower festivals and planting in the palace gardens. Ogier Ghislain de Busbecq, ambassador to Suleyman's court from Ferdinand I Habsburg (r.1503–64), brought bulbs to Austria, and

204
Cushion cover,
Istanbul,
early 18th
century.
Silk velvet with
metallic thread;
67×120 cm,
26¹⁄₃×47¹⁄₄ in.
Royal Armoury,
Stockholm

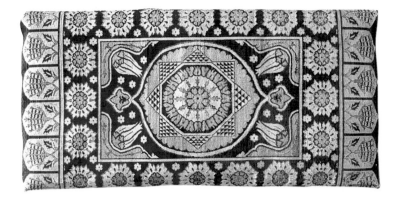

tulip cultivation in Europe was developed through the efforts of Charles de L'Écluse, chair of botany at the University of Leiden. The taste for tulips spread rapidly through Europe, culminating in the great tulipomania in Holland in 1636–7, when fortunes were made or lost on a single exotic bulb.

Fine silks were also woven in other Mediterranean lands, sometimes following Ottoman designs, since the Ottomans controlled all of North Africa except Morocco. Ottoman banners woven from the fifteenth century are often shield-shaped and decorated with a depiction of the legendary two-bladed sword wielded by the Prophet's son-in-law Ali. A large banner of maroon silk and metallic thread (205) was made in 1683 somewhere in North Africa, for its inscription is written in the distinctive *maghribi* script with letters of uniform thickness and low sweeping curves used for manuscripts of the Koran produced there (see 188). The banner was made for members of the Qadiriyya, a Sufi order which flourished in North Africa, and was designed to be carried on the pilgrimage to Mecca. Fine silk banners had long been made in the region (see 123), and the technique and design of this piece show the continuation of the superb silk-weaving traditions developed earlier (see 116).

In India, too, the Mughal emperor's extensive household administered many workshops which produced carpets, textiles and furnishings. Carpet-weaving is not native to India where the hot damp climate makes woollen pile rugs both impractical and

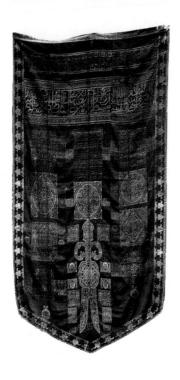

205
Pilgrims'
banner,
North Africa,
1683.
Silk and
metallic thread;
3.61 × 1.88 m,
11 ft 8 in ×
6 ft 2 in.
Harvard
University Art
Museums,
Cambridge,
Massachusetts

unnecessary as floor coverings, and the art was introduced there
in the late sixteenth century by the Mughals, probably by Akbar
who, reportedly, imported weavers from Herat. Mughal carpets
copied Persian examples so closely that it is often difficult to
distinguish Mughal pieces from their Safavid counterparts until a
distinctive style of carpet production emerged in India, when the
naturalistic themes seen in Mughal painting and decorative arts
were also incorporated into carpets.

This new naturalism can be seen in the Widener animal carpet
(206), where the field is treated like a picture. Knotted in woollen
pile on cotton warps and wefts, it has a border filled with shaped
compartments similar to those found on Persian carpets of a
century earlier (see 193) and they are decorated with birds and
animal masks like those found on Safavid velvets (see 198). The
field, however is different from Persian carpets with hunting
scenes (see 194), in which each quarter of the field repeats exactly.
The Mughal carpet shows a hunter riding an elephant – a beast
native to India – surrounded by an elaborate array of lively
animals, including a rhinoceros, crocodile, camels, leopards, tigers

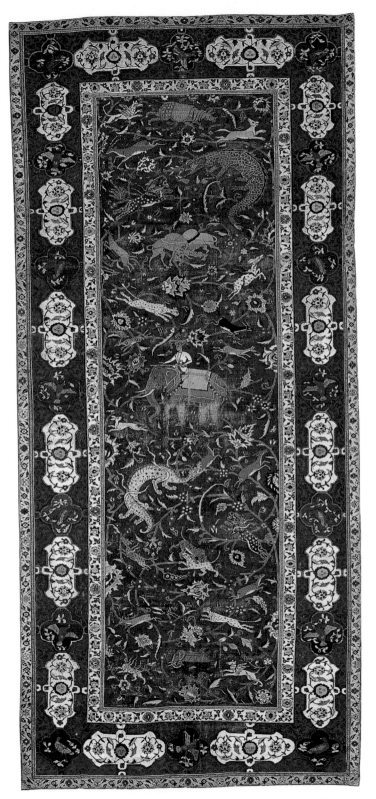

206
Animal carpet,
India,
early 17th
century.
Wool pile on
cotton warps
and wefts;
4.03×1.91 m,
13 ft×6 ft 4 in.
National Gallery
of Art,
Washington,
DC

and dragons. Despite the beauty and inventiveness of the drawing, the carpet is only of moderate technical quality.

The Aynard prayer rug (207), a fragment attributed to the reign of Shah Jahan, is much finer. It is so finely knotted – with an astounding 174 knots per sq. cm – that it looks almost like a woven velvet. Knotted on silk warps and wefts in the lustrous wool used for making Kashmir shawls, the carpet has the deep colouring typical of Mughal carpets. It shows a large flowering plant within a lobed niche. As there are no outer side borders and the centre has been repaired with pieces of identical make and similar design, the Aynard prayer rug may have been part of a larger carpet with multiple arches. The floral design was based on plants shown in European herbals, as at the Taj Mahal (see 151). Floral designs became particularly popular under Jahangir, who had an ecstatic reaction to the flowers of Kashmir after a trip there in the spring of 1620, and the style reached a zenith under his successor Shah Jahan. The design was given a distinctly Mughal aspect by incorporating such Chinese elements as the

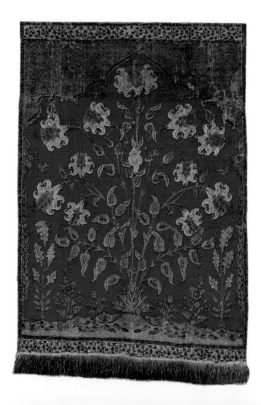

207 Opposite
Prayer rug,
Lahore,
2nd quarter of
17th century.
Wool on silk
warps and
wefts;
125×90 cm,
49×36 in.
Thyssen-
Bornemisza
Collection,
Lugano

208 Right
Riding coat,
India,
c.1630–40.
Silk thread on
white satin;
l.97 cm, 38 in.
Victoria and
Albert
Museum,
London

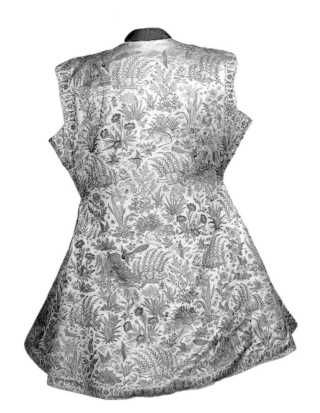

rocky landscape at the bottom and the little clouds inserted
between the blossoms.

Indian woven textiles, especially filmy cottons and glowing silks
dyed in vibrant colours, had been famous for centuries, and the
Mughal rulers further encouraged an already important industry.
Traditional Indian textiles were either plain or had geometric
patterns of checks, stripes and chevrons. During the Mughal
period all this changed, and naturalistic flower and plant motifs
became dominant. Some of these new designs were woven into
the fabric; others designs were embroidered, or sewn onto the
finished fabric (or garment). A particularly fine example is a white
satin riding coat in a new style designed by Jahangir, who, like
his father Akbar, was a natty dresser. The coat is embroidered in
chain stitch using blue, yellow, green and brown silk (192, 208).
The design is a pattern of animals, birds and winged insects in a
rocky landscape of trees and realistic flowers, including poppies
and daffodils. Various felines, including lions, tigers and leopards,

devour their prey or rest peacefully in the shade. The effect is similar to marginal decoration in contemporary manuscripts and albums (see 175), but the flowers are more realistically depicted. The embroidery was probably done by craftsmen from Gujerat, for chain stitch was a speciality there. The garment itself, a knee-length riding coat open to the front, has neither sleeves nor collar, although the absence of embroidery around the neck suggests that the coat once had a fur tippet. Like other rulers, Mughals bestowed robes on courtiers, and the splendour of this example suggests that it was made for a prince.

Most of the textiles in the royal storehouses, however, were related to the construction and decoration of the emperor's tents, which ranged from simple affairs to large multistorey designs that took several days to erect. The reports of Mughal court historians are supplemented by those of Western travellers at the Mughal court, who were awed by the splendour and sumptuousness of these portable palaces. In order to keep his extensive empire under firm control, the emperor went on regular progresses from one district to another to assert imperial authority. The French traveller François Bernier, for example, accompanied Awrangzeb's progress from Delhi to Lahore and Kashmir in 1665.

The camp, particularly the tents of the royal enclosure (209), was laid out according to a standard plan. The royal apartments were set in a great square enclosure of cloth some 2.25 m (7–8 ft) high hung from poles set into the ground at regular intervals. On the outside, the screens were red – the imperial colour – while the inside was lined with calicoes printed with large vases of flowers. Within the enclosure stood the ruler's private tents, enclosed by smaller screens, even more elaborately decorated, of figured satins and chintzes. The women's quarters were similarly enclosed. The tents, like the screens, were covered on the outside with red cloth and lined with hand-painted chintz. Thick cotton mats were spread on the ground and covered with splendid carpets on which were placed large square brocaded cushions. All these tents, screens and other equipment were duplicated so

209
Mughal camp as depicted in *The Arrest of Abu'l-Maali*, from a copy of the *Akbarnama*, India, *c*.1590. Colour on paper; 34.3×20 cm, 13$\frac{1}{2}$×7$\frac{7}{8}$ in. The Art Institute of Chicago

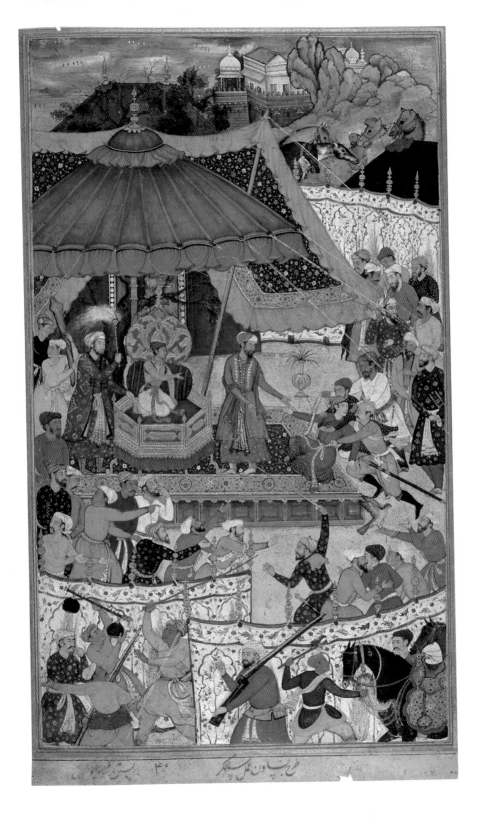

12

In the later period the arts of fire and the other decorative arts faced increased competition with imports from Europe and China which were more readily available due to flourishing international maritime trade. Although brilliant glazed ceramics and fine metalwares were produced in the Islamic lands, only in rare instances, such as the underglaze-painted ceramics associated with Iznik and Istanbul in the sixteenth century, do these wares attain the high artistic qualities achieved by the finest examples of past centuries.

210
Canteen,
Istanbul
mid-16th
century.
Gold incrusted
with jade
plaques and
jewels;
h.27 cm,
10²⁄₃ in.
Topkapi Palace
Museum,
Istanbul

Many of the finest works of art made in the later period were royal implements, jewellery and regalia, for all rulers in the later period – especially the Ottoman sultans, Safavid shahs and Mughal emperors – had rich collections of personal adornments and wares. Earlier rulers, such as the Abbasids and the Fatimids, had similar collections, but most of their jewellery and regalia was melted down and refashioned by later owners. By contrast, much of the later material has survived because many of these dynasties remained in power until modern times. The Ottoman Empire lasted until 1924, and the royal collections went into the treasury at Topkapi Palace in Istanbul and other museums; the Mughals reigned until 1857 and many royal pieces entered colonial collections, particularly in England.

Some rulers in the later period collected works of art associated with past rulers to display their distinguished heritage and enhance their legitimacy. The Mughals, for example, were famous for collecting works of art associated with the Timurids, their putative ancestors. Other rulers simply took the expensive gemstones from earlier works and had them put in new settings. This was a specialty of the Ottomans, and the treasury at Topkapi Palace is full of luxury objects studded with precious gemstones.

Many Iranian works of art and artists came to the Ottoman court following the decisive victory over the Safavids at Chaldiran in September 1514. An inventory in the Topkapi Palace archives lists some of the prodigious booty that arrived – gold and silver vessels, jades, porcelains, furs, rich brocades and carpets – and some of the many craftsmen – tailors, furriers, marquetry-workers, goldsmiths and musicians. Many of these craftsmen were put to work in the imperial studios at Istanbul. The Persian artist Shahquli, for example, became the head draughtsman in charge of twenty-nine artists and twelve apprentices, and in 1529 he received the high salary of 22 silver coins. The artist became a favourite of the sultan's: in return for giving Suleyman a picture of a peri or Persian fairy, he received gifts including 2,000 silver coins and brocaded caftans and velvets.

One result of Iranian artists working at the court studio in Istanbul at the beginning of the sixteenth century was the creation of the *saz* style, in which composite flowers are set on delicate scrolls with long jagged leaves. *Saz* designs on paper were transferred to textiles (see 200–2) and ceramics made for the Ottoman court in Istanbul. The major centre of production was Iznik, but archival documents record that there were also workshops in the capital, and without sophisticated technical analysis of the materials used, it is difficult to distinguish wares from the two sites since they share common designs. A large but fragmentary dish with a foliate rim (211) shows how potters assimilated the new designs. The dish is the same size and general shape as the fine blue-and-white dish made at Iznik in the 1480s (see 150), but shows several new features. The rim is scalloped, an imitation of the Chinese blue-and-white porcelains that the Ottomans (and their Safavid counterparts) assiduously collected. The Topkapi Palace collection, for example, contains more than 10,000 pieces of Chinese porcelain and celadon. On the scalloped dish, turquoise has been added to the dark blue used on the earlier dish. The addition of a new colour was a first step on the way to the polychrome wares common in the mid-sixteenth century. Most importantly, the tightly scrolling symmetrical design of arabesques in the centre of

211
Above right
Fragment of a dish with foliate rim, Istanbul or Iznik, 1520s. Fritware underglaze-painted in blue; diam. 38 cm, 15 in. Österreich-isches Museum für Angewandte Kunst, Vienna

212
Below right
Tile panels from the Circumcision Room, Topkapi Palace, Istanbul, c.1527–8. Underglaze-painted fritware

the earlier dish has been transformed on the scalloped dish into
a freer design of a large bird pecking amidst feathery leaves.
The bird and foliage are painted in a different manner than the
surrounding borders of blossoms and leaves, which are stiff and
regular. We can imagine that a master painter was responsible for
the central design and an apprentice executed the borders.

The magnificent design painted in blue and turquoise under the
glaze in the centre of the fragmentary dish is virtually identical to
the designs painted on five enormous tiles (212), now installed on
the façade of the Circumcision Room in Topkapi Palace. These tiles

were probably made by the royal ceramic workshop in Istanbul to decorate the new kiosk that Suleyman added to the palace around 1527–8. The kiosk burned in 1633, but these slabs must have been rescued from the ruins and reassembled in their present location when the Circumcision Room was restored. Perfectly smooth slabs over one metre (3 ft) high, the tiles attest to an extraordinary technical command of fabrication and firing. The designs show birds and Chinese deer-like creatures frolicking amid a loose scroll of feathery leaves and fantastic composite flowers. White chinoiserie clouds on a dark blue ground decorate the upper corners of the tiles, and the resulting niche shape resembles those seen on contemporary prayer rugs (see 200–1). The compositions on the left and right panels, which are in mirror reverse, were undoubtedly taken from stencils supplied by the imperial design studio.

The Ottoman ceramic industry continued to expand in the sixteenth century. Potters extended the palette of blue and turquoise by adding black for outlines and then introducing contrasting colours of grey-green and pale purple, mainly on vessels. Potters also expanded the formal repertory by mastering new shapes, including many large mosque lamps with a pear-shaped body, a flaring neck, and three looped handles at the shoulder from which it could be suspended by chains. These vessels clearly imitate the shape of traditional glass mosque lamps (see 149), but must have been used for symbolic purposes since the opaque ceramic body prevented the light from shining through, making them useless for illumination.

The inscriptions on these ceramic lamps show that they were specific commissions for important mosques, tombs and shrines. Several examples were made in blue and white for the tomb of sultan Bayezid II (d.1512), and a unique example with black and two colours of blue was found in the Dome of the Rock in Jerusalem (213). The singularity of this lamp is underscored by the fact that the artist signed and dated his work around the footring. The lamp may have been commissioned by Suleyman

213
Opposite
right
Decorative lamp made for the Dome of the Rock at Jerusalem, Istanbul or Iznik, 1549. Composite ceramic body with underglaze decoration h.38.5 cm, 15⅛ in. British Museum, London

214
Opposite
below
Dish with floral design, Iznik, c.1570. Underglaze-painted fritware; diam. 33 cm, 13 in. Ashmolean Museum, Oxford

in his restoration of the shrine. The sultan considered himself the second Solomon (Suleyman is the Turkish form of Solomon), and one of his major architectural projects was to refurbish the Dome of the Rock, the earliest example of Islamic architecture and the structure that stood on the site of the first Solomon's temple. He had the damaged Umayyad mosaics on the exterior replaced with tiles (see 8), and the restoration work continued for several decades, perhaps under the direction of the great architect Sinan, who also executed the sultan's mosque complex in Istanbul (see 156–8).

The heyday of Ottoman ceramics took place in the second half of the sixteenth century when potters produced thousands of tiles for imperial Ottoman buildings, private foundations, residences and provincial projects as well as vast numbers of tablewares in a variety of shapes and decorative schemes. These pieces are particularly striking and colourful because of the addition of the distinctive Iznik red, a pigment composed of red clay that stands in relief under the clear transparent glaze. This red pigment appears first on tiles and fittings made for Suleyman's mosque complex in Istanbul which was finished in 1557 (see 156–8). The colour became characteristic of the finest polychrome wares made between 1560 and 1575 in a range of shapes – plates (214), bottles, pitchers, tankards, jars and covered bowls. The vessels are usually decorated with bouquets of charming stylized flowers,

occasionally with birds among the foliage. The rims of dishes are often decorated with compartments of tight black spirals separated by arbitrarily shaped compartments with blue outlines, a stylized version of the wave-and-foam border found on Chinese blue-and-white porcelains.

The colourful tablewares were immensely popular, not only at home but also abroad, thanks to the thriving trade between the Ottoman Empire and the West. Fragments have been dug up in excavations from Fustat (Old Cairo) in Egypt to York Minster in

215
Tile panel,
Damascus,
c.1600.
Underglaze-
painted
fritware;
70×74 cm,
27¹⁄₂×29 in.
Museum of
Fine Arts,
Boston

Britain. Unlike foreign buyers, the Ottoman court paid fixed prices that were pegged to an artificially low scale for these wares, so potters increasingly preferred to make vessels for sale on the open market rather than tiles on commission for the court. A royal decree sent to Iznik in 1585 ordered ceramic workshops to stop making tablewares for the market and turn their energies toward making tiles for the palace in Istanbul; this decree shows how bad the situation had become.

The high prices that Ottoman ceramics commanded meant that they were imitated both abroad in Italy and Hungary and in provincial cities throughout the Ottoman Empire. Iznik was still responsible for royal commissions, and much of the raw material had to be brought from Karahisar in eastern Anatolia and other mining centres, some quite far from Iznik. Syria became a centre for the tile industry, although these provincial wares are not as fine as those produced in Iznik. Instead of the distinctive red, they rely on green and have a thick glaze with a tendency to crackle. A typical Damascus product is represented by a set of nine tiles (215) showing a triple-arched gateway decorated with hanging lamps and the names of the first four caliphs venerated by Sunni Muslims. Several sets are known, including one still in place in the tomb of Muhyi al-Din ibn Arabi at Damascus. Such sets of tiles, made to decorate the walls of mosques, tombs or even private houses, must have been produced for the market over a period of time as they show slight differences in size and colour scheme.

At the beginning of the seventeenth century, the artistic and technical qualities of both tiles and tablewares declined. This decline is clear from the tiles decorating the inside of the mosque of Ahmed I (r.1603–17) in Istanbul. The mosque, often called the Blue Mosque because of these colourful tiles, is well known to tourists because of its prime location in the centre of Istanbul on the site of the ancient Hippodrome. Its foundations were laid in 1609 and opening ceremonies held in 1617. Ahmed was the first Ottoman sultan in more than three decades to erect a major imperial mosque in the capital, but unlike his predecessors, he had no money from booty captured in campaigns to finance the project. Instead, he had to take funds from the treasury, thereby provoking the anger of the religious establishment. Obviously the funds were restricted, for Ahmed was only able to commission some new tiles for his mosque, and they are far inferior to those produced in the mid-sixteenth century. The rest of the tiles for the mosque had to be assembled from stock already to hand and pieces cannibalized from other buildings.

Pottery from the seventeenth century shows a similar decline in technique and draughtsmanship. This was a period of rampant inflation, caused by the vast quantities of silver mined in the New World that were exported by Europeans to the Old. The only way that Ottoman potters could make a profit within the system of fixed prices for materials and finished products was by cutting the cost of labour. They consequently simplified and standardized designs to make them easier to produce: the characteristic border became a monotonous pattern of alternating leaves and spirals, and the same central designs were repeated in many different examples. Dishes became smaller, measuring approximately 30 cm (12 in) across, three-quarters the diameter but only half the size of dishes made a century earlier. Pigments were poorer in quality, and the green underglaze painting is often uneven and thin and runs into the glaze. At the same time, potters tried to broaden the market for their wares by expanding the traditional floral designs to include figures, animals, ships, and even such buildings as pagoda-like pavilions and domed churches. One group of fifteen dishes has inscriptions in Greek, showing that potters wanted to appeal to specialized markets. Potters also made tiles decorated with pictures of the Kaaba at Mecca; these were probably designed as souvenirs for pilgrims. Evliya Chelebi, the Ottoman traveller who visited Iznik in 1648, reported that only nine potteries were still functioning of the hundreds said to have been in operation earlier.

The popularity of Ottoman ceramics led to their imitation in other Mediterranean lands. Fez, one of the capitals of the Sharifan dynasty in Morocco, for example, was a major centre for the production of glazed earthenwares. By the end of the sixteenth century there were some 180 pottery workshops there, and in the seventeenth century the city became renowned for its ceramics with a white slip painted in cobalt blue and polychrome. Typical forms include large plates, bowls, pitchers and small oil flasks, but the most distinctive types are covered jars with a knob handle, used for storing different types of food. Some are short and bulbous (216), others taller with a swelling profile. The earliest pieces were sparsely decorated with geometric and floral motifs, but the decoration gradually became denser until the entire surface was covered in closely worked designs. Colours also became stronger in the eighteenth and nineteenth centuries. Some are decorated in blue and white, others painted in blue, green and yellow-orange, sometimes with brown outlines. A few pieces have both types of decoration, showing that they all were produced in the same workshops. Although relatively coarse, especially in comparision to the finest Iznik wares, Fez pottery is quite charming, and the city is still known to tourists today for its ceramics.

Iznik ceramics were also imitated in Iran. Many of the ceramics produced there in the later period are known as Kubachi wares, after a remote town in the Daghestan region of the Caucasus where, in the late nineteenth century, many examples were found set into the walls of houses. The town, however, was never a centre of ceramic production. In medieval times the inhabitants were renowned smiths who made fine jewellery and weapons, including daggers, sabres and chain mail, and in the later period the town was known for its foundries and firearms. The inhabitants presumably sold these guns to the Safavids in return for dishes which they used to decorate their houses. Heavily potted in a soft and porous white body covered with a thin glassy glaze, Kubachi wares were fired at a low temperature so that the glaze is quite fragile and often develops

216
Covered jar,
Fez, late
19th century.
Underglaze-
painted
earthenware;
h.47 cm,
18½ in.
Musée de
l'Homme, Paris

a crackle. They come in several different types, so they must have been made at several sites in Iran over a period of time.

Some Kubachi wares are closely modelled on Ottoman wares. A shallow dish (217), for example, shows how Iranian artists in the early seventeenth century adapted Ottoman designs. The Kubachi dish is the same size as the polychrome Iznik dish (214) and copies its colour scheme and border design. The central scene, however, has changed. The composite flower in the field of the Iznik dish has been reduced to a subsidiary tree which overhangs and frames a man wearing a large turban. He is a definite Iranian type, seen in contemporary paintings executed by artists at the court of Shah Abbas (see 189). The symmetry and stillness of the model has been changed in the copy, which is more evocative, if technically less fine.

Potters in Safavid Iran also revived the lustre technique that had flourished there five centuries earlier (see 142). Lustrewares are not as common as other Safavid pottery, particularly those underglaze-painted in blue in imitation of Chinese ceramics, and lustreware production must have been confined to a small workshop or group. It may have been active over the second half of the seventeenth century, possibly continuing into the

217 Left
Plate with a turbaned figure, northwest Iran, early 17th century. Underglaze-painted fritware; diam. 33 cm, 13 in. Cincinnati Art Museum

218 Right
Lobed bottle, Iran, late 17th century. Fritware overglaze painted in lustre; h.35 cm, 13¾ in. British Museum, London

early eighteenth, since several different styles of Safavid lustreware are known. Most of the pieces are small bottles, bowls and jugs, but surprisingly there are no tiles. Potters were limited by the kiln and technique and could not control them well enough to ensure consistency of colour and glaze. Unlike the soft Kubachi wares, Safavid lustrewares have a fine body of hard white frit. Vessels are moulded or thrown, often in several sections, and then covered with a white slip under a brilliant and close-fitting transparent glaze before being fired and then painted in lustre. The slip was sometimes stained dark blue or yellow, and some pieces (218) have alternate areas of stained and unstained slip. The painted designs of arabesques, birds and blossoms are derived from the repertory used on Kubachi wares.

219
Shah Jahan's
wine cup,
India, 1656–7.
White jade;
l.14 cm, 5½ in.
Victoria and
Albert
Museum,
London

They closely follow illumination from a century earlier, such
as the superb gold borders around pages in the magnificent
Khamsa made in the early sixteenth century for Shah Tahmasp
(see 182).

No fine ceramics were made in India, probably because of the
risk of pollution between members of different castes using the
same vessel. Disposable earthenwares were certainly made and
are still used today as everyday wares. When the Mughal emperor
wanted to eat or drink, however, he did not use a ceramic vessel
but a gold or hardstone one. Shah Jahan, for example, had a
superb winecup carved of white jade (219). It is inscribed with
the date 1067 (corresponding to the date 1656–7) and the
emperor's title 'Second Lord of the Conjunction', an epithet taken
in homage to his illustrious ancestor Timur who was 'Lord of the
Conjunction'. The idea for Shah Jahan's inscribed jade winecup
came from a white jade jug made for the Timurid prince Ulughbeg
in the mid-fifteenth century. It became a proud possession of the
Mughal emperors, and Jahangir had his name inscribed on it in
1613–14, as did Shah Jahan in 1646–7. By adding their names to
famous Timurid objects, the Mughals were affirming their descent
from this illustrious dynasty and reaffirming their legitimacy as
Mongol rulers of India.

While the idea for Shah Jahan's royal wine cup derived from the Timurids, its artistic sources derived from the international repertory of designs available at the Mughal court. The basic form, a halved fruit or gourd, is borrowed from the Chinese vocabulary, while such features as the scroll handle ending in a goat's head, acanthus leaf decoration and prominent foot are European in origin. The flowering lotus blossom at the base derives from Hindu art, while the realistic portrayal of natural forms is characteristic of Mughal art and can be seen in other media such as the decoration of the Taj Mahal (see 151) and carpets made for the court (see 207). Considered the most exquisite hardstone object made for the Mughals, the winecup shows how disparate elements drawn from an extraordinary variety of sources were combined in seventeenth-century India to produce a masterpiece of design and craftsmanship.

Jade was also prized by Ottoman and Safavid rulers, who admired its hardness and colour, and it was popularly thought to cure digestive complaints and insure victory. Jade was not found in the Islamic lands and had to be imported from Khotan in eastern Turkestan and the Far East. Whereas the wealthy Mughals could import blocks of jade and developed a taste for plain pieces remarkable for their pure lines, other rulers with fewer resources who lived further from the sources had to be content with using jade plaques to decorate luxury objects made of other hardstones or precious metals.

One of the fanciest is a canteen made of hammered gold and encrusted with large rubies and emeralds in the Topkapi Palace treasury (see 210). The sides are set with pale green jade plaques similarly encrusted with rubies and emeralds connected by a tracery of gold wire. The curved gold spout ends in a dragon's head, and two other dragon heads spout from the shoulders, one holding in its mouth a large pearl, the other an emerald. The squat shape is derived from the moulded leather flasks used by soldiers, but the materials and decoration show how an ordinary utensil was elevated to royal use. Such jewelled flasks are depicted in

Ottoman paintings from the sixteenth century showing the Master of the Wardrobe carrying them filled with drinking water for the sultan. Another official carries the sultan's sword. The sword was part of the standard regalia carried by all Islamic rulers, but the royal canteen seems to have been a specifically Ottoman tradition.

The gold canteen exemplifies the bejewelled tradition in Ottoman metalwork, in which jewels were applied to a wide range of objects, from arms and armour to domestic utensils such as candlesticks. The stones were set in floral mounts so that the gold served as the calyx of the jewel flower. Although this style was distinctly Ottoman, it also was part of a broad-based taste found at imperial courts in the Islamic lands and in Europe, where rulers assembled a wide range of curios for their private collections. The Habsburg emperor Rudolf II (r.1576–1612), for example, was one of the great collectors of his age, and his agents ransacked Europe for rare works of art to enhance his capital at Prague.

Royal collections were meant not only for personal enjoyment but also to express the ruler's power. In the sixteenth and seventeenth centuries political rivalry between rulers was sometimes expressed in artistic terms. Suleyman, for example, abandoned the turban – the standard Islamic royal headgear – and ordered instead a spectacular gold helmet from Venetian goldsmiths in 1532. The helmet, known only from Venetian woodcuts and an engraving, consisted of four crowns with enormous pearls, a headband with diamonds, and a neckguard with straps, as well as a jewelled plume. Valued at 144,400 ducats, it was decorated with 50 diamonds, 47 rubies, 27 emeralds, 49 pearls and a large turquoise, and came in a velvet-lined ebony case decorated with gold. The helmet was apparently meant to symbolize Suleyman's political aspirations in western Europe by copying both the crown of the Habsburgs and the tiara of the popes, but its meaning was quickly lost, and it was melted down.

The bejewelled tradition of cut and polished or carved gemstones set into objects of jade or precious metal seen at the Ottoman

220
Jewelled dagger and scabbard, India, early 17th century. I.36 cm, 14¹⁄₃ in. Dar al-Athar al-Islamiyya, Kuwait, on loan from the al-Sabah Collection

court became even more popular under the Mughals, the richest of the Islamic superpowers. Their daggers and scabbards were particularly elaborate. They had blades of watered steel, sometimes decorated with several colours of gold, and hilts of crystal, jade or gold with rubies, emeralds and diamonds set in gold. The scabbards were decorated to match the hilts or covered with red velvet with jade or gold lockets. In his memoirs, the emperor Jahangir devoted many passages to daggers, describing how he presented them to family members and courtiers and received them as gifts. He deemed the skilled craftsmen who made them equals of his favourite artists. One passage written in 1619 says:

I ordered the masters Puran and Kalyan, who had no rivals in the art of engraving, to make dagger-hilts of a shape that was approved at this time and has become known as the Jahangiri fashion. At the same time the blade and the scabbard and fastening were given to skilful men, each of whom was unique in his age in his art. Truly, it was all carried out according to my wish. One hilt came out coloured in such a way as to create astonishment. It used all the seven colours, and some of the flowers looked as if a skilful painter had depicted them in black lines around it with a wonder-working pencil. In short, it was so delicate that I never wish it to be apart from me for a moment. Of all the gems of great price that are in the treasury, I consider it the most precious. On Thursday I girded it auspiciously and with joy around my waist, and the masters who in their completion had exercised great skill and taken great pains were rewarded, Master Puran with the gift of an elephant, a dress of honour and a golden bracelet for the wrist, and Kalyan with the title 'Wonderful Hand', and increased rank, a dress of honour and a jewelled bracelet. In the same way everyone according to his circumstance and skill received favours.

One such dagger and scabbard (220), probably the finest to survive, shows the almost unbelievable wealth available to Mughal craftsmen to decorate weapons and other objects for the court. The steel blade is decorated with gold designs of birds. The solid gold hilt and scabbard of gold-covered wood are set

with ivory, agate, diamonds, rubies and emeralds as well as contrasting pieces of green and blue glass. The decoration contains more than 2,400 stones, all cut and polished except the diamonds, which are left in their natural state and set according to size. The jewels form designs of birds, flowers and trees. One side of the cross-guard ends in a stylized tiger's head. Its teeth are made of ivory, its tongue carved from a ruby, and the inside of its throat and mouth set with three more rubies. The other side ends in a graceful horse's neck and head that arches in a swooping S-shaped curve.

The Mughal taste for highly-decorated surfaces was also met by several decorative techniques introduced from Europe and adopted by Indian craftsmen at this time. In architecture, the traditional method of stone decoration using a mosaic of different coloured marbles was replaced by inlay, in which a slab of marble was embedded with hard and rare stones such as lapis, onyx, topaz, carnelian, agate and jasper. The new technique allowed artists to create much more elaborate designs, and traditional geometric patterns and arabesques were juxtaposed to representational motifs showing wine cups, vases with flowers, cypress trees and even people. For example, the jewel-like tomb erected for Jahangir's minister of finance and father-in-law, Itimad al-Dawla (d.1622) on the banks of the Jumna River in Agra is lavishly decorated in warm golden tones of inlaid marble. The lower walls on the exterior have strapwork patterns, while upper panels on inner surfaces show flowers amidst cypress trees. The cypress is the traditional metaphor in Persian poetry for death and eternity, and its recurrent use on a tomb in India shows how Persian literature was the norm under the Mughals. The wall behind the throne in the audience hall in the Red Fort at Delhi built by Shah Jahan in the 1640s is decorated with several panels of inlaid marble. One at the top showing Orpheus playing his lyre is taken from the Florentine repertory; it is set amid other panels showing traditional Mughal scenes of kingfishers and parakeets.

One of the new jewellery techniques introduced at this time to Mughal India was enamelling, in which metal objects are decorated with glass pastes coloured with metal oxides and fixed by heat. Because of its fragility (enamel cracks and splinters like glass), few early examples have survived, but the technique was probably introduced at the beginning of the early seventeenth century by European jewellers who served at the Mughal court. Indian craftsmen soon adopted the technique and expanded the repertory to jewellery and other objects ranging from thumb rings to thrones. A small covered jar (221), decorated with a white trellis set against a translucent green ground with details highlighted in translucent yellow and pink, shows how Mughal craftsman quickly mastered the technique and adapted designs from architectural decoration (see 151), manuscript illumination (see 175), and carpets (see 207) to enamel objects. Indian enamels, which are remarkable for their clear, rich colours and fine design, were probably produced in the imperial workshops at Agra, Delhi and perhaps Jaipur.

The bejewelled tradition combines the arts of the goldsmith and the jeweller, but another tradition of metalware in the later period involved only the smith. In Safavid Iran, some metalworkers in the early sixteenth century continued the tradition of inlaid brasses that had flourished in the middle period (see Chapter 8), but an even more popular technique

was engraving. It can be seen on many examples of a new type of lamp that appeared in Iran in the 1540s. A tall cylindrical base supports a separate torch containing the reservoir for oil, which can also be carried on a stick. Many of the bases were later converted into candlesticks, with the upper part inserted upside down into the base. For a long time these pieces were wrongly called candlesticks. An example in St Petersburg (222) with both base and torch intact shows the correct assembly. Both parts are inscribed with the name of the owner, Hajji Chelebi, and the date 987 (corresponding to the date 1579–80). The torchstand was later acquired by Count Bobrinsky, the same person who owned the magnificent inlaid bucket made some 400 years earlier (see 138), and like it, the torchstand was eventually acquired by the Hermitage.

The torchstand is engraved all over its surface with boxes and bands containing arabesques and poetic verses. The layout derives from manuscripts, in which bands of poetry are written horizontally or sometimes diagonally in boxes. The texts inscribed on the torchstand are also taken from Persian literature. Like the metaphor of the cypress used to decorate Itimad al-Dawla's tomb at Agra, the verses relate to a famous metaphor from Persian literature in which the moth seeking the candle flame is compared to the human soul seeking God. Looking for heat, the moth draws near to the candle until it is finally burned and consumed by the flame. The image was popular with Sufis, who used it as a visual realization of their concept of *fana* – annihilation. The metaphor became common in Persian poetry, and the verses inscribed on the torchstand are taken from the works of several Persian poets, including one couplet by the beloved Sadi:

I remember one night, when my eyes were not sleeping
I heard a moth tell the candle
'I am in love and I am to die in flames
Why should you weep and get burned?'

These verses, often inscribed on torchstands, would have been appreciated by almost any literate owner. On several torchstands,

221
Above left
Covered jar,
India, c.1700.
Enamelled
gold;
h.14 cm, 5½ in.
Cleveland
Museum of Art

222
Below left
Torchstand,
Iran, 1579–80.
Copper alloy;
h.41 cm,
16⅛ in.
Hermitage, St
Petersburg

the compartments for the owner's name and date are still blank, so it seems that these wares were made for the market, with space for the owner's name and date to be added after purchase. Some bowls produced in the Safavid period include Armenian verses engraved alongside the more common Persian ones. These wares were commissioned by or made for Armenian patrons, probably members of the important Armenian community established by Abbas in New Julfa south of the capital Isfahan (see Chapter 8).

Another technique of metalware popular in the later period involved covering a base-metal alloy with another material. This was done partly for utilitarian reasons – to prevent the poisonous effects of copper in cooking and eating vessels, and partly for decorative ones – to simulate the appearance of precious metals. One method was tinning, which imparts a silvery surface. The technique had been used in Iran under the Timurids to cover a variety of wares and continued to be used under the Safavids. Gilding, which could cover not only silver but also copper, was more popular in the Ottoman lands. Gilt copper (sometimes called *tombak*) was used for lamps, bowls, jugs (223) and candlesticks. Utilitarian objects of gilt copper were richly decorated with flutes or incised designs of flowers and arabesques, but candlesticks were often left plain. Pairs of these candlesticks were set flanking the *mihrab* in many Ottoman mosques, and the bright shiny surfaces must have effectively reflected the light, especially when placed in front of the brilliant glazed tiles that covered the *qibla* wall.

In the seventeenth century a distinctive tradition of metalwork developed in India. It is known as Bidri ware, after Bidar, the city in the Deccan region of south-central India where the technique is thought to have originated. Bidri wares are cast from an alloy of zinc mixed with copper, tin and lead, and then inlaid with silver or brass, occasionally with gold. The objects are subsequently coated with a paste of mud containing sal ammoniac. When the coating is removed and the piece polished, the base metal is left

223
Ewer, Turkey,
16th century.
Tinned copper;
h.24 cm, 9⅝ in.
Metropolitan
Museum of
Art, New York

a rich matt black which provides a foil to the shiny inlay. Bidri wares are commonly depicted in Deccani paintings from the late seventeenth century, so the technique probably developed there earlier in the century. By the eighteenth century, the technique had been adopted in several centres in northern India. It was used for a wide variety of bowls, jugs, covered boxes and dishes, but one of the most common forms is the base for a hookah or water pipe, used for smoking hemp or tobacco (224). These bases could be spherical or bell-shaped and decorated with floral designs or imbrecated patterns that resemble peacock feathers. While hemp had been cultivated in the region for centuries if not millennia, tobacco was a New World plant introduced to Europe, the Far East and the Islamic lands in the sixteenth and seventeenth centuries. Smoking tobacco quickly become popular, to judge from the many surviving examples of water-pipe bases from India as well as Iran. They were made not only in metal, but also in glass and ceramic, testifying to the traditions shared among the arts of fire.

In the eighteenth and nineteenth centuries European powers penetrated the Islamic lands, establishing trading centres and then colonies and protectorates throughout the region. Even the dwindling Ottoman Empire and Qajar Persia, which were never directly colonized, became deeply dependent on European capital. All these lands provided raw materials and markets for the manufactured products of the Industrial Revolution in Europe, such as textiles, crockery and cutlery, which came to replace the products of the traditional craft industries. Already in the eighteenth century European travellers noted that Meissen ceramics were used in the Ottoman provinces, and an imperial porcelain factory modelled on that at Sèvres was established in Istanbul in the 1820s. A British artist at Poona in India in 1790 reported that European articles, including gold watches, painted glass windows, teapots, silk stockings and pianos, would find a ready market there. Conversely, returning colonials brought souvenirs home as well as an appreciation for products in the traditional techniques and styles of the Islamic lands. The artistry of hand craftsmanship was particularly appreciated by William Morris, founder of the Arts and Crafts Movement that decried the mechanization of craft in the West. It was Morris who encouraged the South Kensington Museum (later the Victoria and Albert Museum) to raise £2,000 to purchase the Ardabil Carpet (see 193). Lord Curzon, Viceroy of India at the turn of the twentieth century, was so impressed by the Mamluk metalwork he saw when passing through Cairo that he ordered a lamp made there which he later presented as a gift to the Taj Mahal.

Despite the ravages of colonialism, industrialization and modernization, many of the traditional crafts survive in the Islamic lands. While most people use aluminum pots and pans, Duralex glasses, and mass-produced crockery from the Far East, they also appreciate the traditional crafts and own display pieces. An even more lucrative market is the tourist trade, for few tourists return from a visit to any of the traditional Islamic lands without a hammered copper or brass tray or gaily-coloured ceramic purchased in the bustling bazaar.

224
Base for a hookah or water pipe, Deccan(?), mid-18th century. Zinc alloy; h.17 cm, 6²⁄₃ in. Victoria and Albert Museum, London

In many parts of the Islamic world, the traditional arts of
architecture, the arts of the book, the arts of the loom, and the
arts of fire fell to a nadir in the nineteenth and early twentieth
centuries. This was largely due to the shift of economic and
political power over the preceding centuries from the Islamic
lands to western Europe. Since the sixteenth century the
dominating influence of Europe – from French colonies in North
Africa to the British colony in India – had disrupted traditional
modes of supply and production in the region, and by the
nineteenth century European manufactures, such as textiles and
crockery, flooded Near Eastern and Indian markets and began to
spell the end of the traditional craft system, particularly in cities.
European colonial patrons, with a few notable exceptions, had
little interest in the indigenous arts except to bring them home
as souvenirs of their residence abroad, but by the end of the
nineteenth century, growing appreciation led to the creation of
some of the finest collections of Islamic art in Europe.

In most Islamic lands there was little need or money for new
construction of the types of buildings – mosques, *madrasas*,
caravanserais, etc. – that had been traditional for centuries.
The few structures that were built repeated indigenous forms
in pastiches. For example, the major architectural monument of
the reign of Muhammad Ali – an Ottoman soldier of Armenian
origin who became ruler of Egypt from 1805 to 1848 – was an
enormous mosque on the citadel overlooking Cairo. The mosque,
probably designed by a Greek from Istanbul, is a loose amalgam
of an Ottoman-style mosque with many Europeanizing elements,
such as a stubby clock tower with Gothic tracery and Moorish
arabesques. The clock, which would have been totally useless
for determining the times of prayer because they are reckoned
by the position of the sun, was presented in 1846 by Louis-

225
Mihr Ali,
Portrait of
Fath Ali Shah,
Iran, 1813.
Oil on canvas;
246 × 125 cm,
97 in × 49 in.
Negaristan
Museum,
Tehran

Philippe in exchange for an Egyptian obelisk sent to Paris and erected in the Place de la Concorde.

The ruling classes in Islamic lands came to appreciate exotic forms of Western art, although – or because – they had little connection to local tradition. The most notable new medium was oil painting on canvas. It had been introduced to Iran in the late seventeenth century, but under the Qajar dynasty (r.1779–1924), a distinct style of painting evolved in which Persian and European modes of representation were synthesized. The Qajar monarch Fath Ali Shah (r.1779–1834) appreciated the importance of art in the creation of a regal image. He commissioned innumerable canvases and murals to decorate the walls of the many palaces he erected throughout his realm, such as the life-size portrait (225) by the court artist Mihr Ali. The canvases were mostly full-length portraits of the shah in his favourite pose, showing off his luxuriant black beard and elaborate regalia, which form the foundation of the crown jewels of Iran. A destroyed mural painted by Abdallah Khan in 1812–13 for the Nigaristan Palace in Tehran depicted the monarch enthroned in state with 118 life-size courtiers. The ruler also had himself portrayed in rock reliefs, like the Achaemenid and Sasanian rulers of pre-Islamic Iran, and had

his portrait put on the coinage for the first time since the Arab conquest of Iran in the seventh century.

In order to meet the demand for the new type of representation, some Qajar artists were sent to study in Europe. Abu'l-Hasan Mustawfi Ghaffari, a member of the noted Ghaffari family of painters, is known for his polychrome watercolours and wash drawings produced between 1770 and 1800. His great-nephew Abu'l-Hasan Ghaffari (active 1850–66) was sent to study painting in Italy, and upon his return to Tehran he was made painter laureate and founded an art school. The greatest painter of Qajar times, he was awarded the Persian title Sani al-mulk ('Craftsman of the Realm'), by which he is usually known. The realistic Europeanizing style that he introduced was continued by his nephew Muhammad, known as Kamal al-mulk ('Perfection of the Realm'), who became the most notable painter in Iran at the turn of the twentieth century.

The taste for pictorial art was quite broad in Qajar Iran, and there was a relatively large market for warm and sentimental paintings on a smaller scale. Many such paintings of birds, flowers and people were done in enamel or under varnish (often confusingly called lacquer) on boxes, mirrors, pen-cases and other small objects of metal, wood and papier-mâché. The importance of this art is revealed by the many names and long careers of artists and families of artists. For example, at least fifteen members of the Imami family of Isfahan signed varnished and painted objects, such as a magnificent mirror-case decorated with irises, roses and other naturalistic flowers (226). Painted by Riza Imami in 1866 for the Paris Exposition of 1867, it was acquired in 1869 by the South Kensington (later Victoria and Albert) Museum in London as a notable example of Persian handicraft.

In contrast to Iran, in the Ottoman Empire oil painting tended to follow the models of European Orientalism more closely. Many Turkish artists were sent to study oil painting at the École des Beaux-Arts in Paris, where they worked under such renowned Orientalist painters as Gustave Boulanger and Jean-Léon Gérôme.

For example, the Ottoman painter Osman Hamdi (1842–1910), son of the grand vizier Ibrahim Edhem Pasha, was sent to Paris in 1857. After he returned to Istanbul in 1868, he continued to paint while holding several official positions. In 1881, he became director of the Imperial Ottoman Museum at Topkapi Palace, where archeological antiquities were displayed, and in 1883 he founded and became the first director of the Fine Arts Academy in Istanbul. His paintings, which were often exhibited in Europe, introduced narrative scenes and portraiture to Ottoman eyes.

Prince Abdulmejid (1868–1944), appointed caliph for two years after the last Ottoman sultan was deposed in 1922, was a rather retiring figure who excelled in portraiture and genre scenes. His best-known painting, *Beethoven in the Saray*, now in the Istanbul Museum of Fine Arts, depicts a piano trio performing in the palace in front of a bust of Beethoven, with the artist himself as one of the listeners. Although the artist, as caliph, was briefly the nominal head of the world community of Muslims, his painting has absolutely nothing to do with the long traditions of Islamic art in the Ottoman Empire. Many other members of his generation also saw progress as a rejection of the traditional past and a whole-hearted acceptance of European culture.

Like painting, European architecture had been popular at the Ottoman court throughout the nineteenth century, when new European institutions, such as army barracks, were built to replace traditional military housing. As institutions were Europeanized, buildings in European styles, such as shore-front palaces and train stations, were designed either by Europeans practising in Istanbul or by Ottomans who had studied abroad. Krikor Balyan (1767–1831), for example, belonged to an Armenian family of architects who worked for the Ottomans. The first of his family to train in Europe, he designed mosques and pavilions in a Europeanizing style, which was continued and expanded by his sons and grandson. By the late nineteenth century there was growing interest in creating a national style of architecture. At first orientalist elements were applied to a European frame, but

the next generation of architects sought authenticity in the vernacular traditions of Anatolian domestic architecture. This approach was also popular with the Egyptian architect and theorist Hassan Fathy (1890–1989), whose village of New Gourna (1945) near Luxor in Egypt (227) turned to the vernacular mud-brick buildings of the Egyptian countryside rather than the masonry monuments of Mamluk Cairo.

227
Hassan Fathy,
Mosque
and minaret,
New Gourna,
Egypt, 1945

Following World War II, the pre-eminence of the European International Style made it popular for development projects everywhere, including lands with a strong Islamic tradition. After the partition of India in 1947, for example, new capital cities were needed. The French architect Le Corbusier (1887–1965) was hired to design Chandigarh, the new capital of the Indian province of the Punjab since Lahore was now in Pakistan. The American architect Louis Kahn (1901–74) was hired to design the government buildings in Dacca, the capital of East Pakistan, later Bangladesh. In both instances the relationships to the indigenous traditions of architecture are minimal, at best.

The greatest development in modern Islamic architecture occurred following the rise in the price of petroleum in 1973 and the phenomenal increase in the region's wealth. Enormous development projects were undertaken throughout the region, ranging from new airports and facilities for the millions of pilgrims who go to Mecca and Medina each year to air-conditioned shopping malls and vacation villas for European pilgrims to sun

and sea. As everywhere, these projects have varied in quality, ranging from banal reinforced concrete reproductions of domed Ottoman mosques to sublime explorations of the nature of religious experience in the twentieth century. To encourage the creation of a modern architectural idiom in the Islamic lands, the Aga Khan – leader of the Ismaili Muslims – sponsored an award for architecture, given every three years from 1977.

One of the winners in 1983 was Shereffudin's White Mosque at Visoko, Bosnia. Designed by Zlatko Ugljen, professor of design at the University of Sarajevo, it was completed in 1980. Nestled in a neighbourhood of traditional red-tiled houses, it skilfully combined traditional and modern architectural elements in a bold design of reinforced concrete, travertine, wood and glass. The growth of the Muslim community in Visoko and the trend in Yugoslavia during the late 1970s to emphasize religion had led the architect to seek inspiration within the local tradition of Ottoman-style building complexes, and the new project combined a mosque with an adjacent annex housing a library, auditorium and offices. The architect could not know, however, that the same forces that led to the construction of this mosque complex would also lead to its destruction. This lovely building was one of the many casualities of the Bosnian civil war in the 1990s.

Throughout the Islamic lands – traditional and non-traditional – artists, like other people, grapple with the conflicting demands of being true to one's heritage while still in the twentieth century. Some artists have sought inspiration in Arabic calligraphy, for example, which they have transformed with the gestural techniques more commonly associated with Abstract Expressionism or the three-dimensional forms of modern sculpture. Others have looked to the millennial traditions of arabesque, geometry, and pattern in Islamic art as subjects for their canvases. Few 'modern' artists, however, have yet returned to seek inspiration in the craft traditions of Islamic arts which flourished for fourteen centuries.

Glossary

Abd (Arabic) 'Servant/slave of', used in many Muslim personal names in combination with one of the names of God, as in Abd Allah (God's servant), Abd al-Malik (Servant of the King [ie God]), Abd al-Rahman (Servant of the Merciful One).

Abu (Arabic) 'Father of,' used in many Muslim personal names in combination with the name of the first-born son, as in Abu Zayd (Father of Zayd), or with an honorific epithet, as in Abu Mansur (Father of Victory).

Ali ibn Abu Talib Cousin of the Prophet Muhammad. He married the Prophet's daughter Fatima. Considered to be the first convert to Islam, Ali served as the fourth caliph (r.656–61) until his assassination. Shiites venerate his descendants.

Allah (from the Arabic *allah*, 'the One God') God.

Amir (Arabic) Prince.

Arabesque The distinctive decorative motif on many forms of Islamic art after the tenth century. It is based on such natural forms as stems, leaves or tendrils that are arranged in infinitely repeating geometric patterns.

Basmala (from the Arabic *b'ism allah al-rahman al-rahim*, 'in the name of God the Merciful and Compassionate') The invocation with which a pious Muslim begins most utterances and activities.

Bazaar (from the Persian *bazar*, 'market') A market, usually comprising rows of small shops linked by covered streets and courtyards.

Berber The indigenous inhabitants of northern Africa.

Bevelled style A distinctive style of decoration in relief based on the use of an oblique or slanted cut and abstracted vegetal forms. It was used in many media from the ninth century onwards.

Byzantine (literally, 'from Byzantium', the ancient name of Constantinople/Istanbul) It refers to the Roman Empire in the East, which dated from Constantine's transfer of the capital to Constantinople in 330 until the Ottoman capture of the city in 1453.

Caliph (from the Arabic *khalifa*, 'successor' or 'follower') The title given to leaders of the Islamic community following the death of the Prophet Muhammad in 632.

Caravanserai (from the Persian *karvan*, 'caravan' and *saray*, 'house or lodging') A medieval motel for caravans, often arranged around a central courtyard with stables and storerooms on the ground floor and sleeping quarters above.

Colophon An inscription at the end of a manuscript giving information about the copyist, date, and place of production.

Hadith (from the Arabic *hadith*, 'narrative', 'talk') The traditions relating to the life, deeds and sayings of the Prophet Muhammad. After the Koran, they are considered the second source of Islamic law.

Hajj (from the Arabic *hajj*, 'pilgrimage') The pilgrimage to Mecca, one of the five duties incumbent on all Muslims. It should be performed at least once in a lifetime. A man who has completed the pilgrimage earns the title Hajji.

Hegira (from the Arabic *hijra*, 'emigration') Muhammad's emigration from Mecca to Medina in 622, the date from which the beginning of the Muslim lunar calendar is calculated.

Hypostyle (from the Greek *hupostulos*, 'resting upon pillars') Having a roof or ceiling supported by many columns. This type of structure was commonly used for congregational mosques, particularly in early Islamic times.

Ibn (from the Arabic *ibn*, 'son') Commonly used in Arabic names to link the name of the individual with that of his father, as in Ahmad ibn Tulun (Ahmad the son of Tulun). Sometimes the individual's given name can be dropped, as in Ibn Tulun. Variant forms are *bin*, *ben* and the feminine *bint* (for daughters).

Islam (from the Arabic *islam*, 'submission [to God]') The last of the great monotheistic religions; it was revealed to the Prophet Muhammad and is professed by Muslims. The adjective 'Islamic' is used to refer to the religion, as well as the society and culture associated with it.

Iwan (from the Persian *ayvan*, a kind of room) A vaulted space open at one end. The form was common in Ancient Near Eastern architecture and continued to be popular in Islamic buildings, particularly in arrangements of one or more *iwans* opening onto a courtyard.

Kaaba (from the Arabic *ka'ba*, 'cube') The cubic structure in the centre of the Haram Mosque in Mecca towards which Muslim prayer is directed.

Koran (from the Arabic *qur'an*, 'revelation' or 'recitation') God's word revealed to the Prophet Muhammad. Muslims consider the Koran the primary source of Islamic law.

Kufic (literally, 'from the city of Kufa in Iraq') A style of script characterized by angular forms that was popular in early Islamic times.

Lampas A weaving technique in which two sets of warps and wefts create independent ground and pattern weaves. This complicated technique was used from the eleventh century to produce sumptuous fabrics of silk and gold-wrapped threads.

Madrasa (from the Arabic *madrasa*, 'place of study') A theological college. Madrasas were often founded by **Sunni** Muslims in the middle period to propagate orthodox beliefs.

Maqsura (Arabic) A screened area near the *mihrab* in a mosque, generally reserved for the ruler or his representative.

Mihrab (Arabic) A recessed space in the wall of a mosque facing Mecca, the direction in which Muslims pray.

Minaret (from the Arabic *manara*, 'place of light') A tall tower attached to a **mosque**. It is often used to call the faithful to prayer.

Minbar (Arabic) The stepped pulpit in a **mosque** used by the preacher or community leader for the Friday bidding prayer.

Mosque (from the Arabic *masjid*, 'place of prostration') A place where Muslims worship.

Muqarnas (Arabic) Tiers of niche-like elements that project out from the tier below. Often likened to stalactites, this decorative motif became one of the distinguishing features of Islamic architecture from the middle period.

Muslim (from the Arabic *muslim*, 'one who submits [to God]') A person who follows the religion of Islam.

Qibla (Arabic) The direction of prayer. All Muslims pray towards the **Kaaba** in Mecca.

Ramadan (Arabic) The ninth month of the Muslim lunar calendar during which Muslims must abstain from eating or drinking from sunrise to sunset. This fast is one of the five duties incumbent on all Muslims.

Shiite (from the Arabic *shi'a*, 'party', 'faction') Those Muslims who believe that leadership of the Muslim community passed from the Prophet Muhammad through his son-in-law Ali to his descendants.

Simurgh (Persian) A legendary lion-bird from Persian mythology.

Sufi (from the Arabic, *suf*, 'wool,' on account of the coarse woollen cloaks worn by adherents) Mystics, whose very personal approach to religion became increasingly important alongside the communal practice of Islam.

Sunni (from the Arabic *sunna*, 'way [of Muhammad]') Muslims who follow one of the four 'orthodox' schools of law.

Tiraz (from the Persian *tiraz*, 'embroidery') Inscribed fabrics made in state workshops and distributed by the ruler to his courtiers. By extension, tiraz also refers to the inscriptions on such fabrics.

Major Dynasties

Numbers in square brackets refer to illustrations

Abbasid Dynasty of caliphs that ruled from several capital cities in Iraq between 749 and 1258, although their power was increasingly usurped from the tenth century by local rulers. Baghdad, their principal capital, was the centre of an enormous empire stretching at its peak between the Atlantic and the Indian oceans. Although little Abbasid art from the early period has survived [49–51, 57–8], the artistic legacy of the dynasty can be seen in many arts that reflect the splendid products of the capital and its court [61–2]. Major patrons include al-Mansur (r.754–75), the founder of Baghdad, and al-Mutawakkil (r.847–61) who built the large congregational mosques and palaces at Samarra [6, 15–16, 23–5].

Aghlabid Dynasty of governors that ruled North Africa for the **Abbasids** from 800 to 909. The mosque in their capital at Kairouan, Tunisia is one of the best-preserved examples of a hypostyle congregational mosque from the early period and is remarkable for its fine furnishings, including a **mihrab**, **minbar** and **maqsura** [18–20].

Fatimid Shiite dynasty of caliphs that ruled North Africa and Egypt from 909 to 1171. Their splendid capital at Cairo was a major centre for the production of luxury arts, including exquisitely carved rock crystals, glittering lustre ceramics and fine textiles [123, 134–5].

Ilkhan Dynasty of Mongol sultans that ruled greater Iran from 1258 to 1335. Following their capture of Baghdad and the fall of the Abbasid caliphate in 1258, they established several capitals in northwest Iran [87–8] as subordinates (Ilkhan) to the great Mongol khan in China. Under their auspices, the illustrated and illuminated book became a major form of artistic expression in Iran [104–7].

Mamluk Sequence of sultans, originally Turkish or Circassian slaves (Arabic *mamluk*, hence their name), that ruled Egypt, Syria, and Arabia from 1250 to 1517. Cairo, their capital, became one of the largest cities in the medieval world, and, after the fall of Baghdad to the Mongols, the centre of Arab-Islamic culture. Mamluk rulers endowed the city with many fine buildings, particularly large complexes combining charitable institutions with their tombs [94–6] and furnished them with fine fittings and magnificent manuscripts of the Koran [108, 148–9].

Mughal Dynasty of emperors that ruled the Indian subcontinent from 1526 to 1857. They claimed descent from the Mongols, hence their name. The richest and most powerful of the great Islamic empires in the later period, the Mughals are famed for their immense palaces and tombs built of red sandstone and white marble and set in lush gardens [3, 151, 172–4]. They also commissioned illustrated manuscripts [175, 186–7], sumptuous textiles [192, 206–9], and extraordinary precious and bejewelled objects [219–21].

Nasrid The last Muslim dynasty in Spain, the Nasrid sultans (r.1230–1492) ruled a shrinking but splendid realm from the Alhambra palace in Granada [2, 71, 73, 98–100]. Their lustre ceramics and textiles [116] were esteemed in all the courts of Europe.

Ottoman Turkish dynasty of sultans that ruled Anatolia and much of the Mediterranean and Near East from 1281 to 1924. The longest-lasting of the Islamic empires of the later period, the Ottomans presided over an international court at their capital Istanbul. Their religious architecture is characterized by stone **mosques** with cascading lead-covered domes framed by pencil-shaped **minarets** [155–9]. Their court workshops produced manuscripts [176–9, 183–5, 191], textiles [200–4], and ceramics [150, 211–14], many of which were brightly decorated with flowers and leaves.

Safavid Dynasty of shahs that ruled Iran from 1501 to 1732 and made Shiism the state religion. Their capital at Isfahan [154, 160–9] became the centre of a vast commercial network based on the production and export of fibres and textiles [193–8]. They commissioned some of the finest illustrated manuscripts ever produced [152, 181–2].

Saljuq Dynasty of Turks from Central Asia who ruled Iran from 1038 to 1194. Another branch controlled Anatolia from 1077 to 1307. The Saljuqs, the major power in the middle period, set the style for much Islamic art and architecture in the eastern Islamic lands. The four-*iwan* plan, for example, became ubiquitous [81–3, 92] and the figural style of decoration associated with them became wildly popular throughout the region in ceramics and metalwork [138–47].

Sultanate Refers to the six dynasties of sultans that ruled northern India from Delhi between 1206 and 1555. They were responsible for introducing Islam to northern India, and their arts, particularly architecture [78–80] and the arts of the book, combine local and Persian elements.

Timurid Mongol dynasty descended from the great steppe conqueror Timur (or Tamerlane, r.1370–1405) that ruled Iran and Central Asia from 1370 to 1501. Their buildings were enveloped in webs of brilliantly coloured glazed tiles [89–91]; their books represent the classical moment in Persian painting [111–14].

Umayyad The first Islamic dynasty (r.661–750). Ruling as caliphs from their capital at Damascus in Syria, they controlled an empire stretching from Spain to Central Asia. Their art adapts Classical, Byzantine and Sasanian forms and motifs to the new taste in a series of splendid religious and secular structures [8–11, 13–14], metalwares [12, 30–33, 66] and textiles [49]. The Arabic script became a major vehicle of artistic expression under the Umayyads [29, 34–6]. Following their defeat by the Abbasids, the sole surviving member of the Umayyad family founded another branch that ruled from Córdoba in Spain [74–6, 136–7] between 756 and 1031.

Key Dates

Numbers in square brackets refer to illustrations

North Africa, Europe and Byzantium	Near East and Iran	Central Asia, India and China
	*c.*570 Birth of Muhammad at Mecca	
	*c.*610 Muhammad's first revelation	
		618 Tang dynasty established in China
	622 Hegira to Medina	
	632 Death of Muhammad	
	638 Muslim armies conquer Jerusalem	
	661 Umayyad caliphate established (to 750); capital moved to Damascus in Syria	
		667 Arab armies cross River Oxus
	692 Jerusalem, *Dome of the Rock* [8–10]	
	705 Damascus, *Umayyad Mosque* begun [11, 13]	
711 Muslims cross Straits of Gibraltar into Spain		
726 Iconoclastic controversy in Byzantium begins		
	730s *Khirbat al-Mafjar* palace complex, Palestine [14]	
732 Battle of Poitiers in France: Charles Martel defeats Muslims		
	750 Abbasid caliphate established (to 1258)	
		751 Battle of Talas in Central Asia: Muslims defeat Chinese
756 Umayyad emirate established at Córdoba in Spain		
	762 Founding of Abbasid capital at Baghdad	
771 Charlemagne becomes King of the Franks		
784 *Mosque of Córdoba* begun [75]		
	796 *Ewer* made by Sulayman [67]	
800 Aghlabid amirate founded in North Africa; Charlemagne crowned emperor		
	819 Samanid dynasty established in Persia (to 1005)	

North Africa, Europe and Byzantium	Near East and Iran	Central Asia, India and China
	836 Abbasids establish new captital at *Samarra* [6, 15–16]; Kairouan, *Mosque of Sidi 'Uqba* [18–20]	
	879 Cairo, *Mosque of Ahmad ibn Tulun* [17]	
		908 End of Tang dynasty in China
909 Fatimid dynasty established in North Africa (to 1171)		
910 Monastery at Cluny founded		
		920s Bukhara, *Tomb of the Samanids* [84]
922 Córdoba becomes autonomous caliphate		
		960 Song dynasty established in China
		961 *Shroud of St Josse* [118]
965 Córdoba, *Maqsura of Mosque* [74, 76]		
	975–96 *Aziz ewer* [135]	
	1000 *Ibn al-Bawwab Koran* [102]	
1004 *Pamplona Casket* [137]		
	1006 Gurgan, *Gunbad-i Qabus* [86]	
	1009 al-Sufi's *Book of the Fixed Stars* [101]	
	1010 Firdawsi composes the *Shahnama*	
1031 Fall of Umayyad caliphs in Spain		
	1038 Saljuq dynasty established (to 1194)	
1040 Paris, Choir of St Denis built		
1054 Great Schism between Rome and Byzantium		
1066 Battle of Hastings: Normans invade Britain		
1071 Battle of Manzikert in Anatolia: Byzantines defeated by Saljuq Turks		
	1088 Isfahan, *North Dome of Congregational mosque* [81]	
1092 Normans complete conquest of Sicily from Muslims		
	1096 *Veil of Ste Anne*	
	1099 First Crusade takes Jerusalem	
		1112 Angkor Wat temple complex begun in Cambodia
	1114 Caravanserai Ribat Sharaf built, northern Iran [92]	

North Africa, Europe and Byzantium	Near East and Iran	Central Asia, India and China
1133 *Mantle of Roger II* [122]		
	1147–9 Second Crusade	
		1163 *Bobrinsky Bucket* [138] made at Herat
		1190s Delhi, *Quwwat al-Islam Mosque* begun [78–9]
1194 Chartres Cathedral begun		
1196 Beginning of Marinid dynasty, Fez (to 1549)		
		1199 Delhi, *Qutb Minar* begun [80]
1204 Fourth Crusade takes Constantinople		
		1206 Founding of first Delhi sultanate; Genghis Khan proclaimed chief of Mongols
	1210 *Scalloped lustre plate* [142]	
1215 Magna Carta signed in England		
		1227 Death of Genghis Khan and division of his empire
1230 Nasrids established in Spain and make Granada their capital (to 1492)		
	1232 *Blacas ewer* [145]	
	1237 Yahya al-Wasiti copies *Maqamat* [103]	
	1250 Mamluk sultanate established in Egypt and Syria (to 1517)	
	1256 Ilkhanid dynasty of Mongols established in Iran (to 1336)	
	1258 Mongols overthrow Abbasid caliphate and take Baghdad	
	1261 Mongols sack Mosul in northern Iraq	
		1264 Kubilai Khan establishes capital at Peking/Beijing
		1271–95 Marco Polo of Venice travels through Asia to China
1273 Rudolf of Habsburg elected Emperor		
		1279 Southern Song dynasty overthrown by Yüan dynasty in China
1281 Ottoman dynasty founded		
*c.***1306** Giotto completes fresco cycle in Arena Chapel, Padua, Italy		
	1313 Sultaniyya, *Mausoleum of Uljaytu* [87–8]; *Koran manuscript* made at Hamadan [106–7]	

North Africa, Europe and Byzantium	Near East and Iran	Central Asia, India and China
	1314 *Universal History* of Rashid al-Din [44, 104]	
1321 Death of Dante, author of the *Divine Comedy*		
1325 Fez, *Attarin madrasa* [93]		
	1330s Great Mongol *Shahnama* [105]	
	1336 Jalayirid dynasty established in Iraq and Azerbajan (to 1432)	
1337 Beginning of Hundred Years' War		
	1347 Plague in Egypt	
1348 Black Death reaches Europe		
	1356 Cairo, *Funerary Complex of Sultan Hasan* [94–5]	
		1368 Ming dynasty in China
		1370 Accession of Timur (to 1405)
	1396 *Khwaju Kirmani's poems* [110] illustrated at Baghdad	
		1398 Turkestan City, *Shrine of Ahmad Yasavi* [89–91]
1400 Death of Chaucer, author of the *Canterbury Tales*		
1445 Gutenberg prints first book with moveable type in Europe		
1452 Habsburgs become Holy Roman Emperors		
1453 Ottomans take Constantinople; end of Hundred Years' War		
		1488 Bihzad illustrates *Bustan* manuscript [112] for Sultan Husayn Mirza at Herat
1492 Christians conquer Granada and expel Muslims from Spain; Columbus sails to New World		
		1498 Vasco da Gama reaches India by sea
	1501 Safavid dynasty of Iran established	
***c.*1503** Leonardo da Vinci (1452–1519) paints the *Mona Lisa*		
1508–12 Michelangelo (1475–1564) paints ceiling of Sistine Chapel, Vatican, Rome		
1509 Accession of Henry VIII of England (to 1547)		
	1514 Ottomans defeat Safavids at Battle of Chaldiran	
	1516–17 Ottomans take Syria, Egypt and Arabia	

North Africa, Europe and Byzantium	Near East and Iran	Central Asia, India and China
1517 Martin Luther attaches 95 theses to church door in Wittenberg		
1519 Charles I of Spain becomes Holy Roman Emperor Charles V (to 1556)		
1520 Accession of Ottoman sultan Suleyman (to 1566)		
	1525–35 Shah Tahmasp's copy of the *Shahnama* [152, 181] illustrated	
		1526 Mughal dynasty established in India
1529 First Ottoman siege of Vienna		
	1539 *Ardabil Carpets* [193]	
1557 *Suleymaniye complex* [156–8] completed in Istanbul		
1558 Accession of Elizabeth I of England (to 1603)		
1564–5 Marrakesh, *Ben Yusuf Madrasa* [171] completed		
1571 Battle of Lepanto: Holy League defeats Ottomans		**1571** Mughal emperor Akbar founds new capital at *Fatehpur Sikri* [172–3]
	*c.***1587** Riza paints *Young Man in a Blue Coat* [189]	*c.***1587** *Akbarnama* illustrated in India [186]
1588 English defeat Spanish Armada		
	1590s Safavid shah Abbas I transfers capital to Isfahan [160]	
*c.***1600** Shakespeare (1564–1616) writes *Hamlet*		
1620 Pilgrim Fathers arrive in Massachusetts		
1632 Essay on solar system by Galileo (1564–1642)		
1642 Rembrandt (1606–69) paints *The Night Watch*		
1643 Accession of French king, Louis XIV (to 1715)		
		1644 Manchus take power in China
		1647 Agra, *Taj Mahal* [3, 151, 174]
1683 Second Ottoman siege of Vienna		
	1732 End of Safavid dynasty	
1764 James Hargreaves invents spinning-jenny; Industrial Revolution begins		
1776 American Revolution/War of Independence begins (to 1781)		
	1779 Qajar dynasty established in Iran	

North Africa, Europe and Byzantium	Near East and Iran	Central Asia, India and China
1789 Storming of Bastille; French Revolution		
	1798 Napoleon invades Egypt	
	1813 Mihr Ali paints *Portrait of Fath Ali Shah* [225]	
1815 Battle of Waterloo		
1821–30 Greek war of independence from Ottomans		
1830 French colony established in Algeria	**1830** Opening of Suez Canal	
1837 Accession of Queen Victoria (to 1901)		
1854–6 Crimean War: Ottomans, British and French versus the Russians		
		1857 Direct British rule established in India; end of Mughal dynasty
1861–5 American Civil War		
	1869 Pahlavis replace Qajar dynasty in Iran	
1914–18 World War I		
1924 Turkish republic replaces Ottoman dynasty		

Further Reading

General

General works on Islamic art include
Ettinghausen and Grabar (1987) and Blair and
Bloom (1994), Brend (1991), Grube (1966),
Rogers (1976), Sourdel-Thomine and Spuler
(1973); General works on Islamic history and
culture include Sourdel (1968), Hodgson
(1974) and Lapidus (1988). General works on
Islam include Gibb (1973), Endress (1988) and
The Encyclopaedia of Islam. Persian art is
discussed in *The Encyclopaedia Iranica,* Pope
and Ackerman (1977) and Ferrier (1989).

Many of the arts produced under the dynas-
ties of the middle and later periods are treated
together in colloquia and exhibition cata-
logues, including Hillenbrand (1994) on the
Saljuqs, Atıl (1981) on the Mamluks, Lentz and
Lowry (1989) on the Timurids, Atıl (1987) and
Rogers and Ward (1988) on the Ottomans,
Welch (1973–4) on the Safavids, *The Indian
Heritage* (1982), Brand and Lowry (1985) and
Welch (1988) on the Mughals. Many intercon-
nections between Islamic art and other tradi-
tions are discussed and illustrated in
Sievernich and Budde (1989) and Levenson
(1991).

Esin Atıl, *The Age of Sultan Süleyman the
Magnificent* (exh. cat., National Gallery of Art,
Washington, DC, 1987)

—, *Renaissance of Islam: Art of the Mamluks*
(exh. cat., Washington, DC, 1981)

Sheila S Blair and Jonathan M Bloom, *The Art and
Architecture of Islam, 1250–1800*, The Yale-
Pelican History of Art (London and New Haven,
1994)

Michael Brand and Glenn D Lowry, *Akbar's India:
Art from the Mughal City of Victory* (exh. cat.,
Asia Society Galleries, New York, 1985)

Barbara Brend, *Islamic Art* (Cambridge, MA,
1991)

Richard Ettinghausen and Oleg Grabar, *The Art
and Architecture of Islam: 650–1250*, The
Pelican History of Art (Harmondsworth, 1987)

The Encyclopaedia of Islam, eds H A R Gibb *et al.*
(new edn, Leiden, 1960–)

Gerhard Endress, *An Introduction to Islam*, trans.
by Carole Hillenbrand (Edinburgh, 1988)

R. W. Ferrier, *The Arts of Persia* (New Haven and
London, 1989)

H A R Gibb, *Mohammedanism, an Historical
Survey* (Oxford, 1973)

Ernst J Grube, *The World of Islam*, Landmarks of
the World's Art (New York and Toronto, 1966)

Robert Hillenbrand (ed.), *The Art of the Saljūqs in
Iran and Anatolia: Proceedings of a Symposium
held in Edinburgh in 1982* (Costa Mesa, CA,
1994)

Marshall G S Hodgson, *The Venture of Islam:
Conscience and History in World Civilization*, 3
vols (Chicago, 1974)

*The Indian Heritage: Court Life and Arts under
Mughal Rule* (exh. cat., Victoria & Albert
Museum, London, 1982)

Ira M Lapidus, *A History of Islamic Societies*
(Cambridge, 1988)

Thomas W Lentz and Glenn D Lowry, *Timur and
the Princely Vision* (exh. cat., Los Angeles
County Museum of Art, Los Angeles, 1989)

Jay A Levenson (ed.), *Circa 1492: Art in the Age
of Exploration* (exh. cat., National Gallery of Art,
Washington, DC, 1991)

A U Pope and P Ackerman (eds), *A Survey of
Persian Art from Prehistoric Times to the
Present*, 16 vols (London, 1938–9; 3rd edn,
Tokyo, 1977)

[J] Michael Rogers, *The Spread of Islam* (Oxford,
1976)

J M Rogers and R M Ward, *Süleyman the
Magnificent* (exh. cat., London, 1988)

Gereon Sievernich and Hendrik Budde (eds),
Europa und der Orient (exh. cat., Berlin, 1989)

D. & J. Sourdel, *La Civilisation de L'Islam
Classique* (Paris, 1968)

Janine Sourdel-Thomine and Bertold Spuler, *Die
Kunst Des Islam*, Propyläen Kunstgeschichte
(Berlin, 1973)

Anthony Welch, *Shah 'Abbas and the Arts of
Isfahan* (exh. cat., Fogg Art Museum,
Cambridge, MA and the Asia Society, New York,
1973–4)

Stuart Cary Welch, *India: Art and Culture
1300–1900* (exh. cat., The Metropolitan
Museum of Art, New York, 1988)

Ehsan Yarshater (ed.), *The Encyclopaedia Iranica*
(London, Boston, Henley, 1985–90; Costa Mesa,
CA, 1992–)

Arts of Building

General works on Islamic architecture include
Hoag (1977), Michell (1978) and Hillenbrand
(1994). For virtually all of the buildings
discussed in the first chapter, see the incom-
parable work of Creswell (1969). The forma-
tive period of Islamic architecture and art is
discussed by Grabar (1973) in an unusually
imaginative fashion. The early history of
Jerusalem and the Dome of the Rock are

discussed in J Raby and J Johns (1992), with full bibliography. For the Great Mosque in Damascus, see also Finster (1970) and Brisch (1988). An unusually lively and readable account of Khirbat al-Mafjar is provided by Hamilton (1988), who excavated the site between 1934 and 1948. On the *dolce vita* in Umayyad palaces, see Hillenbrand (1982). In addition to Creswell and Grabar, cited above, the early Abbasid period and the foundation of Baghdad is best approached through two works by Lassner (1970 and 1980). Similarities between late Umayyad and early Abbasid palaces have been discussed by Grabar (1959). For Samarra, in addition to the works of Creswell, see Rogers (1970) and Hodges and Whitehouse (1983) as well as the continuing work of Northedge (1993). The mosque of Kairouan is discussed by Creswell, as are the mosques of the Three Doors and Bu Fatata. For the nine-bay mosque type, see King (1989), which provides a convenient catalogue and bibliography, although his interpretation of the type as an honorific structure is open to question. For the palace at Baghdad, see Bloom (1993) and Lassner (1970).

No one work covers all the regional developments touched on in Chapter 5. In addition to such surveys as Ettinghausen and Grabar (1987) and Blair and Bloom (1994), for particular regions see works by Creswell (1979) and Meinecke (1992) on Egypt; Marçais (1954) and Barrucand and Bednorz (1992) on North Africa and Spain; Pope (1965), Seherr-Thoss (1968), Wilber (1969), and Golombek and Wilber (1988) on Iran and Central Asia. For the Friday Mosque at Isfahan, see Grabar (1990). For the development of the minaret, see Bloom (1989). For the development of the institution of the madrasa, see Makdisi (1981); some of the architectural developments are discussed by Creswell (1979). For Ibn Khaldun, see Ibn Khaldūn (1967). On Eurasian trade, see Abu-Lughod (1989). For Timur and his times, see Manz (1989). On the domestication of the camel and the rise of caravan trade, see Bulliet (1975). For the Alhambra, see Grabar (1978) as well as the review by Dickie (1981).

Ottoman buildings are accessible through Goodwin (1971). For the Safavids, see Hillenbrand in Jackson and Lockhart (1986). The expansion of Bukhara is discussed by McChesney (1987). The architecture of Mughal India is clearly and comprehensively presented in Asher (1992).

Janet L Abu-Lughod, *Before European Hegemony: The World System AD 1250–1350* (New York, 1989)

Catherine B Asher, *Architecture of Mughal India*, The New Cambridge History of India (Cambridge, 1992)

Marianne Barrucand and Achim Bednorz, *Moorish Architecture in Andalusia* (Cologne, 1992)

Sheila S Blair and Jonathan M Bloom, *The Art and Architecture of Islam, 1250–1800*, The Yale-Pelican History of Art (London and New Haven, 1994)

Jonathan M Bloom, *Minaret: Symbol of Islam* (Oxford, 1989)

—, 'The Qubbat Al-Khadrā' in Early Islamic Palaces', *Ars Orientalis*, 23 (1993), pp.131–7

Klaus Brisch, 'Observations on the Iconography of the Mosaics in the Great Mosque of Damascus', in *Content and Context of Visual Arts in the Islamic World*, ed. Priscilla P Soucek (University Park, PA and London, 1988), pp.13–24

Richard W Bulliet, *The Camel and the Wheel* (Cambridge, MA, 1975)

K A C Creswell, *Early Muslim Architecture*, 2 vols (Oxford, 1932–40; 2nd edn of vol.1 in 2 parts, Oxford, 1969; repr. New York, 1979)

—, *The Muslim Architecture of Egypt*, 2 vols (Oxford, 1952–9; repr. New York, 1979)

James Dickie, 'The Alhambra: Some Reflections Prompted by a Recent Study by Oleg Grabar', in *Studia Arabic et Islamica: Festschrift for Ihsan 'Abbas on his Sixtieth Birthday*, ed. W al-Qadi (Beirut, 1981), pp.127–49

Richard Ettinghausen and Oleg Grabar, *The Art and Architecture of Islam: 650–1250*, The Pelican History of Art (Harmondsworth, 1987)

Barbara Finster, 'Die Mosaiken der Umayyadenmoschee', *Kunst Des Orients*, 7 (1970), pp.83–141

Lisa Golombek and Donald Wilber, *The Timurid Architecture of Iran and Turan*, 2 vols (Princeton, 1988)

Godfrey Goodwin, *A History of Ottoman Architecture* (Baltimore, MD, 1971)

Oleg Grabar, *The Alhambra* (Cambridge, MA, 1978)

—, 'Al-Mushatta, Baghdād, and Wāsiṭ', in *The World of Islam; Studies in Honour of P. K. Hitti* (London, 1959), pp.99–108

—, *The Formation of Islamic Art* (New Haven and London, 1973)

—, *The Great Mosque of Isfahan* (New York, 1990)

Robert Hamilton, *Walid and His Friends: An Umayyad Tragedy* (Oxford, 1988)

Robert Hillenbrand, '*La dolce Vita* in Early Islamic Syria: The Evidence of Later Umayyad Palaces', *Art History*, v (1982), pp.1–35

—, *Islamic Architecture: Form, Function and Meaning* (Edinburgh, 1994)

John D. Hoag, *Islamic Architecture*, History of World Architecture, gen. ed., Pier Luigi Nervi (New York, 1977)

Richard Hodges and David Whitehouse, *Mohammed, Charlemagne and the Origins of Europe* (Ithaca, NY, 1983)

Washington Irving, *Legends of the Alhambra* (New York, 1832)

Ibn Khaldūn, *The Muqaddimah: An Introduction to History*, trans. by Franz Rosenthal, 3 vols (Princeton, 1958; 2nd edn 1967)

Peter Jackson and Laurence Lockhart (eds), *The Timurid and Safavid Periods*, The Cambridge History of Iran (Cambridge, 1986)

Geoffrey R D King, 'The Nine Bay Domed Mosque in Islam', *Madrider Mitteilungen*, 30 (1989), pp.332–90

Jacob Lassner, *The Shaping of 'Abbàsid Rule* (Princeton, 1980)

—, *The Topography of Baghdad in the Early Middle Ages* (Detroit, 1970)

Robert D McChesney, 'Economic and Social Aspects of the Public Architecture of Bukhara in the 1560s and 1570s', *Islamic Art*, 2 (1987), pp.217–42

George Makdisi, *The Rise of Colleges: Institutions of Learning in Islam and the West* (Edinburgh, 1981)

Beatrice Forbes Manz, *The Rise and Rule of Tamerlane* (Cambridge, 1989)

Georges Marçais, *Architecture Musulmane d'Occident* (Paris, 1954)

Michael Meinecke, *Die Mamlukische Architektur in Ägypten und Syrien*, 2 vols (Glückstadt, 1992)

George Michell (ed.), *Architecture of the Islamic World: Its History and Social Meaning* (London, 1978)

Alastair Northedge, 'An Interpretation of the Palace of the Caliph at Samarra (Dar al-Khilafa or Jawsaq al-Khaqani)', *Ars Orientalis*, 23 (1993), pp.143–70

Arthur Upham Pope, *Persian Architecture: The Triumph of Form and Color* (New York, 1965)

Julian Raby and Jeremy Johns (eds), *Bayt Al-Maqdis: 'Abd Al-Malik's Jerusalem, Part One* (Oxford, 1992)

J M Rogers, 'Sàmarrà: A Study in Medieval Town-Planning', in *The Islamic City*, eds A. H. and S. M. Stern Hourani ([Oxford and Philadelphia], 1970), pp.119–56

Sonia P Seherr-Thoss and Hans C Seherr-Thoss, *Design and Color in Islamic Architecture: Afghanistan, Iran, Turkey*, with an introduction by Donald N Wilber (Washington, DC, 1968)

Donald Wilber, *The Architecture of Islamic Iran: The Il Khânid Period* (Princeton, 1955; reprinted New York, 1969)

Arts of Writing and of the Book

For the Koran, see Watt (1970); the most readable version in English is by Arberry (1955), although many other versions exist. For pre-Islamic poetry, see Nicholson (1930) and Beeston *et al.* (1983). The comprehensive publication of Arabic inscriptions, beginning with that at al-Namara is by Combe *et al.* (1931–). For the inscription on the Dome of the Rock and related inscriptions on coins and milestones, see Blair (1992) and Bates (1986). The Fig milestone was published by Sharon (1966). The attribution of early manuscripts of the Koran has most recently been dealt with by Whelan (1990) and Déroche (1992). Examples of Koranic calligraphy can be found in many publications, including Lings (1976) and Lings and Safadi (1976). The publications of Koran manuscripts in the Nour collection are most magnificent and give a wonderful sense of the manuscripts as works of art; the 'Kufic' manuscripts have been published by Déroche (1992). Contemporary papyrus documents in the Nour collection have been published by Khan (1993).

For a general introduction to the history of the Islamic book, see Pedersen (1984). For the development of calligraphy, see Schimmel (1984). Many examples are illustrated in A. Welch (1979). On Ibn al-Bawwab and the Dublin manuscript see Rice (1955). The development of the illustrated Arabic book is discussed by Ettinghausen (1962). On the Maqamat, see Grabar (1984). For the general development of Persian book illustration from the fourteenth century, the most convenient introduction is still Gray (1961). Canby (1993) illustrates many examples from the British Museum/Library. For Rashid al-Din and his *Universal History*, see Rice (1976), Gray (1978) and Blair (1995). For the complicated and intriguing history, reconstruction and attribution of the Great Mongol *Shahnama*, see Grabar and Blair (1980). Koran manuscripts of the period are discussed by James (1988). Good colour illustrations of many of the finest Timurid manuscripts can be found in Lentz and Lowry (1989). The text of the colophon to the Turkoman *Khamsa*, as well as many other translations of contemporary documents, is given by Thackston (1989).

Safavid manuscripts of the Koran are discussed by James (1992). Safavid painting in particular is discussed by A Welch (1976) and S C Welch (1979). The great Tahmasp *Shahnama* is the subject of a popular book by S C Welch (1972) and of a luxury set by Dickson and Welch (1982). A good introduction to Ottoman painting is Atıl's essay in Atıl (1980). For the Suleymanname, see Atıl (1986). For Mughal painting, see Beach (1992) and Rogers (1993).

Arthur J Arberry, trans. *The Koran Interpreted* (New York, 1955)

Esin Atıl, *Süleymanname: The Illustrated History of Süleyman the Magnificent* (exh. cat., National Gallery of Art, Washington, DC, 1986)

—, *Turkish Art* (Washington, DC, 1980)

M L Bates, 'History, Geography and Numismatics in the First Century of Islamic Coinage', in *Revue Suisse de Numismatique*, 65 (1986), pp.231–62.

Milo Cleveland Beach, *Mughal and Rajput Painting*, The New Cambridge History of India (Cambridge, 1992)

A F L Beeston, T M Johnstone, R B Serjeant and G R Smith, *Arabic Literature to the End of the Umayyad Period*, The Cambridge History of Arabic Literature (Cambridge, 1983)

Sheila S Blair, *A Compendium of Chronicles: Rashid al-Din's Illustrated History of the World* (London, 1995)

—, 'What is the Date of the Dome of the Rock?', in *Bayt Al-Maqdis: 'Abd Al-Malik's Jerusalem, Part One*, eds Julian Raby and Jeremy Johns (Oxford, 1992), pp.59–88

Sheila R Canby, *Persian Painting* (New York, 1993)

Et Combe *et al.*, *Repertoire Chronologique d'Epigraphie Arabe*, 19 vols (Cairo, 1931–)

François Déroche, *The Abbasid Tradition: Qur'ans of the 8th to the 10th Centuries AD*, ed. Julian Raby (London, 1992)

Martin B Dickson and Stuart Cary Welch, *The Houghton Shahnama*, 2 vols (Cambridge, MA, 1982)

Richard Ettinghausen, *Arab Painting* (Geneva, 1962)

Oleg Grabar, *The Illustrations of the Maqamat* (Chicago, 1984)

Oleg Grabar and Sheila [S] Blair, *Epic Images and Contemporary History: The Illustrations of the Great Mongol Shah-nama* (Chicago, 1980)

Basil Gray, *Persian Painting* (Geneva, 1961)

—, *The World History of Rashid Al-Din: A Study of the Royal Asiatic Society Manuscript* (London, 1978)

David James, *After Timur: Qur'ans of the 15th and 16th Centuries*, ed. Julian Raby (London, 1992)

—, *Qur'ans of the Mamluks* (London, 1988)

Geoffrey Khan, *Bills, Letters and Deeds: Arabic Papyri of the 7th to 11th Centuries*, ed. Julian Raby (London, 1993)

Thomas W Lentz and Glenn D Lowry, *Timur and the Princely Vision* (exh. cat., Los Angeles County Museum of Art, Los Angeles, 1989)

Martin Lings, *The Qur'ānic Art of Calligraphy and Illumination* (London, 1976)

Martin Lings and Yasin Safadi, *The Qur'an* (exh. cat., London, 1976)

R A Nicholson, *Literary History of the Arabs* (Cambridge, 1930)

Johannes Pedersen, *The Arabic Book*, ed. and introduction Robert Hillenbrand, trans. by Geoffrey French (Princeton, 1984)

D. S. Rice, *The Unique Ibn Al-Bawwāb Manuscript in the Chester Beatty Library* (Dublin, 1955)

David Talbot Rice, *The Illustrations to the 'World History' of Rashid al-Din*, ed. Basil Gray (Edinburgh, 1976)

J M Rogers, *Mughal Miniatures* (New York, 1993)

Annemarie Schimmel, *Calligraphy and Islamic Culture* (New York, 1984)

M Sharon, 'An Arabic Inscription from the Time of the Caliph 'Abd Al-Malik', *Bulletin of the School of Oriental and African Studies*, 29 (1966), pp.369–72

Wheeler M Thackston, *A Century of Princes: Sources on Timurid History and Art* (Cambridge, MA, 1989)

W Montgomery Watt, *Bell's Introduction to the Qur'ān* (Edinburgh, 1970)

Anthony Welch, *Artists for the Shah* (New Haven, 1976)

—, *Calligraphy in the Arts of the Muslim World* (Austin, TX, 1979)

S C Welch, *A King's Book of Kings* (exh. cat., Metropolitan Museum of Art, New York, 1972)

—, *Wonders of the Age: Masterpieces of Early Safavid Painting, 1501–1576*, contributions by Sheila R Canby and Nora Titley (exh. cat., Fogg Art Museum, Cambridge, MA, 1979)

Estelle Whelan, 'Writing the Word of God: Some Early Qur'ān Manuscripts and their Milieux, Part I', *Ars Orientalis*, 20 (1990 [1991]), pp.113–48

Arts of the Loom

The bewildering array of textile terminology is clearly explained in Emery (1980). The principal study (in French) of textiles in Islamic society is Lombard (1978), a collection of the author's lectures given at the Collège de France. Some of the economic basis for textiles and other manufactures in Asia is discussed by Chaudhuri (1990). A suggestive essay on the role of textiles in Islamic society and art was written by Golombek (1988). Much of the textual evidence for early Islamic textiles was assembled by Serjeant (1972), and much anecdotal information taken from contemporary texts is collected by Ahsan (1979). Zandaniji textiles were identified by Shepherd and Henning (1959) and by Shepherd (1981). There are useful articles on the basic fibres – linen, cotton, and silk in the *Dictionary of the Middle Ages* and *The Encyclopaedia of Islam*. The basic publication on tiraz is by Kühnel (1952). The Moshchevaya Balka caftan was published by Riboud (1976) and Jeroussalimskaja (1978).

For the Cairo Geniza, see Goitein (1967–94). For the Veil of Ste Anne, see Marçais and Wiet (1934). For the shroud of St Josse, see Bernus, Marchal and Vial (1971). For the Buyid silks, see Blair, Bloom and Wardwell (1993). Most of the important Spanish-Islamic textiles and carpets are discussed and illustrated in Dodds (1992). A convenient introduction to the bewildering world of carpets is Black (1985). The best introduction to Persian carpets is the *Encyclopaedia Iranica*, under the heading 'Carpets' (1987). Safavid textiles are discussed in Bier (1987).

M M Ahsan, *Social Life Under the Abbasids* (London and New York, 1979)

M Bernus, H Marchal and G Vial, 'Le Suaire de Saint-Josse', *Bulletin de Liaison du Centre International d'Etudes des Textiles Anciens*, 33 (1971), pp.1–57.

Carol Bier (ed.), *Woven from the Soul, Spun from the Heart: Textile Arts of Safavid and Qajar Iran 16th–19th Centuries* (exh. cat., The Textile Museum, Washington, DC, 1987)

David Black (ed.), *The Macmillan Atlas of Rugs & Carpets* (New York, 1985)

Sheila S Blair, Jonathan M Bloom and Anne E Wardwell, 'Reevaluating the Date of the "Buyid" Silks by Epigraphic and Radiocarbon Analysis', *Ars Orientalis*, 22 (1993), pp.1–42

K N Chaudhuri, *Asia Before Europe: Economy and Civilisation of the India Ocean from the Rise of Islam to 1750* (Cambridge, 1990)

Jerrilynn D Dodds (ed.), *Al-Andalus: The Art of Islamic Spain* (exh. cat., Metropolitan Museum of Art, New York, 1992)

Irene Emery, *The Primary Structures of Fabrics: An Illustrated Classification* (Washington, DC, 1966; repr. with corrections 1980)

The Encyclopaedia of Islam, eds H A R Gibb *et al.* (new edn, Leiden, 1960–)

S D Goitein, *A Mediterranean Society*, 6 vols (Berkeley and Los Angeles, 1967–94)

Lisa Golombek, 'The Draped Universe of Islam', in *Content and Context of Visual Arts in the Islamic World*, ed. Priscilla P Soucek (University Park, PA and London, 1988), pp.25–49

A Jeroussalimskaja, 'Le cafetan aux simourghs du tombeau de Mochtchevaja Balka (Caucase Septentrional)', *Studia Iranica*, 7 (1978), pp.182–212

Ernst Kühnel, *Catalogue of Dated Tiraz Fabrics: Umayyad, Abbasid, Fatimid*, technical analysis by Louisa Bellinger (Washington, DC, 1952)

Maurice Lombard, *Les Textiles dans le Monde Musulman VIIe–XIIe Siècle*, Civilisations et Sociétés 61 (Paris-La Haye-New York, 1978)

Georges Marçais and Gaston Wiet, 'Le "voile de Sainte Anne" d'Apt', *Academie des Inscriptions et Belles-Lettres, Fondation Eugène Piot, Monuments et Mémoires*, 34 (1934), pp.1–18

Krishna Riboud, 'A Newly Excavated Caftan from the Northern Caucasus', *Textile Museum Journal*, 4 (1976), pp.21–42

R B Serjeant, *Islamic Textiles: Material for a History to the Mongol Conquest*, collected articles published in *Ars Islamica* (Beirut, 1972)

Dorothy Shepherd, 'Zandaniji Revisited', in *Documenta Textilia: Festschrift für Sigrid Müller-Christensen*, eds Mechthild Flury-Lemberg and Karen Stolleis (Deutscher Kunstverlag, 1981), pp.105–22

Dorothy Shepherd and W Henning, 'Zandaniji Identified?', in *Aus der Welt der Islamischen Kunst: Festschrift für Ernst Kühnel* (Berlin, 1959), pp.15–40

Joseph R Strayer (ed.), *The Dictionary of the Middle Ages*, 13 vols (New York, 1982–9)

The Arts of Fire and Other Arts

Most of the basic techniques of ceramics, glassmaking and metallurgy are explained in al-Hassan and Hill (1992). Ceramic techniques are further discussed in Soustiel (1985). The classic work on early Islamic ceramics is still Lane (1947). The basic publication of unglazed relief pottery is by Reitlinger (1951). For the history of blue-and-white, see Carswell (1985). A convenient introduction to Islamic glass is found in Jenkins (1986). Islamic metalwares are discussed by Baer (1983) and Ward (1993). Technical issues are addressed by Allan (1979) and Atıl, Chase and Jett (1985).

The clearest résumé of Islamic ceramics is by Watson (1985). Many of the ceramics in the Freer Gallery have been published by Atil (1973), and those in the Benaki Museum by

Philon (1980). The Gerona and Pamplona caskets are discussed in Dodds (1992). The Bobrinsky Bucket has been studied by Ettinghausen (1943). The general development of Persian lustrewares is studied by Watson (1985). The specific iconography of the Freer plate is discussed by Guest and Ettinghausen (1961), the Freer beaker by Simpson (1981). Islamic metalwork with Christian themes has been studied by Baer (1989). The date and meaning of the Baptistère of Saint-Louis is still a matter of lively debate: see Atıl (1981), Bloom (1987) and Behrens-Abouseif (1988–9).

Iznik ceramics are discussed by Atasoy and Raby (1989). Many of the luxury objects made for the Ottomans are discussed in Köseoğlu (1987). Bidri ware is the subject of a catalogue by Stronge (1985).

Y Ahmad al-Hassan and Donald R Hill, *Islamic Technology, an Illustrated History* (Cambridge, 1992)

James W Allan, *Persian Metal Technology: 700–1300 AD*, appendix by Alex Kaczmarczyk and Robert E M Hedges (London, 1979)

Esin Atıl, W T Chase and Paul Jett, *Islamic Metalwork in the Freer Gallery of Art* (Washington, DC, 1985)

—, *Renaissance of Islam: Art of the Mamluks* (exh. cat., Washington, DC, 1981)

Nurhan Atasoy and Julian Raby, *Iznik: The Pottery of Ottoman Turkey* (London, 1989)

Esin Atıl, *Ceramics from the World of Islam* [in the Freer Gallery of Art] (Washington, DC, 1973)

Eva Baer, *Ayyubid Metalwork with Christian Images* (Leiden, 1989)

—, *Metalwork in Medieval Islamic Art* (Albany, NY, 1983)

Doris Behrens-Abouseif, 'The Baptistère de Saint Louis: A Reinterpretation', *Islamic Art*, 3 (1988–9), pp.3–9

Jonathan M Bloom, 'A Mamluk Basin in the L A Mayer Memorial Institute', *Islamic Art*, 2 (1987), pp.15–26

John Carswell, *Blue and White: Chinese Porcelain and Its Impact on the Western World* (exh. cat., The David and Alfred Smart Gallery, University of Chicago, 1985)

Jerrilynn D Dodds (ed.), *Al-Andalus: The Art of Islamic Spain* (exh. cat., Metropolitan Museum of Art, New York, 1992)

Richard Ettinghausen, 'The Bobrinski "Kettle": Patron and Style of an Islamic Bronze', *Gazette des Beaux-Arts*, 6 sér., 24 (1943), pp.193–208

Grace D Guest and Richard Ettinghausen, 'The Iconography of a Kashan Luster Plate', *Ars Orientalis*, 4 (1961), pp.25–64

Marilyn Jenkins, 'Islamic Glass: A Brief History', *The Metropolitan Museum of Art Bulletin*, 44: 2 (1986), entire issue

Cengiz Köseoğlu, *The Topkapi Saray Museum: The Treasury*, trans., expand. & ed. J M Rogers (Boston, 1987)

Arthur Lane, *Early Islamic Pottery* (London, 1947)

Helen Philon, *Early Islamic Ceramics: Ninth to Late Twelfth Centuries*, catalogue, Benaki Museum, Athens (London, 1980)

Gerald Reitlinger, 'Unglazed Relief Pottery from Northern Mesopotamia', *Ars Islamica*, 15–16 (1951), pp.11–22

Marianna Shreve Simpson, 'The Narrative Structure of a Medieval Iranian Beaker', *Ars Orientalis*, 12 (1981), pp.15–31

Jean Soustiel, *La Céramique Islamique: Le Guide du Connaisseur* (Fribourg, 1985)

Susan Stronge, *Bidri Ware: Inlaid Metalwork from India* (London, 1985)

Rachel Ward, *Islamic Metalwork* (New York, 1993)

Oliver Watson, 'Ceramics', in *Treasures of Islam*, ed. Toby Falk (London, 1985)

—, *Persian Lustre Ware* (London, 1985)

Index

Numbers in **bold** refer to illustrations

Acknowledgements

We are indebted to many friends and colleagues
for help in preparing this book. Marc Jordan, who
first suggested the idea to us, genially encour-
aged us to finish the manuscript; Pat Barylski and
Julia MacKenzie nurtured the transformation of a
manuscript into this handsome volume. Robert
Hillenbrand and Margaret Ševčenko read drafts of
several chapters and offered invaluable advice,
saving us from egregious errors and infelicitous
phrases. Students at Trinity College, Hartford,
read an early version of the text and offered
candid comments. Carol Bier, Stefano Carboni,
Wheeler M Thackston and Anne Wardwell
graciously answered specific questions. The
incomparable facilities of the Harvard University
Library were generously made available through
the Center for Middle Eastern Studies at Harvard
and its director, William A Graham.

J B and S B

In memory of Yetta

Photographic Credits

Collection Prince Sadruddin Aga Khan: 152, 181; al-Sabah Collection, Dar al-Athar al-Islamiyah, Kuwait: 130, 140, 220; American Numismatic Society, New York: 12, 30, 31, 32, 33; Ancient Art and Architecture Collection: 78, 79, 80; Art Institute of Chicago, Lucy Maud Buckingham Collection: 209; Arxiu Mas: 136, 137; Ashmolean Museum, Oxford: 214; Benaki Museum, Athens: 134; Bildarchiv Preussischer Kulturbesitz, Berlin: 6, 25, 62, 63, 64, 120, 191; Jonathan M Bloom & Sheila S Blair: 10, 21, 52, 53, 66, 81, 82, 88, 89, 90, 91, 93, 94, 96, 99, 151, 166, 171; Bodleian Library, Oxford: 101; Bridgeman Art Library: 103, 139, 182, 186; British Library, London, 34, 110, 188; British Museum, London, Department of Oriental Antiquities: 41, 57, 145, 149, 218; Cairo National Library: 106, 107, 108, 112; Chester Beatty Library, Dublin: 38, 39, 102, 180; Cincinnati Art Museum, gift of the children of Mr & Mrs Charles F Williams: 217; Cleveland Museum of Art: Leonard C Hanna Jr Fund 116, J H Wade Fund 198; K A C Creswell, *Early Muslim Architecture*, 2 vols, 1932: 17; Professor Walter B Denny: 77, 159, 196, 197; Dr François Déroche: 36; John Donat: 87; Edifice: 3; Edinburgh University Library, Scotland: 44, 104; Freer Gallery of Art, Smithsonian Institution, Washington, DC: 65, 133, 141, 142, 143, 144, 146, 147, 175; Fine Arts Museums of San Francisco, Museum Purchase, Roscoe and Margaret Oakes Income Fund: 45; Gemeentemuseum, The Hague: 150; Glasgow Museums, The Burrell Collection: 195; Sonia Halliday Photographs: 164; R W Hamilton, *Khirbat al-Mafjar – An Arabian Mansion in the Jordan Valley*, 1959, after Oleg Grabar, drawing by G U Spencer Corbett: 54; Robert Harding Picture Library: 16, 74, 86, 100, 154, 161, 165, 167, 168, 169; Robert Harding Picture Library: photo Mohamed Amin 4, photo Robert Frerck 98, 156, photo Michael Jenner 13, 212, photo Christopher Rennie 71, 170, photo G M Wilkins 76, photo Adam Woolfitt 158; Harvard University Art Museums: Francis H Burr Memorial Fund 37; courtesy of the Arthur M Sackler Museum, gift of John Goelet 205; Hermitage, St Petersburg: 67, 138, 222; Hutchison Library: 173; Yasuhiro Ishimoto: 1, 73, 174; Ann & Peter Jousieffe: 97; A F Kersting: 172; Nasser D Khalili Collection of Islamic Art, Nour Foundation: 35; Anthony King/Medimage: 2; Kunsthistorisches Museum, Vienna: 122; Leiden University Library: 155; Marlborough Photographic Library: frontispiece, 95, 113, 114, 124, 127, 177, 178, 183, 184, 189, 202, 211, 213, 221; Fred Mayer/Magnum Photos: 9; Metropolitan Museum of Art, New York: 60, 125, gift of Mrs Charles S Payson 55, gift of V Everit Macy 56, excavations of the Metropolitan Museum of Art-Rogers Fund 59, 68, gift of Horace Havemeyer 61, Cloisters Collection 132, gift of James F Ballard 201, gift of Ruth Blumka 223; Monastery of Las Huelgas, Burgos: 123; Mountain High Maps, copyright © 1995 Digital Wisdom Inc: 5, 72, 153; Musée Historique de Lorraine, Nancy: 42; Musée de l'Homme, Paris: 216; Museum of Fine Arts, Boston: Helen and Alice Colburn Fund 46, Francis Bartlett Donation of 1912 and Picture Fund 190, Ellen Page Hall Fund 121, gift of Mrs S D Warren 215; National Gallery, London: 126, 128; National Gallery of Art, Washington, DC: 206; Professor Bernard O'Kane: 92; Österreichisches Museum für Angewandte Kunst, Vienna: 200; Private collection: 225; Zev Radovan: 8, 14; RMN, Paris: 118, 148; Royal Armoury, Stockholm: 199, 204; Arthur M Sackler Gallery, Smithsonian Institution, Washington, DC: 105, 109; Scala, Florence: 70, 194; Staatliches Museum für Volkerkunde, Munich: 58; Textile Museum, Washington, DC: 50, 51, 119, acquired by George Hewitt Myers 131; Thyssen-Bornemisza Collection, Lugano: 207; Topkapi Palace Library, Istanbul: 111, 115, 117, 176, 185, 203, 210; Trip Photographic Library/H Rogers: 19; Francesco Venturi/KEA: 84, 85; Victoria and Albert Museum, London: 47, 48, 49, 192, 193, 208, 219, 224, 226; Walters Art Gallery, Baltimore: 187; Ole Woldbye: 43, 69; Roger Wood/© Corbis: 18, 20, 163

Phaidon Press Limited
Regent's Wharf
All Saints Street
London N1 9PA

First published 1997
© Phaidon Press Limited 1997

ISBN 0 7148 3176 X

A CIP catalogue record for this book is
available from the British Library.

Typeset in Univers

Printed in Hong Kong

Cover illustration Ceramic lamp made for
the Dome of the Rock, Jerusalem, 1549
(see pp.394–5)